T0292442

Mechanik, Werkstoffe und Konstruktion im Bauwesen

Band 46

Institutsreihe zu Fortschritten bei Mechanik, Werkstoffen, Konstruktionen, Gebäudehül-
len und Tragwerken.

Johannes K. Kuntsche

Mechanisches Verhalten von Verbundglas unter zeitabhängiger Belastung und Explosionsbeanspruchung

Mechanical behaviour of laminated
glass under time-dependent
and explosion loading

Johannes K. Kuntsche
Institut für Statik und Konstruktion
Technische Universität Darmstadt
Deutschland

Vom Fachbereich 13 – Bau- und Umweltingenieurwissenschaften
der Technischen Universität Darmstadt

zur Erlangung des akademischen Grades eines
Doktor-Ingenieurs (Dr.-Ing.)
genehmigte Dissertation von

Dipl.-Ing. Johannes K. Kuntsche

aus Köln

1. Gutachten: Prof. Dr.-Ing. Jens Schneider
2. Gutachten: Prof. Dr.-Ing. habil. Stefan Kolling
Tag der Einreichung: 15. Juni 2015
Tag der mündlichen Prüfung: 28. August 2015
Darmstadt 2015
D17

Mechanik, Werkstoffe und Konstruktion im Bauwesen
ISBN 978-3-662-48830-0 ISBN 978-3-662-48831-7 (eBook)
DOI 10.1007/978-3-662-48831-7
Die Deutsche Nationalbibliothek verzeichnet diese Publikation in der Deutschen Nationalbibliografie;
detaillierte bibliografische Daten sind im Internet über http://dnb.d-nb.de abrufbar.

Springer Vieweg
© Springer-Verlag Berlin Heidelberg 2015

Gedruckt auf säurefreiem und chlorfrei gebleichtem Papier

Springer-Verlag Berlin Heidelberg ist Teil der Fachverlagsgruppe Springer Science+Business Media
(www.springer.com)

Danksagung

Einen ganz herzlichen Dank möchte ich allen Personen aussprechen, die mich bei der Erstellung der vorliegenden Arbeit unterstützt und begleitet haben. Die Zeit als wissenschaftlicher Mitarbeiter am Institut für Statik und Konstruktion der Technischen Universität Darmstadt war für mich rückblickend ein besonderer und sehr positiver Lebensabschnitt.

Herrn Prof. Dr.-Ing. Jens Schneider danke ich für die großartige Möglichkeit, an seinem Lehrstuhl zu promovieren. Ich habe dort ein sehr angenehmes Umfeld mit einer ausgeglichenen Atmosphäre vorgefunden, welche ein selbständiges Arbeiten bei gleichzeitiger fachlicher Unterstützung ermöglichte. Herrn Prof. Dr.-Ing. habil. Stefan Kolling danke ich für die Übernahme des Korreferats und die äußerst interessanten und motivierenden Diskussionen.

Für weitere fachliche und auch mentale Unterstützung bedanke ich mich bei allen Kollegen am Institut – sowohl bei den mittlerweile Ehemaligen als auch bei der aktuellen zweiten Generation. Insbesondere möchte ich Johannes Franz und Stephan Buddenberg für die unzähligen Gespräche danken, die wir in Bezug auf unsere sich fachlich ergänzenden Themen geführt haben. Ein großer Dank gilt auch den Studierenden, die mich im Rahmen von Studienarbeiten bei meiner Forschungsarbeit unterstützt haben.

Meiner Familie, insbesondere meiner Frau Ina danke ich für die uneingeschränkte Unterstützung und Motivation in dieser gesamten Zeit.

Darmstadt, im September 2015 *Johannes K. Kuntsche*

Kurzfassung

Das mechanische Verhalten von Verbundglas ist unter anderem abhängig vom zeitlichen Verlauf der Belastung und in dieser Hinsicht noch nicht hinreichend erforscht. In der vorliegenden Arbeit wurden unterschiedliche Aspekte des Tragverhaltens von Verbundglas unter zeitabhängiger Belastung und insbesondere unter Explosionsbeanspruchung untersucht. Dabei wurden sowohl der Werkstoff Glas als auch verschiedene Zwischenschichtmaterialien sowie das Zusammenwirken beider Komponenten betrachtet.

Die Festigkeit von Glas ist aufgrund des subkritischen Risswachstums von der Belastungsdauer abhängig. Anhand von experimentellen und theoretischen Untersuchungen wurden Festigkeitswerte für kurzzeitige dynamische Beanspruchungen ermittelt. Es wurde eine deutliche Steigerung der Festigkeit gegenüber quasistatischer Belastung festgestellt.

An den Zwischenschichten wurden Dynamisch-Mechanisch-Thermische Analysen durchgeführt, um die Steifigkeit im Bereich kleiner Verzerrungen in Abhängigkeit von Belastungsdauer und Temperatur zu untersuchen. Für die anschließende Parameteridentifikation der verwendeten Materialmodelle wurde ein Optimierungsverfahren entwickelt. Die Ergebnisse wurden anhand von Kriechversuchen am Verbundglas validiert. Damit kann dessen mechanisches Verhalten bis zum Zeitpunkt des Glasbruchs vollständig beschrieben werden.

Durch experimentelle Untersuchungen im Stoßrohr und deren numerischer Simulation wurde gezeigt, dass im Lastfall Explosion eine linear-elastische Beschreibung der Zwischenschicht ausreichend ist, solange das Glas nicht bricht.

Nach dem Glasbruch ändert sich das Tragverhalten: Die Zwischenschicht erfährt große Dehnungen und löst sich lokal vom Glas ab. Anhand von uniaxialen Zugversuchen mit unterschiedlichen Belastungsraten wurde das mechanische Verhalten verschiedener Zwischenschichten bis hin zu großen Dehnungen untersucht und bewertet. Der Einfluss von Steifigkeit und Haftung auf das Nachbruchverhalten im Lastfall Explosion wurde experimentell anhand von Kleinbauteil- und Stoßrohrversuchen aufgezeigt. Demnach soll eine optimierte Zwischenschicht eine geringe Haftung, eine geringe Steifigkeit und eine hohe Bruchdehnung aufweisen. Die experimentellen Ergebnisse wurden mit numerischen Simulationen, welche auch das Nachbruchverhalten erfassen, verglichen.

Abstract

The mechanical behaviour of laminated glass depends, inter alia, on the time history of the applied load. As this relation has not been sufficiently investigated yet, the present work discusses different aspects of the structural behaviour of laminated glass under time-dependent loading and particularly under explosion loading. In this context, the material glass and different interlayer materials as well as the interaction of both components were investigated.

The strength of glass depends on load duration due to the subcritical crack growth. On the basis of experimental and theoretical investigations, strength values for short-term dynamic loads were determined. Compared to quasi-static loading, a significant increase of the strength was ascertained.

Dynamic Mechanical Thermal Analyses were performed on the interlayers to investigate the effect of load duration and temperature on the stiffness at small strains. Subsequently, an optimization method was developed to identify parameters for the applied material models. The results were validated by creep tests on laminated glass specimens. Thus, the mechanical behaviour of laminated glass can be fully described until glass breakage occurs.

Under explosion loading, a linear elastic modelling of the interlayer is sufficient as long as the glass is unbroken. This was shown by experimental studies in a shock tube and associated numerical simulations.

After glass breakage occurs, the structural behaviour changes: The interlayer suffers large strains and delaminates locally from the glass. On the basis of uniaxial tensile tests at different loading rates, the mechanical behaviour of different interlayers was investigated up to large strains. The influence of stiffness and adhesion on the post-breakage behaviour under explosion loading was demonstrated experimentally in small-scale experiments and shock tube tests. Accordingly, an optimized interlayer should have low adhesion, low stiffness and high failure strain. The experimental results were compared to numerical simulations, which also capture the post-breakage behaviour.

Résumé

Le comportement mécanique du verre feuilleté dépend entre autre de l'évolution temporel du chargement et n'a pas encore été suffisamment étudié à cet égard. Dans le présent travail, différents aspects du comportement structurel du verre feuilleté soumis à des charges dépendantes du temps et surtout des contraintes explosives ont été examinés en prenant compte des propriétés mécaniques du verre et de l'intercalaire, ainsi que de l'interaction entre ces matériaux.

Dû à la fissuration sous-critique, la résistance du verre dépend de la durée du chargement. Sur la base de recherches expérimentales et théoriques, des valeurs de résistance ont été déterminées pour des charges dynamiques à courte durée. Une augmentation significative de la résistance par rapport à une charge quasi-statique a été constatée.

Des analyses mécaniques dynamiques thermiques ont été effectuées sur des films intercalaires afin d'examiner l'influence de la durée de chargement et de la température sur la rigidité pour des faibles déformations. Pour l'identification des paramètres du matériau, un procédé d'optimisation a été développé. Les résultats ont été validés par des tests de fluage sur du verre feuilleté. Ceci permet de décrire le comportement mécanique du verre feuilleté jusqu'à la rupture du verre.

Il a été montré par des études expérimentales dans le tube à choc et par leur simulation numérique, que pour le cas de charge explosion, une description linéaire élastique de l'intercalaire est suffisante jusqu'à la rupture du verre.

Après la rupture du verre, le comportement structurel change: L' intercalaire subit une grande déformation et se sépare localement du verre. Sur base des essais de traction uniaxiale sous différents vitesses de chargement, le comportement mécanique des intercalaires a été étudiée pour des grandes déformations. L'influence de la rigidité et de l'adhésion au comportement après rupture sous le cas de charge explosion a été démontrée expérimentalement en utilisant des tests de tube à choc et des essais sur petits composants. En conséquence, un intercalaire optimisé devrait avoir une adhérence et rigidité faible et un allongement à la rupture élevé. Les résultats des études expérimentaux ont été comparés avec des simulations numériques qui capturent aussi le comportement après rupture.

Inhaltsverzeichnis

Abkürzungen und Formelzeichen

Wichtige Abkürzungen

abZ	allgemeine bauaufsichtliche Zulassung
BG	Building Grade (Standard PVB)
Boro33	Borosilikat-Floatglas mit $\alpha_T = 3{,}3 \cdot 10^{-6}\,\mathrm{K}^{-1}$
Boro40	Borosilikat-Floatglas mit $\alpha_T = 4{,}0 \cdot 10^{-6}\,\mathrm{K}^{-1}$
DMR	Dehnmessrosette
DMS	Dehnmessstreifen
DMTA	Dynamisch-Mechanisch-Thermische Analyse
DRBV	Doppelring-Biegeversuch
DSC	Differential Scanning Calorimetry
ES	Extra Strong (Steifes PVB)
ESG	Einscheibensicherheitsglas
EVA	Ethylenvinylacetat
FEM	Finite-Elemente-Methode
KNS	Kalknatron-Silikatglas
KNS-ESG	Kalknatron-Silikat-ESG
KNS-Float	Kalknatron-Silikat-Floatglas
PSV	Pendelschlagversuch
PVB	Polyvinylbutyral
Pyran	Borosilikat-ESG aus Boro40
SC	Sound Control (Schallschutz PVB)
SG	SentryGlas®
TCB	Through Cracked Bending
TCT	Through Cracked Tensile
TMA	Thermomechanische Analyse
TPU	Thermoplastisches Polyurethan
TVG	Teilvorgespanntes Glas
VAC	Vinylacetat

VG	Verbundglas
VSG	Verbundsicherheitsglas
WLF	Williams-Landel-Ferry
ZiE	Zustimmung im Einzelfall
ZTV	Zeit-Temperatur-Verschiebungsprinzip

Formelzeichen und Symbole

Für Formelzeichen aus der Kontinuumsmechanik wird auf Abschnitt 2.3.4 verwiesen.

α_T	Temperaturausdehnungskoeffizient
a	Risstiefe
a_i	initiale Risstiefe (Anfangsrisstiefe)
a_T	Verschiebungsfaktor (Zeit-Temperatur-Verschiebungsprinzip)
A	Querschnittsfläche
A_Z	Zerfallkoeffizient (Friedlander-Gleichung)
c_1, c_2	Konstanten in der Williams-Landel-Ferry (WLF) Gleichung
C_R	Reflektionsfaktor
δ	Phasenwinkel
$\tan\delta$	Verlustfaktor
Δ	Separation im Through Cracked Tensile Test
D	Delamination im Through Cracked Tensile Test
ε_0	technische Dehnung
$\varepsilon, \varepsilon_w$	wahre Dehnung
ε_b	Reißdehnung (Bruchdehnung, technisch)
η	Viskosität
E	Elastizitätsmodul
f	Frequenz
f_k	charakteristischer Wert der Festigkeit
f_m	Mittelwert der Festigkeit
F	Kraft
γ	Scherung (Gleitung)
g	relativer Schubmodul
G	Schubmodul
G^*	komplexer Schubmodul
G'	Speichermodul
G''	Verlustmodul
h	Dicke

i_+	positiver Impuls
J	Scherkomplianz (Schernachgiebigkeit)
k_A	Arrhenius-Konstante
k_B	Boltzmann-Konstante
k_{mod}	Modifikationsbeiwert für Lasteinwirkungsdauer
K_I	Spannungsintensitätsfaktor (Modus I)
K_{Ic}	kritischer Spannungsintensitätsfaktor (Bruchzähigkeit)
K_{I0}	Ermüdungsschwelle
ν	Querkontraktionszahl
n	Risswachstumsparameter
n_V	Anzahl an Verschlaufungen oder Vernetzungspunkten
ω	Kreisfrequenz
φ	Fluidität
P	Druck
P_0	Umgebungsluftdruck
P_E	einfallender Überdruck
P_R	reflektierter Überdruck
ρ	Dichte
σ_0	technische Spannung
σ, σ_w	wahre Spannung
σ_1	Erste Hauptspannung (Hauptzugspannung)
σ_b	Reißfestigkeit (Bruchspannung, technisch)
σ_r	Oberflächendruckspannung
s	Standardabweichung
τ	Schubspannung
τ_i	Relaxationszeit im verallgemeinerten Maxwell-Modell
t	Zeit
t_+	Dauer der positiven Druckphase
T	Temperatur
T_g	Glasübergangstemperatur
T_m	Kristallitschmelztemperatur
T_{ref}	Referenztemperatur
T_s	Schmelztemperatur
T_z	Zersetzungstemperatur
v	Risswachstumsgeschwindigkeit
v_0	Risswachstumsgeschwindigkeit bei K_{Ic}
V	Variationskoeffizient

x	Auslenkung
\bar{x}	Mittelwert
Z	skalierter Abstand

1 Einleitung

1.1 Motivation

Der zunehmende Einsatz von Glas im Bauwesen, bedingt durch den architektonischen Wunsch nach filigranen und transparenten Strukturen, erfordert ein grundlegendes Verständnis für eine materialgerechte Konstruktion und Bemessung dieses Werkstoffs. Dem spröden, unangekündigten Bruchverhalten von Glas wird durch den Einsatz von Verbundglas begegnet, bei welchem Kunststoffschichten zwischen zwei oder mehreren Glasplatten angeordnet werden. Sind nach dem Glasbruch sicherheitsrelevante Aspekte wie Splitterbindung und Resttragfähigkeit der Konstruktion sichergestellt, spricht man von Verbundsicherheitsglas.

Diese Produktbezeichnung lässt bereits auf die üblichen Einsatzgebiete von Verbundgläsern schließen, bei denen die Gefährdung von Personen durch einen Glasbruch zu verhindern ist. Beispiele hierfür sind Horizontalverglasungen mit darunter befindlichen Verkehrsflächen sowie absturzsichernde, begehbare oder zu Reinigungszwecken betretbare Verglasungen. Auch Verglasungen, die eine Schutzfunktion gegenüber Einbruch, Beschuss oder Explosion aufweisen sollen, werden üblicherweise mit Verbundglas ausgeführt. Die Verwendung von monolithischen Verglasungen führt insbesondere bei dem Lastfall Explo-

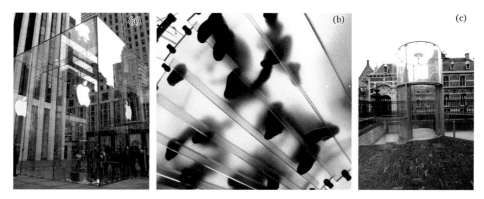

Abbildung 1.1 Anwendung von Verbundglas im Bauwesen: konstruktiver Werkstoff, Absturzsicherung und Horizontalverglasung (a) sowie begehbare Verglasung im Apple Store New York (b); konstruktiver Werkstoff, Absturzsicherung und Horizontalverglasung im Museum Mauritshuis Den Haag (c)

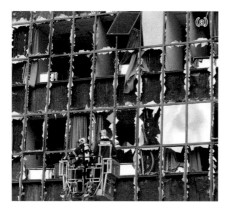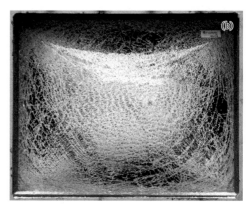

Abbildung 1.2 Auswirkungen einer Explosion auf ein Gerichtsgebäude in Athen mit monolithischem Glas, Bildnachweis: dpa (a); Verbundglas nach einer Prüfung auf Explosionsschutz im Stoßrohr (b)

sion zu einem hohen Sicherheitsrisiko: Eine Vielzahl an Verletzungen entsteht bei einem solchen Ereignis durch fliegende Glassplitter (NORVILLE, 2005).

Immer häufiger wird Glas zudem als konstruktiver Werkstoff eingesetzt. Hier ist ein unangekündigtes Versagen des Glasbauteils, welches zum vollständigen Versagen der Konstruktion führt, nicht akzeptabel. In Abbildung 1.1 werden typische Anwendungen von Verbundgläsern dargestellt.

In Abbildung 1.2 wird die signifikante Verbesserung des Nachbruchverhaltens und die damit einhergehende Reduktion des Gefährdungspotentials von Verbundglas gegenüber monolithischen Verglasungen im Lastfall Explosion verdeutlicht. Während bei monolithischen Verglasungen (a) die Glassplitter mit hoher Geschwindigkeit in den Schutzbereich fliegen, werden sie bei Verbundgläsern (b) von der Folie zurückgehalten.

Die Verwendung von Zwischenschichten aus Kunststoff führt zu der Fragestellung nach der Dauer der Belastung und der dabei vorherrschenden Temperatur, da beide Einflussfaktoren signifikante Auswirkungen auf die mechanischen Eigenschaften des Kunststoffs haben. Für das wachsende Angebot unterschiedlicher Zwischenschichtmaterialien sind vergleichende Untersuchungen nötig, um Materialeigenschaften und die Eignung für bestimmte Anwendungssituationen zu beurteilen.

Im intakten Zustand, wenn keine Glasplatte gebrochen ist, wirkt sich die Steifigkeit der Zwischenschicht direkt auf die Schubkopplung der Glasplatten und damit auf die erzeugten Deformationen und Spannungen im Glas aus. Zur realitätsnahen Modellierung eines Verbundglases ist daher die temperatur- und zeitabhängige Steifigkeit der Zwischenschicht zu berücksichtigen.

Bei einem Bruch der Glasplatten erfährt die Zwischenschicht große Dehnungen bis zum Versagen. Dabei löst sich lokal an den Bruchstellen die Verbindung von Folie und

Glas (Delamination), sodass neben der Steifigkeit auch die Haftung einen maßgebenden Einfluss auf das Nachbruchverhalten ausübt.

Die Steifigkeit des Werkstoffs Glas zeigt im baupraktischen Einsatzbereich demgegenüber keine Abhängigkeit von Belastungsdauer und Temperatur, die Festigkeit dagegen schon.

Untersuchungen zum mechanischen Verhalten von Verbundglas im Lastfall Explosion, welcher als außergewöhnlicher Lastfall in bestimmten Bauprojekten maßgebend werden kann, wurden bisher nur wenige veröffentlicht. Die Besonderheit gegenüber den im Bauwesen üblichen Einwirkungen liegt in der zwar kurzzeitigen aber hohen Intensität der Belastung. Ein Tragfähigkeitsnachweis wird derzeit üblicherweise mittels zeit- und kostenintensiver Experimente geführt, da noch keine zuverlässigen rechnerischen Bemessungsmethoden existieren.

Die experimentelle Ermittlung und rechnerische Berücksichtigung der mechanischen Eigenschaften von Verbundglas im intakten und im gebrochenen Zustand stellt ein aktuelles wissenschaftliches und wirtschaftliches Interesse dar und wird in der vorliegenden Arbeit behandelt. Der intakte Zustand wird dabei allgemeingültig für beliebige Belastungsdauern und -temperaturen und im Besonderen für den Lastfall Explosion betrachtet. Die Untersuchungen zum gebrochenen Zustand, welcher in mechanischer Hinsicht wesentlich komplexer zu beschreiben ist, beschränken sich auf den Lastfall Explosion.

1.2 Zielsetzung

Das Verständnis zur Beschreibung des mechanischen Verhaltens von Verbundglas beinhaltet unterschiedliche Aspekte, die sich auf den Werkstoff Glas, die verwendete Zwischenschicht oder die Interaktion beider Werkstoffe beziehen. Die hierfür angestrebten Forschungsbeiträge dieser Arbeit werden in diesem und dem folgenden Abschnitt verdeutlicht und in den aktuellen Stand der Forschung eingeordnet.

Das isotrope Materialverhalten des Werkstoffs Glas lässt sich ausreichend genau mithilfe der linearen Elastizitätstheorie beschreiben. Die Materialparameter zur Beschreibung der Steifigkeit sind bekannt und in hinreichendem Maß bestätigt (SCHOLZE, 1988, DIN EN 572-1). Für eine Versagensprognose werden darüber hinaus Festigkeitswerte benötigt. Hier zeigt Glas eine Abhängigkeit von der Belastungsdauer. Der quasistatischen Belastung widmen sich bereits eine Vielzahl von Untersuchungen. Für kurzzeitige dynamische Einwirkungen, denen auch der Lastfall Explosion zuzuordnen ist, liegen dagegen nur wenige Veröffentlichungen vor. Im Rahmen dieser Arbeit werden daher experimentelle Untersuchungen durchgeführt und mit der Theorie der linear-elastischen Bruchmechanik verglichen, um Werte für die Kurzzeitfestigkeit im Lastfall Explosion abzuleiten.

Zur Charakterisierung des mechanischen Verhaltens der Kunststoff-Zwischenschichten ist eine Unterscheidung zwischen der Belastung im intakten und im gebrochenen Verbundglas zweckmäßig. Die beschränkten Verzerrungen, welche die Zwischenschicht im intak-

ten Verbundglas erfährt, ermöglicht die Anwendung der linearen Viskoelastizität. In Verbindung mit dem Zeit-Temperatur-Verschiebungsprinzip kann die Steifigkeit vollständig in Abhängigkeit von Belastungszeit und Temperatur beschrieben werden. Hierzu werden experimentelle Untersuchungen durchgeführt und Auswertemethoden entwickelt, um Parameter für geeignete Materialmodelle abzuleiten. Eine Validierung der Materialparameter erfolgt anhand von Bauteilversuchen. Die Untersuchungen erfolgen im Hinblick auf im Bauwesen übliche Belastungsdauern und darüber hinaus auf den Lastfall Explosion.

Nach einem Versagen der Gläser erfährt die Zwischenschicht große Dehnungen im Bereich der Bruchstellen. Die Anwendung der linearen Viskoelastizität ist hierfür nicht mehr gerechtfertigt, da die Kunststoffe sich sowohl in Bezug auf die Elastizität als auch auf die Viskosität bei großen Dehnungen nichtlinear verhalten. Im Lastfall Explosion entstehen diese großen Dehnungen in sehr kurzer Zeit, weshalb die Dehnraten (Ableitung der Dehnung nach der Zeit) nicht mit denen aus quasistatischen Belastungen vergleichbar sind. Der Einfluss der Dehnrate auf das Spannungs-Dehnungs-Verhalten wird daher in dieser Arbeit experimentell untersucht.

Neben den in Verbundglas überwiegend eingesetzten Folien aus Polyvinylbutyral (PVB) werden für bestimmte Anwendungen andere Zwischenschichten beispielsweise aus Ethylenvinylacetat (EVA), Ionoplast oder thermoplastischem Polyurethan (TPU) verwendet. Zur Beurteilung der Materialeigenschaften und Empfehlung hinsichtlich einer geeigneten Materialauswahl in Abhängigkeit des Anwendungsfalls beleuchten die Untersuchungen dieser Arbeit einen Großteil der im Bauwesen verwendeten Zwischenschichten im direkten Vergleich.

Schließlich wird das mechanische Verhalten von Verbundglas im Lastfall Explosion unter Beachtung der Interaktion von Glas und Zwischenschicht untersucht. Die Berechnung des intakten Zustands ist mithilfe der Finiten Elemente Methode (FEM) möglich. Eine Validierung dessen erfolgt anhand experimenteller und numerischer Untersuchungen, um zukünftig zeit- und kostenintensive Bauteilprüfungen zu reduzieren.

Das mechanische Verhalten im gebrochenen Zustand wird durch mehrere Aspekte beeinflusst. Maßgeblich ist neben der Steifigkeit der Zwischenschicht bei großen Dehnungen auch die Haftung zum Glas. Der Einfluss beider Parameter auf das Nachbruchverhalten im Lastfall Explosion wird im Hinblick auf eine Optimierung untersucht. Die Berechnung des gebrochenen Zustands ist noch nicht zuverlässig möglich. Ein Vergleich mit den derzeit möglichen Berechnungsmethoden und dem realen Tragverhalten wird durchgeführt und kritisch hinterfragt, um eine Orientierung für weiterführenden Forschungsbedarf abzuleiten.

1.3 Aktueller Stand der Forschung

Nachfolgend wird der Stand der Forschung bezüglich des mechanischen Verhaltens von Verbundglas unter zeitabhängiger Belastung und Explosionsbeanspruchung zusammenfassend dargelegt. Der Struktur dieser Arbeit entsprechend erfolgt dies durch eine Gliederung in die Bereiche Glasfestigkeit, Zwischenschichten, intaktes Verbundglas und Nachbruchverhalten. Dabei werden noch offene Aspekte angesprochen, zu denen im Rahmen dieser Arbeit Beiträge geleistet wurden.

Eine gesicherte Aussage zur **Festigkeit von Glas** unter kurzzeitigen dynamischen Einwirkungen ist derzeit nur eingeschränkt möglich. Das ist insbesondere begründet durch die geringe Anzahl an experimentellen Untersuchungen in Verbindung mit der üblichen starken Streuung bei Festigkeitsuntersuchungen mit Glas. Hier sind die Arbeiten von SCHNEIDER, 2001, NIE et al., 2010 und PERONI et al., 2011 zu nennen, deren Ergebnisse in Abschnitt 2.2.2 ausführlich dargelegt werden.

Die linear-elastische Bruchmechanik ist eine geeignete Theorie zur Beschreibung des Versagens von spröden Werkstoffen. Wird das bei Glas beobachtete subkritische Risswachstum erfasst, kann der Einfluss der Belastungsdauer auf die Festigkeit anhand von Lebensdauerprognosen quantifiziert werden. Eine umfängliche Berücksichtigung der verschiedenen Bereiche des subkritischen Risswachstums zur Prognose der Kurzzeitfestigkeit von Glas ist bisher allerdings noch nicht erfolgt.

Unterschiedliche Aspekte des mechanischen Verhaltens von **Verbundglas-Zwischenschichten** wurden bereits an einzelnen Produkten untersucht. Das zeit- und temperaturabhängige Verhalten von Folien aus PVB bei kleinen Verzerrungen wurde in VALLABHAN et al., 1992, FRIED, 1995, SOBEK et al., 2000, SCHULER, 2003, ENSSLEN, 2005, KASPER, 2005 und SACKMANN, 2008 anhand von Kriech- oder Relaxationsversuchen im Glaslaminat untersucht. Ergebnisse aus Dynamisch-Mechanisch-Thermischen Analysen (DMTA) sind in VAN DUSER et al., 1999, HOOPER, 2011, BARREDO et al., 2011 und KOTHE, 2013 veröffentlicht. Für Ionoplastfolien hat der damalige Hersteller des Produkts SentryGlas® Steifigkeitsparameter in Abhängigkeit von Zeit und Temperatur publiziert (BENNISON et al., 2008). Darüber hinaus wurden Kriechversuche bei verschiedenen Temperaturen in CALLEWAERT, 2011 und DMTA in KOTHE, 2013 durchgeführt.

Kriech- oder Relaxationsversuche am Laminat zeigen starke Einschränkungen bei der messtechnischen Erfassung des breiten Steifigkeitsbereichs eines Kunststoffs. Hier und in Bezug auf die Gesamtprüfzeit zeichnen sich DMTA durch eine höhere Effizienz aus. Der Einfluss des Belastungsmodus (Zug, Scherung, Torsion etc.) auf die Ergebnisse über den gesamten Steifigkeitsbereich ist aber auch hier signifikant und wurde bisher nicht untersucht. Eine wissenschaftlich belastbare Empfehlung, wie eine DMTA zur Ermittlung von mechanischen Materialparametern für Verbundglas-Zwischenschichten durchzuführen ist, steht somit nicht zur Verfügung.

Viskoelastische Materialmodelle in Form von Prony-Reihen wurden für PVB in VAN
DUSER et al., 1999, SCHULER, 2003, ENSSLEN, 2005, SACKMANN, 2008, BARREDO
et al., 2011 und HOOPER, 2011 veröffentlicht. Ein Vergleich wird in Abschnitt 4.3.3 dar-
gestellt. Die maximale Anzahl an Reihengliedern ist bei allen Modellen eingeschränkt,
sodass nur ein bestimmter Zeitbereich erfasst werden kann. Zusammenfassend ist festzu-
stellen, dass die Beschreibung des zeitabhängigen Materialverhaltens mithilfe der linearen
Viskoelastizität bereits mehrfach angewandt wurde. Eine strukturierte Vorgehensweise zur
Ermittlung der benötigten Materialparameter bis hin zur experimentellen Validierung liegt
jedoch noch nicht vor.

Das uniaxiale Spannungs-Dehnungs-Verhalten der Zwischenschicht bei großen Deh-
nungen bis zum Bruch kann anhand von Zugversuchen ermittelt werden. Die Zeitabhän-
gigkeit lässt sich dabei über die Belastungsgeschwindigkeit erfassen. Kurzzeitige dynami-
sche Belastungen, die bei dem Lastfall Explosion auftreten, lassen sich in Hochgeschwin-
digkeitsprüfmaschinen realisieren. Diesbezügliche Untersuchungen an PVB-Folien wur-
den erst in jüngerer Zeit durchgeführt und von BENNISON et al., 2005, IWASAKI et al.,
2007, MORISON, 2007 und HOOPER, 2011 veröffentlicht. Zu Ionoplastfolien existieren
bisher nur Untersuchungen des Herstellers (BENNISON et al., 2005). Andere Untersuchun-
gen beschränken sich auf quasistatische Belastungsgeschwindigkeiten (MEISSNER et al.,
2005; BELIS et al., 2009; PULLER, 2012; KOTHE, 2013). In Abschnitt 4.3.3 werden die
Ergebnisse der genannten Untersuchungen verglichen. Folien aus EVA oder TPU wurden
bisher nicht in Versuchen mit unterschiedlichen Belastungsgeschwindigkeiten untersucht.
Parameter für geeignete Materialmodelle wurden selten abgeleitet. Zudem erfolgte bei kei-
ner der Untersuchungen eine Auswertung zu Spannungs-Dehnungs-Beziehungen bei kon-
stanter wahrer Dehnrate, die für einen aussagekräftigen Vergleich von unterschiedlichen
Materialien untereinander sowie für eine Implementierung in geeignete Materialmodelle
erforderlich sind.

Das **mechanische Verhalten eines intakten Verbundglases** lässt sich bei Kenntnis
der Zwischenschichtsteifigkeit im für die jeweilige Problemstellung relevanten Zeit- und
Temperaturbereich beschreiben. Für eine konstant angenommene Zwischenschichtstei-
figkeit existieren analytische Näherungsverfahren (STAMM et al., 1974; WÖLFEL, 1987;
KUTTERER, 2005). Zur Abbildung komplexer Geometrien oder zur Berücksichtigung der
Zeit- und Temperaturabhängigkeit stehen eine Vielzahl kommerzieller Finite-Elemente-
Programme zur Verfügung. Bisher wurde noch nicht anhand experimenteller Untersuchun-
gen umfassend validiert, dass mithilfe eines solchen FE-Modells der Deformations- und
Spannungsverlauf in einer intakten Verglasung im Lastfall Explosion bei Berücksichtigung
von Lagerungssituation und Massenträgheit realitätsnah abgebildet werden kann.

Rechnerische Prognosen zum **mechanischen Verhalten eines gebrochenen Verbund-
glases** stellen ein wesentlich komplexeres Problem dar. Untersuchungen unter quasistati-
scher Belastung wurden bereits mehrfach veröffentlicht. Jedoch stellen sowohl die ex-
perimentelle Auswertung bestimmter Aspekte (Rissfortschritt im Glas, Delamination der

Zwischenschicht vom Glas, Verzerrungen der Zwischenschicht an der Bruchstelle) als auch deren numerische Abbildung noch nicht abschließend gelöste Fragestellungen dar (SESHADRI et al., 2002; KOTT, 2006; FAHLBUSCH, 2007; NIELSEN et al., 2009; BUT-CHART et al., 2012; FRANZ, 2015).

Für den kurzzeitigen dynamischen Lastfall Explosion können einige Aspekte der quasistatischen Belastung vereinfacht werden. Beispielsweise kann die Zeitabhängigkeit der Belastung durch eine Dehnratenabhängigkeit der Zwischenschicht im Modell erfasst werden. Die Simulation von Kriechprozessen ist hiermit nicht möglich aber auch nicht erforderlich.

Bisherige **Untersuchungen zur Explosionsbeanspruchung** von Verglasungen stammen insbesondere aus Großbritannien und den USA. Oftmals wurde dabei für eine Bemessung eine Reduktion auf einen Einfreiheitsgradschwinger durchgeführt (ARA, 2005; WEI et al., 2006; MORISON, 2007; ZOBEC et al., 2015). Eine realitätsnahe Abbildung der Schwingung des Plattenmittelpunkts über die Ermittlung von Ersatzsteifigkeit und -masse ist für den intakten Zustand auch unter Beachtung geometrischer Nichtlinearität ohne Weiteres möglich (BIGGS, 1964; SMITH, 2001; MORISON, 2007; UFC 3-340-02, 2008). Problematisch ist dagegen die Berücksichtigung des Nachbruchverhaltens und die Ermittlung des Versagens, welches als Auslenkungskriterium (Verformungskriterium) definiert werden muss. Letzteres erfolgt in der Regel mittels experimenteller Untersuchungen, konservativer Abschätzungen oder Finite-Elemente-Berechnungen. Eine Übertragbarkeit des Auslenkungskriteriums auf andere Geometrien, Randbedingungen, Abmessungen und Glasaufbauten ist daher nur eingeschränkt möglich und nicht validiert. Die gestiegene Leistungsfähigkeit von Rechnern und Finite-Element-Programmen stellt zudem die Berechtigung solcher vereinfachter Bemessungsmodelle in Frage.

Aktuelle Dissertationen zum mechanischen Verhalten von explosionshemmenden Verglasungen stammen von MORISON, 2007 und HOOPER, 2011. MORISON, 2007 fasst die früheren Untersuchungen zu Einfreiheitsgradschwingern zusammen und entwickelt darauf aufbauend eine Analysemethode zur Bemessung von Verbundglas unter Explosionsbelastung. Nach Glasbruch wird dabei dem Einfreiheitsgradschwinger die Steifigkeit der reinen PVB-Membran zugewiesen. HOOPER, 2011 führte experimentelle und numerische Untersuchungen zu silikonverklebten Verglasungen unter Explosionsbelastung durch. Das dabei erstellte FE-Modell berücksichtigt das Nachbruchverhalten durch eine global reduzierte Steifigkeit in Verbindung mit einem Plastizitätsmodell. Ein Schwerpunkt der Untersuchungen lag in der Dimensionierung der Silikonverklebung.

Nur wenige Ergebnisse experimenteller Untersuchungen von Verglasungen unter Explosionsbelastungen liegen bisher als frei zugängliche Veröffentlichungen vor (KRANZER et al., 2005; BURMEISTER et al., 2005; MORISON, 2007; HOOPER, 2011; LARCHER et al., 2012). Insofern besteht generelles Forschungsinteresse, weitere Versuchsergebnisse unter Angabe der gewählten Instrumentierung und validierungsfähiger Ergebnisgrößen zu veröffentlichen.

Die Haftung (Adhäsion) zwischen Glas und Zwischenschicht beeinflusst maßgeblich das Delaminationsverhalten und damit das Nachbruchverhalten von Verbundgläsern. Eine hierzu geeignete Untersuchungsmethode im Kleinformat ist der Through Cracked Tensile (TCT) Test, welcher quasistatisch bereits mehrfach mit Zwischenschichten aus PVB oder Ionoplasten durchgeführt wurde (SESHADRI et al., 2002; FERRETTI et al., 2012; BUTCHART et al., 2012; DELINCÉ, 2014; FRANZ, 2015). Untersuchungen mit hohen Belastungsgeschwindigkeiten, die den Lastfall Explosion beschreiben, liegen dagegen kaum vor. Lediglich HOOPER, 2011 führte quasistatische und dynamische TCT Tests mit mehrfach gebrochenen PVB-Laminaten durch, um den Einfluss von Belastungsgeschwindigkeit und Foliendicke auf das Delaminationsverhalten zu untersuchen und ein verschmiertes (globales) Materialmodell für das gebrochene Verbundglas abzuleiten. Der Einfluss unterschiedlicher Haftgrade und Zwischenschichtsteifigkeiten auf das Nachbruchverhalten wurde bisher weder in TCT Tests noch in Explosionsversuchen untersucht.

Die Simulation des Nachbruchverhaltens von Verbundglas unter Explosionsbeanspruchung mit der Methode der Finiten Elemente beinhaltet noch einige ungelöste Fragestellungen. Neben der Abbildung des Rissfortschritts im Glas betrifft dies insbesondere das Materialverhalten der Zwischenschicht sowie die lokale Delamination der Zwischenschicht vom Glas an den Bruchstellen. Die heute gängige Methode zur Rissfortschrittssimulation unter kurzzeitigen dynamischen Beanspruchungen ist das Löschen von Elementen bei Erreichen eines definierten Versagenskriteriums (Erosion). Neue Methoden wie beispielsweise die Extended FEM (XFEM) (BELYTSCHKO et al., 2009) zeigen diesbezüglich vielversprechende Ansätze, sind jedoch in ihrer Anwendung auf komplexe Bruchvorgänge hinsichtlich Rissverzweigung und einer großen Anzahl an Rissen noch beschränkt.

Die angewandten Modellierungstechniken reichen von der Simulation des gesamten Verbundglases mit Ein-Schalen-Modellen bis zur Abbildung aller Schichten mit Volumenelementen (SCHNEIDER et al., 2004; TIMMEL et al., 2007; KONRAD et al., 2010; THOMPSON, 2010; LARCHER et al., 2012). Eine thermodynamisch konsistente Kopplung des viskoelastischen Verhaltens der Zwischenschicht und der Nichtlinearität bei großen Dehnungen ist derzeit noch nicht als zuverlässiges Materialmodell in kommerziellen FE-Programmen verfügbar. Eine vereinfachte Möglichkeit stellt die dehnratenabhängige Hyperelastizität dar (KOLLING et al., 2007). Die Delamination der Zwischenschicht vom Glas kann mittels Kohäsivzonenelementen numerisch abgebildet werden (SESHADRI et al., 2002; WU et al., 2010; FRANZ, 2015).

Insgesamt ist festzustellen, dass es derzeit noch nicht möglich ist, mit einem FE-Modell das mechanische Verhalten eines gebrochenen Verbundglases prognosesicher abzubilden.

1.4 Inhalt und Gliederung der Arbeit

Die Gliederung der vorliegenden Arbeit ist in Abbildung 1.3 dargestellt.

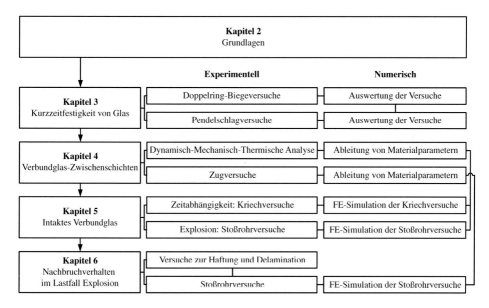

Abbildung 1.3 Übersicht über experimentelle und numerische Untersuchungen dieser Arbeit

In **Kapitel 2** werden die für diese Arbeit relevanten **Grundlagen** zusammengefasst. Ausgehend von einer zeitlichen Einordnung der im Glasbau üblichen Einwirkungen werden die Besonderheiten des Lastfalls Explosion dargelegt. Anschließend wird das mechanische Verhalten des Werkstoffs Glas und von Kunststoffen erläutert. Darauf aufbauend folgt eine Beschreibung des Bauprodukts Verbundglas sowie dessen Zwischenschichten und der Anwendung als explosionshemmende Verglasung. Die Beschreibung der Zwischenschichten wird ausführlich gehalten, da diese einen Schwerpunkt der vorliegenden Arbeit darstellen und bisher in keinem Standardwerk vergleichbar dargestellt wurden. Schließlich werden wichtige Aspekte bei der numerischen Behandlung zeitabhängiger Probleme erläutert.

Die eigenen Untersuchungen werden in den Kapiteln 3 bis 6 beschrieben. Diese Kapitel sind, sofern möglich, symmetrisch aufgebaut mit einer allgemeinen Einführung, der Darstellung der experimentellen und numerischen Untersuchungen und einer Zusammenfassung am Ende des Kapitels.

Kapitel 3 behandelt die durchgeführten **Untersuchungen zur Kurzzeitfestigkeit von Glas**. Um die Steigerung der Festigkeit bei kurzzeitiger Beanspruchung gegenüber den

normativ angegebenen Werten experimentell zu untersuchen, wurden quasistatische Doppelring-Biegeversuche (DRBV) und dynamische Pendelschlagversuche (PSV) durchgeführt. Die Auswertung der Ergebnisse erfolgte mit numerischen Hilfsmitteln: Für die Doppelring-Biegeversuche wurde ein FE-Modell erstellt, um die Spannungen im Glas bei der jeweils gemessenen Kraft sowie die vorliegenden Elastizitätsmoduln der verschiedenen Glasarten zu ermitteln. Die Pendelschlagversuche wurden ebenfalls exemplarisch mithilfe eines FE-Modells nachgerechnet. Für die Auswertung der Versuche war die bruchmechanische Ermittlung der Anfangsrisstiefe entscheidend, welche für die dynamischen Pendelschlagversuche anhand einer transienten Simulation numerisch erfolgte. Hierbei wurden erstmals alle Bereiche des subkritischen Risswachstums berücksichtigt. Darauf aufbauend erfolgte eine Prognose der Kurzzeitfestigkeit in Abhängigkeit der Anfangsrisstiefe und der Spannungsrate.

In **Kapitel 4** werden die **Untersuchungen zum mechanischen Verhalten von Verbundglas-Zwischenschichten** dargestellt. Zur Charakterisierung der Steifigkeit verschiedener Verbundglas-Zwischenschichten in Abhängigkeit von Belastungszeit und Temperatur im Bereich kleiner Verzerrungen wurden Dynamisch-Mechanisch-Thermische Analysen (DMTA) durchgeführt. Ein Vergleich verschiedener Belastungsmodi dient dazu, Empfehlungen für geeignete Prüfmethoden abzuleiten. Das zeitabhängige Verhalten bei großen Dehnungen wurde anhand von uniaxialen Zugversuchen bei Raumtemperatur untersucht. Hierbei wurden verschiedene Belastungsgeschwindigkeiten realisiert, um quasistatische Belastungen bis hin zu Explosionsbeanspruchungen zu erfassen. Anschließend erfolgte eine Auswertung zu Spannungs-Dehnungs-Beziehungen bei konstanter wahrer Dehnrate.

Aus den DMTA an PVB wurden Materialparameter für viskoelastische Materialgesetze (Prony-Reihen) und Zeit-Temperatur-Verschiebungsansätze abgeleitet. Hierfür wurde ein allgemein anwendbares Optimierungswerkzeug entwickelt, welches eine beliebige Anzahl an unbekannten Parametern zulässt. Aus den Zugversuchen wurden linear-elastische und hyperelastische Materialparameter ermittelt. Neben einem umfassenden Vergleich der untersuchten Materialien untereinander wird ein Vergleich der ermittelten Materialkennwerte mit Literaturangaben dargestellt.

Die in **Kapitel 5** beschriebenen **Untersuchungen zum mechanischen Verhalten von intaktem Verbundglas** gliedern sich in zwei Aspekte. Anhand von Kriechversuchen wurden die viskoelastischen Materialparameter von PVB validiert. Der Lastfall Explosion wurde mittels Stoßrohrversuchen an zwei Verbundglasaufbauten mit jeweils drei Probekörpern untersucht. Die Belastung im Stoßrohr wurde dabei stufenweise bis zum Glasbruch gesteigert. Mithilfe zweier Finite-Elemente-Modelle wurden die Stoßrohrversuche abgebildet und mit den experimentellen Ergebnissen verglichen.

In **Kapitel 6** werden die **Untersuchungen zum Nachbruchverhalten von Verbundglas im Lastfall Explosion** dargestellt. Neben Glasart, Glasdicke und der Lagerung der

Verglasung wird das Nachbruchverhalten maßgeblich durch die Steifigkeit und das De-
laminationsverhalten der Zwischenschicht beeinflusst. Letzteres wurde mit verschiedenen
Zwischenschichten im Rahmen von Haftungsversuchen sowie Through Cracked Tensile
(TCT) Tests bei verschiedenen Belastungsgeschwindigkeiten untersucht. Die Durchfüh-
rung der TCT Tests in einer Hochgeschwindigkeitsprüfmaschine ermöglichte vergleich-
bare Belastungsgeschwindigkeiten wie bei einer Explosionsbeanspruchung. Der Einfluss
von Steifigkeit und Haftung auf das Nachbruchverhalten im Lastfall Explosion wurde zu-
dem mittels einer weiteren Versuchsserie im Stoßrohr experimentell untersucht. Hierbei
wurden im Vergleich zur Untersuchung des intakten Zustands dünnere Verbundglaslami-
nate mit dickeren Zwischenschichten geprüft, um ein ausgeprägtes Nachbruchverhalten
zu erzielen. Diese Versuche wurden ebenfalls aufwändig instrumentiert, um validierungs-
fähige Ergebnisse wie die zeitliche Auslenkung des Plattenmittelpunkts zu erhalten. An-
schließend wurden zwei FE-Modelle erstellt, um das Nachbruchverhalten zu simulieren:
Zum einen mittels einer Reduktion der gesamten Plattensteifigkeit bei Erreichen eines
Bruchkriteriums für das Glas und zum anderen durch eine diskrete Simulation der Risse
mittels Löschen einzelner Elemente (Erosion). Verschiedene in dem kommerziellen FE-
Programm *LS-DYNA* zur Verfügung stehende Mittel wurden dabei angewendet, um das
mechanische Verhalten von Verbundglas im Lastfall Explosion auch unter Berücksichti-
gung des Nachbruchverhaltens möglichst realitätsnah zu erfassen. Dabei wurden die in
Kapitel 4 ermittelten Spannungs-Dehnungs-Beziehungen der Zwischenschicht bei kon-
stanter wahrer Dehnrate genutzt. Die Ansätze und Ergebnisse der Simulationen werden
schließlich kritisch diskutiert.

In **Kapitel 7** wird die Arbeit zusammengefasst und ein Ausblick für weiterführende
Untersuchungen gegeben.

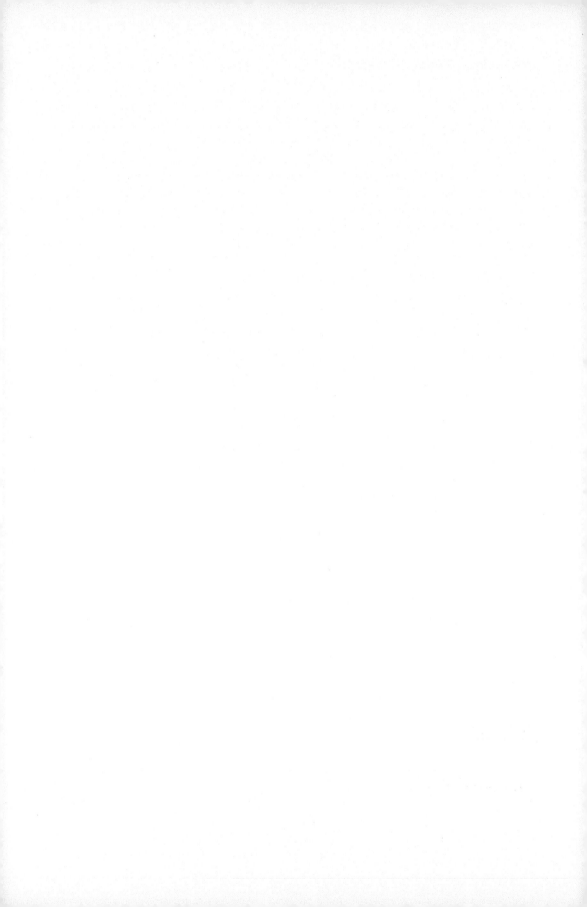

2 Grundlagen

2.1 Einwirkungen

2.1.1 Allgemeines

Das mechanische Verhalten von Verbundglas ist aufgrund der Zwischenschichten aus Kunststoff abhängig von Temperatur und Belastungsdauer. Darüber hinaus zeigt die Festigkeit von Glas ebenfalls eine Abhängigkeit von der zeitlichen Belastungshistorie. Aus diesem Grund sollen zu Beginn dieser Arbeit die Einwirkungen, denen Verglasungen ausgesetzt sein können, betrachtet werden. Daraus lassen sich für die Widerstandsseite die baupraktisch relevanten Temperatur- und Zeitbereiche eingrenzen.

Abbildung 2.1 veranschaulicht das breite Zeitspektrum der Einwirkungen auf Verglasungen. In Tabelle 2.1 sind alle Einwirkungen, die bei der Bemessung von Verglasungen üblicherweise zu beachten sind, zusammengefasst. Neben einem Verweis auf die relevanten Regelwerke wird die der Bemessung zugrunde liegende Einwirkungsdauer genannt. Die Belastung durch eine Stoßwelle infolge einer Explosion (Detonation), welche hier einen Schwerpunkt darstellt, wird als Vergleich ebenfalls aufgeführt und in Abschnitt 2.1.2 ausführlich behandelt.

Angaben zum Temperaturbereich können DIN EN 1991-1-5 entnommen werden. Hierin sind für Deutschland Außenlufttemperaturen von $-24\,°C$ bis $37\,°C$ anzunehmen. Im Bauteil selbst können jedoch durch Absorption der Sonnenstrahlung deutlich höhere Temperaturen auftreten. Ein Temperaturbereich von $-20\,°C$ bis $80\,°C$ ist realistisch, wobei bisher nur wenige Forschungsergebnisse diesbezüglich veröffentlicht wurden. In klaren Verbundgläsern ohne Bedruckung, Färbung oder Kontakt zu opaken Flächen ist ei-

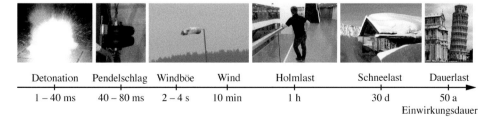

Detonation	Pendelschlag	Windböe	Wind	Holmlast	Schneelast	Dauerlast
$1-40$ ms	$40-80$ ms	$2-4$ s	10 min	1 h	30 d	50 a

Einwirkungsdauer

Abbildung 2.1 Zeitstrahl der Einwirkungsdauern für Verglasungen

Tabelle 2.1 Baupraktisch relevante Einwirkungen auf Verglasungen

Einwirkung	Einwirkungsdauer	Regelwerke
Detonation	1 ms bis 40 ms	DIN EN 13541
Pendelschlag	40 ms bis 80 ms	DIN 18008-4, DIN EN 12600
Wind	2 s bis 10 min	DIN EN 1991-1-4
Horizontale Nutzlast (Holmlast)	1 h[a]	DIN EN 1991-1-1
Klimalastanteile aus Temperatur- und Luftdruckunterschieden	keine Angaben	DIN 18008-1
Schnee	30 d[b]	DIN EN 1991-1-3
Dauerlast (z.B. Eigengewicht, Klima- lastanteil aus Ortshöhendifferenz)	25 a bis 50 a	DIN EN 1991-1-1, DIN 18008-1

[a] Festlegung der Fachkommission Bautechnik
[b] nach CHRISTOFFER, 1990

ne maximale Temperatur von 50 °C eine zutreffende Annahme (DIBT, 2011). Wird die Verglasung im Innenbereich eingesetzt, ist ein Nachweis bei Raumtemperatur (23 °C) in der Regel ausreichend.

Es ist festzustellen, dass insbesondere bei der Verwendung von Kunststoffen im Baubereich ein dringender Forschungsbedarf bezüglich realistischer Lastkollektive mit zeitlichen Last- und Temperaturhistorien besteht. Derzeit müssen noch zu viele Annahmen getroffen werden, die häufig weit auf der sicheren Seite liegen. Dies führt zu unwirtschaftlichen Bemessungen oder sogar dazu, die Verwendung des Bauprodukts vollständig auszuschließen.

2.1.2 Lastfall Explosion

Einführung

Eine Explosion stellt eine plötzliche physikalische oder chemische Zustandsänderung dar, bei welcher eine hohe Menge an Energie in sehr kurzer Zeit freigesetzt wird. Dadurch entsteht eine Druckwelle, die sich räumlich und zeitlich ausbreitet.

Explosionsereignisse lassen sich durch Merkmale wie den Typ der Explosion (physikalische, chemische oder nukleare Explosion) oder durch das verbrannte Material charakterisieren.

Für die Bemessung von Bauteilen ist es zweckmäßig, eine makroskopische Differenzierung von Explosionen bezüglich der entstehenden Druckwelle vorzunehmen. Hierbei unterscheiden die Begriffe „Deflagration" und „Detonation" nach der Ausbreitungsgeschwindigkeit der Druckwelle im verbrennenden Medium (COURANT et al., 1948).

Bei einer Deflagration breitet sich die Druckwelle mit einer Geschwindigkeit aus, die unterhalb der Schallgeschwindigkeit liegt. Die verbrannten Partikel bewegen sich dabei

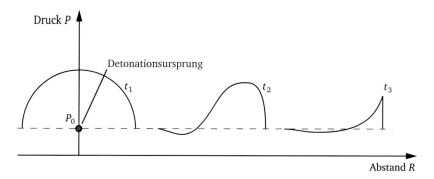

Abbildung 2.2 Aufsteilen einer Druckwelle zur Stoßwelle: Druck in Abhängigkeit des Abstands zu drei Zeitpunkten $t_1 < t_2 < t_3$

entgegen der Ausbreitungsgeschwindigkeit der Druckwelle. Beispiele für Deflagrationen sind Staub- oder Gasexplosionen.

Bei Detonationen liegt die Ausbreitungsgeschwindigkeit der Druckwelle oberhalb der Schallgeschwindigkeit des verbrennenden Mediums und die verbrannten Partikel bewegen sich in Richtung der Druckwelle. Beispiele hierfür sind Sprengstoffexplosionen oder nukleare Explosionen. Da sich die Druckwelle bei hohen Druckamplituden schneller ausbreitet, entsteht unabhängig von der ursprünglichen Form der Druckwelle in einem gewissen Abstand vom Detonationsursprung ein sprunghafter Anstieg des Luftdrucks (Abb. 2.2). Dieser Vorgang, der auf nichtlineare Zusammenhänge in der Wellenausbreitung zurückzuführen ist, wird als Aufsteilen bezeichnet (COURANT et al., 1948). Druckwellen, die sich mit Überschallgeschwindigkeit ausbreiten und eine derartige Form aufweisen, nennt man Stoßwellen oder Schockwellen.

Im Folgenden wird von dem baupraktischen Schutzszenario einer Stoßwelle infolge einer Detonation ausgegangen. Der Lastfall Explosion ist in dieser Arbeit synonym mit dieser Beanspruchung zu sehen.

Charakterisierung von Stoßwellen

Die charakteristische Form des einfallenden Druck-Zeit-Verlaufs in einem festen Abstand vom Detonationsursprung zeigt Abbildung 2.3. Der Luftdruck steigt sprunghaft vom Umgebungsdruck P_0 auf den maximalen Druck P_{max} an. Die Differenz wird bei einer sich ungestört ausbreitenden Welle als maximaler einfallender Überdruck P_E bezeichnet. Anschließend folgt ein exponentieller Abfall, welcher auch unter den Umgebungsdruck fällt. Die Fläche unterhalb der Druck-Zeit-Kurve im Überdruckbereich wird als positiver Impuls i_+, die Dauer der positiven Druckphase als t_+ bezeichnet.

Trifft die Druckwelle auf Hindernisse, so wird sie reflektiert. Das Hindernis erfährt dabei durch die Reflektion und das Aufstauen der Luftpartikel eine mindestens doppelt so

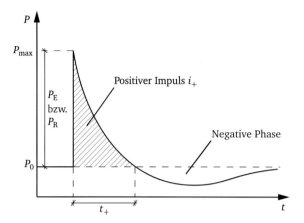

Abbildung 2.3 Friedlander-Kurve (FRIEDLANDER, 1946)

hohe Beanspruchung gegenüber dem einfallenden Druck. Diese Beanspruchung wird als reflektierter Überdruck P_R bezeichnet und ist bei einer Bauteilbemessung anzusetzen. Die charakteristische Form der Druck-Zeit-Kurve nach Abbildung 2.3 bleibt dabei erhalten.

Analytische Ermittlung der Beanspruchung

Für die einfachen Fälle einer sphärischen (kugelförmigen) und einer hemisphärischen (halbkugelförmigen) Ausbreitung der Druckwelle kann der maximale einfallende sowie reflektierte Überdruck, die Dauer der positiven Druckphase, der positive Impuls sowie auch die Parameter zur Beschreibung der Sogphase abgeschätzt werden.

Eingangsparameter für diese Berechnungen ist üblicherweise der skalierte Abstand

$$Z = \frac{R}{W^{1/3}} \qquad \left[\frac{\text{m}}{\text{kg TNT-Äquivalent}^{1/3}} \right], \tag{2.1}$$

welcher die Masse W der Sprengladung und den Abstand R zum Detonationsursprung berücksichtigt. Die Sprengmasse wird in der Einheit „kg TNT-Äquivalent" angegeben, um die unterschiedlichen spezifischen Energien anderer explosiver Materialien erfassen zu können.

Für eine ungestörte sphärische Ausbreitung der Druckwelle hat BRODE, 1955 Differentialgleichungen zur Beschreibung der Gasbewegung numerisch ausgewertet. Damit kann der einfallende Überdruck zu

$$P_E = \frac{611}{Z^3} + \frac{150}{Z^2} + \frac{95}{Z} - 2 \qquad \text{für } 10 < P_E < 1000 \qquad [\text{kPa}] \tag{2.2}$$

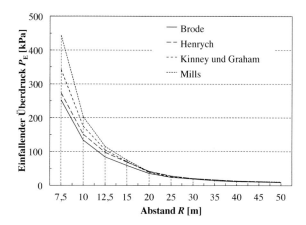

Abbildung 2.4 Vergleich des analytisch ermittelten einfallenden Überdrucks ($W = 100\,\mathrm{kg}$ TNT-Äquivalent)

abgeschätzt werden. Bei dieser nicht einheitengetreuen Gleichung ist der skalierte Abstand Z gemäß den Einheiten in Gleichung (2.1) einzusetzen.

Ähnliche Ergebnisse zeigen die experimentellen Untersuchungen von HENRYCH, 1979 und Untersuchungen von KINNEY et al., 1985 oder MILLS, 1987. Abbildung 2.4 zeigt einen Vergleich des ermittelten Überdrucks in Abhängigkeit des Abstands vom Detonationsursprung für ein Beispielszenario von 100 kg TNT. Insbesondere im Nahbereich zeigen die verschiedenen Ansätze deutliche Unterschiede.

Der Erhöhungsfaktor für senkrechte Reflektionen an starren Oberflächen lässt sich nach HENRYCH, 1979 zu

$$C_\mathrm{R} = \frac{P_\mathrm{R}}{P_\mathrm{E}} = 2 + \frac{6P_\mathrm{E}}{P_\mathrm{E} + 7P_0} \qquad [-] \tag{2.3}$$

bestimmen. Es ergeben sich theoretische Erhöhungsfaktoren gegenüber dem einfallenden Druck von 2 bis 8. Diese Formeln gehen von der Annahme eines idealen Gases aus. Bei hohen Drücken ist diese Annahme nicht mehr korrekt, weswegen tatsächlich auch höhere Reflektionsfaktoren auftreten können.

Auch für nichtsenkrechte Reflektionen können Reflektionsfaktoren ermittelt werden. Hierfür sowie für eine detaillierte Zusammenfassung der analytischen Ermittlung der Belastungsparameter sei an dieser Stelle auf RUTNER et al., 2008 verwiesen.

Sind die Parameter bekannt, kann der Druck-Zeit-Verlauf für den reflektierten Druck (Abb. 2.3) mittels der Friedlander-Gleichung (2.4) (FRIEDLANDER, 1946) bestimmt wer-

den. Der dimensionslose Zerfallkoeffizient A_Z steuert dabei die Form des exponentiellen Abfalls und kann Werte zwischen 0 und 4 annehmen (DIN EN 13123-2):

$$P(t) = P_0 + P_R \left(1 - \frac{t}{t_+} \right) e^{-A_Z \frac{t}{t_+}} . \qquad (2.4)$$

Computerprogrammen wie beispielsweise *A.T.-Blast* (ARA, 2010), welche aus der Angabe von Sprengmasse und Abstand zum Detonationsursprung die Parameter der reflektierten Druckwelle bestimmen, liegen die vorgestellten oder vergleichbare analytische Zusammenhänge zugrunde.

Numerische Ermittlung der Beanspruchung

Mithilfe von expliziten Finite-Elemente-Programmen (Hydrocodes, siehe z.B. BENSON, 1992) ist eine computergestützte Simulation der Druckwellenausbreitung möglich. Dabei können Reflektionen an starren Wänden sowie an elastischen Strukturen mittels Fluid-Struktur-Interaktion berücksichtigt werden. Während die analytische Ermittlung der Druckwellenparameter auf einfache Situationen beschränkt ist, können mithilfe der FEM beliebige Bauwerksumgebungen berücksichtigt werden.

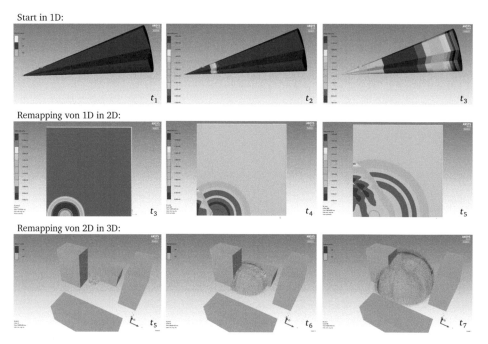

Abbildung 2.5 Numerische Simulation eines Explosionsereignisses in *Ansys Autodyn* (ANSYS INC., 2012b) mit Remapping

Wie in der Strömungsmechanik üblich, wird die Druckwellenausbreitung mittels einer Betrachtungsweise nach Euler simuliert, bei welcher sich das Material durch das raumfeste FE-Netz bewegt. Insbesondere im Bereich des Sprengstoffes ist eine sehr feine Diskretisierung erforderlich, um gute Prognosen zu erzielen (Du Bois et al., 2012). Um die Rechenzeit möglichst gering zu halten, kann der Ansatz der Modellerweiterung („Remapping") verfolgt werden, bei dem von einer eindimensionalen fein diskretisierten Modellierung die Ergebnisse der ersten Zeitschritte in zwei- und dreidimensionale Berechnungen mit einer gröberen räumlichen Diskretisierung übernommen werden (Abb. 2.5).

Normative Umsetzung

Eine graphische Ermittlung der Beanspruchung durch Explosionen stellen verschiedene Regelwerke zur Verfügung. So bietet beispielsweise die US-amerikanische Norm ASTM F 1642 ein Diagramm zur Ermittlung von reflektiertem Druck und Impuls in Abhängigkeit des skalierten Abstands Z. Die Richtlinie des US-amerikanischen Verteidigungsministeriums UFC 3-340-02 ermöglicht die graphische Ermittlung der Druckwellenparameter für unterschiedlichste Szenarien.

Mit der Kenntnis des Druckwellenverlaufs kann anschließend eine Bemessung der Bauteile erfolgen, beispielsweise durch eine dynamische Berechnung. Eine übliche Vereinfachung stellt hierbei die Linearisierung der Friedlander-Kurve unter Beibehaltung des positiven Impulses dar, was gleichbedeutend ist mit der Wahl des Grenzfalls $A_Z = 0$ nach Gleichung (2.4).

Da Explosionen als Einwirkung nicht bauaufsichtlich geregelt sind, definiert der Bauherr mit Sonderberatern mögliche Anforderungen an die zu widerstehende Beanspruchung für Bauwerk und Fassaden.

2.2 Werkstoff Glas

2.2.1 Allgemeines

Der Werkstoff Glas kann auf unterschiedlichste Weisen beschrieben werden. In DIN 1259-1 wird Glas definiert als ein „anorganisches nichtmetallisches Material, das durch völliges Aufschmelzen einer Mischung von Rohmaterialien bei hohen Temperaturen erhalten wird, wobei eine homogene Flüssigkeit entsteht, die dann bis zum festen Zustand abgekühlt wird, üblicherweise ohne Kristallisation". Es handelt sich um einen amorphen (ungeordneten) und durchsichtigen Feststoff, dessen Hauptbestandteil das anorganische Siliziumdioxid (SiO_2) ist. Die weiteren Bestandteile variieren je nach Glasart (Tab. 2.2).

Beim Übergang von der Schmelze zum Festkörper gibt es keinen definierten Erstarrungspunkt sondern analog den Kunststoffen einen Glasübergangsbereich (s. Abschn. 2.3.2). Dieser liegt bei Kalknatron-Silikatglas bei $T_g \approx 530\,^{\circ}\mathrm{C}$, weswegen Glas oftmals auch als der erstarrte Zustand einer unterkühlten Flüssigkeit bezeichnet wird (TAMMANN, 1933).

Im festen Zustand ist ein nahezu ideales isotropes linear-elastisches Materialverhalten bis zum spröden Bruch zu beobachten. Der Zusammenhang zwischen Spannungen und Verzerrungen (Steifigkeit) lässt sich somit vollständig mit Angabe zweier Elastizitätsparameter beschreiben, beispielsweise Elastizitätsmodul E und Querkontraktionszahl ν. Die Abhängigkeit der Steifigkeit von Zeit und Temperatur ist in baupraktischen Anwendungen vernachlässigbar (SCHNEIDER, 2005) und auch bei hochdynamischen Lasten kann keine signifikante Änderung des Elastizitätsmoduls beobachtet werden (PERONI et al., 2011). Die Materialparameter von verschiedenen Glasarten sind in Tabelle 2.3 zusammengefasst.

Die Bemessung von Bauteilen aus Glas wird in Deutschland in der DIN 18008-Reihe geregelt, die im Jahr 2013 die alten Regelwerke TRLV (DIBT, 2006b), TRPV (DIBT, 2006a) und TRAV (DIBT, 2003) in der Musterliste der Technischen Baubestimmungen (MLTB) abgelöst hat (DIBT, 2013c) und damit den aktuellen Stand der Technik darstellt. An einer europäischen Bemessungsnorm wird derzeit gearbeitet (SAT-REPORT, 2013).

Tabelle 2.2 Glasarten im Bauwesen und deren Zusammensetzung in Massen-%

Glasart	SiO_2	CaO	Na_2O	MgO	Al_2O_3	B_2O_3	K_2O	andere
Kalknatron-Silikatglas (DIN EN 572-1)	69-74	5-14	10-16	0-6	0-3	-	-	0-5
Borosilikatglas (DIN EN 1748-1-1)	70-87	-	0-8	-	0-8	7-15	0-8	0-8
Aluminosilikatglas (PANZNER et al., 2014)	63-68	-	8-16	0-9	10-14	0-7	0-4	0-19

Tabelle 2.3 Materialkenngrößen von Baugläsern bei Raumtemperatur

Eigenschaften	Einheit	Kalknatron-Silikatglas (DIN EN 572-1)	Borosilikatglas (DIN EN 1748-1-1)
Dichte ρ	$\mathrm{kg\,m^{-3}}$	2500	2200 - 2500
Elastizitätsmodul E	MPa	70 000	60 000 - 70 000
Querkontraktionszahl ν	-	0,2	0,2
Charakteristische Biegezugfestigkeit f_k	MPa	45	45
Temperaturausdehnungskoeffizient α_T	$\mathrm{K^{-1}}$	$9,0\cdot 10^{-6}$	$3,1-6,0\cdot 10^{-6}$
Temperaturwechselbeständigkeit	K	40	80

Ausführliche Beschreibungen für den Werkstoff Glas, dessen Eigenschaften und die Grundlagen des Glasbaus finden sich beispielsweise in WÖRNER et al., 2001, SCHITTICH et al., 2006 und SIEBERT et al., 2012.

Im Folgenden werden die Grundlagen zur Festigkeit von Glas allgemein und unter kurzzeitiger Beanspruchung erläutert. Anschließend werden die Glasprodukte, welche im Bauwesen eingesetzt werden, beschrieben. Auf Verbundglas wird in Abschnitt 2.4 ausführlich eingegangen.

2.2.2 Festigkeit von Glas

Bruchmechanische Grundlagen

Die Bemessung von Bauteilen aus Glas erfolgt üblicherweise nach der Hauptnormalspannungshypothese (Rankine-Kriterium (RANKINE, 1857)). Dabei werden die maximalen unter den Bemessungslasten im Bauteil auftretenden Hauptzugspannungen mit Widerstandswerten verglichen, welche normativ angegeben sind (s. Tab. 2.3) (DIN 18008-1; DIN EN 572-1; DIN EN 12150-1) oder anhand von experimentellen Untersuchungen gewonnen werden (DIN EN 1288-1).

Dieser Ansatz ist ein in der Praxis gängiges Hilfsmittel. Tatsächlich wird das Versagen von Glas durch Spannungskonzentrationen an Oberflächendefekten bestimmt. Sollen die Vorgänge, die zum Bruch führen, und deren Einflüsse studiert werden, bedarf es einer Betrachtung auf bruchmechanischer Ebene. Für den spröden Werkstoff Glas ist die Anwendung der linear-elastischen Bruchmechanik gerechtfertigt. Die folgende Einführung beschränkt sich auf das Konzept des Spannungsintensitätsfaktors (K-Konzept), welcher die „Stärke" der Spannungssingularität an der Rissspitze beschreibt. Bei der linear-elastischen Bruchmechanik ist das K-Konzept gleichwertig dem Konzept der Energiefreisetzungsrate (G-Konzept) oder dem J-Integral. Da die Oberflächendefekte in Glas im baupraktischen

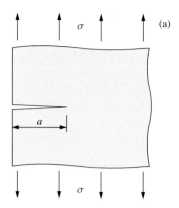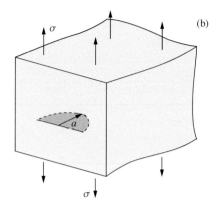

Abbildung 2.6 Gerader Oberflächenriss mit Risstiefe a im halbunendlichen Körper unter konstanter äußerer Zugspannung σ im Modus I (a), Half-Penny-Crack (b)

Einsatz vorwiegend durch Normalzugspannungen belastet werden, ist eine Beschreibung des Modus I (Abb. 2.6a) ausreichend.

Die am Riss mit der Risstiefe a vorherrschende Spannungsintensität

$$K_\mathrm{I} = \sigma\, Y \sqrt{\pi a} \qquad\qquad (2.5)$$

lässt sich bei konstanter äußerer Spannung σ bestimmen. Der Korrekturfaktor Y beschreibt die Geometrie des Oberflächendefekts. Die baupraktisch relevanten Rissgeometrien liegen zwischen den Grenzwerten des geraden Oberflächenrisses (Abb. 2.6a, $Y = 1,1215$) und des Half-Penny-Cracks (Abb. 2.6b, $Y = 0,7216$) (GROSS et al., 2011a).

Das Versagenskriterium (Irwinsches Bruchkriterium) stellt das Erreichen einer kritischen Spannungsintensität (Bruchzähigkeit K_Ic) dar:

$$K_\mathrm{I} = K_\mathrm{Ic}. \qquad\qquad (2.6)$$

Sowohl für Kalknatron-Silikatglas als auch für Borosilikatglas schwanken die in der Literatur angegebenen Werte der Bruchzähigkeit zwischen $0{,}72\,\mathrm{MPa\,m^{1/2}} \leq K_\mathrm{Ic} \leq 0{,}82\,\mathrm{MPa\,m^{1/2}}$ (MENCIK, 1992; SALEM et al., 2010).

Das Irwinsche Bruchkriterium besagt, dass erst Spannungsintensitäten oberhalb der Bruchzähigkeit zu instabilem Risswachstum und damit zum Glasbruch führen. Bei Glas kann aber auch unterhalb dieses Grenzwertes ein stabiles Risswachstum erfolgen. Dieses Phänomen wird statische Ermüdung, subkritisches Risswachstum oder Spannungsrisskorrosion genannt. Abbildung 2.7a veranschaulicht die Risswachstumsgeschwindigkeit v in Abhängigkeit der Spannungsintensität K_I und der Luftfeuchtigkeit. Die unterschiedlichen Bereiche (Abb. 2.7b) lassen sich mit empirisch hergeleiteten Gleichungen bereichsweise

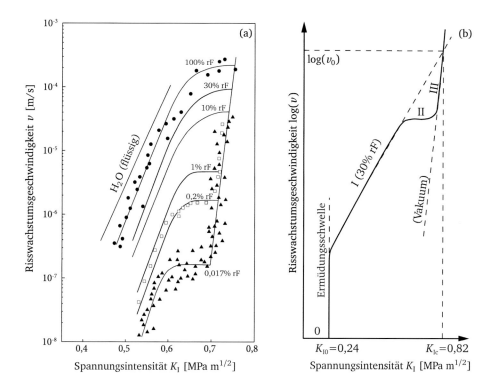

Abbildung 2.7 Einfluss der Luftfeuchtigkeit auf das Risswachstum in Kalknatron-Silikatglas (a, nach WIEDERHORN, 1967) und schematische Darstellung der Ermittlung der Risswachstumskonstanten bei einer Luftfeuchtigkeit von 30 % rF (b)

erfassen, sodass das zeitabhängige Risswachstum in Abhängigkeit der Spannungsintensität bei gegebener Initialrisstiefe a_i berechnet werden kann.

Bereich 0 Unterhalb der Ermüdungsschwelle K_{I0} findet kein bzw. kein messbares Risswachstum statt. Für Kalknatron-Silikatglas liegt diese nach CICCOTTI, 2009 bei $K_{I0} \approx 0{,}24 \, \mathrm{MPa} \, \mathrm{m}^{1/2}$. Die Risswachstumsgeschwindigkeit liegen unterhalb $v = 10^{-10} \, \mathrm{m \, s}^{-1}$ (GY, 2003).

Bereich I Dieser Bereich wird eigentlich als subkritisches Risswachstum bezeichnet. Die Abhängigkeit $v(K)$ kann in diesem Bereich mittels Exponentialgesetzen nach *Wiederhorn* oder *Lawn* beschrieben werden. Da der Wertebereich von K sehr klein ist, wird üblicherweise jedoch ein empirisches Potenzgesetz angewandt (CICCOTTI, 2009):

$$v = \frac{da}{dt} = v_0 \left(\frac{K_I}{K_{Ic}} \right)^n . \tag{2.7}$$

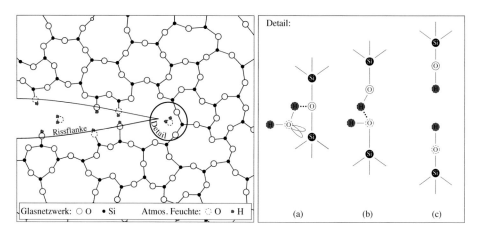

Abbildung 2.8 Modell zur Beschreibung der Spannungsrisskorrosion (nach MICHALSKE et al., 1983)

Der Faktor v_0 beschreibt die Risswachstumsgeschwindigkeit, die sich in Verlängerung des Bereichs I bei $K_I = K_{Ic}$ ergibt. Der Exponent n ist ein Maß für die Steigung der Kurve.

Einige Werte aus der Literatur sind in Tabelle 2.4 zusammengestellt. Die Werte von WIEDERHORN, 1967 wurden anhand des Diagramms aus Abbildung 2.7a ermittelt unter der Voraussetzung, dass v_0 für alle Bereiche gleich ist und $K_{Ic} = 0{,}82\,\mathrm{MPa}\,\mathrm{m}^{1/2}$ beträgt.

Ein Modell, welches den Vorgang des subkritischen Risswachstums auf molekularer Ebene beschreibt, ist in Abbildung 2.8 dargestellt. In den Riss eindringende Wassermo-

Tabelle 2.4 Risswachstumsparameter v_0 und n

Literaturquelle, Glasart	Umgebungsbedingungen	$v_0\ [\mathrm{m\,s^{-1}}]$	n [-]
WIEDERHORN, 1967, Kalknatron-Silikatglas	H_2O	$1{,}84 \cdot 10^{-1}$	20,8
	100 % rF		24,3
	30 % rF		28,0
	0,2 % rF		36,1
	0,017 % rF		39,3
	Vakuum		85,7
KERKHOF et al., 1981, Kalknatron-Silikatglas	H_2O	$5{,}01 \cdot 10^{-2}$	16,0
	50 % rF	$2{,}5 \cdot 10^{-3}$	18,8
	Vakuum	$4{,}5 \cdot 10^{-7}$	70
SALEM et al., 2010, Borosilikatglas	95 % rF	$2{,}0 \cdot 10^{-3}$	17,1
	3 % rF	$3{,}0 \cdot 10^{-4}$	24,5
	1 % rF	$1{,}1 \cdot 10^{-6}$	30,0

leküle spalten das Glasnetzwerk und ermöglichen so ein Risswachstum. Die anliegende Spannung wirkt sich stark beschleunigend auf den Prozess aus.

Neben der Luftfeuchtigkeit bzw. dem Partialdruck des Wasserdampfs wirken sich Temperatur, pH-Wert und Glaszusammensetzung wesentlich auf das subkritische Risswachstum aus (GY, 2003).

Bereich II Die Risswachstumsgeschwindigkeit ist durch die Transportgeschwindigkeit der Wassermoleküle an die Rissspitze begrenzt, es stellt sich ein Plateau ein.

Bereich III Die Risswachstumsgeschwindigkeit ist schneller als der Korrosionsmechanismus, sie steigt in diesem Bereich unabhängig von den Umgebungsbedingungen steil mit der Spannungsintensität an. Diese befindet sich im Bereich der Bruchzähigkeit K_{Ic} und es findet der Übergang zum instabilen Risswachstum statt.

Auch Bereich III lässt sich durch das Potenzgesetz (2.7) beschreiben. Es sind jedoch die im Vakuum ermittelten Risswachstumsparameter zu verwenden.

Die Rissausbreitungsgeschwindigkeit liegt in diesem Bereich zwischen $10^{-3}\,\mathrm{m\,s}^{-1} \leq v \leq 1\,\mathrm{m\,s}^{-1}$. Die maximale Rissausbreitungsgeschwindigkeit von Kalknatron-Silikatglas beträgt $v \approx 1500\,\mathrm{m\,s}^{-1}$ (GY, 2003; NIELSEN et al., 2009). Wird diese erreicht, verzweigt der Riss und die Geschwindigkeit verringert sich.

Mithilfe der vorgestellten Gesetzmäßigkeiten lässt sich das Risswachstum in Abhängigkeit von der Spannungsintensität K_I berechnen. Eine von der Zeit abhängige Spannung $\sigma(t)$ kann ebenfalls berücksichtigt werden. Lassen sich die Belastungsverläufe analytisch erfassen, können oftmals die Lebensdauer und die maximale Belastungsamplitude durch analytische Gleichungen bestimmt werden. Diese berücksichtigen stets jedoch nur den Bereich I, dem das empirische Potenzgesetz zugrunde gelegt wird. In jedem Fall ist eine numerische Zeitintegration auch unter Beachtung der Bereiche 0, II und III möglich.

Normativ wird das subkritische Risswachstum in thermisch entspanntem Floatglas über belastungszeitabhängige Abminderungsfaktoren k_{mod} bei der Bemessung berücksichtigt, siehe Gleichung (2.14) (DIN 18008-1; DIN PREN 16612). In thermisch vorgespanntem Glas ist für quasistatische Belastungen keine Zeitabhängigkeit zu berücksichtigen, da die Bemessungswerte für die Festigkeit unter den Werten der eingeprägten Oberflächendruckspannung liegen und somit kein subkritisches Risswachstum stattfinden kann (s. Abschn. 2.2.3).

Für eine detaillierte Einführung in die Bruchmechanik von Gläsern, das subkritische Risswachstum und die Herleitung der analytischen Zusammenhänge wird auf MENCIK, 1992, CICCOTTI, 2009 und GROSS et al., 2011a verwiesen.

Analytische Lebensdauerprognosen ausgewählter Spannungs-Zeit-Verläufe

In Abbildung 2.9 sind die für diese Arbeit relevanten Spannungs-Zeit-Verläufe dargestellt. Da Glasplatten überwiegend durch Belastungen senkrecht zur Plattenebene beansprucht werden, sind Hauptzugspannungen infolge Biegebelastungen angegeben.

Der konstante Verlauf (a) stellt schematisch eine statische Dauerlast dar. Der lineare Verlauf (b) mit einer Steigung von $\dot{\sigma} = 2\,\mathrm{MPa\,s^{-1}}$ entspricht der quasistatischen Belastung in Normprüfungen nach der DIN EN 1288-Reihe. Eine sinusförmige Halbwelle entsteht näherungsweise bei der kurzzeitigen dynamischen Belastung eines Pendelschlags (c). Bei einer Detonationsdruckwelle, welche ebenfalls eine kurzzeitige dynamische Belastung

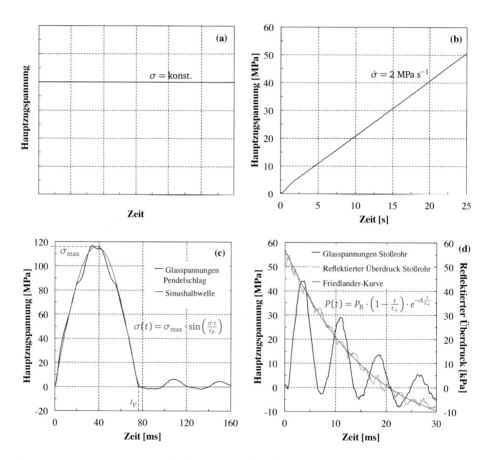

Abbildung 2.9 Spannungs-Zeit-Verläufe: schematisch bei konstanter Belastung (a), Normprüfung im Doppelring (b, aus Abschn. 3.2.1), Pendelschlag (c, aus Abschn. 3.2.2) und Detonationsdruckwelle (d, aus Abschn. 5.2.2)

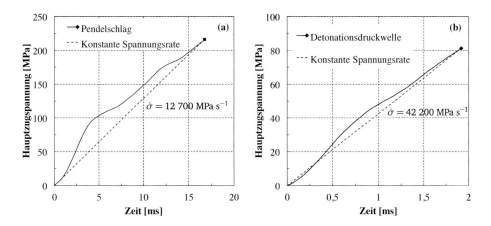

Abbildung 2.10 Spannungs-Zeit-Verläufe in Plattenmitte (vierseitige Lagerung) bei Pendelschlag mit Glasbruch (a, aus Abschn. 3.2.2) und Detonationsdruckwelle mit Glasbruch (b, aus Abschn. 5.2.2)

darstellt, kann die Einwirkung mithilfe der Friedlander-Gleichung (2.4) beschrieben werden. Die entstehenden Glasspannungen stellen periodische gedämpfte Schwingungen dar, welche sich nicht mit einer einfachen Funktion approximieren lassen (d).

Bricht das Glas infolge eines Pendelschlags oder einer Detonationsdruckwelle, so liegt der Zeitpunkt des Glasbruchs in der Regel vor dem Erreichen des Maximums im Spannungs-Zeit-Verlauf. Die kurzzeitig wirkende hohe Spannungsintensität führt zu einer sehr hohen Risswachstumsgeschwindigkeit, welche den Bruch des Glases zur Folge hat.

Bricht das Glas nicht beim Erreichen der maximalen Spannung, sinkt anschließend die Risswachstumsgeschwindigkeit aufgrund des stark nichtlinearen Zusammenhangs mit der Spannungsintensität (s. Gl. (2.7)) so stark ab, dass ein Glasbruch nur noch selten initiiert wird. Somit entstehen Spannungs-Zeit-Verläufe mit einer nahezu linearen Steigung (konstante Spannungsrate) bis zum Bruch (Abb. 2.10). Die Spannungsraten sind hierbei aber deutlich höher als bei den Normprüfungen.

Für den Fall der **zeitlich konstanten Belastung** (Abb. 2.9a) bestimmt sich die statische Lebensdauer $t_{b,s}$ bei gegebener konstanter Beanspruchung σ und Initialrisstiefe a_i aus Integration von Gleichung (2.7) in Kombination mit Gleichung (2.5) zu

$$t_{b,s} = \frac{2\,K_{Ic}{}^{n}}{(n-2)v_0\,\sigma^n\,(Y\sqrt{\pi})^n\,a_i^{(n-2)/2}} \tag{2.8}$$

und die maximale konstante Beanspruchbarkeit $\sigma_{b,s}$ bei gegebener Belastungszeit t und Initialrisstiefe a_i zu

$$\sigma_{b,s} = \left(\frac{2\,K_{Ic}{}^n}{(n-2)v_0\,t\,(Y\sqrt{\pi})^n\,a_i^{(n-2)/2}} \right)^{1/n}. \tag{2.9}$$

Die Initialrisstiefe kann umgekehrt mit gemessener Beanspruchung und Lebensdauer zurückgerechnet werden:

$$a_i = \left(\frac{2\,K_{Ic}{}^n}{(n-2)v_0\,\sigma^n\,(Y\sqrt{\pi})^n\,t_{b,s}} \right)^{\frac{2}{n-2}}. \tag{2.10}$$

Bei einer **konstanten Belastungsrate** $\dot{\sigma}$ (Abb. 2.9b) ergeben sich folgende Gleichungen für die quasistatischen Größen:

$$t_{b,qs} = \left(\frac{2(n+1)\,K_{Ic}{}^n}{(n-2)v_0\,\dot{\sigma}^n\,(Y\sqrt{\pi})^n\,a_i^{(n-2)/2}} \right)^{\frac{1}{n+1}}, \tag{2.11}$$

$$\sigma_{b,qs} = \dot{\sigma}\,t_{b,qs}\,, \tag{2.12}$$

$$a_i = \left(\frac{2(n+1)\,K_{Ic}{}^n}{(n-2)v_0\,\dot{\sigma}^n\,(Y\sqrt{\pi})^n\,t_{b,qs}^{n+1}} \right)^{\frac{2}{n-2}}. \tag{2.13}$$

Sind die Spannungsraten gering, so ist eine Beschränkung auf die Bereiche 0 und I ausreichend. Dies trifft nicht auf kurzzeitige dynamische Einwirkungen wie Pendelschlag oder Stoßwellen zu. Hier wirken sich die Bereiche II und III signifikant auf die Lebensdauerprognosen aus. Dies wird in Abschnitt 3.2.2 näher betrachtet.

Kurzzeitfestigkeit von Glas

Für die Bestimmung der Kurzzeitfestigkeit von Glas mittels der vorgestellten Gesetze zur Lebensdauerprognose ist die Ermüdungsschwelle K_{I0} nicht relevant. Ebenso können mögliche Rissheilungseffekte vernachlässigt werden. Für weitergehende Erläuterungen dieser Aspekte wird daher an dieser Stelle auf SCHULA, 2015 und HILCKEN, 2015 verwiesen.

Bei konstanter Beanspruchung kann mittels Gleichung (2.9) die statische Belastbarkeit in Abhängigkeit der Belastungsdauer und Initialrisstiefe a_i bestimmt werden. Hierbei werden die Bereiche II und III vernachlässigt und die Steigung aus Bereich I bis zur kriti-

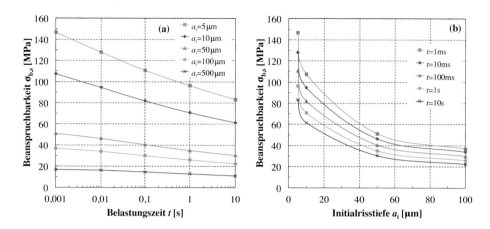

Abbildung 2.11 Statische Beanspruchbarkeit aufgetragen über die Belastungszeit bei unterschiedlichen Initialrisstiefen (a) und über die Initialrisstiefe bei unterschiedlichen Belastungszeiten (b) (nach OVEREND et al., 2012)

schen Spannungsintensität K_{Ic} extrapoliert. Abbildung 2.11 zeigt eine graphische Auswertung dieses Zusammenhangs für unterschiedliche Anfangsrisstiefen $5\,\mu m \leq a_i \leq 500\,\mu m$ (OVEREND et al., 2012). Hiermit können Abschätzungen für die Kurzzeitfestigkeit in Abhängigkeit der Belastungsdauer getroffen werden. Es ist erkennbar, dass die statische Beanspruchbarkeit $\sigma_{b,s}$ bei Verringerung der Belastungszeit t oder der Initialrisstiefe a_i steigt.

SCHNEIDER, 2001 hat den Maximalwert der Spannung während eines einmaligen Pendelstoßes mittels Lebensdauerprognose beruhend auf Gleichung (2.7) für den Bereich I ermittelt. Diese Betrachtung ergab eine theoretische Festigkeitssteigerung bei thermisch entspanntem Floatglas von 30 % bis 50 % bezogen auf den 5 %-Fraktilwert ($f_k = 45\,MPa$) und von 40 % bis 60 % bezogen auf den Mittelwert von fabrikneuen Gläsern ($f_m = 115\,MPa$). Darüber hinaus wurde anhand rückgerechneter Anfangsrisstiefen ein Grenzwert für die Kurzzeitfestigkeit mittels des Irwinschen Bruchkriteriums (2.6) bestimmt. Die damit ermittelten Festigkeitssteigerungen liegen bei 55 % für den charakteristischen Wert (5-%-Fraktilwert) und 96 % für den Mittelwert. Die berechneten Ergebnisse wurden mit zehn Pendelschlagversuchen an Verbundgläsern verglichen. Die experimentellen Ergebnisse zeigten eine starke Streuung, dennoch konnte eine Tendenz zu den theoretisch hergeleiteten höheren Festigkeiten unter kurzzeitiger dynamischer Beanspruchung identifiziert werden.

Die Ergebnisse aus SCHNEIDER, 2001 werden in der aktuellen deutschen Bemessungsnorm für absturzsichernde Verglasungen (DIN 18008-4) berücksichtigt. Hierin sind Bemessungswerte für Pendelschlag nach Tabelle 2.5 angegeben. Diese Werte stellen allerdings keine 5 %-Fraktilwerte sondern eher konservative Mittelwerte für die Kurzzeitfestig-

keit von gealterten Baugläsern dar. Der Bemessungswert für die Kurzzeitfestigkeit ergibt
sich nach DIN 18008-1 zu

$$R_{\mathrm{d}} = \frac{k_{\mathrm{mod}}\, k_{\mathrm{c}}\, f_{\mathrm{k}}}{\gamma_{\mathrm{M}}} \qquad\qquad (2.14)$$

mit

k_{mod}	Modifikationsbeiwert zur Berücksichtigung der Lasteinwirkungsdauer [-],
k_{c}	Beiwert zur Berücksichtigung der Art der Konstruktion [-],
f_{k}	Charakteristischer Wert der Biegezugfestigkeit [MPa],
γ_{M}	Teilsicherheitsbeiwert [-].

Für Glasplatten unter Detonationsdruckwellen sind in CORMIE et al., 2009 dynamische
Festigkeitswerte nach Tabelle 2.6 angegeben, welche ebenfalls anhand des empirischen
Potenzgesetzes unter ausschließlicher Beachtung von Bereich I ermittelt wurden.

Experimentelle Untersuchungen an Kleinproben (Probenabmessungen 5 mm) aus ei-
senoxidarmen Glas zeigen PERONI et al., 2011 mit quasistatischen und dynamischen
Druck- und Spaltzugversuchen. Die dynamischen Versuche wurden im Split-Hopkinson-
Pressure-Bar (SHPB) (siehe z.B. CHEN et al., 2011) durchgeführt. Ein bemerkenswertes
Ergebnis der Untersuchungen ist, dass der Elastizitätsmodul von Glas keine nennenswerte
Änderung selbst bei extrem hohen Verzerrungsraten aufweist. Bezüglich der Bruchspan-
nung wurde im Spaltzug eine Erhöhung um 50 % im Mittelwert festgestellt bei Steigerung
der Spannungsrate von $\dot{\sigma} \approx 1 \cdot 10^2\,\mathrm{MPa\,s^{-1}}$ auf $\dot{\sigma} \approx 1 \cdot 10^8\,\mathrm{MPa\,s^{-1}}$. Aufgrund der gerin-
gen Probengröße, der abweichenden Belastungsart und der sehr hohen Spannungsrate ist

Tabelle 2.5 Bemessungswerte der Glasfestigkeit unter Pendelschlag nach DIN 18008-4

Glasart	Modifikationsbeiwert k_{mod} [-]	Bemessungsspannung R_{d} [MPa]
Thermisch entspanntes Glas (z.B. Floatglas)	1,8	81
Teilvorgespanntes Glas (TVG)	1,7	119
Einscheibensicherheitsglas (ESG)	1,4	168

Tabelle 2.6 Dynamische Glasfestigkeit unter Detonationsdruckwellen nach CORMIE et al., 2009

Glasart	dynamische Bruchspannung $\sigma_{\mathrm{b,dyn}}$ [MPa]
Thermisch entspanntes Glas (z.B. Floatglas)	80
Teilvorgespanntes Glas (TVG)	100-120
Einscheibensicherheitsglas (ESG, UK)	180-250
Einscheibensicherheitsglas (ESG, US)	120-180

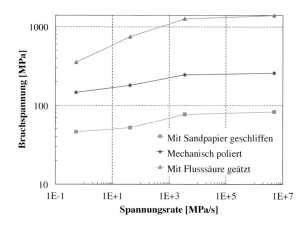

Abbildung 2.12 Versuchsergebnisse der Untersuchungen in N IE et al., 2010, Angabe der Mittelwerte in Abhängigkeit der Spannungsrate und Oberflächenbehandlung

eine Übertragung auf baupraktische Anwendungen diskussionswürdig. Selbst bei Detonationsdruckwellen werden in Verglasungen nur maximale Spannungsraten von $\dot{\sigma} \leq 1 \cdot 10^5 \, \mathrm{MPa\,s^{-1}}$ erreicht (s. Tab. 5.3).

N IE et al., 2010 haben ebenfalls SHPB-Versuche mit Glas durchgeführt. Hierbei wurden 3,3 mm dicke Borosilikatproben mit verschiedenen Oberflächenbehandlungen in einem Miniatur-Doppelring ($r_1 = 12{,}5 \, \mathrm{mm}$, $r_2 = 25 \, \mathrm{mm}$) bei vier verschiedenen Spannungsraten geprüft. Abbildung 2.12 fasst die Ergebnisse zusammen. Auch bei diesen Versuchsergebnissen ist die Übertragbarkeit auf baupraktische Situationen fragwürdig. Es kann vermutet werden, dass das in den Versuchen beobachtete Versagen aufgrund des Verhältnisses von Last- und Stützring zur Probendicke eher infolge Durchstanzen als durch Biegezugbeanspruchung hervorgerufen wird.

Alle vorgestellten Untersuchungen weisen einen geringen experimentellen Umfang auf. Eine belastbare Aussage über die Festigkeit von Glas bei kurzzeitigen dynamischen Einwirkungen wie Pendelschlag und Detonationsdruckwellen ist daher derzeit nur eingeschränkt möglich.

H ILCKEN, 2015 hat zyklische Belastungsversuche mit Frequenzen bis zu 15 Hz ($\dot{\sigma} \approx 2{,}5 \cdot 10^3 \, \mathrm{MPa\,s^{-1}}$) im Bereich I durchgeführt und festgestellt, dass eine Prognose der Lebensdauer über das empirische Potenzgesetz (2.7) auch bei hohen Spannungsraten möglich ist und andersartige dynamische Effekte keinen oder nur einen vernachlässigbaren Einfluss auf das subkritische Risswachstum haben.

Es kann davon ausgegangen werden, dass die vorgestellten bruchmechanischen Zusammenhänge auch bei kurzzeitigen dynamischen Einwirkungen wie Pendelschlag oder Detonationsdruckwellen gültig sind. Dies wird in Kapitel 3 anhand von quasistatischen

Doppelring-Biegeversuchen und dynamischen Pendelschlagversuchen tiefergehend unter-
sucht, wobei auch die Bereiche II und III in die Betrachtung mit einbezogen werden.

2.2.3 Glasprodukte

Bei Glasprodukten ist zunächst zwischen den Basisgläsern und den Veredelungsprodukten
zu unterscheiden. Gängige Basisgläser, welche in der DIN EN 572-Reihe geregelt wer-
den, sind Floatglas (Spiegelglas), Gussglas (Ornamentglas), Drahtglas, gezogenes Glas
und Profilbaugläser. Üblicherweise wird Flachglas im Floatverfahren hergestellt, bei wel-
chem die Glasschmelze auf ein flüssiges Zinnbad fließt. Hierdurch wird eine im Vergleich
zu gegossenem oder gezogenem Glas hervorragende Oberflächenqualität erreicht.

Die Basisgläser können nach ihrer Bearbeitung (Zuschnitt, Kantenbearbeitung, evtl.
Bohrung, Beschichtung) weiteren Veredelungsprozessen unterzogen werden. Durch eine
thermische Vorspannung wird ein über die Dicke parabelförmiger Eigenspannungszustand
im Glas erzeugt, welcher die Oberflächen unter Druck setzt und somit zu einer Steigerung
der Biegezugfestigkeit führt. Die Höhe der Druckzone beträgt hierbei 20 % der Glasdicke.
Die erzeugten Bauprodukte werden nach ihrem Vorspanngrad Einscheibensicherheitsglas
(ESG) oder Teilvorgespanntes Glas (TVG) genannt.

Bei einer chemischen Vorspannung entsteht durch Ionentausch an der Oberfläche eben-
falls eine Druckvorspannung, welche nur bis maximal 300 μm in das Glas reicht (WÖRNER
et al., 2001). Abbildung 2.13 veranschaulicht die Eigenspannungszustände von thermisch
und chemisch vorgespanntem Glas.

Durch den Verbund mindestens zweier Glasplatten mit Zwischenschichten aus Kunst-
stoff werden Verbundgläser hergestellt. Die Beschreibung dieses Produkts und dessen Her-
stellung folgt ausführlich in Abschnitt 2.4.

Als Isoliergläser werden Verglasungseinheiten bezeichnet, bei welchen ein Gasvolu-
men (Luft, Argon, Krypton oder Xenon) zwischen zwei Glasplatten eingeschlossen wird.
Dies wird durch einen umlaufenden eingeklebten Randabstandhalter ermöglicht. Um eine
höhere Wärmedämmung zu erreichen, werden zunehmend Dreifach-Isoliergläser mit drei
Glasplatten und zwei Gaszwischenräumen verbaut.

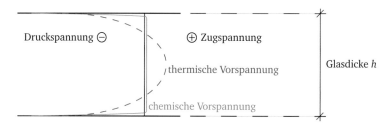

Abbildung 2.13 Spannungsverlauf bei thermisch bzw. chemisch vorgespanntem Glas

Gebogenes Glas kann auf drei Arten hergestellt werden: Durch Warmbiegen der Basisgläser bei Temperaturen oberhalb der Glasübergangstemperatur T_g, durch Kaltbiegen über Zwangsverformungen aus der Lagerung und durch Laminationsbiegen. Letzteres wird stets als Verbundglas ausgeführt und die Krümmung während des Laminationsprozesses eingebracht. Um eine dauerhafte Krümmung sicherzustellen, ist eine ausreichend hohe Steifigkeit der Zwischenschicht auch bei hohen Temperaturen und langen Belastungszeiten erforderlich.

Weitergehende Informationen zu den vorgestellten und weiteren Bauprodukten aus Glas, deren Herstellung, Eigenschaften und Bearbeitung finden sich unter anderem in WÖRNER et al., 2001, SCHITTICH et al., 2006 und SIEBERT et al., 2012.

2.3 Kunststoffe und deren mechanisches Verhalten

2.3.1 Allgemeines

Um das mechanische Verhalten der verschiedenen Kunststoffe, die als Verbundglas-Zwischenschichten eingesetzt werden, zu verstehen und einzuordnen, werden im Folgenden die Grundlagen der Polymermechanik erläutert.

Die Begriffe „Polymer" und „Kunststoff" werden im allgemeinen Sprachgebrauch oftmals synonym verwendet. In dieser Arbeit wird jedoch die folgende Unterscheidung angewandt: Ein Polymer besteht aus Makromolekülen, die aus vielen gleichartigen Grundbausteinen, den sogenannten Monomeren, bestehen. Kunststoffe können als „synthetisch-organische Werkstoffe, die als wesentliche Bestandteile Makromoleküle enthalten" (KAISER, 2011) definiert werden. Somit sind Polymere die Rohstoffe für einen Kunststoff (Werkstoff), der neben den Makromolekülen eines Polymers weitere Substanzen (Additive) beinhalten kann. Der Begriff Makromolekül oder hochmolekularer Stoff lässt sich nach KAISER, 2011 mit einer Mindestanzahl von 1000 Atomen pro Molekül definieren. Diese sind im Gegensatz zu Metallen oder Keramiken linienförmig oder verzweigt aufgebaut und durch kovalente Bindungen (Elektronenpaarbindung) zwischen den Atomen charakterisiert. Diese chemische Bindung ist in ihrer Bindungsenergie bis zur Zerfallstemperatur unabhängig von der Temperatur. Zwischen den verschiedenen Ketten der Makromoleküle herrscht eine schwächere, physikalische Bindung (Wasserstoffbrückenbindung, Van-der-Waals-Kräfte) oder eine Ionenbindung, welche die Beweglichkeit der Kettenmoleküle und damit die mechanischen Eigenschaften definiert und stark temperaturabhängig ist (RÖSLER et al., 2012). Makromoleküle beinhalten in der Regel 10^3 bis 10^5 Monomere und sind einige Mikrometer lang. Die mittlere Anzahl an Monomeren in einem Makromolekül wird Polymerisationsgrad genannt (RÖSLER et al., 2012).

Der Begriff „organisch" in der Definition von Kunststoffen deutet bereits auf das erste der beiden häufigsten Elemente hin, den Kohlenstoff (Formelzeichen C). Das zweite ist der Wasserstoff (H), der durch seine niedrige Molmasse bei Kunststoffen im Allgemeinen zu einer geringen Dichte führt. Weitere Eigenschaften, die auf den Großteil aller Kunststoffe zutreffen, sind leichte Formbarkeit aufgrund niedriger Verarbeitungstemperaturen, niedrige thermische und elektrische Leitfähigkeit, chemische Beständigkeit, temperaturabhängiges mechanisches Verhalten, Gasdurchlässigkeit, Recyclingfähigkeit, Schlagzähigkeit, Viskoelastizität, Kriechneigung und das Aufweisen von Alterungserscheinung. Darüber hinaus sind viele Kunststoffe UV-beständig und transparent. Ein großer Vorteil gegenüber anderen Werkstoffen liegt in der Möglichkeit, die Steifigkeit und die Festigkeit von Kunststoffen bei der Herstellung gezielt beeinflussen zu können (KAISER, 2011).

Weitere wichtige Eigenschaften wie Löslichkeit, Quellbarkeit, thermisches Verhalten, mechanisches Verhalten und Lichtdurchlässigkeit sind stark vom Typ des jeweiligen Kunststoffs abhängig und müssen bei Bedarf für jedes Produkt charakterisiert werden.

2.3.2 Grundlegendes mechanisches Verhalten

Kunststoffe weisen im Vergleich zu den klassischen Werkstoffen des Bauwesens (Stahl, Beton, Holz und Glas) ein komplexeres mechanisches Verhalten im baupraktischen Temperatur- und Zeitbereich auf. Die Werkstofftemperatur sowie der zeitliche Verlauf der mechanischen Belastung haben große Auswirkungen auf Steifigkeit und Festigkeit. Darüber hinaus ist das Spannungs-Dehnungs-Verhalten bei größeren Deformationen meist nichtlinear und es können irreversible Deformationen auftreten. Zudem ist eine Zug-Druck-Asymmetrie im Steifigkeitsverhalten oft nicht zu vernachlässigen.

Abbildung 2.14 verdeutlicht das typische Spannungs-Dehnungs-Verhalten aus uniaxialen Zugversuchen (s. Abschn. 2.3.7) bis hin zu großen Deformationen bei unterschiedlichen Temperaturen. Eine Verringerung der Belastungsgeschwindigkeit, was einer Verringerung der Dehnrate $\dot{\varepsilon}$ entspricht, hat dabei eine vergleichbare Wirkung wie eine Erhöhung der Temperatur T. Kann das Zeit-Temperatur-Verschiebungsprinzip (ZTV) angewandt werden, so spricht man von einem thermorheologisch einfachen Materialverhalten (s. Abschn. 2.3.6). Ist dies nicht möglich, nennt man das Materialverhalten thermorheologisch komplex.

Eine signifikante Änderung des mechanischen Verhaltens von amorphen Polymeren tritt bei der sogenannten Glasübergangstemperatur T_g auf, welche den energieelastischen Bereich (Glaszustand) vom entropieelastischen Bereich (gummielastischer Bereich) abgrenzt. Im energieelastischen Bereich unterhalb der Glasübergangstemperatur wird durch die starke Wirkung der physikalischen Bindungen zwischen den Makromolekülen eine hohe Steifigkeit erzeugt. Die mikrobrownsche Bewegung, welche die thermische Bewegung der Makromoleküle ohne Platzwechsel kennzeichnet, ist eingefroren (HABENICHT, 2009). Die Querkontraktionszahl liegt dann üblicherweise zwischen $0,3 \leq \nu \leq 0,35$. Tempera-

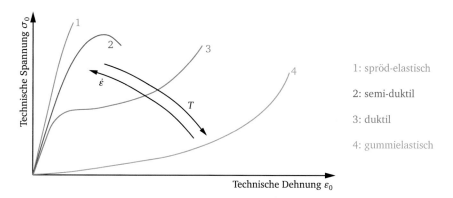

1: spröd-elastisch

2: semi-duktil

3: duktil

4: gummielastisch

Abbildung 2.14 Schematische Darstellung des Spannungs-Dehnungs-Verhaltens von Kunststoffen unter uniaxialem Zug (siehe z.B. BRINSON et al., 2008)

tursteigerungen führen hier zu einem geringen aber steten Steifigkeitsabfall (SCHWARZL, 1990).

Bei T_g fällt die Steifigkeit stark ab: Die thermische Energie reicht aus, um Umlagerungen der Makromoleküle ohne äußere Spannungseinwirkungen zu ermöglichen (RÖSLER et al., 2012) – die mikrobrownsche Bewegung kann stattfinden (HABENICHT, 2009). Dieser Übergang geschieht nicht sprunghaft, sondern in einem Temperaturbereich, der Glasübergangsbereich, primäre Dispersionserscheinung oder auch α-Relaxation genannt wird. Im anschließenden entropieelastischen Bereich wird die Steifigkeit durch das Bestreben der Makromoleküle erzeugt, sich in den Zustand höchster Unordnung (Zustand hoher Entropie) anzuordnen. Hierbei werden Querkontraktionszahlen im Bereich $v \approx 0,5$ beobachtet, das Material verhält sich nahezu inkompressibel (SCHWARZL, 1990). In diesem Bereich kann der Schubmodul bei kleinen Verzerrungen (initialer Schubmodul G_0) nach folgendem Zusammenhang bestimmt werden (SCHWARZL, 1990):

$$G_0 = n_V k_B T \tag{2.15}$$

mit

n_V	Anzahl der Verschlaufungen bzw. Vernetzungspunkte pro Volumeneinheit,
$k_B = 1,38 \cdot 10^{-23} \, \mathrm{J\,K^{-1}}$	Boltzmann-Konstante,
T	absolute Temperatur in K.

Weitere markante Steifigkeitsunterschiede können durch sogenannte sekundäre Dispersionserscheinungen hervorgerufen werden, welche auf Bewegung von Seitenketten, lokale Bewegungen in der Hauptkette oder das Aufschmelzen von kristallinen Phasen zurückzuführen sind (SCHWARZL, 1990). Eine detaillierte Beschreibung des mechanischen Verhaltens verschiedener Polymergruppen erfolgt in Abschnitt 2.3.3.

Die Abhängigkeit des Materialverhaltens von der Dehnrate sowie Relaxations- und Kriecheffekte können mithilfe viskoelastischer Modelle beschrieben werden (Abschn. 2.3.5). Zur Beschreibung der Nichtlinearität bei großen Verformungen wird in Abschnitt 2.3.4 die Hyperelastizität vorgestellt. Für die Beschreibung weiterer Phänomene (nicht reversibles, plastisches Verhalten, Viskoplastizität, nichtlineare Viskosität) wird an dieser Stelle auf weiterführende Literatur (z.B. BRINSON et al., 2008, SCHWARZL, 1990 oder RÖSLER et al., 2012) verwiesen.

2.3.3 Klassifizierung von Polymeren

Polymere können nach folgenden Gesichtspunkten klassifiziert werden:

- Zusammensetzung der Monomere: Homopolymere und Copolymere,

- Bildungsreaktionen: Kettenpolymerisation, Polykondensation und Polyaddition,

- Vernetzung: unvernetzt und vernetzt,

- Ordnungszustand: amorph und teilkristallin,

- Polymerstruktur und mechanisches Verhalten: Thermoplaste, Elastomere und Duroplaste,

- Chemische Zusammensetzung: Polyolefine, Fluorpolymere, Chlorpolymere etc.

Zusammensetzung der Monomere Ein Polymeraufbau aus nur einem Monomertyp wird als Homopolymer bezeichnet. Bilden zwei oder mehrere verschiedene Monomertypen das Makromolekül, so spricht man von Copolymeren oder Heteropolymeren.

Bildungsreaktionen Die Entstehung der Makromoleküle aus den Monomeren wird durch die Bildungsreaktion beschrieben. Bei einer Kettenpolymerisation werden die Doppelbindungen der Monomere aufgebrochen und eine Verbindung der Monomere untereinander ermöglicht. Die Reaktion läuft nach einmaliger Aktivierung selbständig fort, bis alle Monomere aktiviert wurden. Dabei entstehen keine Nebenprodukte und es findet keine Atomumlagerung statt. Eine Polykondensation oder Kondensationspolymerisation bezeichnet die Verbindung von verschiedenen Monomeren unter Abspaltung eines Nebenprodukts. Hierbei wird die ursprüngliche Atomanordnung verändert. Der Vorgang ist eine Stufenwachstumsreaktion und kann daher unterbrochen und wieder aktiviert werden. Die Polyaddition ist ebenfalls eine Stufenwachstumsreaktion, bei der aber keine Nebenprodukte entstehen. Die Verbindung entsteht durch Atomumlagerungen zwischen den Monomeren. Eine detaillierte Beschreibung der Bildungsreaktionen findet sich beispielsweise in KAISER, 2011.

Vernetzung Bestehen zwischen den so entstandenen Makromolekülen keine Verbindungspunkte, spricht man von unvernetzten Polymeren. Bilden sich dagegen kovalente Bindungen zwischen verschiedenen Makromolekülen aus, entsteht eine Netzstruktur und man spricht von chemisch vernetzten Polymeren. Durch starke physikalische Bindungen können ebenfalls Vernetzungspunkte zwischen verschiedenen Makromolekülen entstehen. Man spricht dann von physikalisch vernetzten Polymeren. Der Begriff Vernetzungsgrad kennzeichnet den prozentualen Anteil vernetzter Makromoleküle an der Gesamtzahl aller Makromoleküle.

Ordnungszustand Eine weitere Unterscheidung betrifft den Grad der Kristallisation der Polymere. Vollständig kristallin aufgebaute Polymere können wegen der statistischen Molekülanordnung im Allgemeinen nicht hergestellt werden, sodass Polymere stets zumindest teilweise amorph sind. Durch Auffaltung von Molekülketten können aber bei unvernetzten Polymeren kristalline Phasen zwischen den amorphen Zonen entstehen (RÖSLER et al., 2012). Man spricht hierbei von teilkristallinen Polymeren. Bei chemisch vernetzten Polymeren können sich aufgrund der Verbindungspunkte keine kristallinen Phasen bilden. Der prozentuale Anteil der kristallinen Phasen wird Kristallinität genannt. Eine hohe Kristallinität führt zu einer Steigerung von Dichte, Festigkeit, Steifigkeit und Schmelztemperatur und zu einer Verringerung der Licht- und Gasdurchlässigkeit (KAISER, 2011).

Polymerstruktur Art und Grad von Vernetzung und Kristallisation haben einen maßgeblichen Einfluss auf die thermisch-mechanischen Eigenschaften des Polymers. Daher ist eine Unterscheidung nach der inneren Struktur der Polymere üblich und sinnvoll. Hierbei werden Polymere in der Literatur überwiegend in die Hauptgruppen Thermoplaste, Elastomere und Duroplaste eingeteilt und es lassen sich diesen Gruppen typische Eigenschaften zuordnen. Abbildung 2.15 veranschaulicht die unterschiedlichen Gruppen. Die mittlerweile zurückgezogene deutsche Norm DIN 7724 fasst diese Unterscheidung prägnant zusammen.

Thermoplaste zeichnen sich dadurch aus, dass die linearen Makromoleküle unvernetzt sind und die Polymere daher durch Wärmezufuhr plastisch verformbar (schmelzbar) sind. Sie können amorph oder teilkristallin sein, wobei sich das typische Steifigkeitsverhalten dadurch maßgeblich ändert (Abb. 2.16).

Bei Gebrauchstemperatur befinden sie sich vorwiegend im energieelastischen Bereich und zeigen deutliche irreversible Verformungen, wenn die Streckgrenze überschritten wird (DIN 7724). Bei **amorphen Thermoplasten** sind die Kettenmoleküle in tiefen Temperaturen eingefroren, das Polymer befindet sich im energieelastischen Bereich und verhält sich steif, elastisch und spröde. Es existiert ein ausgeprägter Glasübergangsbereich, welcher in der Regel einen Temperaturbereich zwischen 10 °C und 20 °C umfasst und die Steifigkeit auf ein Tausendstel bis ein Zehntausendstel reduziert (KAISER, 2011; SCHWARZL,

| Amorpher Thermoplast | Teilkristalliner Thermoplast | Elastomer | Duroplast |

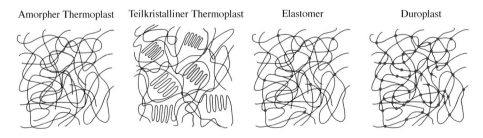

Abbildung 2.15 Schematische Darstellung der verschiedenen Kunststoffstrukturen

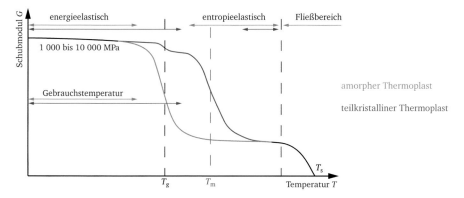

Abbildung 2.16 Schematische Darstellung der Steifigkeit in Abhängigkeit von der Temperatur bei amorphen und teilkristallinen Thermoplasten (siehe z.B. DIN 7724)

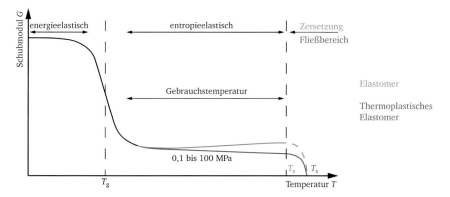

Abbildung 2.17 Schematische Darstellung der Steifigkeit in Abhängigkeit von der Temperatur bei Elastomeren und thermoplastischen Elastomeren (siehe z.B. DIN 7724)

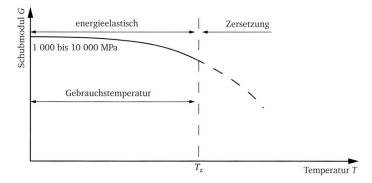

Abbildung 2.18 Schematische Darstellung der Steifigkeit in Abhängigkeit von der Temperatur bei einem Duroplast (siehe z.B. DIN 7724)

1990). Bei Temperaturen oberhalb von T_g verhalten sich amorphe Thermoplasten entropie-elastisch bis ein Fließen einsetzt, die Verschlaufungen der Makromoleküle gelöst werden und das Polymer bei der Schmelztemperatur T_s aufschmilzt. Bei **teilkristallinen Thermo-plasten** fällt die Steifigkeitsabnahme bei T_g deutlich geringer aus und es wird ein zweiter Steifigkeitsabfall identifiziert, der durch das Aufschmelzen der Kristalle entsteht. Die Temperatur, die diesen Temperaturbereich kennzeichnet, wird Kristallitschmelztemperatur T_m genannt (KAISER, 2011).

Elastomere sind chemisch weitmaschig vernetzte Polymere und liegen somit nur in amorpher Form vor. Durch die Vernetzung ist ein Aufschmelzen nicht möglich. Bei hohen Temperaturen kommt es zu einer Zersetzung des Polymers (T_z). Die Glasübergangstemperatur T_g liegt typischerweise bei Temperaturen weit unter 0 °C. Im Gebrauchstemperaturbereich verhalten sich Elastomere daher entropieelastisch, zeigen nahezu keine irreversiblen Verformungen und verzeichnen einen leichten Anstieg der Steifigkeit bei steigender Temperatur aufgrund der höheren Entropie (Abb. 2.17).

Duroplaste sind engmaschig chemisch vernetzte Polymere und damit amorph und nicht schmelzbar. Die Zersetzungstemperatur T_z liegt meist im Bereich der Glasübergangstemperatur oder sogar darunter. Daher zeigen Duroplasten nahezu ausschließlich ein steifes, elastisches und sprödes Verhalten im energieelastischen Bereich (Abb. 2.18).

Neben diesen drei Hauptgruppen gibt es **thermoplastische Elastomere**, bei denen die Makromoleküle physikalisch untereinander vernetzt sind. Sie sind Copolymere und bestehen aus mindestens zwei Monomertypen, wobei im Gebrauchstemperaturbereich sich einer im Glaszustand, der andere im gummielastischen Zustand befindet. Insgesamt bewirkt die physikalische Vernetzung bei Gebrauchstemperatur ein entropieelastisches Verhalten, bei höheren Temperaturen wird die physikalische Vernetzung aufgehoben und die Polymere verhalten sich wie gewöhnliche Thermoplaste und schmelzen auf (Abb. 2.17) (KAISER, 2011). Die Glasübergangstemperatur liegt in der Regel unter 0 °C.

Chemische Zusammensetzung Schließlich lassen sich Polymere nach ihrer chemischen Zusammensetzung einteilen. Für Kunststoffe in Verbundglas sind hierbei Polyolefine (Alkene als Monomere), Vinylpolymere (Monomere mit Vinylgruppe) und Polyurethane (Makromoleküle mit Urethangruppe) zu nennen. Diese Art der Einteilung von Kunststoffen lässt allerdings keine direkten Rückschlüsse auf die thermisch-mechanischen Eigenschaften zu und wird daher hier nicht weiter ausgeführt.

2.3.4 Hyperelastizität

In Abbildung 2.19 wird schematisch die Spannungs-Dehnungs-Beziehung eines hyperelastischen Materialmodells unter uniaxialem Zug dargestellt. Es wird deutlich, dass die Beziehung nichtlinear ist, große Verzerrungen aufweist, die Spannungsantwort unabhängig von der Belastungsgeschichte ist und das Materialverhalten vollständig elastisch ist. Es können keine Hysteresen aus viskosen Effekten, Schädigungen oder irreversible Verformungen erfasst werden. Eine solches Materialverhalten kann bei vielen Polymeren im entropieelastischen Bereich näherungsweise angenommen werden, insbesondere bei Elastomeren.

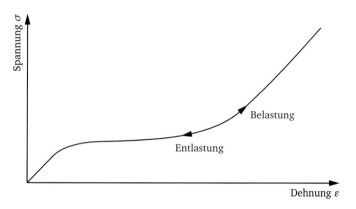

Abbildung 2.19 Spannungs-Dehnungs-Beziehung unter uniaxialem Zug bei Hyperelastizität

Für die Beschreibung der Hyperelastizität werden einige Begriffe aus der Kontinuumsmechanik benötigt. Die hier gewählte Notation folgt der folgenden Konvention:

- Vektoren werden mit Vektorpfeil und Tensoren fett geschrieben.

- Die Ausgangskonfiguration wird mit Großbuchstaben für Vektoren und Tensoren sowie Index 0 an Bezeichnungen gekennzeichnet.

- Die Momentankonfiguration wird mit Kleinbuchstaben für Vektoren und Tensoren oder keinem Index an Bezeichnungen gekennzeichnet.

- Der Einheitstensor wird mit $\mathbf{1}$, der Nulltensor mit $\mathbf{0}$ beschrieben.

- Partielle Ableitungen werden mit ∂ gekennzeichnet, das totale Differential mit d.

- Die doppelte Überschiebung wird mit : (Doppelpunkt) gekennzeichnet und entspricht der zweifachen Verjüngung bei einem Tensorprodukt.

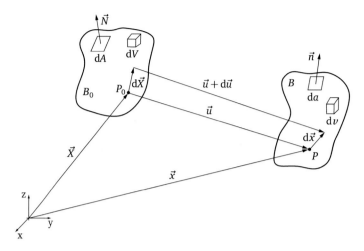

Abbildung 2.20 Körper in der Ausgangs- und der Momentankonfiguration

In Abbildung 2.20 ist ein Körper in der Ausgangs- und in der Momentankonfiguration dargestellt. Hierauf beziehen sich die im Folgenden erläuterten Begriffe. Für die Herleitung und eine detaillierte Erläuterung der Zusammenhänge wird auf weiterführende Literatur z.B. HOLZAPFEL, 2000, GROSS et al., 2011b und ALTENBACH, 2012 verwiesen.

Geometrische Maße

- Verschiebungsgradient:

$$H = \frac{\mathrm{d}\vec{u}}{\mathrm{d}\vec{X}} = \mathrm{Grad}(\vec{u})$$

 Dieser beschreibt die Relativverschiebung zweier benachbarter Punkte bezogen auf die Ausgangskonfiguration.

- Deformationsgradient:

$$F = \frac{\mathrm{d}\vec{x}}{\mathrm{d}\vec{X}} = \mathrm{Grad}(\vec{x}) = 1 + H$$

 Dieser beschreibt die lineare Abbildung eines Linienelements $\mathrm{d}\vec{X}$ von der Ausgangs- in die Momentankonfiguration und beinhaltet Verzerrung und Rotation. Bei einer reinen Starrkörperverschiebung ergibt er den Wert $F = 1$. Die Determinante des Deformationsgradienten ergibt die Jakobi-Determinante $J = \mathrm{d}v/\mathrm{d}V$, welche die Volumenänderung eines Volumenelements zwischen Ausgangs- und Momentankonfiguration beschreibt.

- Rechts-Cauchy-Green Tensor:
$$C = F^T F$$
Dieser liegt in der Ausgangskonfiguration und ergibt ohne Verzerrung den Wert $C = 1$.

- Links-Cauchy-Green Tensor:
$$b = F F^T$$
Dieser liegt in der Momentankonfiguration und ergibt ohne Verzerrung den Wert $b = 1$. Die Invarianten des Links-Cauchy-Green Tensors entsprechen denen des Rechts-Cauchy-Green Tensors. Beide Tensoren beschreiben nur die Verzerrung ohne Rotation.

- Green-Lagrange-Verzerrungstensor:
$$E = \frac{1}{2}(C - 1)$$
Dieser liegt in der Ausgangskonfiguration und ergibt ohne Verzerrung den Wert $E = 0$.

- Euler-Almansi-Verzerrungstensor:
$$e = \frac{1}{2}(1 - b^{-1})$$
Dieser liegt in der Momentankonfiguration und ergibt ohne Verzerrung den Wert $e = 0$. Der Euler-Almansi-Verzerrungstensor und der Green-Lagrange-Verzerrungstensor beschreiben die Änderung des Abstandsquadrates zweier Punkte zwischen Ausgangs- und Momentankonfiguration.

- Infinitesimaler Verzerrungstensor:
$$\varepsilon = \frac{1}{2}(H + H^T)$$
Bei kleinen Verzerrungen gibt es keinen Unterschied mehr zwischen Ausgangs- und Momentankonfiguration. Der infinitesimale Verzerrungstensor ist ein lineares Verzerrungsmaß und beschreibt nur die Verzerrungen ohne Rotation.

Spannungsmaße

- Cauchyscher Spannungstensor:
$$\vec{t} = \sigma \vec{n}$$
Hierbei bezeichnet \vec{t} den Spannungsvektor in einer Schnittfläche der Momentankonfiguration und \vec{n} den Normalenvektor auf die Schnittfläche. Der Cauchysche Spannungstensor σ wird auch als „wahre Spannung" bezeichnet und ist aufgrund der Drehimpulsbilanz symmetrisch.

- Erster Piola-Kirchoff Tensor:
 $$P = J \, \boldsymbol{\sigma} \, F^{-T}$$
 Dieser beschreibt die technische Spannung, da er die Spannung in der Momentankonfiguration auf die Fläche der Referenzkonfiguration bezieht. Er ist im Allgemeinen aber unsymmetrisch und damit als Rechengröße ungeeignet.

- Zweiter Piola-Kirchhoff Tensor:
 $$S = F^{-1} \, P = J \, F^{-1} \, \boldsymbol{\sigma} \, F^{-T}$$
 Dieser ist symmetrisch und die thermodynamisch konjugierte Größe zum Green-Lagrange-Verzerrungstensor. Bei kleinen Verzerrungen fallen der erste und der zweite Piola-Kirchhoff Tensor sowie der Cauchysche Spannungstensor zusammen.

Konstitutive Gleichungen

Der erste Hauptsatz der Thermodynamik liefert den Zusammenhang zwischen Spannung und Verzerrung über die Formänderungsenergiedichte W für den ersten und den zweiten Piola-Kirchhoff Tensor:

$$P = \frac{\partial W}{\partial F}, \tag{2.16}$$

$$S = \frac{\partial W}{\partial E} = 2 \frac{\partial W}{\partial C}. \tag{2.17}$$

Im Fall kleiner Verzerrungen gilt

$$\boldsymbol{\sigma} = \frac{\partial W}{\partial \boldsymbol{\varepsilon}}. \tag{2.18}$$

Die Formänderungsenergie beschreibt die geleistete Arbeit zur Transformation eines Körpers von der Ausgangs- in die Momentankonfiguration. Der Zusatz „Dichte" deutet an, dass diese Transformationsarbeit auf eine Volumeneinheit bezogen ist. Die Formänderungsenergiedichte kann in Abhängigkeit verschiedener Verzerrungsmaße (C, b, E oder e) bzw. deren Invarianten I oder Hauptstreckungen $\lambda_i = 1 + \varepsilon_i$ (mit den Hauptdehnungen ε_i) definiert werden.

Die mit den konstitutiven Gleichungen ermittelten Spannungen sind ausschließlich vom aktuellen Verformungszustand und nicht von der Belastungsgeschichte abhängig. Die Modelle der linearen Elastizität und der Hyperelastizität beruhen auf dieser Annahme.

Invarianten

Die Invarianten eines zweistufigen Tensors stellen Größen dar, die unabhängig vom ge-
wählten Bezugssystem sind. Für den infinitesimalen Verzerrungstensor ergeben sich

$$
\begin{aligned}
I_{\varepsilon 1} &= \mathrm{spur}(\boldsymbol{\varepsilon}), \\
I_{\varepsilon 2} &= \frac{1}{2}\left[\mathrm{spur}(\boldsymbol{\varepsilon})^2 - \mathrm{spur}(\boldsymbol{\varepsilon}^2)\right], \\
I_{\varepsilon 3} &= \det(\boldsymbol{\varepsilon}).
\end{aligned}
\tag{2.19}
$$

Volumetrisch-deviatorische Zerlegung

Ein Verzerrungs- oder Spannungstensor lässt sich in seinen volumetrischen und deviato-
rischen Anteil aufspalten. In der Materialmodellierung wird dieses Vorgehen oftmals an-
gewandt, da nach dem ersten Axiom der Rheologie eine volumetrische Änderung als rein
elastisch angenommen wird. Die Gestaltänderung kann dagegen auch viskos oder plastisch
sein (ALTENBACH, 2012). Die volumetrisch-deviatorische Zerlegung für den infinitesima-
len Verzerrungstensor lautet

$$
\begin{aligned}
\varepsilon_{\mathrm{m}} &= \frac{1}{3}\mathrm{spur}(\boldsymbol{\varepsilon}) \quad \text{(mittlere Dehnung)}, \\
\boldsymbol{\varepsilon} &= \varepsilon_{\mathrm{m}}\,\mathbf{1} + \boldsymbol{\varepsilon}_{\mathrm{D}}.
\end{aligned}
\tag{2.20}
$$

Die Invarianten des Deviators des infinitesimalen Verzerrungstensors $\boldsymbol{\varepsilon}_{\mathrm{D}}$ ergeben sich
dann zu

$$
\begin{aligned}
I_{\varepsilon_{\mathrm{D}}1} &= 0, \\
I_{\varepsilon_{\mathrm{D}}2} &= \frac{1}{2}\,\boldsymbol{\varepsilon}_{\mathrm{D}} : \boldsymbol{\varepsilon}_{\mathrm{D}}, \\
I_{\varepsilon_{\mathrm{D}}3} &= \det(\boldsymbol{\varepsilon}_{\mathrm{D}}).
\end{aligned}
\tag{2.21}
$$

Neben der additiven Aufspaltung kann die volumetrisch-deviatorische Zerlegung auch
multiplikativ über den Deformationsgradienten erfolgen:

$$
\boldsymbol{F}_{\mathrm{D}} = J^{-\frac{1}{3}}\,\boldsymbol{F}.
\tag{2.22}
$$

Die Jakobi-Determinante des deviatorischen Anteils ist dann $J_{\mathrm{D}} = \det(\boldsymbol{F}_{\mathrm{D}}) = 1$. Die ers-
te Invariante des Deviators ist im Gegensatz zur additiven Zerlegung ungleich null. Die
multiplikative Zerlegung wird bei den vorgestellten hyperelastischen Materialmodellen
angewandt.

Lineare Elastizität

Für die lineare Elastizität lässt sich die Beziehung zwischen Spannungen und Verzerrungen über den Elastizitätstensor vierter Stufe beschreiben. Da die lineare Elastizität für alle Werkstoffe im Bereich kleiner Deformationen gilt, findet der infinitesimale Verzerrungstensor und der Cauchysche Spannungstensor Anwendung:

$$\boldsymbol{\sigma} = \boldsymbol{E} : \boldsymbol{\varepsilon}. \tag{2.23}$$

Auch eine Formulierung über die Konstitutivgleichung (2.18) ist möglich. Die Formänderungsenergiedichte

$$W = \frac{1}{2}\boldsymbol{\varepsilon} : \boldsymbol{E} : \boldsymbol{\varepsilon} = \frac{1}{2}K I_{\varepsilon 1}^2 - 2G I_{\varepsilon_D 1} \tag{2.24}$$

lässt sich dabei sowohl in den Verzerrungen als auch in den Invarianten des infinitesimalen Verzerrungstensors bzw. dessen Deviators angeben. Dabei wird eine additive Zerlegung in den volumetrischen Anteil mit dem Kompressionsmodul K und den deviatorischen Anteil mit dem Schubmodul G vollzogen (NASDALA, 2010).

Hyperelastische Materialmodelle

Zur mathematischen Beschreibung der Hyperelastizität muss eine Formänderungsenergiedichte W definiert werden, die diese nichtlineare Spannungsantwort ermöglicht. Im Folgenden werden die in dieser Arbeit zur Anwendung kommenden hyperelastischen Materialmodelle und deren Formänderungsenergiedichtefunktionen vorgestellt. Diese sind in den Invarianten des Deviators vom Rechts- bzw. Links-Cauchy-Green Tensor oder deren Hauptstreckungen formuliert, wobei eine multiplikative volumetrisch-deviatorische Zerlegung durchgeführt wird (HOLZAPFEL, 2000). Falls sich das Material in ausreichender Näherung inkompressibel verhält ($\nu \approx 0,5$), kann der Druckanteil in der Formänderungsenergie vernachlässigt werden: Der Druckanteil wird durch die dritte Invariante des Verzerrungstensors erfasst, welche der quadrierten Jakobi-Determinante J^2 entspricht. Beträgt diese konstant $J = 1$, so wird keine Arbeit aufgrund von Volumenänderung geleistet. Dies trifft in vielen Fällen auf Polymere im entropieelastischen Bereich zu.

Die einfachste Form der Beschreibung hyperelastischen Materialverhaltens ist das **Neo-Hookesche Modell (1943)**, welches nur die erste Invariante des Deviators berücksichtigt (KALISKE et al., 1997; ALI et al., 2010; ANSYS INC., 2012a):

$$W = C_{10}(I_{b_D 1} - 3) + \frac{1}{D}(J - 1)^2 \tag{2.25}$$

mit

$$C_{10} = \frac{G_0}{2},$$

G_0 initialer Schubmodul,

$I_{b_D 1}$ erste Invariante des Deviators vom Cauchy-Green-Tensor,

$D = \frac{2}{K_0}$ Kompressibilitätsparameter (bei Inkompressibilität $D = 0$),

K_0 initialer Kompressionsmodul,

$J = I_{b3}^{1/2} = I_{C3}^{1/2} = \det(\boldsymbol{F})$ Jakobi-Determinante (bei Inkompressibilität $J = 1$).

Das generalisierte Modell von **Mooney und Rivlin (1940)** berücksichtigt zudem die zweite Invariante des Deviators (MOONEY, 1940; TRELOAR, 2005; ALI et al., 2010; AN-SYS INC., 2012a):

$$W = \sum_{i,j=0}^{n} C_{ij}(I_{b_D 1} - 3)^i (I_{b_D 2} - 3)^j + \sum_{i=1}^{n} \frac{1}{D_i}(J - 1)^{2i} \tag{2.26}$$

mit

$C_{00} = 0,$

$I_{b_D 2}$ zweite Invariante des Deviators vom Cauchy-Green-Tensor,

D_i Kompressibilitätsparameter (bei Inkompressibilität $D_i = 0$).

Die vorwiegend verwendete Variante ist das ursprüngliche zweiparametrige Mooney-Rivlin-Modell:

$$W = C_{10}(I_{b_D 1} - 3) + C_{01}(I_{b_D 2} - 3) + \frac{1}{D}(J - 1) \tag{2.27}$$

mit

$$C_{10} + C_{01} = \frac{G_0}{2}.$$

Die Wahl von $C_{01} = 0$ ergibt das Neo-Hookesche Modell (2.25).

Das Materialmodell von **Ogden (1972)** ist in den Hauptstreckungen des Deviators definiert (TRELOAR, 2005; ALI et al., 2010; ANSYS INC., 2012a):

$$W = \sum_{i=1}^{n} \frac{\mu_i}{\alpha_i}\left(\lambda_{b_D 1}^{\alpha_i} + \lambda_{b_D 2}^{\alpha_i} + \lambda_{b_D 3}^{\alpha_i} - 3\right) + \sum_{i=1}^{n} \frac{1}{D_i}(J - 1)^{2i} \tag{2.28}$$

mit

μ_i, α_i Modellparameter,

$\lambda_{b_D i} = J^{-\frac{1}{3}}\lambda_{bi}$ Hauptstreckungen des Deviators vom Cauchy-Green Tensor,

λ_{bi} Hauptstreckungen des Cauchy-Green Tensors.

Mit $G_0 = \frac{1}{2}\sum_{i=1}^{n} \alpha_i \mu_i$ ist der Zusammenhang zwischen den Modellparametern und dem initialen Schubmodul gegeben. Die Wahl $n = 1$ und $\alpha_1 = 2$ liefert das Neo-Hookesche Modell (2.25). Die Wahl $n = 2$, $\alpha_1 = 2$ und $\alpha_2 = -2$ liefert das zweiparametrige Modell von Mooney-Rivlin (2.27).

Das Materialmodell von **Yeoh (1990)** erweitert das Neo-Hookesche Modell um die Berücksichtigung der ersten Invariante des Deviators mit höherer Ordnung (ALI et al., 2010; ANSYS INC., 2012a):

$$W = \sum_{i=1}^{3} C_{i0}(I_{\mathrm{bD}1} - 3)^i + \sum_{i=1}^{3} \frac{1}{D_i}(J - 1)^{2i}. \tag{2.29}$$

Dadurch können mehrere Krümmungswechsel in der Spannungs-Dehnungs-Beziehung realisiert werden.

Weitere hyperelastische Materialmodelle sind beispielsweise Blatz-Ko, Gent, Arruda-Boyce, Van-der-Waals, Extended Tube und der Polynomansatz. Für eine detailliertere Ausführung wird auf weiterführende Literatur verwiesen (KALISKE et al., 1997; ALI et al., 2010).

Eine Modellierung des hyperelastischen Materialverhaltens kann auch ohne explizites Aufstellen der Formänderungsenergiedichte erfolgen, indem mittels experimenteller Daten direkt die Ableitungen nach den Invarianten bestimmt werden (KOLLING et al., 2007; ANSYS INC., 2012a).

2.3.5 Viskoelastizität

Zur Einführung in die Viskoelastizität wird ein einfacher Schubversuch betrachtet, bei welchem die Scherung (Gleitung) γ und die Schubspannung τ als mechanische Größen auftreten. Für eine detailliertere Beschreibung wird auf SCHWARZL, 1990 verwiesen.

Der Begriff „Viskoelastizität" vereint die Begriffe „Elastizität" und „Viskosität", welche zunächst für sich erläutert werden.

Im Modell der Elastizität ist die Verzerrung eine eindeutige Funktion der Spannung, wobei der Zusammenhang sowohl linear als auch nichtlinear sein kann. Bei der linearen Elastizität ist dieser Zusammenhang proportional, es gilt das Hookesche Gesetz, welches im Falle des Schubversuchs folgendermaßen lautet:

$$\gamma = \frac{\tau}{G_0} = J_0 \tau \tag{2.30}$$

mit

γ Scherung,

τ Schubspannung,

G_0 Schubmodul,

J_0 Scherkomplianz (Schernachgiebigkeit).

Das Materialverhalten von Glas im energieelastischen Bereich kann im gesamten Verzerrungsbereich bis zum Bruch mithilfe der linearen Elastizität beschrieben werden. Für Stahl und Beton ist das Modell bei kleinen Verzerrungen im baupraktischen Temperatur- und Zeitbereich ebenfalls zutreffend.

Die nichtlineare Elastizität kann mittels Hyperelastizität nach Abschnitt 2.3.4 beschrieben werden.

Bei einem viskosen Materialverhalten ist die Verzerrungsrate eine eindeutige Funktion der Spannung. Der Zusammenhang kann ebenfalls linear oder nichtlinear sein. Da die Verzerrungsrate die zeitliche Ableitung der Verzerrung ist, ist das Materialverhalten zeitabhängig und die Belastungshistorie muss beachtet werden. Bei der linearen Viskosität ist der Zusammenhang proportional. Dieses Modell wird auch Newtonsches Fließen genannt:

$$\frac{d\gamma}{dt} = \dot{\gamma} = \frac{\tau}{\eta_0} = \varphi_0\, \tau \tag{2.31}$$

mit

$\dot{\gamma}$ Scherrate,

η_0 Viskosität,

φ_0 Fluidität.

Beim Modell der Viskoelastizität wird die Elastizität mit der Viskosität kombiniert. Es ergibt sich ein zeitabhängiges Materialverhalten, bei welchem die Verzerrungen infolge eines konstanten Spannungssprungs teilweise sofort und ansonsten durch Kriechen entstehen. Dabei können irreversible Verformungen auftreten oder das Material federt nach Entlastung und ausreichender Wartezeit vollständig zurück. Solange der unverformte Zustand nicht wieder erreicht wurde, ist die Belastungshistorie zu beachten.

Eine Erhöhung der Verzerrungsrate, die sich aus der Belastungsgeschwindigkeit ergibt, führt bei viskoelastischen Materialien zu einer steiferen Materialantwort. Bei einer Be- und Entlastung entstehen Hysteresen in der Spannungs-Dehnungs-Kurve. Die durch die Hysteresen eingeschlossene Fläche wird in Wärmeenergie umgewandelt.

Auch bei der Viskoelastizität wird in linear und nichtlinear unterschieden. Wird von nichtlinearer Viskoelastizität gesprochen, ist zu differenzieren, ob die Elastizität, die Viskosität oder beides nichtlinear ist. Ist beides linear, liegt also lineare Viskoelastizität vor, so ist die zeitabhängige Verformung proportional zur angelegten Spannung. Dies kann anhand von Kriech- oder Relaxationsversuchen mit verschiedenen Spannungsniveaus ver-

anschaulicht werden. Wird die konstante Spannung bei einem Kriechversuch mit einem linear viskoelastischen Material verdoppelt, so verdoppelt sich zu jedem betrachteten Zeitpunkt die Verzerrung (Abb. 2.21a). Diese kann somit mittels einer einheitlichen Kriechfunktion beschrieben werden:

$$\gamma(\bar{\tau},t) = \bar{\tau}J(t) \tag{2.32}$$

mit

$\bar{\tau}$ konstante Spannung im Kriechversuch,
$J(t)$ Kriechfunktion.

Analog verhält es sich bei der Relaxation (Abb. 2.21b), bei welcher die Spannung mittels der angelegten konstanten Verzerrung und der Relaxationsfunktion bestimmt werden kann:

$$\tau(\bar{\gamma},t) = \bar{\gamma}G(t) \tag{2.33}$$

mit

$\bar{\gamma}$ konstante Scherung im Relaxationsversuch,
$G(t)$ Relaxationsfunktion.

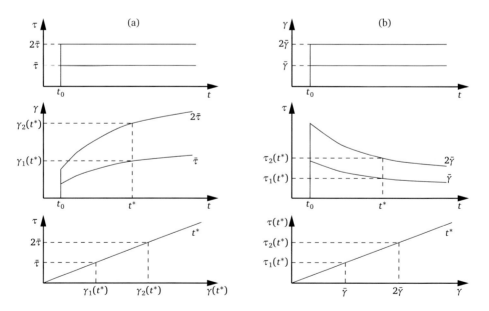

Abbildung 2.21 Kriechen (a) und Relaxation (b) bei linear viskoelastischem Materialverhalten

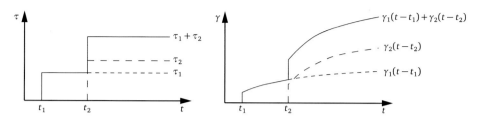

Abbildung 2.22 Superpositionsprinzip beim Kriechversuch

Liegt lineare Viskoelastizität vor, gilt das Superpositionsprinzip nach *Boltzmann*. Dieses besagt, dass zu einem bestimmten Zeitpunkt die Summe der Verzerrungen infolge mehrerer einzelner Belastungen gleich der Gesamtverzerrung aus der Summe der Belastungen entspricht. Abb. 2.22 veranschaulicht dies anhand eines Kriechversuchs mit zwei konstanten Spannungen τ_1 und τ_2, welche zu unterschiedlichen Zeitpunkten t_1 und t_2 aufgebracht werden. Die Summe der jeweils entstehenden Scherungen γ_1 und γ_2 entspricht der Scherung, welche durch eine Belastung $\tau_1 + \tau_2$ hervorgerufen wird. Somit kann eine beliebige zeitabhängige Beanspruchung in infinitesimal kleine konstante Spannungsblöcke zerlegt werden. Die daraus resultierende Scherung ergibt sich unter Kenntnis der Kriechfunktion für einen bestimmten Zeitpunkt t zu

$$\gamma(t) = \int_{-\infty}^{t} J(t - \xi)\, \dot{\tau}(\xi)\, d\xi = J_0\, \tau(t) + \int_{-\infty}^{t} J(t - \xi)\, \tau(\xi)\, d\xi \qquad (2.34)$$

mit

J_0 Initialwert der Kriechfunktion (Momentanwert der Nachgiebigkeit),
ξ Zeitpunkt zwischen $-\infty \leq \xi \leq t$.

Analog kann das Superpositionsprinzip für die Ermittlung der Spannung bei vorgegebener Verzerrungshistorie verwendet werden:

$$\tau(t) = \int_{-\infty}^{t} G(t - \xi)\, \dot{\gamma}(\xi)\, d\xi = G_0\, \gamma(t) + \int_{-\infty}^{t} \dot{G}(t - \xi)\, \gamma(\xi)\, d\xi \qquad (2.35)$$

mit

G_0 Initialwert der Relaxationsfunktion (Momentanwert des Schubmoduls).

Die Kriechfunktion ist eine positive, monoton steigende Funktion, die gegen einen realen Grenzwert strebt, falls keine irreversiblen Verformungen auftreten. Dieses Verhalten nennt man viskoelastisches Verhalten ohne Fließen. Ein rheologisches Modell zur Beschreibung dieses Deformationsverhaltens ist das **verallgemeinerte Kelvin-Voigt-Modell**, welches in Abbildung 2.23 dargestellt ist. Obwohl die rheologischen Symbole den uniaxi-

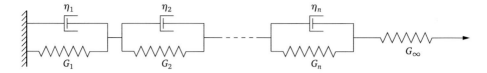

Abbildung 2.23 Verallgemeinertes Kelvin-Voigt-Modell

alen Zug darstellen, werden weiterhin die Bezeichnungen für den einfachen Schubversuch
verwendet.

Die Kriechfunktion ergibt sich damit zu

$$J(t) = \frac{1}{G_\infty} + \sum_{i=1}^{n} \frac{1}{G_i} (1 - e^{\frac{-t\,G_i}{\eta_i}}). \tag{2.36}$$

Strebt die Kriechfunktion gegen den uneigentlichen Grenzwert $+\infty$, spricht man von
viskoelastischem Verhalten mit Fließen und es entstehen irreversible Verformungen. Hier-
für muss dem rheologischen Modell in Abbildung 2.23 ein in Reihe geschalteter Dämpfer
mit der Dämpfungskonstante η_0 hinzugefügt werden, Gleichung (2.36) wird um den Term
t/η_0 additiv ergänzt.

Ein mechanisch äquivalentes Modell zum verallgemeinerten Kelvin-Voigt-Modell ist
das **verallgemeinerte Maxwell-Modell**, welches in Abbildung 2.24a dargestellt ist. Die
Relaxationsfunktion, welche auch als Prony-Reihe bezeichnet wird, ergibt sich hierbei zu

$$G(t) = G_\infty + \sum_{i=1}^{n} G_i\, e^{\frac{-t\,G_i}{\eta_i}}. \tag{2.37}$$

Oftmals wird durch die Division mit dem initialen Schubmodul $G_0 = G_\infty + G_1 +
G_2 + ... + G_n$ eine dimensionslose Darstellung der Prony-Reihe bevorzugt:

$$g(t) = \frac{G(t)}{G_0} = \frac{G_\infty}{G_0} + \sum_{i=1}^{n} \frac{G_i}{G_0} e^{\frac{-t}{\tau_i}} = g_\infty + \sum_{i=1}^{n} g_i\, e^{\frac{-t}{\tau_i}} = 1 - \sum_{i=1}^{n} g_i (1 - e^{\frac{-t}{\tau_i}}). \tag{2.38}$$

Die hierbei eingeführten Relaxationszeiten $\tau_i = \eta_i/G_i$ sind ein Maß für die Dauer
des zu den jeweiligen Relaxationsstärken G_i gehörenden Relaxationsprozesses. Zum Zeit-
punkt $t = \tau_i$ ist der Relaxationsprozess zu $1 - e^{-1} = 63\,\%$ abgeschlossen. In Abbildung
2.24b ist für drei verschiedene Relaxationszeiten τ der zeitliche Verlauf des relativen
Schubmoduls g von einem Maxwell-Element abgebildet. Es ist erkennbar, dass ein
Maxwell-Element im Bereich der jeweiligen Relaxationszeit innerhalb einer Zeitdekade
nahezu vollständig relaxiert. Somit ist je abzubildender Zeitdekade ein Prony-Reihenglied
notwendig.

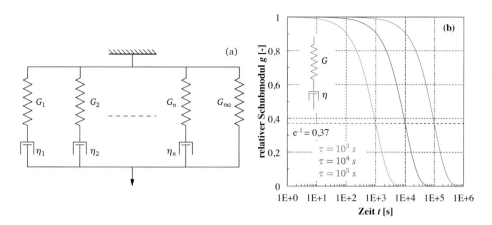

Abbildung 2.24 Verallgemeinertes Maxwell-Modell (a), zeitlicher Einfluss einzelner Feder-Dämpfer-Elemente mit unterschiedlichen Relaxationszeiten (b)

Handelt es sich um Viskoelastizität mit Fließen, sind die parallel geschaltete Feder G_∞ in Abbildung 2.24 und die entsprechenden Terme in den Gleichungen (2.37) und (2.38) zu entfernen.

Es ist zu beachten, dass beide vorgestellten rheologischen Modelle zwar bei gleicher Anzahl an Feder-Dämpfer-Paaren mechanisch äquivalent, die Konstanten G_i bzw. η_i allerdings nicht identisch sind. Um eine Umrechnung zwischen der Kriechfunktion des verallgemeinerten Kelvin-Voigt-Modells und der Relaxationsfunktion des verallgemeinerten Maxwell-Modells vorzunehmen, bedarf es einer inversen Laplace-Transformation (SCHWARZL, 1990).

Eine Erweiterung des reinen Schubzustands auf den allgemeinen dreidimensionalen Spannungszustand ist für isotrope Werkstoffe einfach möglich. Wie in Abschnitt 2.3.4 erläutert, wird in der linearen Elastizität unter der Voraussetzung kleiner Verzerrungen der Zusammenhang zwischen Spannung und Verzerrung über den Elastizitätstensor oder ein Potential hergestellt. Im isotropen Fall verbleiben dabei zwei unabhängige Materialkonstanten, beispielsweise der Schubmodul G und der Kompressionsmodul K. Im linear viskoelastischen Fall sind diese beiden Parameter nicht mehr konstant sondern zeitabhängig und können als Prony-Reihen abgebildet werden. Wird eine konstante Querkontraktionszahl v angenommen, muss schließlich nur die Schub-Prony-Reihe $G(t)$ berücksichtigt werden. Diese Annahme ist für die Beschreibung der Schubkopplung in intaktem Verbundglas gerechtfertigt, da die Volumenänderung der Zwischenschicht hierauf einen vernachlässigbaren Einfluss hat.

Die lineare Viskoelastizität ist bei ausreichend geringer Verzerrung für alle Kunststoffe anwendbar. Der Übergang zur nichtlinearen Viskoelastizität wird Linearitätsgrenze genannt. GRELLMANN et al., 2011 nennen als generell gültige Linearitätsgrenze für feste

Kunststoffe eine Verzerrung von 1 %. Im entropieelastischen Bereich können die Linearitätsgrenzen bei deutlich größeren Verzerrungen liegen (SCHWARZL, 1990).

2.3.6 Zeit-Temperatur-Verschiebungsprinzip

Wie in Abschnitt 2.3.2 beschrieben, bewirkt eine Temperaturerhöhung eine Steifigkeitsverringerung und ist damit vergleichbar mit einer längeren Belastungsdauer. Dies kann auf die thermische Aktivierung der molekularen Bewegungs- und Umlagerungsvorgänge im Polymer zurückgeführt werden, welche bei höheren Temperaturen schneller ablaufen.

Eine Temperaturerhöhung entspricht also einer Reduktion der Relaxationszeiten des viskoelastischen Materials und damit einer horizontalen Verschiebung der Relaxationsfunktion $G(t)$ auf der Zeitachse. Diese wird üblicherweise wie in Abbildung 2.25 logarithmiert aufgetragen, sodass für den Verschiebungsfaktor $a_\mathrm{T}(T, T_\mathrm{ref})$ folgt:

$$\log_{10} a_\mathrm{T}(T, T_\mathrm{ref}) = \log_{10} t^* - \log_{10} t_\mathrm{ref} = \log_{10} \frac{t^*}{t_\mathrm{ref}}. \tag{2.39}$$

Dieses Vorgehen nennt man Zeit-Temperatur-Verschiebungsprinzip (ZTV). Der Verschiebungsfaktor $a_\mathrm{T}(T, T_\mathrm{ref})$ ist dabei von der betrachteten Temperatur T als auch von der Referenztemperatur T_ref, welche frei gewählt werden kann, abhängig. Für die Relaxationszeiten ergibt sich daraus folgender Zusammenhang:

$$\tau_i(T) = a_\mathrm{T}(T, T_\mathrm{ref})\, \tau_i(T_\mathrm{ref}) \tag{2.40}$$

mit

$\tau_i(T)$ i-te Relaxationszeit bei der Temperatur T,
$\tau_i(T_\mathrm{ref})$ i-te Relaxationszeit bei der Referenztemperatur T_ref,
$a_\mathrm{T}(T, T_\mathrm{ref})$ temperaturabhängiger Verschiebungsfaktor.

Ist es möglich, das ZTV anzuwenden, nennt man das Material **thermorheologisch einfach**. Das bedingt, dass alle Relaxationszeiten die gleiche Temperaturabhängigkeit haben

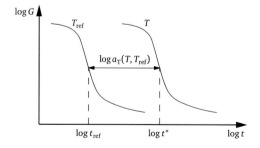

Abbildung 2.25 Zeit-Temperatur-Verschiebungsprinzip

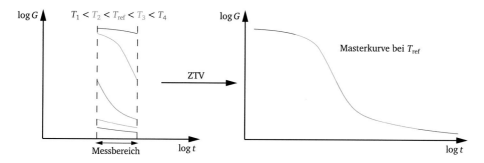

Abbildung 2.26 Erstellung einer Masterkurve mittels ZTV (siehe z.B. GRELLMANN et al., 2011)

müssen, was nur zutrifft, wenn eine Temperaturänderung die Geschwindigkeit der molekularen Prozesse ändert, nicht aber deren Art und Anzahl (GRELLMANN et al., 2011). Das ZTV ist nur eine Näherung, welche für Ingenieuranwendungen aber oftmals ausreichend ist (SCHWARZL, 1990).

Ist ein Material nicht thermorheologisch einfach, so sind die Relaxationskurven bei verschiedenen Temperaturen nach der Horizontalverschiebung nicht deckungsgleich und das ZTV kann nicht angewandt werden.

Ein großer Vorteil, der aus dem ZTV gewonnen wird, ist die Erweiterung des zeitlichen Messbereichs. So können anhand von zeitlich beschränkten Messungen bei verschiedenen Temperaturen Aussagen über kürzere und längere Messdauern getroffen werden. Abbildung 2.26 veranschaulicht dieses Vorgehen. Die so erstellte Kurve wird **Masterkurve** genannt.

Für verschiedene Dispersionsgebiete (s. Abschn. 2.3.2) können Verschiebungsansätze gemacht werden, um den temperaturabhängigen Verschiebungsfaktor $a_T(T, T_{\text{ref}})$ mathematisch zu beschreiben (SCHWARZL, 1990).

Der empirische **Verschiebungsansatz nach William, Landel und Ferry (WLF)**

$$\log_{10} a_T(T, T_{\text{ref}}) = -\frac{c_1 \left(T - T_{\text{ref}}\right)}{c_2 + T - T_{\text{ref}}} \tag{2.41}$$

findet dabei am häufigsten Anwendung (FERRY, 1980). Die zu bestimmenden Konstanten c_1 [-] und c_2 [°C] sind von der Referenztemperatur abhängig, sodass neben der Messkurve bei Referenztemperatur noch zwei weitere Kurven vorliegen müssen. Der Ansatz beschreibt eine Hyperbel mit einer Polstelle bei $T = -(c_2 - T_{\text{ref}})$ und findet oftmals gute Übereinstimmung mit Versuchsergebnissen im Glasübergangsbereich und im entropieelastischen Bereich (SCHWARZL, 1990).

Der **Verschiebungsansatz nach Arrhenius** ist motiviert durch die thermische Aktivierung sekundärer Dispersionserscheinungen (Seitenkettenbewegungen, lokale Bewe-

gungen in der Hauptkette der Makromoleküle oder Aufschmelzen kristalliner Phasen) und
beschreibt somit vorwiegend den energieelastischen Bereich (SCHWARZL, 1990):

$$\log_{10} a_{\mathrm{T}}(T, T_{\mathrm{ref}}) = -k_{\mathrm{A}} \left(\frac{1}{T} - \frac{1}{T_{\mathrm{ref}}} \right) \tag{2.42}$$

mit

$k_{\mathrm{A}} = \log_{10}(e) \frac{E_{\mathrm{A}}}{R_{\mathrm{m}}} = 0{,}434 \frac{E_{\mathrm{A}}}{R_{\mathrm{m}}}$	Arrhenius-Konstante,
E_{A}	Material- und prozessspezifische
	Aktivierungsenergie [$\mathrm{J\,mol^{-1}}$],
$R_{\mathrm{m}} = 8{,}314\,\mathrm{J\,mol^{-1}\,K^{-1}}$	universelle Gaskonstante,
T	Temperatur in Kelvin [K].

Beide Verschiebungsansätze sind in der Literatur teilweise auch mit positivem Vorzei-
chen zu finden. Darüber hinaus gibt es weitere Verschiebungsansätze, welche weniger weit
verbreitet sind, beispielsweise nach Narayanaswamy-Tool (ANSYS INC., 2012a) oder den
Arcustangens-Ansatz (WOICKE et al., 2004).

Die thermorheologische Einfachheit ist ein notwendiges aber nicht hinreichendes Kri-
terium, um die vorgestellten Verschiebungsansätze anwenden zu können. Ist das ZTV an-
wendbar und geht die Betrachtung über mehrere Dispersionsgebiete hinaus, so können
unter Umständen die vorgestellten Verschiebungsansätze kombiniert werden. Eine detail-
lierte Beschreibung und Herleitung des ZTV findet sich beispielsweise in FERRY, 1980
und SCHWARZL, 1990.

2.3.7 Prüfmethoden

Im Folgenden werden Prüfmethoden aufgeführt, welche zur Bestimmung mechanischer
Eigenschaften dienen. Schwerpunkt wird hierbei auf die Dynamisch-Mechanisch-Thermi-
sche Analyse (DMTA) und den uniaxialen Zugversuch gelegt, da diese im Rahmen der
Arbeit angewandt wurden. Neben einer Erläuterung des Versuchsprinzips und der Aus-
wertung wird Bezug auf die relevanten Regelwerke genommen. Weitere Prüfmethoden
werden anschließend kurz der Vollständigkeit halber erläutert.

Dynamisch-Mechanisch-Thermische Analyse

Die Dynamisch-Mechanisch-Thermische Analyse (DMTA) ist ein Verfahren, um die zeit-
und temperaturabhängigen Eigenschaften eines Werkstoffes im Bereich kleiner Verzer-
rungen zu untersuchen. Es dient zudem der Identifikation von Modellparametern bei An-
nahme der linearen Viskoelastizität. Dem Probekörper wird eine sinusförmige Anregung,
welche weg- bzw. verzerrungsgesteuert oder kraft- bzw. spannungsgesteuert sein kann,
aufgezwungen und die Reaktion gemessen. Die folgende Erläuterung beschränkt sich auf

eine verzerrungsgesteuerte Anregung (s. Abb. 2.27). Für eine spannungsgesteuerte Anregung gelten die Ausführungen analog.

Die Ergebnisse der Messungen im Frequenzbereich werden – wie bei Schwingungen üblich – im komplexen Zahlenraum angegeben. Diese müssen anschließend in den Zeitbereich und den reellen Zahlenraum überführt werden. Ziel der Untersuchungen ist es, die mechanischen Kennwerte zur Beschreibung der Viskoelastizität wie die Prony-Reihen-Parameter und die ZTV-Konstanten zu bestimmen. Gegenüber statischen Kriech- oder Relaxationsexperimenten bei verschiedenen Temperaturen zeichnet sich die DMTA durch eine höhere Effizienz in der Versuchsdauer aus.

Ein wichtiger Parameter, welcher im Voraus festzulegen ist, ist die Probekörpersteifigkeit. Ist diese zu hoch, werden die Messungen von der Nachgiebigkeit der Werkzeuge, welche die Probe in der Maschine fixieren, verfälscht. Ist die Probekörpersteifigkeit zu niedrig, dominiert die Massenträgheit der Werkzeuge und es treten Resonanzeffekte auf. Dem Versuchsaufbau und der Materialsteifigkeit entsprechend ist daher eine angepasste Probekörpergeometrie zu wählen.

Je nach Belastungsmodus wird der Schubmodul, der Elastizitätsmodul oder der Kompressionsmodul ermittelt. Für eine Umrechnung untereinander müssen zwei der Größen oder die Querkontraktionszahl bekannt sein. Letztere ist aber bei viskoelastischen Materialien keine Konstante, sondern wie die Moduln eine Funktion von Temperatur und Frequenz bzw. Zeit (s. Abschn. 2.3.2). Im Folgenden wird analog der Beschreibung der Viskoelastizität in Abschnitt 2.3.5 vom einfachen Schubversuch ausgegangen, um die Notation einheitlich zu halten.

Die zeitabhängige Scherung wird gemäß

$$\gamma(t) = \bar{\gamma} \sin(\omega t) \tag{2.43}$$

aufgebracht. Hierbei sind

$\bar{\gamma}$	Amplitude der Anregung,
$\omega = 2\pi f$	Kreisfrequenz der Anregung,
f	Frequenz der Anregung.

Es wird eine sinusförmige Spannungsantwort gemessen, welche um den Betrag δ zur Anregung versetzt ist (Abb. 2.27a):

$$\tau(t) = \bar{\tau} \sin(\omega t + \delta) = \bar{\tau} \sin(\omega t) \cos(\delta) + \bar{\tau} \cos(\omega t) \sin(\delta) \tag{2.44}$$

mit

$\bar{\tau}$	Amplitude der Spannungsantwort,
δ	Phasenwinkel.

Es ist erkennbar, dass ein Teil der Antwort mit der Anregung und ein Teil um 90° verschoben schwingt. Der in Phase schwingende Teil beschreibt die elastische, der ge-

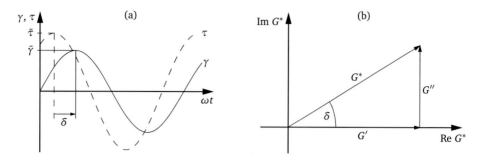

Abbildung 2.27 Phasenverschiebung zwischen Anregung und Antwort (a), Definition des komplexen Moduls G^* in der Gaußschen Zahlenebene (b)

genphasige die viskose Komponente. So ergibt sich für ein ideal elastisches Material ein Phasenwinkel $\delta = 0$ und für ein ideal viskoses Material $\delta = \pi/2$. Ein viskoelastisches Material befindet sich dazwischen. Dementsprechend wird ein komplexer Schubmodul G^* eingeführt, welcher sich aus einem elastischen Anteil (Speichermodul) und einem viskosen Anteil (Verlustmodul) zusammensetzt (siehe z.B. SCHWARZL, 1990 oder BRINSON et al., 2008):

$$G^* = G' + iG'' \tag{2.45}$$

mit

$$|G^*| = \frac{\bar{\tau}}{\bar{\gamma}},$$

$$G' = \frac{\bar{\tau}}{\bar{\gamma}} \cos\delta \quad \text{Speichermodul,}$$

$$G'' = \frac{\bar{\tau}}{\bar{\gamma}} \sin\delta \quad \text{Verlustmodul.}$$

Abbildung 2.27b veranschaulicht den Zusammenhang zwischen den verschiedenen Moduln in der Gaußschen Zahlenebene. Der Tangens des Phasenwinkels δ wird als Verlustfaktor oder inneres Dämpfungsmaß bezeichnet und ergibt sich zu

$$\tan\delta = \frac{G''}{G'}. \tag{2.46}$$

Für die Anwendung der vorgestellten Theorie muss sichergestellt sein, dass die Linearitätsgrenze eingehalten ist und sich das Material linear viskoelastisch verhält. Dies wird in einem ersten Schritt mittels eines **Amplitudensweeps** geprüft. Dabei wird bei konstanter Frequenz und Temperatur die Amplitude der Anregung schrittweise gesteigert. Bleibt der dabei ermittelte Modul konstant, so befindet man sich im linear viskoelastischen Bereich. Ab einer gewissen Anregungsamplitude ändert sich der gemessene Modul und es

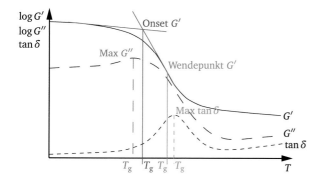

Abbildung 2.28 Ansätze zur Festlegung der Glasübergangstemperatur

liegt keine lineare Viskoelastizität mehr vor. Sind die Linearitätsgrenzen bekannt, können die eigentlichen Messungen durchgeführt werden.

Bei einem **Temperatursweep** werden Anregungsamplitude und Frequenz konstant gehalten und die Temperatur variiert. Diese Messungen dienen einer Beurteilung der Temperaturabhängigkeit und der Ermittlung der Dispersionsgebiete. Bei der Festlegung der Glasübergangstemperatur T_g gibt es verschiedene Ansätze, die mitunter deutlich unterschiedliche Ergebnisse liefern. Bei der Angabe einer ermittelten Glasübergangstemperatur muss demnach neben der Prüffrequenz auch der gewählte Auswertungsansatz mit angegeben werden. Abbildung 2.28 verdeutlicht die gängigen Ansätze, wobei auch eine lineare anstelle der üblichen logarithmischen Ordinatenachse verwendet werden kann. Sekundäre Dispersionsgebiete können anhand von weiteren lokalen Maxima im Verlustfaktor identifiziert werden. Bei einem Temperatursweep wird häufig die Prüffrequenz zu $f = 1\,\mathrm{Hz}$ gewählt.

Ein isothermer Versuch mit variierender Frequenz bei konstanter Anregungsamplitude wird **Frequenzsweep** genannt. Er gibt Aufschluss über die Zeitabhängigkeit des Materials. Werden mehrere Frequenzsweeps bei unterschiedlichen jeweils konstanten Temperaturen durchgeführt, können Masterkurven erstellt und die ZTV-Konstanten ermittelt werden. Dieses Vorgehen erfolgt analog Abbildung 2.26, jedoch im Frequenzbereich anstelle des Zeitbereichs.

Für die **Umrechnung von Frequenz- in Zeitbereich** gibt es unterschiedliche Ansätze. Mathematisch korrekt wird ausgehend von Gleichung (2.44) und dem Boltzmannschen Superpositionsprinzip (2.35) die zeitabhängige Prony-Reihe (2.38) in den Frequenzbereich überführt, wobei die unbekannten Prony-Parameter (g_i, τ_i, G_0) unverändert bleiben. Eine

ausführliche Herleitungen hierzu findet sich in SCHWARZL, 1990. Die in den Frequenzbereich überführte Prony-Reihe lautet:

$$G'(\omega) = G_\infty + \sum_{i=1}^{n} \frac{G_i \omega^2 \tau_i^2}{1 + \omega^2 \tau_i^2} = G_0 \left(1 - \sum_{i=1}^{n} g_i + \sum_{i=1}^{n} \frac{g_i \omega^2 \tau_i^2}{1 + \omega^2 \tau_i^2} \right), \tag{2.47}$$

$$G''(\omega) = \sum_{i=1}^{n} \frac{G_i \omega \tau_i}{1 + \omega^2 \tau_i^2} = G_0 \sum_{i=1}^{n} \frac{g_i \omega \tau_i}{1 + \omega^2 \tau_i^2}. \tag{2.48}$$

Werden mit diesen Gleichungen die Prony-Parameter aus gemessenem Speicher- und Verlustmodul ermittelt, kann der zeitabhängige reelle Schubmodul mittels Gleichung (2.38) bestimmt werden. Dieses Vorgehen ist notwendig, wenn die Bestimmung der Prony-Parameter das Ziel der Untersuchungen ist.

Für eine überschlägige Umrechnung von Frequenz- in Zeitbereich ohne Bestimmung der Prony-Parameter existieren Näherungslösungen (FERRY, 1980; SCHWARZL, 1990). Einige davon werden in den Gleichungen (2.49) bis (2.51) mit aufsteigender Genauigkeit aufgelistet:

$$G(t) = G'(\omega), \tag{2.49}$$

$$G(t) = G'(\omega) - 0,4G''(0,5\omega), \tag{2.50}$$

$$G(t) = G'(\omega) - 0,4G''(0,4\omega) + 0,014G''(10\omega). \tag{2.51}$$

Es ist erkennbar, dass hierbei die Messungen bei bestimmten Vielfachen der Kreisfrequenz durchgeführt werden müssen. Die Umrechnung zwischen Kreisfrequenz und Zeit unterscheidet sich mit $\omega = 2\pi f = t^{-1}$ von der sonst üblichen Definition ($f = t^{-1}$).

Auch bei der Anwendung des Zeit-Temperatur-Verschiebungsprinzips (ZTV) auf DMTA-Messungen ist zu beachten, dass diese im Frequenz- und nicht im Zeitbereich erfolgt. Dementsprechend ergibt sich aus Gleichung (2.39) für den Frequenzbereich:

$$\log_{10} a_T(T, T_{ref}) = \log_{10} \omega_{ref} - \log_{10} \omega^* = \log_{10} \frac{\omega_{ref}}{\omega^*}. \tag{2.52}$$

Die DMTA an allgemeinen Kunststoffen wird in DIN EN ISO 6721-1 geregelt. Die Folgeteile behandeln jeweils eine bestimmte Versuchsart (Torsion, Zug, Schub etc.). Das US-amerikanische Pendant dazu ist ASTM D4065. Daneben existieren für Elastomere weitere Regelwerke (DIN 53535, DIN 53513). Angaben zur Bestimmung der Glasübergangstemperatur finden sich in DIN PREN 6032 und ASTM E1640.

Im Rahmen dieser Arbeit wurden DMTA an verschiedenen Zwischenmaterialien von Verbundglas durchgeführt. Diese werden in Abschnitt 4.2.2 erläutert.

Uniaxialer Zugversuch

Der uniaxiale Zugversuch stellt den Grundversuch zur Bestimmung des Spannungs-Dehnungs-Verhaltens von Werkstoffen und daraus abgeleiteten Größen (z.B. Reißfestigkeit σ_b, Reißdehnung ε_b) dar. Im Unterschied zum uniaxialen Druckversuch, dem Schubversuch und mehraxialen Zug- und Druckversuchen ist er sehr einfach durchführbar bis hin zu sehr großen Dehnungen.

Bei dem konventionellen Zugversuch wird der Probekörper in eine Prüfmaschine eingespannt und einer konstanten Wegrate (konstante Prüfgeschwindigkeit) unterworfen. Neben der aufgebrachten Verschiebung wird die Kraft gemessen. Der Versuch endet, wenn der Werkstoff versagt. Wie bei Kunststoffen üblich, wird die Prüfung bei Normklima (23 °C, 50 % rF) durchgeführt.

Um einen uniaxialen Zustand zu erzeugen, der nicht von der Einspannung beeinflusst wird, werden sogenannte Schulterstäbe verwendet, welche in der Mitte einen Bereich konstanter Breite aufweisen (probenparalleler Bereich, Messbereich) und an den Enden im Bereich der Einspannung breiter sind. Damit soll erreicht werden, dass der Probekörper im Messbereich und nicht aufgrund der mehraxialen Beanspruchung an der Einspannung versagt. Abbildung 2.29 zeigt beispielhaft einen uniaxialen Zugversuch zu zwei Zeitpunkten und einen Schulterstab.

Mit der vorher vermessenen Probekörpergeometrie können aus Kraft und Längenänderung die Ergebnisse Spannung und Dehnung bestimmt werden. Da während des Versuchs insbesondere bei weichen Kunststoffen ein Schlupf in der Einspannung auftreten kann, ist der Traversenweg jedoch ungeeignet, um exakte Ergebnisse für die Dehnung zu erhalten. Hier liefern berührungslose optische Messverfahren (Laser- oder Videoextensometer) deutlich bessere Ergebnisse, ohne dabei die Probe zu beeinflussen wie unter Umständen bei der Verwendung von Ansetzaufnehmern.

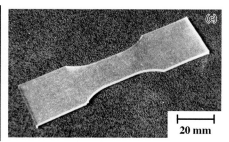

Abbildung 2.29 Uniaxialer Zugversuch mit roten Markierungen auf dem Probekörper für Videoextensometrie zu Beginn (a) und gegen Ende (b) sowie verwendeter Schulterstab (c)

Liegen Kraft F, Ausgangsquerschnitt A_0, Längenänderung Δl und Ausgangslänge l_0 vor, so bestimmen sich Spannung und Dehnung zu

$$\sigma_0 = \frac{F}{A_0}, \tag{2.53}$$

$$\varepsilon_0 = \frac{\Delta l}{l_0}. \tag{2.54}$$

Diese Größen mit dem Index 0 werden technische Spannung und technische Dehnung genannt, da sie sich auf die Ausgangskonfiguration beziehen (s. Abschn. 2.3.4). Ein Bezug auf die Momentankonfiguration mit dem aktuellem Querschnitt A und der aktuellen Messlänge l liefert die wahre Spannung und die wahre Dehnung. Zur Verdeutlichung werden diese Größen mit dem Index w versehen:

$$\sigma_\mathrm{w} = \frac{F}{A}, \tag{2.55}$$

$$\mathrm{d}\varepsilon_\mathrm{w} = \frac{\mathrm{d}l}{l} \quad \Rightarrow \quad \varepsilon_\mathrm{w} = \int_{l_0}^{l} \frac{\mathrm{d}l}{l}. \tag{2.56}$$

Unter der Voraussetzung, dass die Dehnung gleichförmig über den Querschnitt ohne lokale Einschnürung auftritt, können die Größen ineinander überführt werden:

$$\sigma_\mathrm{w} = \sigma_0 \left(1 + \varepsilon_0\right)^{2\nu}, \tag{2.57}$$

$$\varepsilon_\mathrm{w} = \ln(1 + \varepsilon_0). \tag{2.58}$$

Die wahre Dehnung wird dann auch als logarithmische Dehnung bezeichnet. Für kleine Verzerrungen fallen technische und wahre Größen zusammen.

Im Falle lokaler Einschnürung können wahre Spannung und Dehnung mittels einer lokalen optischen Extensometrie (z.B. Grauwertkorrelationsverfahren (GOM, 2007)) bestimmt werden.

Es ist zu beachten, dass selbst bei vernachlässigbarem Schlupf an der Einspannung eine konstante Wegrate nicht zu einer konstanten wahren Dehnrate führt, da die Bezugslänge für die wahre Dehnung während des Versuchs wächst. Sollen Spannungs-Dehnungs-Beziehungen bei konstanter wahrer Dehnrate ermittelt werden, bedarf es eines breiten Spektrums an Wegraten und einer Auswertung über eine Ausgleichsfläche im Spannungs-Dehnungs-Dehnraten-Raum (s. Abschn. 4.2).

Neben der Spannungs-Dehnungs-Beziehung kann bei gemessener Querkontraktion die Querkontraktionszahl ν bestimmt werden. Hierbei müssen, um auch große Dehnungen zu berücksichtigen, die wahren Größen eingesetzt werden:

$$\nu = -\frac{\varepsilon_\mathrm{w,\,quer}}{\varepsilon_\mathrm{w,\,längs}}. \tag{2.59}$$

Die Isotropie eines Werkstoffes kann anhand des uniaxialen Zugversuchs ebenfalls überprüft werden. Sind die Querkontraktionen in Breiten- und Dickenrichtung gleich und spielt die Orientierung bei der Probekörperentnahme aus Platten keine Rolle, so verhält sich der Werkstoff isotrop.

Der uniaxiale Zugversuch an allgemeinen Kunststoffen wird in DIN EN ISO 527-1 und den Folgeteilen geregelt. Hierin werden Vorgaben zum Prüfverfahren sowie charakterisierende Größen definiert, welche aus den Versuchsergebnissen abgeleitet werden können. Beispiele hierfür sind die Bruchspannung σ_b (Reißfestigkeit) und die Bruchdehnung ε_b (Reißdehnung) als technische Größen. Das US-amerikanische Pendant zu der Norm ist ASTM D638. Wie bei der DMTA existieren für Elastomere weitere Regelwerke (DIN 53504, ASTM D412).

Im Rahmen dieser Arbeit wurden uniaxiale Zugversuche mit verschiedenen Wegraten an unterschiedlichen Zwischenmaterialien von Verbundglas durchgeführt. Diese werden in Abschnitt 4.2.3 erläutert.

Weitere Prüfmethoden

Zur Untersuchung der Steifigkeit von Kunststoffen bis hin zu großen Verzerrungen und zur Anpassung von Versagenshypothesen gibt es neben dem uniaxialen Zugversuch weitere Prüfmethoden. Dazu zählen insbesondere biaxiale Zugversuche, Schubversuche, uniaxiale Druckversuche und triaxiale (hydrostatische) Druckversuche. Der versuchstechnische Aufwand ist jedoch deutlich höher als bei dem uniaxialen Zugversuch. Weitere mehraxiale Zustände wie der hydrostatische Zug lassen sich kaum noch realisieren.

Zur Untersuchung des viskoelastischen Materialverhaltens können Zug-, Druck- und Schubversuche auch als Kriech- oder Relaxationsversuche durchgeführt werden. Mit unterschiedlichen Temperaturen können diese zur Ermittlung einer Masterkurve und der ZTV-Konstanten dienen, solange die aufgebrachte Verzerrung den linear viskoelastischen Bereich nicht überschreitet.

Falls Schädigungseffekte wie Mikrorissbildung oder der Mullins-Effekt (HARWOOD et al., 1965) im Material zu beobachten sind, können die genannten Versuche auch zyklisch durchgeführt werden, um Erst- und Wiederbelastung getrennt zu untersuchen. Eine hohe Anzahl an Prüfzyklen kann wiederum zum Versagen eines Werkstoffs führen, sodass dann von Ermüdungsversuchen gesprochen wird.

Die Lage des Glasübergangsbereichs sowie möglicher sekundärer Dispersionsgebiete lässt sich neben der DMTA mittels der Differential Scanning Calorimetry (DSC) bestimmen. Hierbei wird der Wärmestrom einer Materialprobe gegenüber einer Referenz über einen Temperatursweep gemessen. So können endotherme und exotherme Prozesse wie der Glasübergang, Kristallisation, Schmelzen, Zersetzung etc. identifiziert werden. Anhand einer Thermomechanischen Analyse (TMA), bei welcher die Dimensionsänderungen einer Materialprobe in einem Temperatursweep gemessen wird, kann ebenfalls der Glasübergang identifiziert werden.

Weitere Prüfmethoden zur Charakterisierung mechanischer Kennwerte sind Biegeversuche, schlagartige Beanspruchungen und Härteprüfungen. Ein tieferer Einblick in die angeführten sowie in Prüfmethoden für sonstige physikalische Eigenschaften von Kunststoffen findet sich beispielsweise in GRELLMANN et al., 2011.

2.4 Verbundglas

2.4.1 Allgemeines

Verbundglas wird in DIN EN ISO 12543-1 als „Aufbau, bestehend aus einer Glasscheibe mit einer oder mehreren Scheiben aus Glas und/oder Verglasungsmaterial aus Kunststoff, die durch eine oder mehrere Zwischenschichten miteinander verbunden sind", bezeichnet. Üblicherweise ist ein Zweifachverbund nach Abbildung 2.30 gemeint. Als Qualitätsanforderungen an die Beständigkeit des Verbundglases werden in DIN EN ISO 12543-3 Prüfungen bei hoher Temperatur (Lagerung für 16 Stunden bei 100 °C in einem Ofen oder für zwei Stunden in kochendem Wasser), in der Feuchte (zweiwöchige Lagerung bei 50 °C und 100 % rF) und unter Bestrahlung (2000-stündige Einwirkung von simulierter Sonnenbestrahlung bei 45 °C) gefordert. Die Prüfverfahren sind in DIN EN ISO 12543-4 festgelegt.

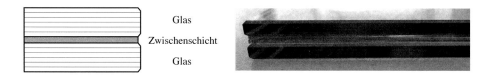

Glas

Zwischenschicht

Glas

Abbildung 2.30 Standardaufbau eines Verbundglases

Ein **Verbundsicherheitsglas** muss darüber hinaus bestimmte Anforderungen im Falle eines Glasbruchs erfüllen, um eine Resttragfähigkeit sicherzustellen sowie das Verletzungsrisiko durch Schnitt- oder Stichverletzungen zu minimieren. Hierzu wird in DIN EN ISO 12543-2 eine Klassifizierung 3(B)3 im Pendelschlagversuch nach DIN EN 12600 gefordert. In Deutschland ist bisher nur Verbundsicherheitsglas mit einer Zwischenschicht aus Polyvinylbutyral (PVB) als Bauprodukt geregelt. In der Bauregelliste A Teil 1 (DIBT, 2014b) werden diesbezüglich weitere Anforderungen an ein Verbundsicherheitsglas gestellt:

- PVB-Folie: Reißfestigkeit $\sigma_b > 20\,\text{MPa}$, Reißdehnung $\varepsilon_b > 250\,\%$ nach DIN EN ISO 527-3,

- Verbundsicherheitsglas aus 2 x 3 mm Floatglas und 0,38 mm PVB: Kugelfallversuch mit 4 m Fallhöhe nach DIN 52338.

Soll das Glas bei Verwendung anderer Zwischenschichten als Verbundsicherheitsglas eingestuft werden, bedarf es in Deutschland einer allgemeinen bauaufsichtlichen Zulassung (abZ) des Deutschen Instituts für Bautechnik (DIBt) oder einer Zustimmung im Einzelfall (ZiE) der obersten Bauaufsichtsbehörde.

Einsatzbereiche für Verbundsicherheitsglas sind Horizontalverglasungen mit darunter befindlichen Verkehrsflächen, absturzsichernde, betretbare oder begehbare Verglasungen sowie Gläser mit Schutzfunktionen (s. Abschn. 2.4.9). In der vorliegenden Arbeit werden keine baurechtlichen Unterscheidungen getroffen sondern einheitlich der Überbegriff „Verbundglas" verwendet.

Das erste Patent einer Folie aus Cellulosenitrat als Zwischenfolie in Verbundglas stammt aus dem Jahr 1905. Getrieben von der Verwendung von Verbundglas als Windschutzscheibe in Automobilen wurden um 1935 die ersten Patente einer Folie auf Polyvinylbutyral-Basis veröffentlicht. Dies stellt in weiterentwickelter Form bis heute das Standardmaterial für Zwischenschichten in Verbundglas dar. Die Zwischenschichten werden üblicherweise in einer Dicke von 0,38 mm oder in Vielfachen davon hergestellt. Eine Erhöhung der Zwischenschichtdicke ist zudem durch die Verwendung mehrerer Lagen möglich. Die Produktionsbreite wurde auf das Bandmaß von Floatglas mit 3,21 m angepasst (KURARAY, 2012).

Das Tragverhalten von Verbundglas unter einer Belastung senkrecht zur Plattenebene wird überwiegend durch die mechanischen Eigenschaften der Zwischenschicht bestimmt. Dabei sind grundsätzlich die beiden Zustände „intaktes Verbundglas" und „gebrochenes Verbundglas" zu unterscheiden.

Der intakte Zustand ist in Abbildung 2.31 dargestellt. Nach DIN 18008-1 sind bei der Bemessung die Grenzfälle kein Verbund (a) und voller Verbund (c) zu berücksichtigen. In Realität stellt sich jedoch je nach Schubkopplung durch die Zwischenschicht ein Teilverbund der Glasplatten ein (b). Zwischen Glas und Folie kann von einer vollständigen Haftung ausgegangen werden, sodass die Steifigkeit der Zwischenschicht bei kleinen Verzerrungen ausreicht, um das mechanische Verhalten des intakten Verbundglases vollständig zu beschreiben. Dabei ist die Abhängigkeit der Kunststoffsteifigkeit von Temperatur und Belastungsdauer zu berücksichtigen (s. Abschn. 2.3.5 und 2.3.6).

Die unterschiedlichen Zustände des Nachbruchverhaltens sind in Abbildung 2.32 dargestellt. Nach dem Bruch der unteren Glasplatte (a) trägt im Bereich des Bruchs hauptsächlich die obere intakte Glasplatte, die Zwischenschicht leistet nur einen geringen Beitrag. An dieser Stelle wird die obere Glasplatte deutlich stärker beansprucht, als in den Bereichen, wo die untere Glasplatte keinen Bruch aufweist und sich somit am Lastabtrag beteiligen kann. Daher ist in diesem Bereich ein Fortschreiten des Risses in die obere Glasplatte wahrscheinlich. Das Auftreten eines koinzidenten Risses oben und unten (b) ist zudem eine ungünstigere Beanspruchung als ein versetzter Riss. Das gebrochene Glas kann lediglich noch Druck übertragen, die Zwischenschicht überträgt die Zugkraft. Bei

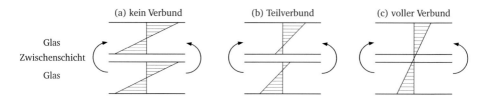

Abbildung 2.31 Mechanisches Verhalten von intaktem Verbundglas in Abhängigkeit der Schubkopplung

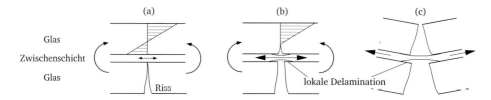

Abbildung 2.32 Mechanisches Verhalten von gebrochenem Verbundglas

größeren Verformungen geht das Tragverhalten von Biegung zu einem Membrantragverhalten (c) über.

Das mechanische Verhalten von Verbundglas wird im vollständig gebrochenen Zustand (Abb. 2.32b und c) von den folgenden Parametern beeinflusst:

Randbedingungen Die gewählte Lagerung, die Abmessungen der Verglasung sowie Art, Intensität und Dauer der Belastung sind maßgebliche aber oftmals festgelegte Einflussfaktoren.

Glasart und Glasdicke Das Bruchbild einer Verglasung hängt maßgeblich vom Grad der thermischen Vorspannung ab, welche in Abhängigkeit der Glasdicke die gespeicherte innere Energie im unbelasteten Zustand ergibt. Diese wird zusammen mit der Energie, welche aus der Belastung resultiert, beim Bruch freigesetzt und bestimmt die Beschleunigung des sich ausbreitenden Risses. Bei einer kritischen Risswachstumsgeschwindigkeit von etwa $v \approx 1500\,\mathrm{m\,s^{-1}}$ verzweigt der Riss (s. Abschn. 2.2.2). Je höher also die freigesetzte innere Energie beim Bruch ist, desto schneller verzweigt sich der Riss und desto kleiner werden die durchschnittlichen Bruchstücke. Gebrochenes Verbundglas mit wenigen groben Bruchstücken weist ein besseres Nachbruchverhalten als eines mit vielen kleinen Bruchstücken auf, weswegen in Deutschland bei Horizontalverglasungen kein VSG aus Einscheibensicherheitsglas (ESG) eingesetzt werden darf (DIN 18008-2). Die Glasdicke wirkt sich zudem auf den inneren Hebelarm zwischen Folienzugkraft und resultierender Kraft aus der Druckspannung in der oberen Glasplatte aus (s. Abb. 2.32b).

Materialverhalten der Zwischenschicht Im Bereich des Glasbruchs muss die Zwischenschicht eine Zugkraft übertragen und erfährt damit große Dehnungen bis hin zur Bruchdehnung. Das Spannungs-Dehnungs-Verhalten der Zwischenschicht unter der gegebenen Dehnrate und Temperatur beeinflusst somit maßgeblich das Nachbruchverhalten von Verbundglas.

Delaminationsverhalten der Zwischenschicht Um eine Zugübertragung zwischen den Rissen, welche eine infinitesimale Breite aufweisen, zu ermöglichen, muss sich die Zwischenschicht in diesem Bereich lokal vom Glas lösen (delaminieren). Dies kann anhand der technischen Dehnung der Zwischenschicht am Riss nach Gleichung (2.54) veranschaulicht werden. Ohne lokale Delamination beträgt die Ausgangsdehnlänge $l_0 = 0$ und die Zwischenschicht würde bei einer endlichen Rissaufweitung im Glas, welcher der Verlängerung der Zwischenschicht Δl entspricht, eine unendlich hohe Dehnung erfahren und damit sofort reißen. Eine Steigerung der Delamination verringert dagegen das Dehnungsniveau in der Zwischenschicht und ermöglicht größere globale Verformungen des Laminats vor dem endgültigen Versagen. Das Delaminationsverhalten wird von der Haftung (Adhäsion) von Zwischenschicht und Glas sowie der Steifigkeit der Zwischenschicht beeinflusst. Diese beiden Parameter sind abhängig von der Belastungsgeschwindigkeit.

2.4.2 Zwischenschichten aus Polyvinylbutyral (PVB)

Zwischenschichten aus Polyvinylbutyral (PVB) stellen mit etwa 90 % Marktanteil das Standardprodukt für Verbundglas im Bauwesen dar. Die folgenden Erläuterungen beziehen sich auf PVB-Folien allgemein und insbesondere auf die in dieser Arbeit untersuchten Produkte der Firma *Kuraray Division Trosifol®*. Andere Hersteller von PVB-Folien für Verbundglas sind *Eastman* (*Solutia*) und *Sekisui*. Folgende PVB-Produkttypen der Firma *Kurary Division Trosifol®* wurden im Rahmen dieser Arbeit untersucht:

- BG (Building Grade): Standardprodukt für den Baubereich. Die Zusatzkennung R10, R15 bzw. R20 kennzeichnet den Haftgrad in aufsteigender Reihenfolge.

- SC (Sound Control): Weichere Folie, die aufgrund ihrer guten Dämpfungseigenschaften als Schallschutzfolie angewandt wird. Sie erreicht nicht die nach Bauregelliste geforderte Reißfestigkeit, besitzt aber eine allgemeine bauaufsichtliche Zulassung (abZ) zur Verwendung in Verbundsicherheitsglas (DIBT, 2012).

- ES (Extra Strong): Folie mit höherer Steifigkeit gegenüber BG für Anwendungen im konstruktiven Glasbau.

- K7026: Prototyp, der eine höhere Steifigkeit gegenüber ES aufweist.

Herstellung und Eigenschaften

Zwischenschichten aus PVB bestehen nach Angaben des Herstellers aus den drei Hauptkomponenten PVB-Harz (70-75 Gew.-% bei BG), Weichmacher (25-30 Gew.-% bei BG) und Additiven (Funktionszusatzstoffe, weniger als 1 Gew.-%).

Das PVB-Harz wird in einem mehrstufigen Prozess synthetisiert (Abb. 2.33): Aus Ethin (Acetylen), einem gasförmigen Kohlenwasserstoff, und Ethansäure (Essigsäure) entsteht das Monomer Vinylacetat, welches mittels Kettenpolymerisation zu dem Thermoplast Polyvinylacetat umgewandelt wird. Dieses reagiert mit Methanol zu Polyvinylalkohol, ebenfalls ein Thermoplast, und dem Nebenprodukt Methylacetat (Essigsäuremethylester). Mit flüssigem Butyraldehyd (Butanal) wird aus dem Polyvinylalkohol schließlich Polyvinylbutyral unter Abspaltung von Wasser erzeugt. Das PVB-Harz besteht jedoch nicht nur aus dem Endprodukt Polyvinylbutyral, sondern ist laut Hersteller eine Verbindung aus Vinylalkohol (x, 18-21%), Vinylacetat (y, <2%) und Vinylbutyral (z, 77-81 %) (Abb. 2.34).

Als Weichmacher werden üblicherweise Ester von Oligoglykolen (3G8) und der Adipinsäure (DHA) eingesetzt (KURARAY, 2012). Durch die Zugabe weiterer Additive werden bestimmte Eigenschaften (z.B. Folienhaftung, Einfärbung, UV-Transmission) gesteuert. Die Additive haben nach Angabe des Herstellers keinen maßgebenden Einfluss auf das Steifigkeitsverhalten der Folien.

PVB-Harz, Weichmacher und Additive werden durch ein Extrusionsverfahren zu einer Folie verarbeitet. Dabei wird insbesondere auf eine definierte raue Oberfläche, die korrekte Folienfeuchte und die Vermeidung von produktionsbedingten Eigenspannungen geachtet.

Abbildung 2.33 Herstellungsprozess von Polyvinylbutyral (nach KURARAY, 2012)

Vinylalkohol Vinylacetat Vinylbutyral

Abbildung 2.34 Chemische Zusammensetzung von PVB-Harz (nach KURARAY, 2012)

Abbildung 2.35 Schematische Darstellung der Haftung zwischen PVB-Folie und Glas (nach KURARAY, 2012)

Um ein Verkleben der Folie auf der Rolle zu vermeiden, muss die Rolle bis zur Verarbeitung bei maximal 8 °C gekühlt oder mit Trennfolien aus Polyethylen aufgewickelt werden. Ein Einschweißen in eine wasserdampfdichte Verpackung verhindert eine Auffeuchtung der Folie.

Die Haftung zwischen der PVB-Folie und dem Glas wird in erster Linie durch die Ausbildung von Wasserstoffbrückenbindungen (physikalische Bindung) zwischen den Hydroxygruppen beider Materialien ermöglicht (Abb. 2.35).

Der Anteil an Polyvinylalkohol ist hierfür maßgebend, kann jedoch nicht beliebig variiert werden, da die mechanischen Eigenschaften sich sonst ebenfalls verändern (KURARAY, 2012). Weiteren Einfluss auf die Haftung zwischen Glas und PVB-Folie haben die Waschwasserqualität (Kalkgehalt bzw. Leitfähigkeit und Verschmutzung durch Öle oder Tenside), die Oberfläche des Glases (Feuerseite oder Zinnbadseite, Bedruckungen) und die Folienfeuchtigkeit. Für eine kontrollierte Variation der Haftung bei gleichzeitigem Beibehalten der mechanischen Eigenschaften und der Prozessparameter beim Laminieren werden Additive verwendet, die in sehr geringen Mengen das Adhäsionsverhalten steuern (Alkali- und Erdalkalisalze). Einen untergeordneten Beitrag zur Adhäsion zwischen Glas und PVB stellt die mechanische Adhäsion (Verzahnung) dar.

Die PVB-Folie sollte eine Folienfeuchte von 0,45 % aufweisen, um die gewünschte Adhäsion zum Glas optimal zu erreichen. Auch die mechanischen Eigenschaften sind in einem gewissen Maße von der Folienfeuchte abhängig. Um die im Herstellwerk eingestellte Folienfeuchte nicht zu verändern, bedarf es bei offener Lagerung einer Umgebungsluft-

Tabelle 2.7 Herstellerangaben zu den untersuchten PVB-Folien (KURARAY, 2012)

Eigenschaften	Norm	Einheit	BG	SC	ES
Dichte ρ	DIN 53479	$\mathrm{g\,m^{-3}}$	1,065	1,058	1,081
Temperaturausdehnungs-koeffizient α_T	-	$\mathrm{K^{-1}}$	$2,2 \cdot 10^{-4}$	$4,14 \cdot 10^{-4}$	-
Reißfestigkeit σ_b	DIN EN ISO 527-1	MPa	>23	>14	≈ 35
Reißdehnung ε_b	DIN EN ISO 527-1	%	>280	>300	≈ 200

feuchtigkeit von 25 % rF bis 30 % rF bei einer empfohlenen Umgebungstemperatur zwischen 18 °C und 20 °C (KURARAY, 2012). Bei 23 °C Raumtemperatur sollte laut Hersteller die Luftfeuchtigkeit 23 % rF betragen. Eine aufgefeuchtete Folie kann durch entsprechende Lagerung wieder rekonditioniert werden.

Die Steifigkeit der Folie wird zum einen durch das verwendete Harz (Länge der Polymerketten, Molekulargewicht) und insbesondere durch Art und Menge des eingesetzten Weichmachers bestimmt. So weist die SC-Folie eine erhöhte und die ES-Folie eine verringerte Menge Weichmacher gegenüber der BG-Folie auf.

Das Polymer Polyvinylbutyral wird den amorphen Thermoplasten zugeordnet. Der Kunststoff PVB-Folie ist schmelzbar und kann somit ebenfalls als Thermoplast bezeichnet werden. Die Glasübergangstemperatur T_g einer BG-Folie liegt etwa bei Raumtemperatur, wodurch bei längeren Belastungen das mechanische Verhalten entropieelastisch ist (s. Abb. 2.16). Dadurch verhält sich der Kunststoff nach Entlastung nahezu vollständig elastisch (reversible Verformungen), allerdings zeitverzögert (viskoelastisch). Bei großen Dehnungen ist der Zusammenhang zwischen Spannung und Dehnung nichtlinear, was bei Temperaturen $T \geq T_g$ in guter Näherung mit der Hyperelastizität beschrieben werden kann. Das mechanische Verhalten der unterschiedlichen PVB-Folien wird in Kapitel 4 untersucht.

Vom Hersteller werden üblicherweise Werte für Reißfestigkeit und Reißdehnung angegeben, da dies mit den Angaben der Bauregelliste verglichen werden kann (s. Abschn. 2.4.1). Für die in dieser Arbeit untersuchten Produkte fasst Tabelle 2.7 die Herstellerangaben zusammen. Für den Prototyp K7026 wurden noch keine Angaben vom Hersteller veröffentlicht.

Laminationsprozess

Nach der Entnahme der PVB-Folie aus der wasserdampfdichten Verpackung ist eine geeignete Lagerung bezüglich Raumtemperatur und Raumluftfeuchte nötig. Vor dem Laminieren wird sie auf das gewünschte Maß zugeschnitten und mit den Glasplatten geschichtet (Layering). Anschließend erfolgt der Vorverbund, welcher entweder im Walzen- oder im Vakuumverfahren bewerkstelligt wird. Die Vakuumverfahren (Vakuumring oder Va-

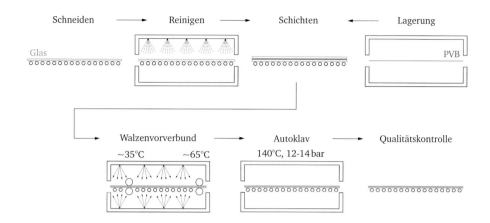

Abbildung 2.36 Laminationsprozess von PVB mit Walzenvorverbund und Autoklaven (schematisch)

Abbildung 2.37 Verbundglasherstellung im Labor der Firma *Kuraray*: Vorverbund im Vakuumsack (a), Walzenvorverbund (b) und Endverbund im Autoklaven (c)

kuumsack) werden insbesondere bei gekrümmten Verglasungen oder Mehrfachlaminaten verwendet. Ziel des Vorverbundes ist es, die Luft zwischen PVB-Folie und Glas herauszupressen, eine erste Verklebung der Materialien herzustellen und die Ränder zu versiegeln, damit im weiteren Prozess keine Luft mehr eindringen kann.

Schließlich wird in einem Autoklaven bei Drücken zwischen 12 bar bis 14 bar und einer Temperatur von 140 °C die verbliebene Luft in der PVB-Folie gebunden, wodurch

sie vollkommen klar wird. Danach ist ein endgültiger, dauerhafter Verbund zwischen Glas und Folie hergestellt. Der Endverbund kann auch autoklavenfrei mittels Vakuumverfahren erfolgen, wobei in diesem Fall die Folie bei einer Luftfeuchte unter 10 % rF konditioniert werden muss (KURARAY, 2012).

Der im Flachglasbereich übliche Laminationsprozess mit Walzenvorverbund und Endverbund im Autoklaven ist schematisch in Abbildung 2.36 dargestellt. In Abbildung 2.37 ist der Laminationsprozess im Labor der Firma *Kuraray* mit Vorverbund im Vakuumsack (a), Walzenvorverbund (b) und Endverbund im Autoklaven (c) gezeigt.

Bei thermisch vorgespannten Gläsern wird zur Verwendung dickerer Folien geraten (mindestens 1,52 mm), um Verwerfungen der Gläser auszugleichen.

Nach dem Laminationsprozess sind aufgrund der Einkapselung der PVB-Folie zwischen den Glasplatten keine besonderen Lagerungsbedingungen mehr notwendig.

2.4.3 Zwischenschichten aus Ethylenvinylacetat (EVA)

Verbundfolien aus Ethylenvinylacetat (EVA oder auch EVAC) werden insbesondere in der Solarindustrie zur Verkapselung der Solarzellen in Glas-Glas- oder Glas-Folien-Modulen verwendet. Der derzeitige Marktanteil von EVA-Folien beträgt im Solarbereich über 95 %. Die Anwendung in der Bauindustrie hat in den vergangenen Jahren zugenommen, dennoch stellen sie gegenüber PVB-Folien mit einem Marktanteil von weniger als 5 % ein Nischenprodukt für Spezialanwendungen dar. Solar-EVA-Folien sind günstiger, Bau-EVA-Folien teurer als Standard-Verbundfolien aus PVB. Die Besonderheit der EVA-Folien ist die dreidimensionale Vernetzung der Molekülketten während des Laminationsprozesses. Dadurch weisen EVA-Folien eine hohe Beständigkeit gegen Hitze und Alterung sowie eine gewisse Mindeststeifigkeit selbst bei hohen Temperaturen bzw. langen Belastungsdauern auf.

Die folgenden Erläuterungen beziehen sich auf EVA-Folien allgemein und insbesondere auf die in dieser Arbeit untersuchten Produkte der Firma *Bridgestone*. Andere Hersteller von EVA-Folien sind *Eastman* (*Solutia*), *Saint-Gobain* oder das *Folienwerk Wolfen*. Folgende EVA-Produkttypen der Firma *Bridgestone* wurden im Rahmen dieser Arbeit untersucht:

- EVASAFE™ G71: Altes Standardprodukt für den Baubereich. Durch einen hohen Vernetzungsgrad wird eine erhöhte Steifigkeit erzielt. Aufgrund der Umstellung auf G77, die im Laufe der Untersuchungen dieser Arbeit erfolgte, nicht mehr am Markt verfügbar.

- EVASAFE™ G77: Neues Standardprodukt für den Baubereich. Die mechanischen Eigenschaften sind mit dem alten G71 nahezu identisch, wesentlicher Unterschied zu G71 ist die Verwendung eines neuen Harzes mit leicht erhöhtem Vinylacetat (VAC)-Gehalt.

- EVASKYTM S11: Altes Standardprodukt für den Solarbereich. Durch einen im Vergleich zu EVASAFETM etwas geringeren Vernetzungsgrad ist die Steifigkeit im entropieelastischen Bereich geringer als bei den EVASAFETM -Folien. Aufgrund der Umstellung auf S88, die im Laufe der Untersuchungen dieser Arbeit erfolgte, nicht mehr am Markt verfügbar.

- EVASKYTM S88: Neues Standardprodukt für den Solarbereich. Die mechanischen Eigenschaften sind mit dem alten S11 nahezu identisch, wesentlicher Unterschied zu S11 ist die Verwendung eines neuen Vernetzers, welcher eine Verarbeitung bei niedrigeren Temperaturen ermöglicht.

Herstellung und Eigenschaften

EVA ist ein durch Kettenpolymerisation hergestelltes Copolymer bestehend aus den Monomeren Ethylen (Ethen) und Vinylacetat (VAC) und gehört damit zu den Polyolefinen (Abb. 2.38). Die Eigenschaften des Polymers sind maßgeblich von der prozentualen Zusammensetzung der beiden Monomere (VAC-Gehalt) abhängig. Durch das VAC wird die Kettenstruktur des Polyethylens gestört. Mit zunehmenden VAC-Gehalt sinken Kristallinität, Härte, Steifigkeit, Glasübergangs- und Schmelztemperatur, wogegen Transparenz, Dichte, Reißdehnung, Haftvermögen, Witterungsstabilität, Vernetzbarkeit und Gasdurchlässigkeit zunehmen. Die Reißfestigkeit durchläuft ein Maximum bei etwa 25 Gew.-% VAC (Abb. 2.39). Aus diesem Grund werden Kunststoffe aus EVA nach ihrem VAC-Gehalt charakterisiert und den Anwendungsgebieten zugeordnet. Neben der Anwendung als Verbundfolie werden Kunststoffe aus EVA beispielsweise als Schmelzklebstoff, Ummantelungen, Dichtungen oder Verpackungsmaterial verwendet (DOMININGHAUS, 2012).

In Folien für den Solarmarkt wird üblicherweise ein VAC-Gehalt von etwa 33 Gew.-% verwendet (KEMPE et al., 2007). Die untersuchten Folien der Firma *Bridgestone* weisen dagegen nach Angaben des Herstellers einen VAC-Gehalt von 25-26 Gew.-% auf.

Neben dem Grundbestandteil EVA in Form von Harz werden den Verbundfolien bei der Herstellung verschiedene Additive zugesetzt, um die gewünschten Eigenschaften im Endprodukt zu erreichen: UV-Absorber, UV-Stabilisatoren, Anti-Oxidatoren, Vernetzer und Haftvermittler (CZANDERNA et al., 1996). Die Vernetzung der Makromoleküle findet erst im Laminationsprozess statt, weshalb vorher der Kunststoff noch schmelzbar ist.

Abbildung 2.38 Herstellungsprozess von Ethylenvinylacetat (siehe z.B. HABENICHT, 2009)

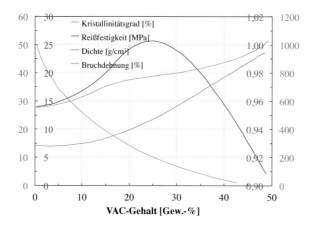

Abbildung 2.39 Eigenschaften der EVA-Copolymere in Abhängigkeit vom VAC-Gehalt (DOMININGHAUS, 2012)

Bei den Materialeigenschaften ist der Zustand vor und nach der Vernetzung zu unterscheiden. Die vom Hersteller angegebenen Materialkennwerte beziehen sich – mit Ausnahme der Schmelztemperatur – auf das vernetzte Endprodukt (Tab. 2.8).

Die Haftung zum Glas wird durch den additiven Haftvermittler ermöglicht. Hierbei werden laut Hersteller Silane (siliziumorganische Verbindungen) eingesetzt, welche eine kovalente Bindung zum Glas ermöglichen. Dies lässt auf eine im Vergleich zu PVB stärkere Haftung schließen.

Aufgrund der weitmaschigen Vernetzung nach dem Laminationsprozess lässt sich der Kunststoff als Elastomer einordnen. Es existieren aber auch EVA-Folien ohne Vernetzer, welche den Thermoplasten zuzuordnen sind.

Tabelle 2.8 Herstellerangaben zu den untersuchten EVA-Folien (Angaben von *Bridgestone*)

Eigenschaften	Einheit	G71	G77	S11	S88
Dichte ρ^{a}	g cm^{-3}	0,95	0,95	0,95	0,95
Temperaturausdehnungs-koeffizient α_{T}	K^{-1}	$3\cdot10^{-3}$	$3\cdot10^{-3}$	-	-
Reißfestigkeit $\sigma_{b}{}^{b}$	MPa	>10	>10	>12	>16
Reißdehnung $\varepsilon_{b}{}^{b}$	%	>500	>500	>800	>950
Vernetzungsgrad	%	93-97	93-97	85-90	85-90
Glasübergangstemperatur T_{g}	°C	-28	-28	-28	-28
Schmelztemperatur T_{m}	°C	79	74	≈ 75	≈ 75

a nach ASTM D1505
b nach DIN EN ISO 527-1

Für die untersuchten Produkte der Firma *Bridgestone* liegen abZ zur Verwendung in VSG vor (DIBT, 2013a; DIBT, 2013b). Des Weiteren besitzt die Produktfamilie EVA-SAFETM eine abZ für den Ansatz eines Schubmoduls bei der Glasbemessung (DIBT, 2014a).

Laminationsprozess

Für das unvernetzte EVA stellt der Hersteller keine besonderen Anforderungen an die Lagerung. So ist bei einer Lagerung unter Normklima (23 °C, 50 % rF) die Verarbeitung bis zu einem Jahr nach der Folienproduktion problemlos möglich. Bei längerer Lagerung verflüchtigen sich allmählich der Haftvermittler und der Vernetzer. Für vernetztes EVA gelten ebenfalls keine besonderen Anforderungen an die Lagerung.

Üblicherweise werden EVA-Laminate im Vakuumverfahren hergestellt, wobei aber auch eine Lamination im Rollenvorverbund mit anschließendem Autoklaven möglich ist.

Das Laminat wird einem zweistufigen Prozess unterzogen: Die Prozesstemperatur ist erst bei der Schmelztemperatur zur Herstellung des Verbundes (70 °C bis 80 °C) und anschließend bei der Temperatur, bei welcher der Vernetzungsprozess stattfindet (120 °C bis 160 °C), zu halten. Die Art des Vernetzers bestimmt in erster Linie die Haltedauer: Bei normal vernetzenden Folien dauert die Vernetzung etwa 60 min, bei schnell vernetzenden Folien nur etwa 7 min (CZANDERNA et al., 1996). Normal vernetzende Folien werden daher nach dem Vorverbund im Vakuumlaminator in einem Ofen weiter gebacken.

Mit schnell vernetzenden Folien ist eine vollständige Vernetzung im Vakuumlaminator wirtschaftlich möglich. Nach dem aktuellen Stand der Technik werden keine normal vernetzenden Folien im Solarbereich mehr eingesetzt. Bei den EVASAFETM -Produkten für den Baubereich sind Haltezeiten bei Vernetzungstemperatur von mindestens 45 min nötig. Geringere Prozesstemperaturen oder höhere Glasdicken führen zu einer längeren Verweilzeit bei Vernetzungstemperatur.

Die Vernetzer sind meist Peroxide mit organischen Resten. Die O-O-Doppelbindung des Peroxids wird durch die hohe Temperatur aufgebrochen. Es entstehen Sauerstoffradikale, welche ein Wasserstoffatom der Makromoleküle abspalten und Radikale in den Makromolekülen bilden. Diese können sich untereinander verbinden, wodurch die dreidimensionale Vernetzung entsteht. Die Verbindung entsteht bevorzugt in den VAC-Gruppen, es können aber auch Ethylengruppen beteiligt sein. Die Bestimmung des Vernetzungsgrads kann beispielsweise mit der Soxhlet-Methode erfolgen (ASTM D2765).

2.4.4 Zwischenschichten aus Ionoplast

Der Begriff Ionoplast ist gleichbedeutend zu dem Begriff Ionomer, welcher von der Firma *DuPont* geprägt wurde. Eine Verbundglas-Zwischenschicht aus Ionoplast ist das Produkt SentryGlas® (SG) der Firma *Kuraray* (ehemals *DuPont*), welches ursprünglich Ende der 90er Jahre für Hurrikan-Verglasungen entwickelt wurde. Ein weiterer Hersteller von Ionoplast-Folien ist *AGP Plastics Inc.* mit dem Produkt Noviflex®, welches aber ebenfalls das Rohmaterial einer älteren SG-Generation beinhaltet.

Aufgrund der deutlich höheren Steifigkeit bei Raumtemperatur wird SG insbesondere im konstruktiven Glasbau verwendet, wenn eine hohe Schubkopplung zwischen den Glasplatten erforderlich ist oder erhöhte Anforderungen an die Resttragfähigkeit gestellt werden. Zudem zeigt das Produkt eine gute Haftung zu Metall und ermöglicht dadurch die Verstärkung (Bewehrung) eines Glasverbundes oder das Anbringen von Anschlussverbindungen (s. FEIRABEND, 2010; LOUTER et al., 2010; PULLER, 2012). Seit 2002 wird das Produkt in Europa vertrieben. In Deutschland gibt es seit 2009 eine abZ zur Verwendung als VSG (DIBT, 2010a), seit 2011 darf bei der Glasbemessung ein günstig wirkender Schubverbund angesetzt werden (DIBT, 2011).

Bei Ionomeren bilden sich neben den üblichen Nebenvalenzbindungen auch Ionenbindungen zwischen den Makromolekülsträngen aus (DOMININGHAUS, 2012).

Herstellung und Eigenschaften

Laut Hersteller handelt es sich bei SG um ein modifiziertes Polyethylen bzw. ein Ethylen-Copolymer, welches den teilkristallinen Thermoplasten zuzuordnen ist. Weitere Informationen zur Zusammensetzung wurden bisher nicht veröffentlicht. Es ist mit der Produktfamilie Surlyn® von *DuPont* verwandt.

Üblicherweise wird zur Herstellung von Ionomeren das Monomer Ethylen mit Acrylsäure oder Methacrylsäure copolymerisiert, wodurch Carboxygruppen an die Polymerkette gelagert werden. Bei Zugabe von alkalischen Metallhydroxiden (meist Zink- oder Natriumhydroxid) bildet sich Wasser unter Abspaltung von Wasserstoffmolekülen an einigen Carboxygruppen und es entstehen negativ geladene Sauerstoffmoleküle (Anionen). Die übrig gebliebenen zweifach positiv geladenen Metallionen (Kationen) gehen eine Ionenbindung ein und bilden dadurch Salze zwischen den Makromolekülen (Abb. 2.40). Die Ionenbindung ist thermoreversibel, wodurch Ionomere jederzeit wieder schmelzbar sind. Bezüglich der Zusammensetzung sind Ionomere den Polyolefinen zuzuordnen (MACKNIGHT et al., 1981; KAISER, 2011; DOMININGHAUS, 2012).

Laut Hersteller gibt es neben dem Ionomer-Harz bei dem üblichen Produkttyp SG5000 als weiteren Bestandteil lediglich einen UV-Absorber. Bei dem ansonsten identischen Produkttyp N-UV fehlt dieser, um UV-durchlässige Verglasungen realisieren zu können. Weitere Additive wie Weichmacher oder Haftvermittler werden nicht zugesetzt (DUPONT, 2010). Der Hersteller verspricht eine im Vergleich zu PVB überlegene Dauerhaftigkeit und

Abbildung 2.40 Herstellungsprozess von Ionomeren (siehe z.B. KAISER, 2011)

Tabelle 2.9 Herstellerangaben zu der untersuchten SG-Folie (DUPONT, 2009)

Eigenschaften	Norm	Einheit	SG
Dichte ρ	ASTM D792	$g\,cm^{-3}$	0,95
Temperaturausdehnungskoeffizient α_T	ASTM D696	K^{-1}	$1{,}0\text{-}1{,}5 \cdot 10^{-4}$
Reißfestigkeit σ_b	ASTM D638	MPa	34,5
Reißdehnung ε_b	ASTM D638	%	400
Schmelztemperatur T_m	-	°C	94

Kantenstabilität. Die Herstellerangaben zu den Eigenschaften der untersuchten SG-Folie finden sich in Tabelle 2.9.

Die Haftung zum Glas wird einerseits mittels Wasserstoffbrückenbindung über die polaren OH-Gruppen analog zum PVB ermöglicht. Daneben bilden sich Ionenbindungen mit den Zinnionen auf der Zinnbadseite der Floatgläser aus.

Laminationsprozess

Das Material wird aufgrund der hohen Steifigkeit in den Dicken 0,89 mm, 1,52 mm und 2,28 mm als Plattenware produziert und geliefert. Die Dicke 0,89 mm ist auch als Rollenware erhältlich. Nach der Entnahme der Folie aus der Herstellerverpackung ist diese trocken zu lagern. Ideal sind Umgebungsfeuchten von unter 10 % rF bei Raumtemperatur. Bei steigender Umgebungsfeuchte steigt die Folienfeuchte schneller an und erreicht höhere Werte (Abb. 2.41). Der Hersteller empfiehlt, Folienfeuchten über 0,2 % nicht mehr zu

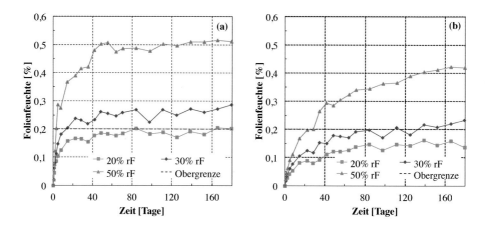

Abbildung 2.41 Folienfeuchte von SG in Abhängigkeit der Lagerungsbedingungen: Foliendicke 0,76 mm (a) und 2,28 mm (b) (DuPONT, 2010)

verwenden, da die Haftung zum Glas ansonsten beeinträchtigt ist. Im Gegensatz zu PVB lässt sich SG nur mit großem Aufwand rekonditionieren.

Der Laminationsprozess gleicht grundsätzlich dem bei der Verwendung von PVB-Folien, eine Vorverbundherstellung im Vakuumverfahren liefert hier wie auch bei PVB die besseren Ergebnisse. Bei SG-Folien werden Mindestanforderungen an die Kühlrate nach der Endverbundherstellung im Autoklaven gestellt, um eine ausgeprägte Kristallisation und eine damit einhergehende Trübung der Zwischenschicht zu verhindern. Auch eine autoklavenfreie Endverbundherstellung ist ausführbar.

Die Glasplatten sind möglichst mit der Zinnbadseite zur Folie hin zu orientieren, um eine optimale Haftung durch die Ionenbindung zu erzielen. Bei der Herstellung von Mehrfachlaminaten wird die Verwendung von Haftvermittlern (Silanen) empfohlen, da hier auch die Feuerseite der Gläser zu der SG-Folie ausgerichtet werden muss (DuPONT, 2010). Durch eine gute Waschwasserqualität wird nach Angabe des Herstellers mit dem aktuellen Produkttyp SG5000 auch ohne die Verwendung von Haftvermittlern eine gute Haftung zur Feuerseite hin ermöglicht.

2.4.5 Zwischenschichten aus thermoplastischem Polyurethan (TPU)

Insbesondere bei der Verwendung von Polycarbonat in einbruch- und beschusshemmenden Verglasungen (s. Abschn. 2.4.9) kommen Folien aus thermoplastischem Polyurethan (TPU oder TPE-U) zum Einsatz. Die hohe Flexibilität der Folien dient dem Ausgleich der unterschiedlichen Temperaturausdehnungskoeffizienten von Glas und Polycarbonat. Zudem stellt sich sowohl zu Glas als auch zu Polycarbonat eine gute Haftung ein und die Lamination ist bei vergleichsweise geringen Temperaturen möglich.

Der Spezialfall der Anwendung verdeutlicht die geringe Verbreitung von TPU im Verbundglasbereich. Die Besonderheit der TPU-Folien liegt in der physikalischen Vernetzung der Molekülketten als thermoplastisches Elastomer (s. Abschn. 2.3.3).

Die folgenden Erläuterungen beziehen sich auf TPU-Folien allgemein und insbesondere auf die in dieser Arbeit untersuchten Produkte der Firma *Huntsman*. Andere Hersteller von TPU-Folien sind beispielsweise *Eastman* (*Solutia*) oder *BASF*. Folgende TPU-Produkttypen der Firma *Huntsman* wurden im Rahmen dieser Arbeit untersucht:

- Krystalflex® PE399: Standardprodukt mit mittlerer Steifigkeit.

- Krystalflex® PE429: Produkt mit geringerer Steifigkeit gegenüber PE399. Lamination bei geringeren Prozesstemperaturen gegenüber PE399 möglich.

- Krystalflex® PE499: Produkt mit geringerer Steifigkeit gegenüber PE429. Lamination bei geringeren Prozesstemperaturen gegenüber PE429 möglich.

- Krystalflex® PE501: Produkt mit erhöhter Steifigkeit gegenüber PE399. Lamination benötigt höhere Prozesstemperaturen gegenüber PE399.

Herstellung und Eigenschaften

Durch Polyaddition von Diisocyanaten mit kurz- und langkettigen Diolen (organische Verbindungen mit zwei Hydroxygruppen) entsteht ein lineares Makromolekül, welches aus Hart- und Weichsegmenten besteht (Abb. 2.42). Die Hartsegmente befinden sich bei Gebrauchstemperatur im energieelastischen, die Weichsegmente im entropieelastischen Bereich. Die Hartsegmente verschiedener Makromoleküle bilden über Wasserstoffbrückenbindung kristalline Bereiche und damit physikalische Vernetzungspunkte (HABENICHT, 2009). Die Weichsegmente stellen einen chemisch gebundenen Weichmacher dar (DOMININGHAUS, 2012). Neben der physikalischen Vernetzung können durch überschüssiges Diisocyanat reversible chemische Vernetzungspunkte entstehen (DOMININGHAUS, 2012).

Als thermoplastisches Elastomer sind Zwischenschichten aus TPU jederzeit wieder schmelzbar, zeigen aber bei Gebrauchstemperatur das mechanische Verhalten eines Elastomers im entropieelastischen Bereich. Über die Zusammensetzung von Hart- und Weichsegmenten kann das mechanische Verhalten gesteuert werden. Neben dem TPU-Harz kön-

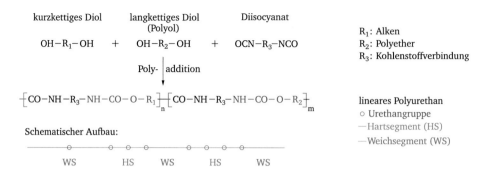

Abbildung 2.42 Herstellungsprozess von thermoplastischem Polyurethan (siehe z.B. HUNTSMAN, 2010)

Tabelle 2.10 Herstellerangaben zu den untersuchten TPU-Folien (HUNTSMAN, 2009)

Eigenschaften	Norm	Einheit	PE 399	PE 429	PE 499	PE 501
Dichte ρ	DIN 53479	$g\,cm^{-3}$	1,07	1,04	1,07	1,07
Reißfestigkeit σ_b	DIN 53504	MPa	45	28	24	45
Reißdehnung ε_b	DIN 53504	%	500	440	850	350
Glasübergangstemperatur T_g	-	°C	-36	-54	-49	-31

nen weitere Additive den Folien zugesetzt werden, um den Verarbeitungsprozess und die Eigenschaften des Endprodukts zu steuern. Dies sind beispielsweise Haftvermittler, UV-Stabilisatoren und zusätzliche Weichmacher (BASF, 2011).

Die im Rahmen dieser Arbeit untersuchten Produkte beinhalten Haftvermittler (HUNTSMAN, 2009) und weisen ausschließlich physikalische Vernetzungspunkte auf (HUNTSMAN, 2010). In Tabelle 2.10 sind die vom Hersteller angegebenen Materialkennwerte zusammengefasst.

Laminationsprozess

Generell weisen TPU-Folien eine hohe Hydrolysebeständigkeit auf, weswegen vom Hersteller keine besonderen Anforderungen an die Lagerung der Folien gestellt wird. Eine zwölfmonatige Lagerung bei Temperaturen unter 32 °C ist unproblematisch (HUNTSMAN, 2009).

Der Laminationsprozess gleicht dem von PVB mit entsprechend angepassten Prozessparametern. Das Standardprodukt PE399 erfordert beispielsweise einen Druck von 8 bar bis 12 bar bei einer Temperatur von 110 °C bis 130 °C im Autoklaven (HUNTSMAN, 2009).

2.4.6 Zwischenschichten aus Gießharz

Gießharze stellen eine Sonderform von Zwischenschichten in Verbundgläsern dar, da sie nicht als Folienmaterial geliefert und laminiert werden, sondern zwischen die Glasplatten gegossen werden.

Es sind einkomponentige von mehrkomponentigen Gießharzen zu unterscheiden. Während einkomponentige Harze durch UV-Bestrahlung vernetzen, werden mehrkomponentige Harze erst kurz vor dem Einbringen in das Verbundglas gemischt. Die Vernetzung findet anschließend autark statt.

Als Gießharze dienen Acrylat- oder Methacrylatharze, welche den Duroplasten zuzuordnen sind. Weitere Additive können Füllstoffe, Haftvermittler, Photoinitiatoren bei einkomponentigen Gießharzen, Weichmacher und Stabilisatoren sein (GALAC et al., 2002).

Der Herstellprozess zum Verbundglas unterscheidet sich maßgeblich von den bisher beschriebenen Vorgehensweisen. Nach dem Reinigen der Gläser wird zwischen zwei Glasplatten ein Abstandhalter umlaufend an den Rändern appliziert, wobei eine Öffnung zum Einfüllen des Gießharzes vorzusehen ist. Üblicherweise werden thermoplastische Abstandhalter (TPS, thermoplastic spacer) aus Polyisobutylen (Butyl) oder transparente Acrylat-Klebebänder eingesetzt. Das Gießharz wird zur Entlüftung in vertikaler Lage eingebracht. Anschließend wird die Einfüllöffnung geschlossen und das Verbundglas horizontal zur Aushärtung bestrahlt bzw. gelagert.

Ein Hersteller von Gießharzen zur Anwendung als Verbundglas ist die Firma *Kömmerling*. Für das zweikomponentige Gießharz Ködistruct LG wurde der Firma *Schollglas* auch eine abZ zur Verwendung als Verbundsicherheitsglas erteilt (DIBT, 2010b).

Im Rahmen dieser Arbeit wurden aufgrund des geringen Marktanteils keine Gießharzprodukte untersucht.

2.4.7 Zwischenschichten aus Wasserglas

Zwischenschichten aus Wasserglas (Hydrogel, Alkalisilikatgel) dienen der Behinderung des Wärmedurchgangs in Brandschutzverglasungen. Im Brandfall schäumen die Wasserglasschichten in einer endothermen Reaktion unter Bildung von Wasser auf, wodurch das Laminat gekühlt wird. Zudem wird der Durchgang der Wärmestrahlung behindert, indem die Zwischenschicht durch Salzbildung opak wird (SCHOTT AG, 2014).

Bei Glasbruch reagieren die Wasserglasschichten in kurzer Zeit mit der Umgebungsluft. Zudem weisen sie nahezu keine Zugfestigkeit auf, weswegen eine Klassifizierung des Laminats als VSG nur in Kombination mit anderen Zwischenschichten (z.B. aus PVB) möglich ist. Bei Anwendungen mit direkter Sonneneinstrahlung werden diese auf der Außenseite des Verbundes angeordnet, da die Wasserglasschichten in der Regel nicht vollkommen UV-stabil sind.

Aufgrund der schnellen Reaktion mit der Umgebungsluft ist eine Untersuchung der Materialeigenschaften von Wasserglas analog der vorgestellten Materialien, die als Folien produziert werden, nicht möglich.

2.4.8 Prüfmethoden

Für Verbundglas können neben den Prüfmethoden zur Beständigkeit nach DIN EN ISO 12543-3 und der Bestimmung der Folienfeuchte (z.B. mittels Infrarotdurchstrahlmethode) weitere Prüfungen zur Identifikation mechanischer Eigenschaften oder als Qualitätskontrolle durchgeführt werden. Die für diese Arbeit relevante Prüfmethoden werden im Folgenden vorgestellt. Probekörper aus Verbundglas sind stets Laminate mit zwei Glasplatten und einer Zwischenschicht. Die Prüfmethoden zur Charakterisierung des reinen Kunststoffmaterials finden sich in Abschnitt 2.3.7.

Pummeltest Bei diesem Haftungstest wird ein Verbundglas aus zwei Floatglasplatten mit einer maximalen Dicke von $2 \times 4\,mm$ auf einer geneigten Metallunterlage mit einem Hammer bearbeitet. Dabei wird das Glas zerstört und anschließend visuell beurteilt. Das Haftungsniveau wird je freigelegter Folienfläche bzw. angehafteten Glassplittern in Pummelwerte von 0 bis 10 eingeordnet (Abb. 2.43).

Bei der Verwendung von Standardfolien aus PVB wird die Probe vorher auf $-18\,°C$ gekühlt, da die Glassplitter ansonsten in die weiche Folie eingedrückt würden und keine visuelle Unterscheidung mehr möglich wäre. Um den Einfluss von Zinnbad- und Feuerseite zu erfassen, werden beide Glasplatten des Verbundglases geprüft. Die Zinnbadseite

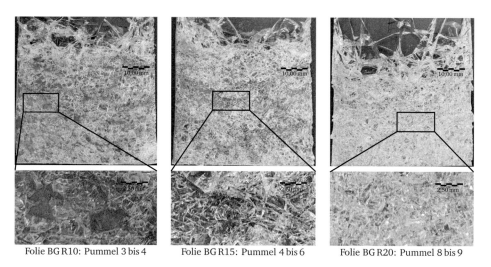

Folie BG R10: Pummel 3 bis 4 Folie BG R15: Pummel 4 bis 6 Folie BG R20: Pummel 8 bis 9

Abbildung 2.43 Unterschiedliche Haftungsniveaus von PVB im Pummeltest

Abbildung 2.44 Schertest (a), Pull-Test (b) und Probekörper mit kreisförmiger PVB-Folie (c)

liefert bei PVB-Folien üblicherweise etwas geringere Pummelwerte als die Feuerseite. Die Probenabmessungen betragen meist etwa 80 mm × 200 mm (KURARAY, 2012). Bei Ionoplasten wird die Probe bei Raumtemperatur geprüft. Für EVA-Folien wird dieser Test selten angewandt, da hierbei stets sehr hohe Pummelwerte erreicht werden und die Aussagekraft daher gering ist. Im Rahmen der vorliegenden Arbeit wurden Pummeltests zur Beurteilung des in den experimentellen Untersuchungen vorliegenden Haftungsniveaus durchgeführt (s. Abschn. 6.2.1).

Schertest Im Schertest wird ein Verbundglas unter reinem Schub abgeschert (Abb. 2.44a). Die technische Schubspannung (Abscherkraft dividiert durch die Folienfläche) gilt als Maß für die Adhäsion auf Schub. Die Verwendung kreisrunder Proben ermöglicht die Vermeidung von Randeffekten (Abb. 2.44c). Im Rahmen der vorliegenden Arbeit wurden Schertests zur Beurteilung des in den experimentellen Untersuchungen vorliegenden Haftungsniveaus durchgeführt. Dabei wurden Verbundgläser mit 2 × 6 mm Floatglas und Abmessungen von 100 mm × 100 mm sowie kreisrunden Zwischenschichten mit einem mittleren Durchmesser von 30 mm verwendet (s. Abschn. 6.2.1).

Pull Test In diesem Versuch werden Verbundglasproben senkrecht zur Plattenebene auf Zug belastet, bis es zu einem Haftverlust von Folie zu Glas kommt (Abb. 2.44b). Die maximale Zugkraft dividiert durch die Folienfläche ist als technische Spannung ein Maß für die Adhäsion auf Zug. Zur Krafteinleitung werden die Probekörper auf Stahlwerkzeuge geklebt, was den Versuch aufwändig macht. Üblich ist die Verwendung rechteckig ausgesägter Verbundgläser als Probekörper. Zur Vermeidung von Randeffekten können auch kreisrunde Folienflächen verwendet werden (Abb. 2.44c). Im Rahmen der vorliegenden Arbeit wurden Pulltests zur Beurteilung des in den experimentellen Untersuchungen vorliegenden Haftungsniveaus durchgeführt. Die Probengeometrie entsprach dabei denen der Schertests (s. Abschn. 6.2.1).

Through Cracked Tensile (TCT) Test Die beiden Glasplatten eines Verbundglases werden in der Mitte definiert gebrochen und der Probekörper anschließend einem Zugversuch unterworfen. Dadurch muss die eingeleitete Kraft an der Bruchstelle vollständig von der Folie übertragen werden. Neben der qualitativen und quantitativen Beurteilung des Delaminationsverhaltens ist hiermit eine Bestimmung der Energiefreisetzungsrate möglich. Eine detaillierte Beschreibung des Versuchs, welcher im Rahmen dieser Arbeit an PVB mit verschiedenen Steifigkeiten, Haftgraden und Versuchsgeschwindigkeiten durchgeführt wurde, erfolgt in Abschnitt 6.2.2.

Pendelschlagversuch In DIN EN 12600 wird das Verfahren und die Klassifizierung von Verglasungen nach ihrer Stoßsicherheit beschrieben. Der weiche Stoß durch den Anprall einer Person mit verschiedenen Geschwindigkeiten wird durch einen Doppelreifen und verschiedene Fallhöhen simuliert. Im Rahmen der vorliegenden Arbeit wurde dieser Versuch zur Bestimmung der Glasfestigkeit unter kurzzeitiger dynamischer Belastung durchgeführt. Eine detaillierte Beschreibung der Versuchsdurchführung folgt in Abschnitt 3.2.2. Ein Verbundsicherheitsglas muss nach DIN EN ISO 12543-2 eine Klassifikation 3(B)3 nach DIN EN 12600 erlangen. Das bedeutet, dass nach Beaufschlagung mit der niedrigsten Fallhöhe des Pendels (190 mm) die Verglasung entweder intakt bleibt oder zumindest keine signifikanten Öffnungen aufweist. Ein Verbundglas muss dagegen keine Anforderungen bezüglich des Pendelschlags erfüllen. Für eine genauere Beschreibung der Klassifikationen wird auf DIN EN 12600 verwiesen.

Weitere Prüfmethoden an Verbundglas sind der Kompressionsschertest, der Torsionstest, der Peeltest und der Kugelfallversuch (KURARAY, 2012). Bis auf den Pendelschlag- und den Kugelfallversuch sind die Tests nicht standardisiert. Eine detailliertere Beschreibung von Schertest und Pull-Test findet sich in FRANZ, 2015. Zur Klassifikation von explosionshemmenden Verglasungen sind spezifische experimentelle Prüfungen durchzuführen (s. Abschn. 2.4.9).

2.4.9 Explosionshemmende Verglasungen

Im Folgenden wird der Stand der Normung sowie der Stand der Technik in der konstruktiven Durchbildung von explosionshemmenden Verglasungen dargelegt. Die Kombination mit weiteren Schutzzielen wird anschließend kurz erläutert.

Stand der Normung

Der Widerstand von Verglasungen gegen Explosionen – auch Sprengwirkungshemmung genannt – wird in Deutschland und Europa in zwei Normenreihen geregelt. Die DIN EN 13541 beschreibt die Anforderungen an die Verglasung als Bauprodukt, die DIN EN 13123 und 13124 regeln die Anforderungen an Fenster als Bauart. Die US-amerikanischen Normen, welche derzeit den weltweiten Standard darstellen, behandeln das Bauprodukt

(ASTM F 1642) und die Bauart (ASTM F 1642 und GSA Security Criteria). Die ISO 16933 und 16934 sind internationale Normen, die Anforderungen an die Verglasung als Bauprodukt regeln. In den Tabellen 2.11 und 2.12 wird eine Übersicht über die Klassifikationen aller Normen gegeben.

Die **DIN EN 13541**: „Prüfverfahren und Klasseneinteilung des Widerstandes gegen Sprengwirkung" unterscheidet in die vier Klassen ER 1 bis ER 4 über das Maximum des positiven reflektierten Überdrucks P_R, den positiven Impuls i_+ und die Dauer der positiven Druckphase t_+ (s. Abschn. 2.1.2). Die Prüfung wird als Stoßrohrversuch ausgeführt. Für eine Klassifizierung müssen drei Probekörper mit den Abmessungen 900 mm x 1100 mm die Prüfung bestehen, wobei die geprüfte Verglasung keine durchgehenden Löcher und keine Öffnungen zwischen dem Einspannrahmen und dem Rand der Verglasung aufweisen darf. Die Widerstandsklasse kann mit der Zusatzbezeichnung „S" oder „NS" versehen werden, je nachdem, ob auf der Rückseite der Verglasung Splitter abgegangen sind. Splitterabgang wird hierbei mit dem Bruch der angriffsabgewandten Seite gleichgesetzt. Eine detaillierte Beschreibung der Stoßrohrversuche folgt in Abschnitt 5.2.2.

Für die Bauart regelt **DIN EN 13123** Anforderungen und Klassifizierung, **DIN EN 13124** das Prüfverfahren. Die Normen sind jeweils in zwei Teile unterteilt, der erste Teil behandelt die Prüfung im Stoßrohr, der zweite Teil den Freilandversuch. Die Prüfung im Stoßrohr simuliert mit einer ebenen Druckwelle eine große Detonation in weiter Entfernung. Die Klassifikation ist weitestgehend mit DIN EN 13541 identisch.

Tabelle 2.11 Klassifikationsanforderungen für Stoßrohrversuche (ebene Druckwelle)

Norm	Klassifikation	P_R [kPa]	i_+ [kPa ms]	t_+ [ms]	Gefährdungsbewertung
DIN EN 13541 DIN EN 13123 DIN EN 13124	ER 1 / EPR 1	50	370	20	Splitterabgang (S, NS)
	ER 2 / EPR 2	100	900	20	
	ER 3 / EPR 3	150	1500	20	
	ER 4 / EPR 4	200	2200	20	
GSA Security Criteria	Level A	keine Anforderungen, nur konstruktive Hinweise			keine Forderung
	Level B				
	Level C	28	192	14	maximal E nach Abb. 2.46
	Level D	69	614	18	maximal D nach Abb. 2.46
	Level E	207	1034	10	keine Angabe
ISO 16934	ER30(X)	30	170	15	X ist Angabe der Gefährdungsbewertung von A bis F
	ER50(X)	50	370	20	
	ER70(X)	70	550	20	
	ER100(X)	100	900	20	
	ER150(X)	150	1500	20	
	ER200(X)	200	2200	20	

Tabelle 2.12 Klassifikationsanforderungen für Freilandversuche (Nahdetonation)

Norm	Klassifikation	P_R [kPa]	i_+ [kPa ms]	Sprengmasse [kg TNT]	Abstand [m]
DIN EN 13123 DIN EN 13124	EXR 1	-	-	3	5,0
	EXR 2	-	-	3	3,0
	EXR 3	-	-	12	5,5
	EXR 4	-	-	12	4,0
	EXR 5	-	-	20	4,0
ISO 16933	SB1(X)	70	150	3	9,0
	SB2(X)	110	200	3	7,0
	SB3(X)	250	300	3	5,0
	SB4(X)	800	500	3	3,0
	SB5(X)	700	700	12	5,5
	SB6(X)	1600	1000	12	4,0
	SB7(X)	2800	1500	20	4,0
ISO 16933	EXV45(X)	30	180	100	45
	EXV33(X)	50	250	100	33
	EXV25(X)	80	380	100	25
	EXV19(X)	140	600	100	19
	EXV15(X)	250	850	100	15
	EXV12(X)	450	1200	100	12
	EXV10(X)	800	1600	100	10

Für die Prüfung im Freilandversuch, welche eine Nahdetonation simuliert, werden anstelle von Maximaldruck und Impuls als Klassifikationsmerkmale die Masse der Sprengladung und der Abstand zum Probekörper definiert. Der Anhang A.6 der Norm gibt zwar Druck- und Impulswerte zum Nachweis der vollständigen Detonation an. Diese stellen aber Mindestwerte für die einfallende Druckwelle dar und lassen sich somit nicht direkt mit den Angaben der anderen Normen vergleichen, da diese sich stets auf die reflektierte Druckwelle beziehen. Abbildung 2.45 zeigt schematisch den Freilandversuch (a) und das Stoßrohr (b).

Die amerikanische Norm **ASTM F 1642** beschreibt das Prüfverfahren für Verglasungen sowie Fenster- und Fassadensysteme unter Explosionsbeanspruchung. Eine Klassifikation wird hier nicht definiert. Die Prüfung darf sowohl im Stoßrohr als auch im Freilandversuch durchgeführt werden. Im Gegensatz zur europäischen Normung wird in ASTM F 1642 die beim Glasbruch entstehende Gefährdung bewertet. Der Prüfkörper wird in einem Testcontainer installiert, an dessen hinterer Seite ein sogenanntes „witness panel" angebracht ist, um die Größe und den Ort des Auftreffens der Glassplitter identifizieren zu können (s. Abb. 2.46a).

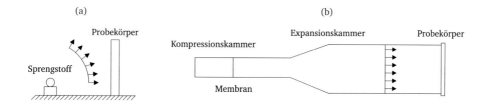

Abbildung 2.45 Schematische Darstellung von Freilandversuch (a) und Stoßrohr (b)

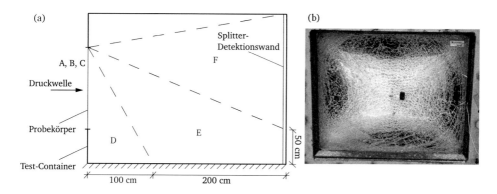

Abbildung 2.46 Gefährdungsbewertung nach ISO 16933 (a) und Probekörper einer explosionshemmenden Verglasung nach einem Stoßrohrversuch (b)

Die **GSA Security Criteria** definiert Anforderungen an Bauteile, die für eine Explosionsbeanspruchung ausgelegt sind. Für bauwerksabschließende Verglasungen werden fünf Level definiert (s. Tab. 2.11). Für Level A und B werden lediglich Hinweise an die Konstruktion gegeben, die etwas verschärft auch für die höheren Klassen gelten. Für Level C und D wird eine maximale Gefährdungsklasse bei einem bestimmten maximalen reflektierten Druck und positivem Impuls definiert. Diese zwei Klassifikationen stellen den weltweiten Standard dar. Level E wird nur bei Gebäuden der höchsten nationalen Sicherheitsstufe gefordert. Bei der Gefährdungsbewertung wird auf die „Standard Test Method for Glazing and Window Systems Subject to Dynamik Overpressure Loadings" (GSA, 2003) verwiesen, welche grundsätzlich der ASTM F 1642 entspricht. Als Belastung darf ein Dreiecksimpuls angenommen werden. Zur Berechnung wird auf die von der Regierung veröffentlichten Computerprogramme (z.B. WINGARD (ARA, 2005)) verwiesen.

Die internationalen Normen, welche die Verglasung als Bauprodukt klassifizieren, finden in Bauprojekten derzeit noch wenig Anwendung, stellen aber dennoch einen aktuellen Standard dar. Die **ISO 16933** definiert Freilandversuche (Nahdetonation, Szenario einer Koffer- bzw. Autobombe), **ISO 16934** definiert Stoßrohrversuche (Szenario einer großen Ferndetonation). Die Klassifikation erfolgt analog zur DIN EN 13541 über den Maximal-

druck und den Impuls. Auch die Größe und die Anzahl der Probekörper ist identisch. Im Unterschied zur europäischen Normung wird die Gefährdung durch Splitterflug in Anlehnung an die amerikanischen Standards erfasst. Abbildung 2.46a zeigt die Abmessungen des Test-Containers und veranschaulicht die Gefährdungsbewertung. Es werden folgende Unterscheidungen getroffen:

A: Kein Glasbruch. Die Verglasung ist nicht gebrochen und es gibt keine sichtbare Beschädigung am Verglasungssystem.

B: Keine Gefährdung. Die Verglasung ist gebrochen, aber die innere Glasplatte ist vollständig im Rahmen gehalten und kein Material ist von der inneren Platte abgesprungen.

C: Minimale Gefährdung. Die Verglasung ist gebrochen, aber die innere Glasplatte ist im Wesentlichen zurückgehalten worden.

D: Sehr niedrige Gefährdung. Die Verglasung ist gebrochen, die wesentlichen Teile liegen nur bis zu 1 m hinter dem Testrahmen.

E: Niedrige Gefährdung. Die Verglasung ist gebrochen, aber die wesentlichen Teile liegen 1 m bis 3 m hinter dem Testrahmen und maximal 0,5 m über dem Boden.

F: Hohe Gefährdung. Die Verglasung ist gebrochen und die Bruchstücke sind in allen Bereichen des Test-Containers zu finden.

Konstruktive Durchbildung

In Projekten mit geringen bis mäßigen Anforderungen an den Explosionsschutz werden die Klassifikationen aus den Normen übernommen, wobei nach Aussagen der Firma *Weidlinger Associates, Inc.* zufolge die Forderung von GSA Level C etwa 80 % aller Fälle ausmacht. In Projekten mit hohen Anforderungen an die Explosionshemmung werden abweichend von den genormten Klassifikationen projektspezifische Szenarien entworfen. Ein derzeit übliches Szenario ist die Detonation von 500 kg TNT-Äquivalent in einer bestimmten Entfernung, welche vom Sicherheitsbereich des Gebäudes (Perimeter) abhängt. Dieser liegt üblicherweise zwischen 10 m bis 30 m, wodurch Belastungen resultieren, welche die normativen Klassifikationen deutlich überschreiten. Die projektspezifische Bestimmung der Belastungsparameter P_R und i_+ kann analytisch oder numerisch erfolgen (s. Abschn. 2.1.2).

 Ziel einer explosionshemmenden Verglasung ist es, den Durchgang der Stoßwelle und den Abgang von Glassplittern in den zu schützenden Raum zu verhindern. Monolithische Verglasungen zeigen bei Glasbruch ein inakzeptables Verhalten durch Splitterflug, daher werden explosionshemmende Verglasungen generell als Verbundglas realisiert (s. Abb.

1.2). Ein Bruch des Glases ist jedoch zulässig und sogar erwünscht, da hierdurch die einwirkende Energie zumindest teilweise vernichtet (dissipiert) wird und die Unterkonstruktion somit eine reduzierte Beanspruchung erfährt. Der Glasbruch stellt einen Zielkonflikt mit einbruch- und beschusshemmenden Verglasungen dar, bei denen dicke Glaslaminate erforderlich sind.

Abbildung 2.46b zeigt den Probekörper einer explosionshemmenden Verglasung nach der Prüfung im Stoßrohr. Bei der Auslegung der Konstruktion sind unterschiedliche Aspekte zu beachten: Die Zwischenschicht darf nicht reißen und soll möglichst gut die Glassplitter binden. Zudem darf die Verglasung nicht als Ganzes aus der Halterung gedrückt und zu einer Gefährdung werden. Eine wirksame Maßnahme ist das Verkleben des Glases in den Rahmen bzw. an die Klemmhalter.

Mit zwei 6 mm dicken Floatglasplatten und einer 1,52 mm starken PVB-Folie kann bereits eine Klassifikation ER 1 nach DIN EN 13541 erreicht werden. Für höhere Beanspruchungen können verschiedene Ansätze verfolgt werden. Auf Seite des Verbundglases sind neben der Dicke und dem Grad der Vorspannung des eingesetzten Glases die mechanischen Eigenschaften der verwendeten Zwischenschicht von entscheidender Bedeutung. Welche Optimierungsmöglichkeiten bezüglich der Steifigkeit und der Haftung zum Glas bestehen, wird in Kapitel 6 aufgezeigt.

Neben der Verglasung kann eine Energiedissipation auch in der Rahmen- und Unterkonstruktion erfolgen. Beide Ansätze werden unter dem Begriff „balanced design" zusammengefasst, welcher eine ausgeglichene Auslegung aller Komponenten einer Fassade unter Explosionsbeanspruchung beschreibt. Damit werden schlankere Unterkonstruktionen ermöglicht als bei vollständig elastischer Dimensionierung.

Um von einem Bruch des Glases und einer damit verbundenen Energiedissipation ausgehen zu können, ist die hohe Streuung der Glasfestigkeit mit einem Variationskoeffizienten von bis zu $V = 25\%$ zu berücksichtigen. Eine sinnvolle Maßnahme kann in diesem Zusammenhang eine definierte Schwachstelle im Glas durch gezielte Vorschädigungen oder lokale Spannungskonzentrationen sein. Das Risiko zur Überbelastung der Unterkonstruktion und dem damit verbundenen Gesamtkollaps der Konstruktion wird so auf ein akzeptables Maß gesenkt (SCHNEIDER et al., 2015).

Weitere Schutzziele

Der Begriff Schutzverglasungen oder Sicherheitssonderverglasungen umfasst die Aspekte Explosionshemmung, Einbruchhemmung und Beschusshemmung. Daneben kann der Brandschutz als weiteres Schutzziel definiert werden. Werden mehrere Schutzziele kombiniert, so spricht man von multifunktionalen Schutzverglasungen.

Hohe Klassifikationen werden bei **einbruch- und beschusshemmenden Verglasungen** nur mit dickeren Glaslaminaten erreicht. Mehrfachlaminate liefern dabei bessere Ergebnisse als die Verwendung von Zweifachlaminaten gleicher Dicke. Ein vielfach verfolgter Ansatz ist die Verwendung steifer Kunststoffplatten wie Polycarbonat im Kern.

Dadurch können geringere Dicken und geringere Flächengewichte bei gleicher Klassifi-kation erreicht werden. Die Anwendungsmöglichkeiten von Polycarbonat-Verbünden sind jedoch beschränkt, da aufgrund des siebenfach höheren Temperaturausdehnungskoeffizi-enten im Vergleich zu Kalknatron-Silikatglas nur kleinere Abmessungen möglich sind und die Dauerhaftigkeit schlechter ist als bei reinen Glaslaminaten. Eine Alternative können hier Zwischenschichten wie Ionoplast-Folien oder steife PVB-Varianten sein.

Der Begriff **Brandschutz** umfasst die zwei Aspekte Brandverhalten von Baustoffen und Feuerwiderstand von Bauteilen. Die Verhinderung von Flammen- und Brandgasdurch-tritt wird üblicherweise durch besondere thermische Vorspannprozesse oder mit Drahtglas, thermisch vorgespannten Borosilikatgläsern und Glaskeramiken erreicht. Aufgrund des niedrigeren Temperaturausdehnungskoeffizient, der damit verbundenen höheren Tempe-raturwechselbeständigkeit und der höheren Glasübergangstemperatur sind Borosilikatglä-ser bezüglich des Feuerwiderstands den Kalknatron-Silikatgläsern deutlich überlegen. Die Behinderung des Wärmedurchgangs wird durch die Verwendung von Brandschutzschich-ten in einem Glaslaminat realisiert (s. Abschn. 2.4.7).

Multifunktionale Schutzverglasungen

Unter dem Begriff der multifunktionalen Schutzverglasung wird in erster Linie die Kom-bination der genannten Schutzaspekte verstanden.

Bei Gebäuden mit hohen Schutzanforderungen und direkter Angriffsmöglichkeit wie beispielsweise dem Pförtnerhaus einer Botschaft oder einer Justizvollzugsanstalt können die drei Schutzanforderungen Einbruch-, Beschuss- und Explosionshemmung gefordert werden. Die Explosionshemmung wird dann allerdings aufgrund der hohen Laminatdi-cke, die für Einbruch- und Beschusshemmung notwendig ist, nicht nach dem „balanced design" sondern elastisch ausgelegt. Bislang gibt es noch wenig Produkte am Markt, wel-che auf sehr hohe und kombinierte Klassen getestet wurden, da eine umfassende Prüfung der Produkte einen hohen Zeit- und Kostenaufwand darstellt.

Die Kombination mit der Anforderungen des Brandschutzes ist ebenfalls möglich. Im Innenbereich von Justizvollzugsanstalten können neben Klassifikationen für Einbruch- und Beschusshemmung auch ein Feuerwiderstand verlangt werden. Andere Beispiele sind Dachverglasungen, die eine explosionshemmende Klassifikation erreichen sollen und als Überkopfverglasung einen Feuerwiderstand bieten müssen, oder Verglasungen in chemi-schen Anlagen. Bei Letzterem handelt es sich jedoch um Innenraumdetonationen, die auf-grund der verbrennenden Stoffe oftmals durch einen niedrigen Maximaldruck und einen hohen Impuls charakterisiert sind oder sogar um Deflagrationen (s. Abschn. 2.1.2).

Neben den genannten Schutzanforderungen werden aber auch bauphysikalische An-forderungen an die Verglasungen gestellt. Da sie üblicherweise als Gebäudeabschluss ein-gesetzt werden, sind hier insbesondere der Wärme- und der Sonnenschutz zu nennen, die verstärkt durch die immer strenger werdenden Vorschriften gefordert werden. Die aktuel-le Energieeinsparverordnung (BMJV, 2013) gibt als Referenzwerte für den Wärmedurch-

gangskoeffizient von Fenstern $U_\mathrm{w} = 1,30\,\mathrm{W\,m^{-2}\,K^{-1}}$ und für den Gesamtenergiedurchlass $g = 0,6$ an, was nur mit Isolierverglasungen und Beschichtungen realisierbar ist. Daneben können auch Anforderungen an den Schallschutz gestellt werden, die aber im Vergleich zu Wärme- und Sonnenschutz eine untergeordnete Rolle spielen.

Eine im Rahmen dieser Arbeit durchgeführte Befragung internationaler Fachplaner für Gebäudesicherheit hat ergeben, dass in vielen außereuropäischen Projekten der Explosionsschutz der bedeutendste Sicherheitsaspekt ist. Innerhalb der USA wird oftmals nur die Explosionshemmung verlangt und konstruktiv nach dem „balanced design" umgesetzt. Eine Kombination mit den Schutzszenarien Einbruch und Beschuss ist dort bisher eher unüblich, Ausnahmen sind Botschaften im Ausland. Der generelle Einsatz von Isolierverglasungen ist auch in den USA mittlerweile Standard.

2.5 Numerische Behandlung zeitabhängiger Probleme

Im Folgenden sollen einige Aspekte der numerischen Behandlung zeitabhängiger mechanischer Probleme erläutert werden, welche zum Verständnis der im Rahmen dieser Arbeit durchgeführten Berechnungen mit der Finiten-Elemente-Methode (FEM) hilfreich sind.

Bei FE-Programmen werden primär statische und transiente Berechnungen unterschieden. Der Unterschied liegt in der Berücksichtigung von Massenträgheit und Dämpfungstermen. Spielen diese bei zeitabhängigen Problemen keine oder eine untergeordnete Rolle wie beispielsweise bei Kriech- oder Relaxationsprozessen, so ist eine statische Analyse ausreichend. Für die Simulation dynamischer Prozesse wie beispielsweise infolge Stoßwellen oder Pendelschlag müssen demgegenüber transiente Berechnungen durchgeführt werden.

Zur Berücksichtigung von Massenträgheit und Dämpfung muss die Newtonsche Bewegungsgleichung gelöst werden. Für einen Schwinger mit einem Freiheitsgrad nach Abbildung 2.47 lautet sie

$$m\ddot{x} + d\dot{x} + kx = F(t) \tag{2.60}$$

mit

x	Auslenkung,
m	Masse,
d	Dämpfungskonstante,
k	Federsteifigkeit,
$F(t)$	zeitliche Funktion der äußeren Kraft.

Die Differentialgleichung stellt bei bekannter Ausgangssituation und zeitlichem Verlauf der äußeren Kraft ein Anfangswertproblem für die Auslenkung x zu einem beliebigen

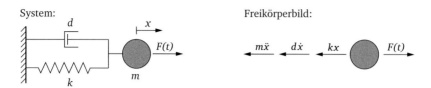

System: Freikörperbild:

Abbildung 2.47 Einfreiheitsgradschwinger

Zeitpunkt t dar, welches numerisch mittels Zeitintegration gelöst wird. Bei Systemen mit mehreren Freiheitsgraden werden die skalaren Werte in Gleichung (2.60) durch Matrizen bzw. Vektoren ersetzt.

Bei der Integration sind zwei Verfahren zu unterscheiden. Eine explizite Zeitintegration wertet die Differentialgleichung zum bekannten vorangegangenen Zeitschritt i aus und das Ergebnis des unbekannten neuen Zeitschritts $i + 1$ kann direkt berechnet werden:

$$x_{i+1} = f(x_i). \tag{2.61}$$

Bei einer impliziten Zeitintegration wird die Differentialgleichung zum unbekannten neuen Zeitschritt $i + 1$ ausgewertet. Es ergibt sich eine implizite Gleichung:

$$x_{i+1} = f(x_i, x_{i+1}). \tag{2.62}$$

Es ist ersichtlich, dass sich explizite Integrationsverfahren bedeutend einfacher lösen lassen, was sich in der Berechnungsdauer für einen Zeitschritt bemerkbar macht. Dagegen kann bei impliziten Verfahren meist ein bedeutend größerer Zeitschritt gewählt werden, was der Begriff „Stabilität" beschreibt: Wird der Fehler, welcher die numerische gegenüber der wahren Lösung unterscheidet, mit jedem Zeitschritt größer, so ist das Verfahren instabil. Wird umgekehrt der Fehler während der Zeitintegration kleiner oder bleibt er konstant, so ist das Verfahren stabil (GROSS et al., 2011b). Bei expliziten Verfahren hängt die Stabilität vom gewählten Zeitschritt ab. Es existiert ein kritischer Zeitschritt, ab welchem das Verfahren instabil wird. Implizite Verfahren können – müssen aber nicht – bedingungslos stabil sein, also unabhängig vom gewählten Zeitschritt.

Die Stabilität eines Verfahrens sagt nichts über die Genauigkeit der Ergebnisse aus. Diese hängt von der Ordnung, also der Potenz, mit welcher der Zeitschritt selbst in die Berechnung eingeht, ab. Je höher die Ordnung eines Verfahrens, desto genauer das Ergebnis aber desto aufwändiger ist die Berechnung (GROSS et al., 2011b).

Im Folgenden werden die Zeitintegrationsverfahren aufgeführt, welche in den hier verwendeten FE-Programmen Anwendung finden.

Methode der zentralen Differenzen

In den verwendeten expliziten FE-Codes *LS-DYNA* und *Ansys Autodyn* wird die Methode der zentralen Differenzen oder eine Variante davon verwendet (LSTC, 2014a; ANSYS INC., 2012b). Diese auch als Leap-Frog-Method oder Mehrschrittverfahren bezeichnete Methode bezieht sich bei der Berechnung des neuen Zeitschritts $i+1$ neben dem aktuellen Zeitschritt i auch auf einen Zwischenschritt $i+1/2$ und ist somit von zweiter Ordnung:

$$x_{i+1} = x_i + \dot{x}_{i+1/2}\Delta t, \tag{2.63}$$

$$\dot{x}_{i+1/2} = \dot{x}_{i-1/2} + \ddot{x}_i\Delta t. \tag{2.64}$$

Damit das Verfahren stabil ist, muss der Zeitschritt kleiner sein, als der kritische Zeitschritt (ANSYS INC., 2012b; COURANT et al., 1928):

$$\Delta t \leq f\left(\frac{h}{c}\right)_{\min} \tag{2.65}$$

mit
f Stabilitätsfaktor (Vorgabewert 0,9),
h Charakteristische Dimension eines Elements (z.B. Länge eines Balkenelements),
c Schallgeschwindigkeit des Materials.

Newmark-Verfahren

Die im Rahmen dieser Arbeit eingesetzten impliziten FE-Codes *Ansys* und *SJ Mepla* verwenden das Newmark-Verfahren (ANSYS INC., 2012a; SJ SOFTWARE GMBH, 2013). Es ist ein Verfahren zweiter Ordnung, bei welchem folgende Gleichungen in die Bewegungsgleichung (2.60) eingesetzt werden:

$$x_{i+1} = x_i + \dot{x}_i\Delta t + [(0,5-\beta)\ddot{x}_i + \beta\ddot{x}_{i+1}]\Delta t^2, \tag{2.66}$$

$$\dot{x}_{i+1/2} = \dot{x}_i + [(1-\delta)\ddot{x}_i + \delta\ddot{x}_{i+1}]\Delta t. \tag{2.67}$$

Die Parameter β und δ steuern den Ansatz für die Beschleunigung und damit auch die Stabilität, Genauigkeit und numerische Dämpfung des Verfahrens. Für eine Wahl $\beta \leq 0,25(\delta+0,5)^2$ und $\delta \leq 0,5$ ist das Verfahren bedingungslos stabil. *SJ Mepla* setzt mit $\beta = 0,25$ und $\delta = 0,5$ eine konstante Beschleunigung ohne numerische Dämpfung während eines Zeitschritts an. In *Ansys* können die Parameter frei gewählt werden. Standardmäßig werden hier 1 % höhere Werte für β und δ als in *SJ Mepla* verwendet, wodurch eine schwache numerische Dämpfung entsteht. Eine Auswirkung der numerischen Dämpfung auf die Berechnungsergebnisse konnte im Rahmen der Untersuchungen nicht festgestellt werden.

3 Untersuchungen zur Kurzzeitfestigkeit von Glas

3.1 Allgemeines

Da noch keine abgesicherte Aussage über die Festigkeit von Glas unter kurzzeitigen dynamischen Einwirkungen wie Pendelschlag oder Detonationsdruckwellen getroffen werden kann, wurden im Rahmen dieser Arbeit experimentelle Untersuchungen durchgeführt. Die Ergebnisse wurden mit dem in Abschnitt 2.2.2 beschriebenen bruchmechanischen Modell ausgewertet, um dessen Gültigkeit im Kurzzeitbereich zu bestätigen beziehungsweise zu widerlegen. Dazu wurden Bruchspannungen unter quasistatischer und dynamischer Belastung ermittelt und die theoretischen Initialrisstiefen mit dem bruchmechanischen Modell zurückgerechnet. Stimmen die Initialrisstiefen aus quasistatischer und dynamischer Belastung überein, so kann das bruchmechanische Modell als bestätigt angesehen werden. Das bruchmechanische Modell berücksichtigt die für die Kurzzeitfestigkeit relevanten Bereiche II und III des subkritischen Risswachstums (s. Abb. 2.7b).

Zur Ermittlung von quasistatischen Festigkeitswerten wurden in einer ersten Versuchsreihe Doppelring-Biegeversuche (DRBV) in Anlehnung an DIN EN 1288-2 durchgeführt. Dieser Versuchsaufbau eignet sich, um die Biegezugfestigkeit in der Fläche einer Glasplatte ohne Einfluss der Kanten zu ermitteln. Die Versuche dienen darüber hinaus der Ermittlung der Elastizitätsmoduln für die untersuchten Glasarten, da diese von den normativen Angaben in Tabelle 2.3 abweichen können.

Anschließend wurde die Festigkeit unter kurzzeitiger dynamischer Beanspruchung anhand von Pendelschlagversuchen (PSV) nach DIN EN 12600 untersucht. Hierbei werden Spannungsraten von $1000\,\mathrm{MPa\,s^{-1}}$ bis $10\,000\,\mathrm{MPa\,s^{-1}}$ erreicht (s. Tab. 3.4). Die experimentellen Untersuchungen an Verglasungen unter Detonationsbelastung in Abschnitt 5.2.2 zeigen Spannungsraten von $10\,000\,\mathrm{MPa\,s^{-1}}$ bis $100\,000\,\mathrm{MPa\,s^{-1}}$. Im Gegensatz zur quasistatischen Belastung von $2\,\mathrm{MPa\,s^{-1}}$ erzeugen also Pendelschlag und Detonationsdruckwellen vergleichbare Spannungsraten.

Folgende Glasarten wurden als monolithische Gläser mit 5 mm Nenndicke untersucht:

- Thermisch entspanntes Kalknatron-Silikat-Floatglas (KNS-Float)
- Thermisch vorgespanntes Kalknatron-Silikat-ESG (KNS-ESG)
- Thermisch entspanntes Borosilikat-Floatglas mit $\alpha_T = 3{,}3 \cdot 10^{-6}\,\mathrm{K}^{-1}$ (Boro33)
- Thermisch entspanntes Borosilikat-Floatglas mit $\alpha_T = 4{,}0 \cdot 10^{-6}\,\mathrm{K}^{-1}$ (Boro40)
- Thermisch vorgespanntes Borosilikat-ESG aus Boro40 (Pyran)

Die Versuche wurden mit fabrikneuen Gläsern ohne Vorschädigung durchgeführt. Die Gläser entstammen für beide Versuchsarten (DRBV und PSV) derselben Herkunft (Floatwerk, Produktionscharge, Veredelungsprozess). Die thermisch entspannten Gläser dienten auch als Basisgläser für die thermisch vorgespannten Gläser. Die Kalknatron-Silikatgläser wurden von der Firma *Glas Trösch*, die Borosilikatgläser von der Firma *Schott* bereitgestellt.

Tabelle 3.1 fasst die durchgeführten Versuche zur Glasfestigkeit mit dem jeweiligen Probekörperumfang zusammen. Eine detaillierte Beschreibung von Versuchsaufbau und -durchführung findet sich in HIPPE, 2013.

Tabelle 3.1 Anzahl der Probekörper bei den durchgeführten Versuchen zur Glasfestigkeit

Glasart Nenndicke 5 mm	Quasistatische **Doppelring-Biegeversuche** in Anlehnung an DIN EN 1288-2 Probengröße 300 mm × 300 mm	Dynamische **Pendelschlagversuche** nach DIN EN 12600 Probengröße 1938 mm × 876 mm
KNS-Float	34	5
KNS-ESG	35	6
Boro33	30	6
Boro40	30	6
Pyran	30	5

3.2 Experimentelle Untersuchungen und deren numerische Auswertung

3.2.1 Quasistatische Belastung: Doppelring-Biegeversuch

Versuchsaufbau

Die Maße des verwendeten Versuchsaufbaus weichen von den Angaben in DIN EN 1288-2 ab: Der Lastring hat einen Radius von $r_1 = 40$ mm, der Stützring $r_2 = 80$ mm. Die Probekörper sind quadratisch mit einer Kantenlänge $L = 300$ mm.

Je Serie wurden mindestens zwei Probekörper mit linearen Dehnmessstreifen (DMS) (*TML FLA-2-8*) in der Mitte beklebt, um den Elastizitätsmodul der untersuchten Glasarten zu ermitteln. Alle Probekörper wurden auf der Oberseite mit einer dünnen Folie beklebt, um den Bruchursprung im Nachgang identifizieren zu können.

Die Versuche wurden mit fabrikneuen Gläsern ohne Vorschädigung in einer Universalprüfmaschine (*Zwick Z050 THW*) mit werksseitig eingebauter Kraftmessdose (*Zwick Roell Xforce K* 50 kN) durchgeführt. Das Signal der DMS wurde über einen *HBM Spider 8* mit der Universalprüfmaschine verbunden und synchronisiert. Der Versuchsaufbau ist in Abbildung 3.1a dargestellt.

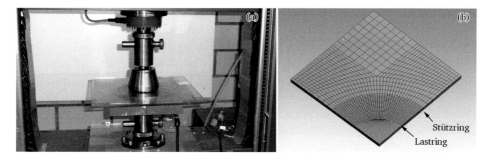

Abbildung 3.1 Doppelring-Biegeversuch mit Dehnungsmessung (a) und Finite-Elemente-Modell unter Ausnutzung der Doppelsymmetrie (b)

Versuchsdurchführung

Die Dicke der Probekörper wurde mit einer digitalen Bügelmessschraube (*Helios Digimet 40 EX*, Genauigkeit 4 µm) an jeweils zwei Stellen vermessen. Die Oberflächendruckspannung wurde spannungsoptisch mit einem *SCALP-04* an drei Stellen ermittelt. Dabei wurden folgende spannungsoptische Konstanten für die verschiedenen Glassorten angenommen:

- KNS: $c = 2{,}7\,\text{TPa}^{-1}$ (GLASSTRESS, 2012),

- Boro33: $c = 4{,}0\,\text{TPa}^{-1}$ (Herstellerangabe),

- Boro40 und Pyran: $c = 3{,}6\,\text{TPa}^{-1}$ (Herstellerangabe).

Die Versuche wurden bei 23 °C und 50 % rF mit einer konstanten Spannungsrate von $\dot{\sigma} = 2\,\text{MPa}\,\text{s}^{-1}$ kraftgeregelt bis zum Bruch der Gläser gefahren. Die Kraft wurde kontinuierlich aufgezeichnet, um die Bruchkraft und die Elastizitätsmodul zu ermitteln.

Versuchsauswertung und Ergebnisse

In einem ersten Schritt wurden die Messdaten der Gläser mit aufgeklebtem DMS verwendet, um die vorliegenden Elastizitätsmodul zu bestimmen. Dazu wurde in einem FE-Modell in *Ansys Workbench 15.0* (ANSYS INC., 2012a) der Elastizitätsmodul variiert, bis die Dehnungs-Kraft-Kurven mit den experimentellen Messungen übereinstimmten. Abbildung 3.1b zeigt das FE-Modell unter Ausnutzung der Doppelsymmetrie, aufgebaut aus 20-Knoten-Volumenelementen (*Solid186*) unter Berücksichtigung geometrischer Nichtlinearität. Neben den Symmetrielagern wurden die Knoten am Stützring senkrecht zur Plattenebene gehalten. Die Belastung wurde als Linienlast auf die Knoten des Lastrings aufgebracht. Als Querkontraktionszahl wurde $\nu = 0{,}2$ angesetzt (s. Tab. 2.3).

Abbildung 3.2 zeigt Dehnungs-Kraft-Kurven von Kalknatron-Silikatglas und Boro33. Es ist erkennbar, dass die Kurven aufgrund der geometrischen Nichtlinearität gekrümmt sind und das untersuchte Borosilikatglas eine größere Streuung als das Kalknatron-Silikatglas aufweist. Die ermittelten Elastizitätsmodul sind in Tabelle 3.2 zusammengefasst.

Tabelle 3.2 Ermittelte Elastizitätsmodul der untersuchten Glasarten

Glasart	Elastizitätsmodul E [MPa]
Kalknatron-Silikat-Floatglas (KNS-Float)	68 500
Kalknatron-Silikat-ESG (KNS-ESG)	68 500
Borosilikat-Floatglas mit $\alpha_\mathrm{T} = 3{,}3 \cdot 10^{-6}\,\text{K}^{-1}$ (Boro33)	59 000
Borosilikat-Floatglas mit $\alpha_\mathrm{T} = 4{,}0 \cdot 10^{-6}\,\text{K}^{-1}$ (Boro40)	62 300
Borosilikat-ESG aus Boro40 (Pyran)	62 300

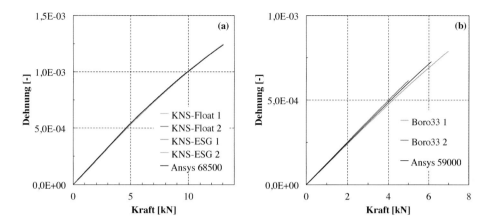

Abbildung 3.2 Dehnungs-Kraft-Kurven zur Ermittlung des E-Moduls: Kalknatron-Silikatglas (a) und Borosilikatglas (Boro33, b)

Bei allen Versuchen wurde der Bruchursprung im Glas identifiziert. Es wurden analog zur DIN EN 1288-2 nur diejenigen Proben in die Auswertung einbezogen, deren Bruchursprung innerhalb des Lastrings lagen. Die Bruchspannungen wurden anhand des FE-Modells ermittelt. Dazu wurde die gemessene Bruchkraft aufgebracht und die resultierende Hauptzugspannung im Glas berechnet. Hierbei wurde die tatsächlich vorliegende Probendicke berücksichtigt, da bei den Borosilikatgläsern diese stark gestreut hat (s. Tab. 3.3). Die Bruchspannungen wurden unter Ansatz einer Weibull-Verteilung nach SACHS et al., 2006 statistisch ausgewertet. Mittels der Bruchspannungen σ_b wurde darüber hinaus die theoretische Initialrisstiefe unter alleiniger Betrachtung des Bereichs I (s. Abb. 2.7b) a_i berechnet. Aus den Gleichungen (2.12) und (2.13) ergibt sich

$$a_i = \left(\frac{2(n+1)K_{\mathrm{Ic}}{}^n}{(n-2)v_0\,\dot{\sigma}^n\,(Y\sqrt{\pi})^n\,\left(\frac{\sigma_b}{\dot{\sigma}}\right)^{n+1}} \right)^{\frac{2}{n-2}}. \tag{3.1}$$

Es wurden folgende Risswachstumsparameter für den Bereich I verwendet (s. Tab. 2.4):

- Kalknatron-Silikatglas (WIEDERHORN, 1967):
 $n = 28,0$, $v_0 = 1,84 \cdot 10^{-1}\,\mathrm{m\,s}^{-1}$, $K_{\mathrm{IC}} = 0,82\,\mathrm{MPa}$,

- Borosilikatglas (SALEM et al., 2010):
 $n = 17,1$, $v_0 = 2,0 \cdot 10^{-3}\,\mathrm{m\,s}^{-1}$, $K_{\mathrm{IC}} = 0,72\,\mathrm{MPa}$.

Unter der Annahme eines geraden Oberflächenrisses (Kratzer) wurde der Korrekturfaktor konstant zu $Y = 1,1215$ gewählt (s. Abb. 2.6). Die ermittelten Initialrisstiefen wurden mittels Weibull-Verteilung ausgewertet.

Tabelle 3.3 Ergebnisse der Doppelringbiegeversuche

		KNS-Float	KNS-ESG	Boro33	Boro40	Pyran
Probendicke h						
Mittelwert \bar{x}	[mm]	4,84	4,84	4,94	4,97	4,97
Standardabweichung s	[mm]	0,01	0,01	0,02	0,05	0,05
Oberflächendruckspannung σ_r						
Mittelwert \bar{x}	[MPa]	0,6	111,0	0,2	0,0	93,9
Standardabweichung s	[MPa]	1,0	10,3	1,4	1,2	2,5
Bruchspannung σ_b						
Mittelwert \bar{x}	[MPa]	129,1	216,2	135,7	141,1	226,5
Variationskoeffizient V	[%]	16,7	11,9	24,7	25,7	14,5
Skalenparameter α	[MPa]	138,0	227,1	149,4	154,7	240,3
Formparameter β	[-]	6,89	9,96	4,23	4,46	7,95
Bestimmtheitsmaß R^2	[-]	0,98	0,92	0,96	0,90	0,93
5%-Fraktilwert bei 95% Aussagewahrscheinlichkeit	[MPa]	87,9	164,2	70,8	73,0	160,1
Initialrisstiefe a_i						
Mittelwert \bar{x}	[μm]	4,1	4,9	3,0	2,5	2,9
Variationskoeffizient V	[%]	42,3	48,2	87,8	56,1	62,5
Skalenparameter α	[μm]	4,6	5,5	3,3	2,8	3,3
Formparameter β	[-]	2,96	2,55	1,61	1,90	1,90
Bestimmtheitsmaß R^2	[-]	0,89	0,95	0,80	0,94	0,93
95%-Fraktilwert bei 95% Aussagewahrscheinlichkeit	[μm]	7,2	8,9	8,4	5,6	6,5

Die Ergebnisse sind in Tabelle 3.3 zusammengefasst. Erneut ist erkennbar, dass die Borosilikatgläser eine höhere Streuung im Vergleich zu den Kalknatron-Silikatgläsern aufweisen. Die einzelnen Ergebnisse und die Auswertungen mittels Weibull-Verteilung finden sich im Anhang A.1.

3.2.2 Kurzzeitige dynamische Belastung: Pendelschlagversuch

Versuchsaufbau

Die Versuche nach DIN EN 12600 wurden an der *Staatlichen Materialprüfungsanstalt (MPA) Darmstadt* durchgeführt.

Jeder Probekörper wurde mit einer Dehnmessrosette (DMR) (*TML FRA-2-8*) in der Mitte der stoßabgewandten Seite beklebt, um den zeitlichen Verlauf der Dehnung in drei Richtungen (0°, 45° und 90°) zu messen. Die Auftreffstelle des Pendels (Plattenmitte) wurde abgeklebt, um das Pendel vor einschneidenden Glassplittern zu schützen.

Das Pendel wurde mit zwei Beschleunigungssensoren (*HBM B12/2000*) direkt unter- und oberhalb des Reifens ausgestattet. Ein Wegmesstaster (*Messotron DTL50Q*) wurde an einer definierten Position am Glas angebracht, um den zeitlichen Verlauf der Auslenkung zu messen. Alle Messsignale wurden über einen *HBM QuantumX MX840A* verstärkt.

Abbildung 3.3 zeigt die Versuchseinrichtung mit eingebautem Probekörper, die Rahmenkonstruktion nach DIN EN 12600 und die Position der Messtechnik auf dem Probekörper.

Versuchsdurchführung

Die Dicke der Probekörper wurde mit einer digitalen Bügelmessschraube (*Helios Digimet 40 EX*, Genauigkeit 4 μm) an jeweils drei Stellen vermessen. Die Oberflächendruckspannung konnte hier aufgrund eines Defekts des Messgeräts nicht ermittelt werden.

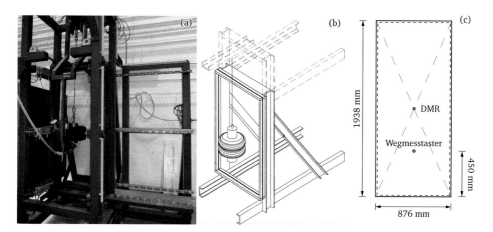

Abbildung 3.3 Versuchseinrichtung der PSV (a), Skizze des Versuchsrahmens aus DIN EN 12600 (b) und Skizze der Probekörper mit Position von DMR und Wegmesstaster (c)

Die Versuche wurden bei etwa 22 °C und 20 % rF bis 40 % rF durchgeführt. Die Messfrequenz wurde zu 9600 Hz festgelegt, um eine ausreichende transiente Auflösung des Pendelaufpralls sicherzustellen.

Die Fallhöhe des Pendels wurde stufenweise nach Tabelle 3.4 bis zum Bruch des Glases gesteigert. Die maximale Fallhöhe betrug 1200 mm. Bei einigen thermisch vorgespannten Gläsern wurde mit dem Standardaufbau nach DIN EN 12600 kein Glasbruch erreicht. In diesen Fällen wurde das Pendelgewicht und der Reifendruck von 50 kg und 3,5 bar auf 83 kg und 5,0 bar erhöht.

Versuchsauswertung und Ergebnisse

Primäres Interesse war die Auswertung der Bruchspannung sowie des zeitlichen Hauptspannungsverlaufs während des Pendelschlags. Darüber hinaus wurden für die untersuchten Kalknatron-Silikatgläser weitere Ergebnisse ausgewertet, welche Tabelle 3.4 zusammenfasst. Die experimentell ermittelten maximalen Hauptzugspannungen in Abhängigkeit der Fallhöhe sowie einen Vergleich zu FE-Berechnungen mit *SJ Mepla* (SJ SOFTWARE GMBH, 2013) zeigt Abbildung 3.4. Für diese Auswertung wurden nur die Ergebnisse herangezogen, bei denen der Versuchsaufbau nach DIN EN 12600 verwendet wurde.

Eine Betrachtung der gemessenen Pendelbeschleunigung und der aus den DMR berechneten Hauptzugspannungen im Mittelpunkt der stoßabgewandten Glasseite zeigt, dass die Einwirkungsdauer des Pendelschlags mit der Dauer der Reaktion in der Glasplatte übereinstimmt (Abb. 3.5a).

Die FE-Berechnungen mit *SJ Mepla* zeigen sehr gute Übereinstimmungen zu den experimentell ermittelten zeitlichen Verläufen von Hauptzugspannung im Glas, Auslenkung des Glases und Pendelbeschleunigung (Abb. 3.5b-d).

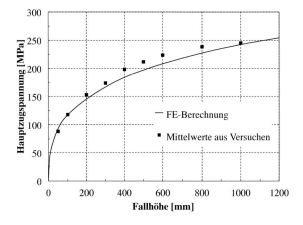

Abbildung 3.4 Hauptzugspannungen im Glas in Abhängigkeit der Fallhöhe

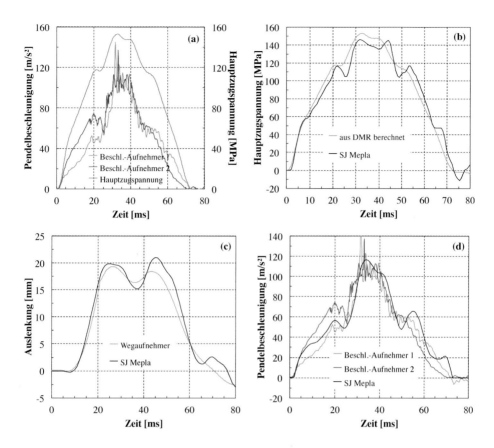

Abbildung 3.5 Exemplarische Ergebnisse eines KNS-Floatglases bei 200 mm Fallhöhe: Vergleich zwischen Pendelbeschleunigung und Glasspannung (a), Vergleich zwischen experimentell gemessenen Ergebnissen und Finite-Elemente-Berechnungen (b) bis (d)

Die experimentell aus den DMR ermittelten Bruchspannungen aller Glasarten sind in Tabelle 3.5 mit einer Auswertung nach der Weibull-Verteilung zusammengefasst. Dieser Auswertung liegt die Annahme zu Grunde, dass der Bruchursprung im Bereich der DMR unterhalb der Pendelauftreffstelle liegt, was anhand von Hochgeschwindigkeitsaufnahmen bestätigt wurde.

Für kurzzeitige dynamische Einwirkungen wie der Pendelschlag ist eine Vernachlässigung der Bereiche II und III aus Abbildung 2.7 nicht mehr gerechtfertigt. Zudem kann mit den analytischen Gleichungen aus Abschnitt 2.2.2 kein Risswachstum durch vorangegangene Pendelstöße, die nicht zum Glasbruch geführt haben, erfasst werden. Für die Kalknatron-Silikatgläser wurde daher die Initialrisstiefe a_i numerisch ermittelt. Für die untersuchten Borosilikatgläser wurden wegen der fehlenden Materialparameter für den Bereich III (Vakuum) keine Simulationen durchgeführt.

Tabelle 3.4 Messergebnisse der Pendelschlagversuche mit 4,85 mm dickem Kalknatron-Silikatglas, Angabe von Mittelwert ± Standardabweichung

Fallhöhe [mm]	Anzahl Proben [-]	Ein- wirkungs- dauer [ms]	Max. Hauptzug- spannung [MPa]	Max. Aus- lenkung [mm]	Max. Pendel- beschleuni- gung [m s^{-2}]	Mittlere Spannungs- rate [MPa s^{-1}]
50	6	$83 \pm 1,5$	$88 \pm 9,5$	$9,5 \pm 4,1$	$41 \pm 5,3$	$2437 \pm 10,1$
100	4	$78 \pm 5,3$	$118 \pm 4,8$	$13,2 \pm 8,9$	$61 \pm 2,8$	$3436 \pm 8,4$
200	4	$72 \pm 1,1$	$153 \pm 1,8$	$19,3 \pm 3,2$	$114 \pm 9,6$	$4790 \pm 4,2$
300	5	$69 \pm 2,6$	$174 \pm 7,3$	$23,4 \pm 3,5$	$142 \pm 8,6$	$5771 \pm 10,0$
400	4	$66 \pm 1,9$	$199 \pm 1,4$	$27,2 \pm 4,0$	$169 \pm 6,1$	$7091 \pm 1,4$
500	3	$64 \pm 2,4$	$212 \pm 0,4$	$28,7 \pm 1,1$	$190 \pm 3,6$	$7957 \pm 2,6$
600	2	$62 \pm 2,3$	$224 \pm 1,3$	$30,6 \pm 0,5$	$213 \pm 6,3$	$8631 \pm 6,7$
800	2	$61 \pm 1,2$	$239 \pm 2,5$	$32,4 \pm 9,2$	$253 \pm 5,3$	$9373 \pm 5,2$
1000	2	$59 \pm 2,4$	$245 \pm 1,6$	$33,6 \pm 15,4$	$285 \pm 7,4$	$9826 \pm 7,3$

Eingangsparameter in die Berechnung sind die nach WIEDERHORN, 1967 ermittelten Risswachstumsparameter aus Tabelle 2.4 und der zeitliche Verlauf der Hauptzugspannung $\sigma(t)$, bestimmt aus den DMR-Messungen. Um zwischen den Bereichen I, II und III zu unterscheiden, wurden die Spannungsintensitäten an den Übergängen bestimmt. Die Grenze zwischen Bereich I und II wurde graphisch anhand Abbildung 2.7a zu $K_{rII} = 0,65\,\mathrm{MPa\,m^{1/2}}$ bei einer Umgebungsfeuchte von 30 % rF ermittelt. Daraus ergibt sich die Risswachstumsgeschwindigkeit im Bereich II zu

$$v_{II} = v_0 \left(\frac{K_{rII}}{K_{Ic}} \right)^{n_{30\,\% \text{ rF}}} = 2,75 \cdot 10^{-4}\,\mathrm{m\,s^{-1}}. \tag{3.2}$$

Die Grenze zwischen Bereich II und III ist damit festgelegt und ergibt sich zu

$$K_{rIII} = K_{Ic} \left(\frac{v_{II}}{v_0} \right)^{n_{\text{Vakuum}}^{-1}} = 0,76\,\mathrm{MPa\,m^{1/2}}. \tag{3.3}$$

Der Bereich 0 unterhalb der Ermüdungsschwelle K_{I0} wurde in der Simulation berücksichtigt, hat aber einen vernachlässigbaren Einfluss.

Die numerische Simulation des Risswachstums erfolgt zu diskreten Zeitschritten Δt. Von der Risstiefe $a(t)$ zum Zeitpunkt t ausgehend wird zu jedem Zeitschritt die Spannungsintensität $K_I(t)$ nach Gleichung (2.5) bestimmt. Daraus lässt sich je nach Bereich die aktuelle Risswachstumsgeschwindigkeit $v(t)$ bestimmen. Aus der Risswachstumsgeschwindigkeit ergibt sich die Risstiefe zum Zeitschritt $t + \Delta t$ zu

$$a(t + \Delta t) = a(t) + v(t)\Delta t. \tag{3.4}$$

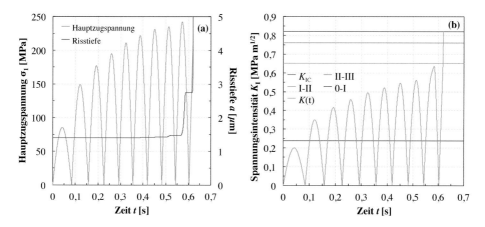

Abbildung 3.6 Risswachstumssimulation unter Beachtung des Vorpendelns und der Bereiche II und III am Beispiel eines Kalknatron-Silikatglases

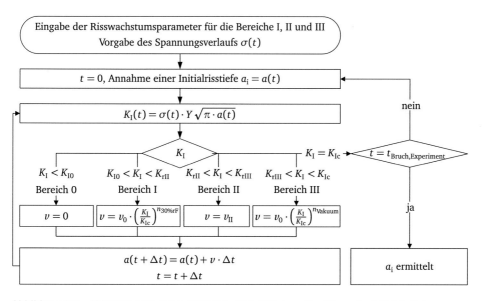

Abbildung 3.7 Ablaufschema der numerischen Simulation zur Ermittlung der Initialrisstiefe a_i

Die zu ermittelnde Initialrisstiefe a_i ist ein Eingangsparameter in die Simulation. Sie wird mittels Zielwertsuche bestimmt, sodass das Irwinsche Bruchkriterium $K_I = K_{Ic}$ zum Zeitpunkt des experimentell beobachteten Versagens erfüllt ist. Abbildung 3.6 zeigt beispielhaft das Ergebnis der Simulation für ein Kalknatron-Silikat-Floatglas. In Abbildung 3.7 wird das Vorgehen bei der numerischen Simulation schematisch dargestellt.

Die Auswirkungen der stufenweisen Steigerung der Fallhöhe auf die Initialrisstiefe wurde über den vorgegebenen Spannungsverlauf berücksichtigt. Bei den thermisch vorgespannten Gläsern wurde der in den Doppelring-Biegeversuchen ermittelte Mittelwert der Oberflächendruckspannung aus Tabelle 3.3 für die Risswachstumssimulation von der experimentell ermittelten Hauptzugspannung abgezogen. Eine Zeitschrittstudie zeigte, dass bei diesen Spannungsraten Zeitschritte von $\Delta t = 0{,}01$ ms ausreichend genaue Ergebnisse liefern.

Mit den so ermittelten Initialrisstiefen a_i kann wiederum die theoretische Bruchspannung ohne Vorpendeln ermittelt werden. Dabei wurde eine konstante Spannungsrate von $10\,000$ MPa s^{-1} nach Tabelle 3.4 angenommen. Die Spannung zu dem Zeitpunkt, bei welchem die kritische Spannungsintensität $K_I = K_{Ic}$ erreicht ist, stellt die Bruchspannung dar.

Bei Vernachlässigung der Bereiche II und III ergibt sich für Kalknatron-Silikat-Floatglas ein Mittelwert der theoretischen Bruchspannung ohne Vorpendeln von $\sigma_b = 201$ MPa. Dieser ist um 6 % geringer, als wenn die Bereiche II und III in der Simulation berücksichtigt werden ($\sigma_b = 213$ MPa, s. Tab. 3.5). Die Ergebnisse der Simulationen sind in Tabelle

Tabelle 3.5 Ergebnisse der Pendelschlagversuche

		KNS-Float	KNS-ESG	Boro33	Boro40	Pyran
Probendicke h						
Mittelwert \bar{x}	[mm]	4,86	4,85	4,96	4,99	4,98
Standardabweichung s	[mm]	0,03	0,01	0,02	0,01	0,04
Experimentell ermittelte Bruchspannung σ_b						
Mittelwert \bar{x}	[MPa]	187,4	339,0	172,6	191,2	241,6
Variationskoeffizient V	[%]	22,5	20,8	14,4	16,5	22,2
Steigerung ggü. DRBV	[%]	45	57	27	36	7
Skalenparameter α	[MPa]	207,6	371,7	184,7	205,1	265,0
Formparameter β	[-]	3,9	4,4	6,6	6,1	4,3
Bestimmtheitsmaß R^2	[-]	0,90	0,90	0,70	0,97	0,96
Initialrisstiefe a_i						
Mittelwert \bar{x}	[µm]	3,8	2,7	-	-	-
Variationskoeffizient V	[%]	88,4	75,5	-	-	-
Skalenparameter α	[µm]	4,3	3,2	-	-	-
Formparameter β	[-]	1,2	1,4	-	-	-
Bestimmtheitsmaß R^2	[-]	0,83	0,78	-	-	-
Theoretische Bruchspannung σ_b ohne Vorpendeln						
Mittelwert \bar{x}	[MPa]	213,0	346,6	-	-	-
Variationskoeffizient V	[%]	28,5	16,1	-	-	-
Steigerung ggü. DRBV	[%]	65	60	-	-	-

3.5 zusammengefasst. Die Einzelergebnisse und die Auswertung nach der Weibullverteilung finden sich im Anhang A.2.

3.3 Bewertung der Ergebnisse

Um die Gültigkeit der bruchmechanischen Modelle für kurzzeitige dynamische Einwirkungen zu beurteilen, wurden die theoretischen Initialrisstiefen a_i für die untersuchten Kalknatron-Silikatgläser unter quasistatischer und dynamischer Belastung ermittelt. Eine Gegenüberstellung der Initialrisstiefen unter Beachtung der Standardabweichung zeigt Abbildung 3.8a. Des Weiteren werden die Mittelwerte der Bruchspannungen aus beiden Versuchsreihen gegenübergestellt (Abb. 3.8b). Hierbei ist zu beachten, dass der direkte Vergleich auf der Spannungsebene durch die verschiedenen genannten Einflussfaktoren (Vorpendeln, unterschiedliche Spannungsraten je Fallhöhe) nur für eine grobe Abschätzung dienen kann.

Insbesondere in Bezug auf die ermittelten Initialrisstiefen (Abb. 3.8a) ist eine starke Streuung in den Ergebnissen erkennbar. Hier stimmen die Mittelwerte des KNS-Float aus quasistatischer und dynamischer Belastung gut überein. Das KNS-ESG zeigt Abweichungen mit einem geringeren Mittelwert der Initialrisstiefe bei dynamischer Beanspruchung. Dies ist gleichbedeutend mit höheren Festigkeiten unter dynamischer Belastung, wobei aufgrund eines Defekts des Messgeräts nicht die tatsächlich vorherrschende Oberflächendruckspannung mit in die Auswertung einbezogen werden konnte. Das Borosilikat-ESG (Pyran) zeigt dagegen eine deutlich geringere Steigerung der Festigkeit bei dynamischer Beanspruchung (Abb. 3.8b) .

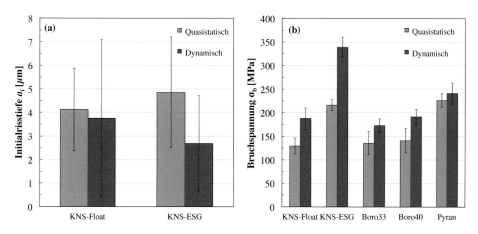

Abbildung 3.8 Vergleich der Ergebnisse aus den quasistatischen und dynamischen Versuchen, Darstellung von Mittelwert und Standardabweichung: Rückgerechnete Initialrisstiefen für Kalknatron-Silikatglas (a) und Bruchspannungen für alle Glasarten (b)

Für eine besser belastbare Aussage ist daher neben einer erhöhten Anzahl an dynamischen Versuchen die Streuung zu minimieren. Dies kann durch eine gezielte Vorschädigung der Probekörper erfolgen, siehe beispielsweise SCHULA, 2015 und HILCKEN, 2015. Die in dieser Arbeit vorgestellten Untersuchungen wurden im Rahmen eines Forschungsprojektes durchgeführt, bei dem auch absolute Werte für die Festigkeit fabrikneuer Gläser ermittelt werden sollten. Aus diesem Grund wurde keine Vorschädigung zur Reduktion der Streuung eingebracht.

Darüber hinaus ist anzumerken, dass sich sowohl die Probekörpergeometrie als auch die Spannungsverteilung bei quasistatischer und dynamischer Beanspruchung unterscheiden. Der Flächeneffekt, welcher durch die stochastische Verteilung der Oberflächendefekte entsteht, wurde in der Auswertung nicht berücksichtigt. FE-Simulationen in *SJ Mepla* zeigen aber, dass die mit der maximalen Spannung beanspruchte Fläche im Pendelschlagversuch mit der durch den Lastring eingeschlossenen Fläche im Doppelring-Biegeversuch vergleichbar ist.

Die Ergebnisse des bruchmechanischen Modells stimmen für das untersuchte KNS-Float gut mit den experimentellen Ergebnissen überein, für das KNS-ESG liegen sie auf der sicheren Seite. Auf Basis dieser Ergebnisse wurden Prognosen für die Kurzzeitfestigkeit von Kalknatron-Silikatgläsern anhand des numerischen bruchmechanischen Modells unter Berücksichtigung aller Bereiche nach Abbildung 2.7 durchgeführt. Tabelle 3.6 fasst die ermittelten Werte für thermisch entspanntes Floatglas in Abhängigkeit einer konstanten Spannungsrate $\dot{\sigma}$ zusammen. Es wurde ein Zeitschritt von $\Delta t = 0,001\,\text{ms}$ gewählt, da Spannungsraten bis $\dot{\sigma} = 100\,000\,\text{MPa}\,\text{s}^{-1}$ berücksichtigt wurden. Die Auswertung beruht auf der in DIN EN 572-1 angegebenen und in FINK, 2000 bestätigten charakteristischen Festigkeit von $f_k = 45\,\text{MPa}$, auf dem Mittelwert der Festigkeit von gealterten (bewitterten) Gläsern $f_m = 80\,\text{MPa}$ nach FINK, 2000 sowie auf dem Mittelwert der Festigkeit von fabrikneuen Gläsern $f_m = 120\,\text{MPa}$ nach Tabelle 3.3 und FINK, 2000.

Für thermisch vorgespannte Gläser sind die Oberflächendruckspannung auf die in Tabelle 3.6 angegebenen Werte zu addieren. Diese haben sich in den vergangenen Jahren tendenziell erhöht und betragen derzeit üblicherweise bei TVG $\sigma_{r,TVG} \approx 60\,\text{MPa}$ und bei ESG $\sigma_{r,ESG} \approx 110\,\text{MPa}$ (s. Tab. 3.3 und SCHULA, 2015).

Aus den Prognosen wird deutlich, dass die untersuchten Spannungsraten zu Festigkeitswerten führen, die nahe an dem Irwinschen Bruchkriterium (2.6) liegen. Höhere Festigkeitswerte sind nach dem bruchmechanischen Modell nicht möglich.

Die ermittelten Ergebnisse liegen im Bereich der bisher veröffentlichten Literaturangaben zur Kurzzeitfestigkeit von Glas (s. Abschn. 2.2.2). Die in DIN 18008-4 angegebenen Bemessungswerte für die Glasfestigkeit bei Pendelschlag (Tab. 2.5) liegen zwischen den prognostizierten charakteristischen Werten und den Mittelwerten der gealterten Gläser. Demgegenüber ist die normativ angegebene Erhöhung bei den thermisch vorgespannten Gläsern konservativ. Für eine konsequente Umsetzung des Bemessungskonzepts nach DIN 18008-1 werden die Modifikationsbeiwerte k_{mod} nach Tabelle 3.7 empfohlen. Für

Tabelle 3.6 Prognose der Kurzzeitfestigkeit von thermisch entspanntem Kalknatron-Silikatglas

		Charakteristischer Wert f_k	Mittelwert gealtert $f_{m,alt}$	Mittelwert fabrikneu $f_{m,neu}$
Quasistatische Festigkeit				
$\dot{\sigma} = 2\,\mathrm{MPa\,s^{-1}}$	[MPa]	45	80	120
Initialrisstiefe a_i	[µm]	38,9	10,8	4,4
Dynamische Festigkeit [a]				
$\dot{\sigma} = 1000\,\mathrm{MPa\,s^{-1}}$	[MPa]	60 (+33%)	105 (+31%)	152 (+27%)
$\dot{\sigma} = 10\,000\,\mathrm{MPa\,s^{-1}}$	[MPa]	63 (+40%)	116 (+45%)	173 (+44%)
$\dot{\sigma} = 100\,000\,\mathrm{MPa\,s^{-1}}$	[MPa]	65 (+44%)	122 (+53%)	187 (+56%)
Irwinsches K_{Ic}-Kriterium	[MPa]	66 (+47%)	126 (+57%)	197 (+64%)

[a] Pendelschlag: $1000\,\mathrm{MPa\,s^{-1}} \leq \dot{\sigma} \leq 10\,000\,\mathrm{MPa\,s^{-1}}$;
Detonationsdruckwellen: $10\,000\,\mathrm{MPa\,s^{-1}} \leq \dot{\sigma} \leq 100\,000\,\mathrm{MPa\,s^{-1}}$

thermisch entspanntes Floatglas ist k_{mod} geringer als in DIN 18008-4. Für thermisch vorgespannte Gläser liegen die empfohlenen Werte über den normativen Angaben. Die Ermittlung der k_{mod}-Werte erfolgte mittels Division der charakteristischen dynamischen Bruchspannung durch die charakteristische quasistatische Festigkeit:

$$k_{mod} = \frac{\sigma_{b,k,dyn}}{f_k}. \tag{3.5}$$

Neben der Festigkeitssteigerung durch den Beiwert k_{mod} ist bei der Verwendung von VSG keine pauschale Erhöhung des Widerstandswerts um 10 % nach DIN 18008-1 anzusetzen, da durch das steife Verhalten der Zwischenschicht ein nahezu vollständiger Verbund wirkt. Ein günstig wirkendes Nachbruchverhalten kann durch den Konstruktionsbeiwert k_c berücksichtigt werden. Für den Lastfall Explosion hängt das Nachbruchverhalten insbesondere von der Steifigkeit und der Haftung der verwendeten Zwischenschicht ab (s. Abschn. 6.2.3).

Tabelle 3.7 Modifikationsbeiwerte k_{mod} zur Ermittlung der Bemessungswerte unter kurzzeitiger dynamischer Einwirkung nach DIN 18008-1

Glasart	Empfehlung	Angabe in DIN 18008-4
Floatglas	1,4	1,8
Teilvorgespanntes Glas (TVG)	1,8	1,7
Einscheibensicherheitsglas (ESG)	1,5	1,4

Um für Borosilikatgläser analoge Prognosen zur Kurzzeitfestigkeit durchführen zu können, bedarf es einer Ermittlung der Risswachstumsparameter für den Bereich III (Vakuum) respektive einer Darstellung von Messdaten äquivalent zu Abbildung 2.7.

3.4 Zusammenfassung

In diesem Kapitel wurden die experimentellen Untersuchungen zur Kurzzeitfestigkeit von verschiedenen Glasarten und deren Auswertung vorgestellt. Der Einfluss der Belastungsgeschwindigkeit auf die Festigkeit wurde anhand von quasistatischen Doppelringbiegeversuchen und dynamischen Pendelschlagversuchen untersucht und mit dem Modell aus der Bruchmechanik ausgewertet. Dabei wurden erstmals auch die Bereiche II und III des zeitabhängigen Risswachstums berücksichtigt, welche für die Kurzzeitfestigkeit relevant sind.

Die experimentellen Ergebnisse zeigen eine für Festigkeitsuntersuchungen mit Glas übliche starke Streuung. In Verbindung mit der geringen Anzahl an dynamischen Versuchen ist eine statistisch abgesicherte Aussage nicht möglich, ein Trend aber durchaus erkennbar. Die Ergebnisse liegen im Bereich bisher veröffentlichter Literaturangaben.

Die mit dem bruchmechanischen Modell ermittelten mittleren Anfangsrisstiefen aus quasistatischer und dynamischer Belastung stimmen für das Kalknatron-Silikat-Floatglas gut überein. Für das Kalknatron-Silikat-ESG liegt das bruchmechanische Modell auf der sicheren Seite.

Auf dieser Basis wurden Prognosen der Festigkeit für unterschiedliche Spannungsraten durchgeführt, die als Anhaltswerte für eine Bemessung dienen können. Für eine konsequente Umsetzung des Bemessungskonzepts nach DIN 18008-1 werden folgende Modifikationsbeiwerte für die charakteristische Festigkeit von Kalknatron-Silikatgläsern unter kurzzeitiger dynamischer Einwirkung vorgeschlagen:

- Floatglas: $k_{\mathrm{mod}} = 1,4$,

- Teilvorgespanntes Glas (TVG): $k_{\mathrm{mod}} = 1,8$,

- Einscheibensicherheitsglas (ESG): $k_{\mathrm{mod}} = 1,5$.

4 Untersuchungen zum mechanischen Verhalten von Zwischenschichten

4.1 Allgemeines

Für ein grundlegendes Verständnis des Verhaltens von Verbundglas unter zeitabhängiger Belastung wurden mit unterschiedlichen Zwischenschichten Dynamisch-Mechanisch-Thermische Analysen (DMTA) sowie uniaxiale Zugversuche bei Normklima (23 °C, 50 % rF) mit verschiedenen Wegraten (Prüfgeschwindigkeiten) durchgeführt. Tabelle 4.1 fasst die experimentellen Untersuchungen zusammen. Entsprechend der mechanischen Belastung der Zwischenschicht in Verbundglas erfolgt zuerst die Beschreibung der DMTA,

Tabelle 4.1 Übersicht über die experimentellen Untersuchungen an Verbundglas-Zwischenschichten

Material	Typ	DMTA	Quasistatische Zugversuche [a]	Dynamische Zugversuche [b]
PVB	BG	X	X	X
	SC	X	X	-
	ES	X	X	-
	K7026	X	X	-
EVA	G71/G77	X	X	X
	S11/S88	X	X	-
Ionoplast	SG5000	X	X	X
TPU	PE399	-	X	X
	PE429	-	X	-
	PE499	-	X	-
	PE501	-	X	-

[a] Wegraten $\leq 200\,\mathrm{mm\,min^{-1}}$
[b] Wegraten $> 200\,\mathrm{mm\,min^{-1}}$

welche für den intakten Zustand relevant ist. Die anschließend erläuterten Zugversuche beschreiben die mechanische Belastung der Zwischenschicht im gebrochenen Zustand.

Ziel der Untersuchungen war ein umfassender direkter Vergleich unterschiedlicher Zwischenschichten zur Bewertung des Materialverhaltens hinsichtlich üblicher baupraktischer Anwendungen und des Lastfalls Explosion. Zudem sollten auch allgemeingültige Methoden zur Ableitung von Materialparametern aus den experimentell gewonnenen Daten entwickelt werden.

In Abschnitt 4.2 werden die durchgeführten experimentellen Untersuchungen und deren Ergebnisse dargestellt. Ein Vergleich der Materialgruppen untereinander, die Ableitung von Parametern für Materialmodelle sowie ein Vergleich der Materialkennwerte mit Literaturangaben folgt anschließend in Abschnitt 4.3. Die untersuchten Zwischenschichten sind in den Abschnitten 2.4.2 bis 2.4.5 beschrieben.

4.2 Experimentelle Untersuchungen

4.2.1 Konditionierte Lagerung der Probekörper

Die Materialien PVB und Ionoplast sind konditioniert zu lagern, um die im Herstellwerk eingestellte Folienfeuchte beizubehalten (s. Abschn. 2.4). Dazu wurden luftdichte Boxen zur Probenlagerung hergestellt, um mit geeigneten Salzen die Luftfeuchtigkeit einzustellen. Für die Folien aus PVB wurde eine gesättigte Kaliumacetatlösung, für die Ionoplastfolie wurde reines Natriumhydroxid verwendet. Die Temperatur und die relative Luftfeuchtigkeit wurden mittels Sensoren in den Klimaboxen permanent gemessen. In Abbildung

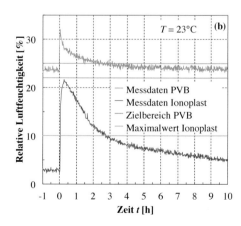

Abbildung 4.1 Klimabox (a) und zeitliche Regulierung der relativen Luftfeuchtigkeit in den Klimaboxen nach einem Öffnen bei $t = 0$ h (b)

4.1 ist eine der Klimaboxen und die gemessene Regulierung der Luftfeuchtigkeit durch die Salze nach einem kurzzeitigen Öffnen der Boxen zur Probenentnahme dargestellt.

4.2.2 Dynamisch-Mechanisch-Thermische Analysen (DMTA)

Das zeit- und temperaturabhängige Materialverhalten von Verbundglas-Zwischenschichten wurde im Rahmen dieser Arbeit im Bereich kleiner Verzerrungen anhand von DMTA untersucht. Zudem sollte die Frage beantwortet werden, welche DMTA-Belastungsmodi für Verbundglas-Zwischenschichten geeignet sind.

Die Grundlagen zur DMTA finden sich in Abschnitt 2.3.7. Zu Beginn ist die Versuchsart (Amplitudensweep, Temperatursweep oder Frequenzsweep) festzulegen. Für alle Materialien und Belastungsmodi wurde in einem ersten Schritt ein Amplitudensweep durchgeführt. Hiermit wurden die in den folgenden Prüfungen angesetzten Deformations- und Kraftgrenzen definiert, sodass sichergestellt war, dass sich das Material im linear viskoelastischen Bereich befindet. Die untersuchten Verzerrungen lagen bei maximal 1,0 %.

Anschließend wurden Temperatursweeps bei konstanter Frequenz und Frequenzsweeps bei konstanten Temperaturen ausgeführt. Die Versuche wurden weggeregelt oder mit einem automatischen Wechsel zwischen Weg- und Kraftregelung gefahren. Detailangaben zur Durchführung jedes Einzelversuchs finden sich im Anhang A.3.

Im Folgenden werden die untersuchten Belastungsmodi vorgestellt und die Ergebnisse aus den Temperatur- und Frequenzsweeps zusammengefasst. Anschließend folgt eine Bewertung der Belastungsmodi hinsichtlich der Anwendbarkeit für Verbundglas-Zwischenschichten.

Detaillierte Beschreibungen zu Teilen der Untersuchungen finden sich in SCHUSTER, 2014 und LANGER, 2015. Des Weiteren wurden einige Aspekte bereits in KUNTSCHE et al., 2015 veröffentlicht.

Untersuchte Belastungsmodi

Zur Durchführung der DMTA stehen unterschiedliche Belastungsmodi wie Zug, Druck, Biegung, Torsion oder Scherung zur Verfügung. Eine Übersicht geben die für die Durchführung von DMTA relevanten Regelwerke DIN EN ISO 6721-1 und ASTM D4065.

Der Versuchsaufbau und die Probekörpersteifigkeit beeinflusst stets die endgültigen Messergebnisse. Zudem ergeben sich je nach Belastungsmodus unterschiedliche direkt ermittelbare Ergebnisgrößen (Zug-, Druck- oder Schubmodul). Die Wahl eines geeigneten Modus sollte sich daher an der Materialsteifigkeit und der zu erwartenden dominierenden Belastung im Bauteil orientieren, wie es auch in DIN EN ISO 6721-1 und den Folgeteilen angemerkt wird. Für Zwischenschichten von Verbundglas existieren bisher keine vergleichenden Untersuchungen. Aus dem Grund wurden vier verschiedene Belastungsmodi untersucht, um ihre Anwendbarkeit für Verbundglas-Zwischenschichten zu bewerten und Empfehlungen abzuleiten. Diese sind in Abbildung 4.2 schematisch dargestellt.

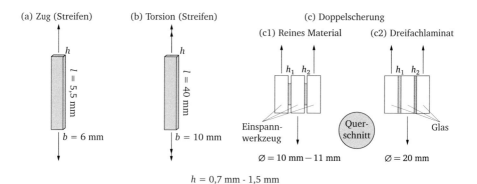

Abbildung 4.2 Schematische Darstellung der untersuchten Belastungsmodi in der DMTA

Abbildung 4.3 Eingespannte Probekörper und Bohrkern eines Dreifachlaminats

Im Normentwurf DIN PREN 16613, welche die Bestimmung mechanischer Eigen-schaften von Verbundglas-Zwischenschichten regelt, wird für isotrope Materialien der Zugmodus vorgeschrieben (Abb. 4.2a). Die dominierende Belastung der Zwischenschicht im intakten Verbundglas ist jedoch die Schubkopplung der Glasplatten. Schub wird im Be-lastungsmodus Torsion (b) oder Doppelscherung (c) erzeugt. Neben der üblichen Variante, das reine Zwischenschichtmaterial in das Prüfwerkzeug einzuspannen und die Schubkopp-lung über Haftreibung zu erzeugen (c1), wurden Bohrkerne aus einem Dreifachlaminat entnommen und der Doppelscherung unterworfen (c2). Dies hat den Vorteil, dass keine ungewollte mehraxiale Beanspruchung durch die Drucknormalkraft zur Erzeugung der Haftreibung initiiert wird.

Der Zugmodus und die Doppelscherung am reinen Material wurden in einer *Mett-ler Toledo DMTA/SDTA863* geprüft. Die Torsionsversuche wurden in einer *Anton Paar*

MCR 702, die Scherversuche am Dreifachlaminat in einer *Gabo EPLEXOR 8000N* durchgeführt. Abbildung 4.3 zeigt für alle Belastungsmodi in die Prüfwerkzeuge eingespannte Probekörper und Bohrkerne eines Dreifachlaminats.

Temperatursweeps

Der Temperatursweep dient der Beurteilung der Temperaturabhängigkeit bei gleichbleibender Belastungsdauer. Tabelle 4.2 fasst die durchgeführten Temperatursweeps zusammen. Die Prüffrequenz betrug $f = 1\,\text{Hz}$ mit Ausnahme der Doppelscherung des Dreifachlaminats ($f = 10\,\text{Hz}$). Die Temperatur wurde von $-60\,°\text{C}$ auf $+80\,°\text{C}$ mit einer konstanten Heizrate von $\dot{T} = 1\,\text{K min}^{-1}$ oder $\dot{T} = 2\,\text{K min}^{-1}$ gesteigert.

Im Folgenden werden für alle Belastungsmodi als Ergebnisse der Speichermodul G' und der Verlustmodul G'' angegeben, aus denen alle weiteren Größen wie der komplexe Modul G^* oder der Verlustfaktor $\tan\delta$ bestimmt werden können. Die Ergebnisse des Zugmodus wurden dabei komponentenweise über den bei isotropen Materialien gültigen Zusammenhang

$$G = \frac{E}{2(1+\nu)} \tag{4.1}$$

in Schubwerte umgerechnet. Die Querkontraktionszahl von Kunststoffen liegt im energieelastischen Bereich bei $\nu \approx 0,3$ und strebt im entropieelastischen Bereich gegen $\nu \approx 0,5$, sodass die Umrechnung nicht mit einer konstanten Querkontraktionszahl erfolgen kann (s. Abschn. 2.3.2). Aus diesem Grund wurde das vereinfachende Vorgehen nach Abbildung 4.4 entwickelt mit einer linearen Interpolation im Bereich von $T_\text{g} - 10\,°\text{C}$ bis $T_\text{g} + 10\,°\text{C}$.

Tabelle 4.2 Versuchsmatrix Temperatursweep, Versuchsanzahl je Belastungsmodus

Material	Typ	Zug (Streifen)[ad]	Torsion (Streifen)[ac]	Doppelscherung (Material)[ad]	Doppelscherung (Laminat)[bc]
PVB	BG	1	1	1	1
	SC	-	-	1	-
	ES	-	-	1	-
	K7026	-	-	1	-
EVA	G77	1	1	1	-
	S88	-	-	1	-
Ionoplast	SG5000	1	1	1	-

[a] Frequenz $f = 1\,\text{Hz}$
[b] Frequenz $f = 10\,\text{Hz}$
[c] Heizrate $\dot{T} = 1\,\text{K min}^{-1}$
[d] Heizrate $\dot{T} = 2\,\text{K min}^{-1}$

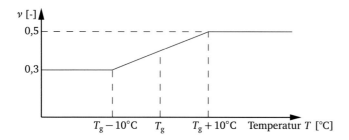

Abbildung 4.4 Ansatz für die Querkontraktionszahl ν zur Umrechnung von Zug in Schub

Darüber hinaus sind in den Diagrammen die Glasübergangstemperaturen T_g eingetragen, welche über das Maximum des Verlustfaktors $\tan\delta$ ermittelt wurden (s. Tab. 4.7).

Der Vergleich der Belastungsmodi mit dem Standard-PVB in Abbildung 4.5 zeigt, in welchen Steifigkeitsbereichen welche Messmethode belastbare Ergebnisse liefert. Der Zugmodus zeigt bei Temperaturen oberhalb der Glasübergangstemperatur ein starkes Rauschen: Der Probekörper ist zu weich für den Belastungsmodus. Unterhalb der Glasübergangstemperatur sind die Ergebnisse stabil. Der Torsionsmodus zeigt ein stabileres Verhalten, jedoch ist auch hier im Bereich hoher Temperaturen ein leichtes Rauschen zu erkennen. Das Rauschen zeigt sich deutlicher im Verlustmodul, da der Phasenwinkel als primäre Ergebnisgröße auf niedrigem absoluten Niveau schwankt ($\delta \leq 0,1$) und damit den Verlustmodul deutlich stärker beeinflusst als den Speichermodul, siehe Gleichung (2.45).

Die Doppelscherung am reinen Material ist im entropieelastischen Bereich stabil, im Bereich tiefer Temperaturen zeigt die Messung ein Rauschen, was auf geringe Materi-

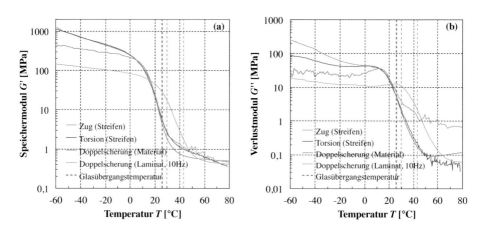

Abbildung 4.5 Ergebnisse der Temperatursweeps mit verschiedenen Belastungsmodi bei 1 Hz (Laminat 10 Hz) an PVB BG: Speichermodul G' (a) und Verlustmodul G'' (b)

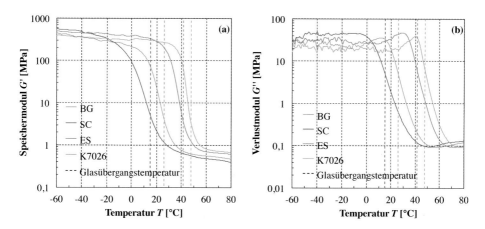

Abbildung 4.6 Ergebnisse der Temperatursweeps mit verschiedenen PVB-Zwischenschichten bei 1 Hz in der Doppelscherung (Material): Speichermodul G' (a) und Verlustmodul G'' (b)

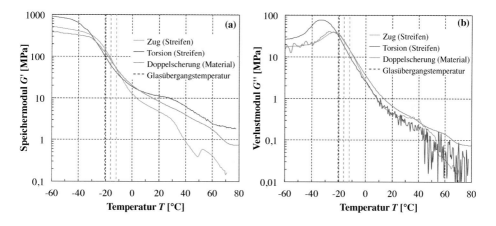

Abbildung 4.7 Ergebnisse der Temperatursweeps mit verschiedenen Belastungsmodi bei 1 Hz an EVASAFE™ G77: Speichermodul G' (a) und Verlustmodul G'' (b)

alantworten bei den vorgegebenen Anregungen hindeutet. Die Doppelscherung am Laminat zeigt ein insgesamt niedrigeres Niveau im Speicher- und Verlustmodul, was dadurch erklärt werden kann, dass die tatsächlich wirksame Schubübertragungsfläche durch den Bohrprozess gestört ist und nicht dem zur Auswertung angesetzten gesamten Bohrkerndurchmesser entspricht. Die horizontale Verschiebung des Glasübergangsbereiches ist durch die höhere Prüffrequenz begründet (s. Abschn. 2.3.6).

Der Einfluss des Weichmachers in den PVB-Folien (SC>BG>ES>K7026) auf die Temperaturabhängigkeit wird im Vergleich der verschiedenen Folientypen in Abbildung 4.6

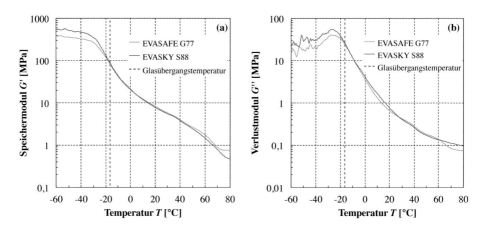

Abbildung 4.8 Ergebnisse der Temperatursweeps mit verschiedenen EVA-Zwischenschichten bei 1 Hz in der Doppelscherung (Material): Speichermodul G' (a) und Verlustmodul G'' (b)

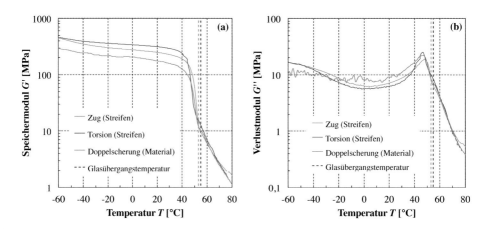

Abbildung 4.9 Ergebnisse der Temperatursweeps mit verschiedenen Belastungsmodi bei 1 Hz an der Ionoplastfolie SG5000: Speichermodul G' (a) und Verlustmodul G'' (b)

deutlich. Die Plateaus im energie- und entropieelastischen Bereich bleiben nahezu gleich, lediglich der Steifigkeitsabfall im Glasübergangsbereich wird mit zunehmendem Weichmachergehalt etwas breiter und verschiebt sich zu niedrigeren Temperaturen.

Die Ergebnisse der EVA-Folien zeigen Abbildung 4.7 und 4.8. Auch hier ist erkennbar, dass die Ergebnisse der Zug-DMTA im Bereich hoher Temperaturen unbrauchbar werden und die Ergebnisse der Torsions-DMTA im Verlustmodul ein Rauschen zeigen. Im Vergleich der beiden Folientypen zeigt die EVASAFETM-Folie im Bereich sehr hoher

Temperaturen eine leicht erhöhte Steifigkeit gegenüber der EVASKYTM-Folie, was auf den höheren Vernetzungsgrad zurückzuführen ist.

Der Glasübergangsbereich der Ionoplastfolie liegt bei höheren Temperaturen, sodass hier alle Belastungsmodi im untersuchten Temperaturbereich gute Ergebnisse liefern (Abb. 4.9). Der Zugmodus zeigt erst bei Temperaturen größer 70 °C, dass die Folie zu weich wird und die Messergebnisse unbrauchbar werden. Des Weiteren ist im Speicher- und im Verlustmodul zu erkennen, dass die Ionoplastfolie einen Knick im Glasübergangsbereich aufweist. Dies deutet darauf hin, dass ein sekundäres Dispersionsgebiet in diesem Bereich existiert, welches beispielsweise auf ein Aufschmelzen teilkristalliner Phasen zurückgeführt werden kann.

Frequenzsweeps

Der Frequenzsweep dient der Beurteilung der Zeitabhängigkeit bei gleichbleibender Temperatur. Aus Frequenzsweeps bei unterschiedlichen Temperaturen können Masterkurven erstellt werden.

Tabelle 4.3 fasst die durchgeführten Frequenzsweeps zusammen. Jede Versuchsserie besteht aus mehreren isothermen Versuchen, beginnend bei niedrigen Temperaturen von −80 °C bis −40 °C bis zu hohen Temperaturen von 50 °C bis 100 °C jeweils in 10 °C-Schritten. Im Torsionsmodus wurde darüber hinaus eine zweite Versuchsserie in 5 °C-Schritten durchgeführt. Die Frequenz wurde bei jedem isothermen Einzelversuch logarithmisch von 0,01 Hz bis mindestens 10 Hz gesteigert. Dabei wurden mindestens fünf Messwerte pro Frequenzdekade erfasst.

In Abbildung 4.10 wird die Auswertung der Masterkurve exemplarisch an dem Torsionsversuch mit 5 °C-Schritten mit dem Material PVB BG gezeigt. In einem ersten Schritt wurden aus den experimentell ermittelten Rohdaten (a) die unbrauchbaren Messdaten bei hohen Temperaturen und Frequenzen gefiltert, da hier Resonanz- und Trägheitseffekte auftraten. Die gefilterten Daten (b) wurden dann nach Gleichung (2.52) horizontal auf der Frequenzachse verschoben, um die Masterkurve (c) zu erhalten. Für diesen Verschiebungsvorgang wurde ein Algorithmus erstellt, welcher eine Überlappung der Kurven optimiert. Wenn sich die Kurven nicht überlappen, wurde eine manuelle Korrektur der Verschiebungsfaktoren (d) vorgenommen, um einen glatten Verlauf der Masterkurve zu erzielen.

Tabelle 4.3 Versuchsmatrix Frequenzsweep, Versuchsserienanzahl je Belastungsmodus

Material	Typ	Torsion (Streifen)	Doppelscherung (Material)	Doppelscherung (Laminat)
PVB	BG	2	1	-
EVA	G77	2	1	1
Ionoplast	SG5000	2	1	1

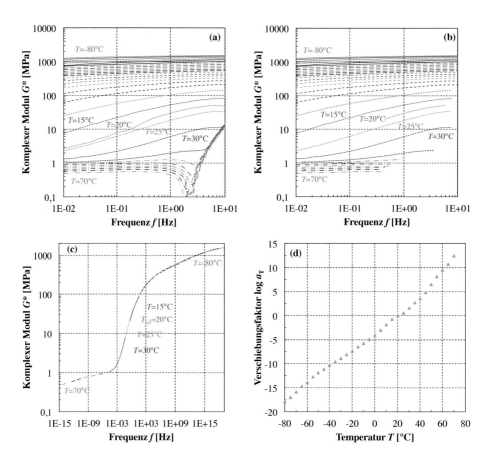

Abbildung 4.10 Ergebnisse der Frequenzsweeps an PVB BG im Torsionsmodus bei verschiedenen konstanten Temperaturen von −80 °C bis +70 °C in 5 °C-Schritten: Rohdaten (a), gefilterte Daten (b), verschobene Daten (c) und zugehörige Verschiebungsfaktoren $\log a_T$ (d)

Die Erstellung der Masterkurve erfolgte am komplexen Modul G^*, als Referenztemperatur wurde $T_{\text{ref}} = 20\,°\text{C}$ gewählt.

Im Folgenden werden die Masterkurven der komplexen Moduln G^* und die zugehörigen Verschiebungsfaktoren $\log a_T$ von allen Belastungsmodi und Materialien dargestellt und erläutert.

Die verschiedenen Versuchsserien mit der PVB-Folie in Abbildung 4.11 zeigen vergleichbare und insgesamt plausible Ergebnisse. Der komplexe Schubmodul G^* aus dem Torsionsversuch mit 5 °C-Schritten liegt leicht über den Ergebnissen der beiden anderen Versuchen, mit stärkeren Abweichungen im entropieelastischen Bereich. Dies kann neben allgemeinen Messungenauigkeiten auf die verringerte Genauigkeit bei weichen Proben zu-

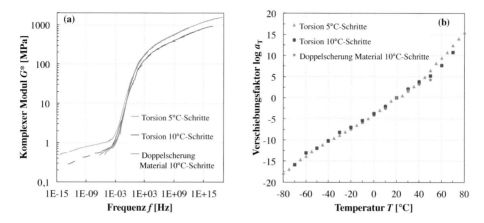

Abbildung 4.11 Vergleich der Masterkurven von PVB BG: komplexer Schubmodul G^* (a) und zuge-
hörige Verschiebungsfaktoren $\log a_{\mathrm{T}}$ (b)

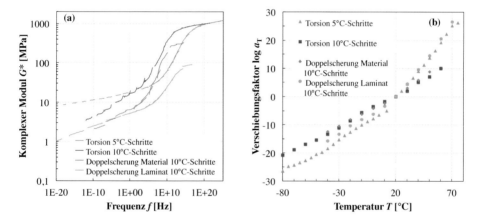

Abbildung 4.12 Vergleich der Masterkurven von EVASAFE™ G77: komplexer Schubmodul G^* (a)
und zugehörige Verschiebungsfaktoren (b) $\log a_{\mathrm{T}}$

rückgeführt werden. Im entropieelastischen Bereich sind 10 °C-Schritte nicht ausreichend,
um eine Überlappung nach der Zeit-Temperatur-Verschiebung zu erreichen.

Die Ergebnisse der EVA-Folie zeigen in Abbildung 4.12 eine deutlich stärkere Streu-
ung. Sowohl die Lage des Glasübergangsbereichs als auch die der Plateaus im energie-
und entropieelastischen Bereich variieren. Ebenso zeigen die Verschiebungsfaktoren für
die Masterkurve $\log a_{\mathrm{T}}$ große Abweichungen. Vergleichbar dazu sind die Ergebnisse mit
der Ionoplastfolie in Abbildung 4.13. Für die EVA- und die Ionoplastfolie sollten Wie-
derholungsmessungen durchgeführt werden, um die statistische Streuung der einzelnen

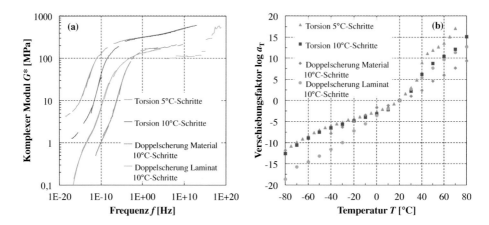

Abbildung 4.13 Vergleich der Masterkurven von Ionoplast SG5000: komplexer Schubmodul G^* (a) und zugehörige Verschiebungsfaktoren $\log a_1$ (b)

Messmethoden von methodischen Abweichungen zu differenzieren. Eine belastbare Aussage, welche der Messungen zutreffend ist, kann anhand dieser Ergebnisse nicht getroffen werden.

Die Kurvenverläufe der Ionoplastfolie lassen trotz der starken Streuung vermuten, dass ein sekundäres Dispersionsgebiet im Bereich des Glasübergangs existiert. Neben einem zweiten Krümmungswechsel im komplexen Modul ist ein Knick in allen Verläufen der Verschiebungsfaktoren bei etwa $T \approx 20\,°C$ erkennbar. Dies passt zu den Beobachtungen aus den Temperatursweeps.

Bewertung der Belastungsmodi

Die Untersuchungen lassen Rückschlüsse auf die Eignung der DMTA-Prüfmethoden hinsichtlich der Charakterisierung der zeit- und temperaturabhängigen Steifigkeit von Verbundglas-Zwischenschichten zu. In Tabelle 4.4 sind die beobachteten Vor- und Nachteile zusammengefasst. Es werden folgende Schlussfolgerungen gezogen:

Der Zugmodus ist aufgrund der in Tabelle 4.4 genannten Nachteile nicht für die Charakterisierung von Verbundglas-Zwischenschichten geeignet.

Die Doppelscherung am Dreifachlaminat lieferte ebenfalls keine verwertbaren Ergebnisse, da durch das angewendete Bohrverfahren die Grenzfläche zwischen Glas und Zwischenschicht im Randbereich gestört wurde. Der Belastungsmodus ist aber prinzipiell geeignet, falls die Grenzfläche beim Bohren nicht signifikant gestört wird. Dies kann möglicherweise durch ein verbessertes Bohrverfahren erreicht werden.

Die Ermittlung belastbarer Werte über den gesamten Zeit- und Temperaturbereich ist mit keiner Methode uneingeschränkt möglich. Der bei allen Materialien beobachtete Steifigkeitsunterschied von vier Zehnerpotenzen führt bei gleicher Versuchsanordnung und

Tabelle 4.4 Vor- und Nachteile der in der DMTA untersuchten Belastungsmodi hinsichtlich der Ermittlung zeit- und temperaturabhängiger Eigenschaften von Verbundglas-Zwischenschichten

Belastungsmodus	Vorteile	Nachteile
a) Zug (Streifen)	• Einfache Installation in der Prüfmaschine möglich.	• Oszillation erfolgt um ausgelenkte (vorgespannte) Lage. Dadurch entstehen Probleme insbesondere im entropieelastischen Bereich, da das Material wegkriecht. • Die Probe wird in Zugrichtung belastet. Die dominante Belastung im Bauteil ist aber Schub. • Zur Umrechnung in den Schubmodul wird die Querkontraktionszahl v benötigt, welche aber nicht konstant ist sondern auch von Temperatur und Zeit abhängt. • Die Klemmung im Einspannbereich beeinflusst den uniaxialen Zugspannungszustand.
b) Torsion (Streifen)	• Einfache Installation in der Prüfmaschine möglich. • Torsion erzeugt Schubzustand.	• Für eine stabile Messung wird eine geringe Normalkraft benötigt. Diese kann zu einem quasistatischen Kriechen und damit zu ungenauen Messergebnissen bei hohen Temperaturen führen. • Die Klemmung im Einspannbereich beeinflusst den reinen Schubzustand.
c1) Doppelscherung (Material)	• Erzeugt Schubzustand. • Probekörpertemperatur kann präzise bestimmt werden.	• Präparation, Vermessung und Installation der Probekörper ist aufwändig. • Zur Erzeugung der Haftreibung wird eine Drucknormalkraft benötigt. Dies beeinflusst den reinen Schubzustand.
c2) Doppelscherung (Laminat)	• Erzeugt einen reinen Schubzustand.	• Präparation, Vermessung und Installation der Probekörper ist sehr aufwändig. • Bohrung mit Diamantkrone beeinflusst die Grenzfläche zwischen Glas und Zwischenschicht im Randbereich. Dadurch kann die tatsächliche Schubübertragungsfläche nicht bestimmt werden. • Glastabletten müssen sehr vorsichtig im Einspannwerkzeug geklemmt werden.

Probekörpergeometrie entweder im energie- oder im entropieelastischen Bereich zu Ungenauigkeiten in den Messungen. Es wird empfohlen, unter- und oberhalb des Glasübergangsbereichs unterschiedliche Belastungsmodi zu verwenden. Im energieelastischen Bereich ist die Torsion eines Streifens gut geeignet, im entropieelastischen Bereich wird die Doppelscherung empfohlen.

Neben den in dieser Arbeit untersuchten Belastungsmodi wird die Torsionsschwingung in einem Rheometer mit Platte-Platte-Anordnung als gut geeignet erachtet, insbesondere im entropieelastischen Bereich. Eine vergleichende Untersuchung dieser Anordnung wird empfohlen.

Eine Schrittweite von $\Delta T = 10\,^{\circ}\mathrm{C}$ ist im Glasübergang und im anschließenden entropieelastischen Bereich nicht ausreichend. Hier sind kleinere Schrittweiten zu wählen, welche von dem auswertbaren Frequenzbereich abhängen. Im energieelastischen Bereich sind auch größere Schrittweiten ausreichend.

Bei der Versuchskonzeption sind die Ober- und Untergrenzen der Temperaturen im Frequenzsweep dem späteren Anwendungsbereich anzupassen. Ist nur das Langzeitverhalten von Interesse, werden Tieftemperaturmessungen ($T < 0\,^{\circ}\mathrm{C}$) nicht benötigt.

4.2.3 Quasistatische und dynamische uniaxiale Zugversuche

Im Rahmen eines Forschungsprojektes zu multifunktionalen Schutzverglasungen mit der Firma *Schott* wurden uniaxiale Zugversuche durchgeführt, um die Steifigkeit verschiedener Zwischenschichten bei kurzzeitiger dynamischer Einwirkung zu studieren. Das Versuchsprogramm wurde anschließend erweitert, um weitere Aspekte wie die Isotropie von PVB und die Steifigkeit weiterer Zwischenmaterialien unter quasistatischer Beanspruchung zu untersuchen. Der Begriff Steifigkeit umfasst in diesem Zusammenhang die uniaxiale Spannungs-Dehnungs-Beziehung bis hin zu großen Dehnungen.

Bei einigen Materialien wurde ein breites Spektrum an Wegraten (Prüfgeschwindigkeiten) untersucht. Dies ermöglichte eine Auswertung zu Spannungs-Dehnungs-Beziehungen bei konstanten wahren Dehnraten. Ansonsten sind als Endergebnis Spannungs-Dehnungs-Beziehungen bei konstanten Wegraten angegeben. Zusätzlich wurden die Querkontraktionszahl in Abhängigkeit der Längsdehnung sowie Reißfestigkeit und Reißdehnung ermittelt. In Tabelle 4.5 sind die Anzahl der durchgeführten Versuche je Wegrate und Folientyp zusammengefasst. Der Begriff quasistatisch bei den Zugversuchen umfasst Wegraten bis einschließlich 200 mm min^{-1}. Zugversuche mit größeren Wegraten werden als dynamisch bezeichnet.

Da die Verbundglas-Zwischenschichten als Folien mit einer gewissen Oberflächenstruktur vorliegen, wurde in einem ersten Schritt untersucht, ob diese einen Einfluss auf die Spannungs-Dehnungs-Beziehung hat. Dazu wurde ein Vergleich von geglätteten zu den original rauen Oberflächen mit den Materialien PVB BG und der Ionoplastfolie SG5000 durchgeführt. Die glatten Probekörper wurden angefertigt, indem die Zwischenmaterialien mit Trennfolien aus Polyethylenterephthalat (PET) zwischen zwei Glasplatten einem

Abbildung 4.14 Lichtmikroskopaufnahmen der Oberflächenstruktur von PVB (a,b) und Ionoplast (c,d)

Laminationsprozess unterzogen wurden. Abbildung 4.14 zeigt zwei- und dreidimensionale Aufnahmen der originalen Oberflächenstruktur mit einem Lichtmikroskop (*Keyence VHX-500*).

Tabelle 4.5 Versuchsmatrix der uniaxialen Zugversuche an Verbundglas-Zwischenschichten; Versuchsanzahl je Wegrate

Material	Typ	Nenndicke [mm]		quasistatisch [mm min^{-1}]			dynamisch [m s^{-1}] [d]		
				5	50	200	0,1	1,0	3,5
PVB	BG	0,76	quer[a]	3	5	-	-	-	-
	BG	0,76	längs[b]	-	3	3	-	-	-
	BG	1,52	quer[a]	3	5	3	4	4	5
	BG	1,52	längs[b]	-	3	-	-	-	-
	BG	1,52	glatt[c]	2	-	-	-	-	-
	BG	2,28	quer[a]	3	5	-	-	-	-
	BG	2,28	längs[b]	-	3	2	-	-	-
	SC	0,76	-	-	5	-	-	-	-
	ES	0,76	-	-	5	-	-	-	-
	K7026	0,76	-	-	5	-	-	-	-
EVA	G71	1,60	-	-	5	-	4	6	6
	S11	0,92	-	-	5	-	-	-	-
Ionoplast	SG5000	1,52	-	3	4	-	4	4	4
	SG5000	1,52	glatt[c]	3	-	-	-	-	-
TPU	PE399	0,6	-	-	5	-	4	7	5
	PE429	0,6	-	-	5	-	-	-	-
	PE499	1,3	-	-	5	-	-	-	-
	PE501	0,6	-	-	5	-	-	-	-

[a] In Extrusionsquerrichtung entnommen
[b] In Extrusionslängsrichtung entnommen
[c] Ansonsten mit original Rauigkeit
[d] $1{,}0\,\mathrm{m\,s^{-1}} \triangleq 60\,000\,\mathrm{mm\,min^{-1}}$

Detaillierte Beschreibungen zu Teilen der Untersuchungen finden sich in EIRICH, 2013 und ORTNER, 2014. Des Weiteren wurden einige Aspekte bereits in KUNTSCHE et al., 2012, SCHNEIDER et al., 2012, KUNTSCHE et al., 2013b und KUNTSCHE et al., 2014b veröffentlicht. Die Grundlagen zum uniaxialen Zugversuch sind in Abschnitt 2.3.7 dargelegt.

Versuchsaufbau

Die Versuche wurden bei Wegraten bis zu $200\,\text{mm}\,\text{min}^{-1}$ am *Institut für Statik und Konstruktion* durchgeführt, die höheren Wegraten wurden am *Fraunhofer Institut für Betriebsfestigkeit und Systemzuverlässigkeit LBF* realisiert. Es wurde stets die gleiche Probekörpergeometrie verwendet, welche sich nach BECKER, 2009 sowohl für quasistatische als auch für dynamische Zugversuche eignet. Abbildung 4.15a zeigt den verwendeten Probekörper und fasst die geometrischen Abmessungen zusammen. Alle Probekörper wurden mit einer CNC-Maschine aus den gelieferten Folien herausgefräst. Bei den weichen Materialien wurden Deckplatten aus harten Thermoplasten verwendet, um ein Ausfransen und Verrutschen der Probe zu verhindern. Probekörper aus PVB und Ionoplast wurden nach der Fertigung bis zur Versuchsdurchführung in den Klimaboxen konditioniert gelagert (s. Abschn. 4.2.1).

Die Dehnung wurde bei allen Versuchen mittels Videoextensometrie ermittelt, um den Schlupf bei der Einspannung zu berücksichtigen und nur den probenparallelen Bereich auszuwerten.

Die **quasistatischen Zugversuche** wurden an der Universalprüfmaschine *Zwick Z050 THW* mit der darin enthaltenen Kraftmessdose *Zwick Roell Xforce K* 50 kN durchgeführt (Abb. 4.15b). Die Genauigkeit des Kraftsignals bei den in den Versuchen aufgetretenen vergleichsweise geringen Kräften wurde im Voraus anhand einer in Reihe geschalteten 500 N-Kraftmessdose bestätigt. Als Einspannwerkzeug wurden pneumatische Keilspannbacken *TH175* der Firma *Grip Engineering* verwendet.

Abbildung 4.15 Verwendeter Probekörper nach BECKER, 2009, Angaben in mm (a); quasistatischer Versuchsaufbau (b) und gewähltes Punktmuster für die Videoextensometrie (c)

Abbildung 4.16 Dynamischer Zugversuch: Versuchsaufbau (a); Grauwertmuster für die Videoextensometrie (b)

Für die Videoextensometrie kam eine *uEye UI-2280SE* mit einer Auflösung von 5 Megapixel und einer maximalen Bildrate von 3,19 fps zum Einsatz, welche in die Prüfsoftware *testXpert II* eingekoppelt wurde. Als Markierungen wurden rote Punkte gewählt, welche kurz vor dem Versuch mit einem Folienstift aufgebracht wurden. Es wurden verschiedene Punktmuster untersucht, wobei sich das Muster nach Abbildung 4.15c als gut geeignet herausgestellt hat, um mögliche Einschnürungen zu erfassen und gleichzeitig den Aufwand zur Auswertung gering zu halten.

Die **dynamischen Zugversuche** wurden am *Fraunhofer LBF* mit der Hochgeschwindigkeitsprüfmaschine *Zwick Amsler HTM 5020* durchgeführt. Als Einspannwerkzeug wurden manuelle Keilspannbacken verwendet. Um eine konstante Wegrate ohne Beschleunigungsphase zu realisieren, wurde eine freie Anlaufstrecke mit einem gedämpften Anschlag vorgeschaltet. Abbildung 4.16a zeigt den Versuchsaufbau mit Keilspannbacken, freier Anlaufstrecke und Hochgeschwindigkeitskamera.

Für die Videoextensometrie wurde eine s/w-Hochgeschwindigkeitskamera mit 10 000 fps und einer Auflösung von 260×1060 Pixel verwendet. Anstelle roter Markierungen wurde hier ein Grauwertmuster verwendet. Abbildung 4.16b zeigt zwei präparierte Probekörper mit dem Grauwertmuster.

Versuchsdurchführung

Breite und Dicke der gefrästen Probekörper wurden mit einer digitalen Bügelmessschraube (*Helios Digimet 40 EX*, Genauigkeit 4 μm) im probenparallelen Bereich vermessen, anschließend wurde das Farbmuster aufgebracht. Diese Vorbereitung dauerte nur wenige

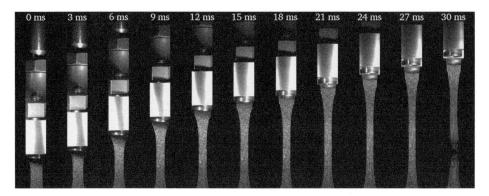

Abbildung 4.17 Dynamischer Zugversuch an PVB mit einer Wegrate von $3{,}5\,\mathrm{m\,s^{-1}}$

Minuten, sodass die zu konditionierenden Materialien PVB und Ionoplast keine relevante Veränderung der Folienfeuchte erfuhren.

Nach dem Einspannen erfolgte bei den quasistatischen Versuchen ein manuelles Nachfahren der Traverse, da durch die Keilspannbacken eine Druckkraft bzw. ein Ausbauchen der Probekörper erzeugt wird. Bei den dynamischen Versuchen war dies aufgrund der freien Vorlaufstrecke nicht nötig.

Die Prüfung erfolgte lagegeregelt mit den in Tabelle 4.5 angegebenen Wegraten. Der Versuch endete mit dem Reißen der Folie oder einem Herausrutschen aus den Keilspannbacken. Abbildung 4.17 zeigt beispielhaft verschiedene Zeitpunkte der Hochgeschwindigkeitsaufnahme eines dynamischen Zugversuchs an einer PVB-Folie mit einer Wegrate von $3{,}5\,\mathrm{m\,s^{-1}}$.

Die Prüftemperatur betrug bei allen Temperaturen zwischen $22\,^\circ\mathrm{C}$ und $23\,^\circ\mathrm{C}$. Die Raumfeuchte konnte am *Fraunhofer LBF* nicht geregelt werden und lag daher insgesamt zwischen $30\,\%$ rF und $50\,\%$ rF. Die hydrophilen Materialien PVB und Ionoplast wurden jedoch bis kurz vor der Prüfung in den Klimaboxen konditioniert gelagert, sodass diese Abweichung zum Normklima vernachlässigt werden kann.

Versuchsauswertung und Ergebnisse

Als primäre Ergebnisse der Versuchsreihen lagen der Kraft-Zeit-Verlauf und die Daten aus der Videoextensometrie vor, welche im Nachgang synchronisiert wurden. Anhand der gemessenen Anfangsgeometrie konnten technische Spannung und Dehnung berechnet werden. Die Auswertung der wahren Größen erfolgte bei den quasistatischen Versuchen mittels Gleichungen (2.58) und (2.57), bei den dynamischen Versuchen wurde die wahre Dehnung inkrementell nach Gleichung (2.56) bestimmt. Da die Änderung der Dicke nicht gemessen wurde, wurde angenommen, dass das Material isotrop ist und die Querdehnung in Dicken- und Breitenrichtung gleich ist. Falls eine Einschnürung auftrat, wur-

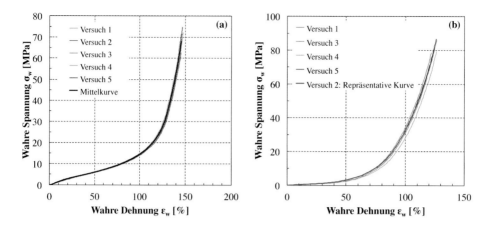

Abbildung 4.18 Mittelung der Einzelkurven einer Serie am Beispiel von EVASAFE™ G71 bei 50 mm min⁻¹(a), repräsentative Kurve für eine Serie am Beispiel von PVB BG bei 50 mm min⁻¹ (b)

de die Querdehnung in diesem Bereich lokal ausgewertet, um die korrekte wahre Spannung zu ermitteln. Im Folgenden werden, solange nichts anderes angegeben wird, wahre Spannungs-Dehnungs-Beziehungen dargestellt.

Die Videoextensometrie erfolgte bei den quasistatischen Versuchen über einen am *Institut für Statik und Konstruktion* entwickelten Algorithmus, welcher die farbigen Markierungen verfolgt (s. Abb. 4.15c). Eine Beschreibung des Algorithmus findet sich in FRANZ, 2015. Die Daten der dynamischen Versuche wurden vom *Fraunhofer LBF* aufbereitet und bereitgestellt. Da bei der Grauwertkorrelation eine Auswertung der Dehnung nicht immer bis zum Versuchsende möglich war, stimmt das Ende der dynamischen Spannungs-Dehnungs-Kurven nicht unbedingt mit dem Versuchsende oder dem Riss der Folien überein.

Die ermittelten Spannungs-Dehnungs-Beziehungen unterlagen einer sehr geringen Streuung, sodass oftmals nur drei Wiederholungen ausreichten, um ein belastbares Ergebnis zu erhalten. Die Kurven wurden bei gleichen Dehnungswerten gemittelt oder es wurden repräsentative Kurven identifiziert und für die gesamte Serie verwendet. In Abbildung 4.18 werden beispielhaft die einzelnen Messkurven einer Serie und die daraus gemittelte Kurve (a) bzw. verschiedene Messkurven einer anderen Serie und eine dafür repräsentative Kurve (b) dargestellt. Die Kurven der Einzelversuche sind im Anhang A.4 dargestellt, im Folgenden wird jeweils eine Kurve je Serie wiedergegeben.

Bei den Materialien PVB BG, EVASAFE™ G71, Ionoplast SG5000 und TPU PE399 wurden neben den quasistatischen auch dynamische Zugversuche durchgeführt, sodass ein breiter Bereich an Wegraten abgedeckt wurde. Um aus den Ergebnissen bei konstanter Wegrate Spannungs-Dehnungs-Beziehungen bei konstanter wahrer Dehnrate zu erzeugen, wurde die Spannung dreidimensional über Dehnung und Dehnrate aufgetragen und eine

Ausgleichsfläche (3D-Fit) nach der Methode der kleinsten Fehlerquadratsumme angepasst (s. Abb. 4.19b). Diese Fläche kann dann bei konstanten Dehnraten wiederum ausgewertet werden. Sie folgt einem auf G'SELL et al., 1979 beruhenden Ansatz, wie er in BECKER, 2009 beschrieben ist:

$$\sigma(\varepsilon, \dot{\varepsilon}) = \sigma^*(\varepsilon) \left(\frac{\dot{\varepsilon}}{\dot{\varepsilon}^*} \right)^{m(\varepsilon)} \tag{4.2}$$

mit

$\sigma^*(\varepsilon)$ Grundkurve (quasistatische Spannungs-Dehnungs-Beziehung),

$\dot{\varepsilon}^*$ Dehnrate der Grundkurve (gewählt zu $\dot{\varepsilon}^* = 10^{-3}\,\mathrm{s}^{-1}$),

$m(\varepsilon)$ Parameter zur Berücksichtigung der Dehnratenabhängigkeit (von ε abhängig).

Bei der Ermittlung der Querkontraktionszahl ν nach Gleichung (2.59) wird deutlich, dass im Anfangsbereich die Ergebnisse von großen Ungenauigkeiten behaftet sind. Erst bei größeren Dehnungen und nur solange keine Einschnürung auftritt, ist die ermittelte Querkontraktionszahl plausibel. Um im Bereich kleiner Dehnungen belastbare Ergebnisse zu erhalten, ist eine hohe optische Auflösung in diesem Bereich ($\geq 10\,\mathrm{px\,mm^{-1}}$) nötig.

Polyvinylbutyral (PVB)

Die Ergebnisse der Untersuchungen an der BG-Folie zeigt Abbildung 4.19. Es ist eine ausgeprägte Abhängigkeit des Spannungs-Dehnungs-Verhaltens von der Wegrate zu erkennen (a). Zum Vergleich sind hier auch die dynamischen Wegraten in mm min^{-1} angegeben. Mittels des beschriebenen 3D-Fits (b) wurden Spannungs-Dehnungs-Beziehungen bei konstanter Dehnrate ermittelt (c). Anhand des Vergleichs mit unterschiedlich dicken Folien und Entnahmeorientierungen wird deutlich, dass für PVB die Annahme der Isotropie gerechtfertigt ist (d). Der Vergleich zwischen geglätteter Oberfläche und original rauer Oberfläche zeigt vernachlässigbare Unterschiede (e).

Abbildung 4.19f vergleicht die Steifigkeit verschiedener PVB-Folien bei einer konstanten Wegrate von 50 mm min^{-1}. Mit niedrigerem Weichmachergehalt (SC>BG>ES>K7026) verhält sich die Folie steifer. Die Folien SC und BG verhalten sich bei Raumtemperatur und quasistatischer Wegrate gummielastisch, die Folien ES und K7026 duktil (s. Abb. 2.14).

Die Querkontraktionszahl ν ist in Abhängigkeit der wahren Dehnung in Abbildung 4.20 dargestellt. Unterschiedliche Wegraten zeigen bei der BG-Folie keinen signifikanten Einfluss auf die Querkontraktionszahl (a). Erst bei der höchsten Wegrate von $3{,}5\,\mathrm{m\,s^{-1}}$ ist eine Reduktion der Querkontraktionszahl im Bereich kleiner Dehnungen zu erkennen. Durch eine hohe Dehnrate bzw. eine kurze Belastungsdauer wird eine Wirkung äquivalent zu einer Verringerung der Temperatur erreicht (s. Abschn. 2.3.2). Es wird daher vermutet, dass bei sehr hohen Dehnraten der Glasübergangsbereich unterschritten wird und die Querkontraktionszahl im kleinen Verzerrungsbereich zu $\nu \to 0{,}3$ tendiert.

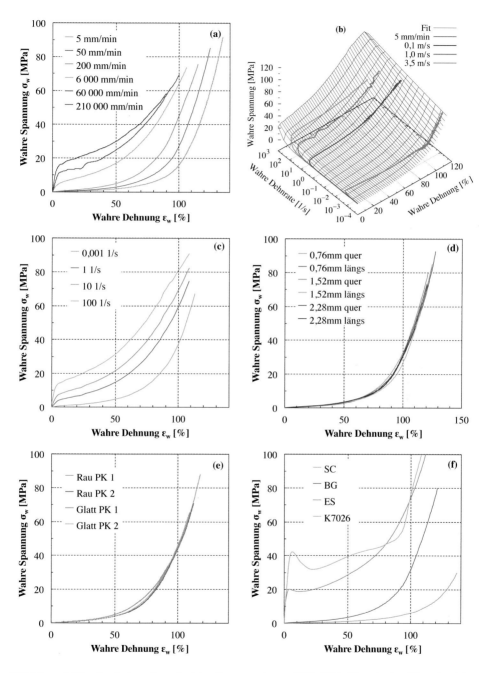

Abbildung 4.19 Ergebnisse der uniaxialen Zugversuche an PVB: BG bei konstanten Wegraten (a), 3D-Fit (b), BG bei konstanten Dehnraten (c), Isotropie von BG (d), Einfluss der Oberflächenrauigkeit bei BG (e) und Vergleich verschiedener PVB-Folien bei einer Wegrate von $50\,\mathrm{mm\,min^{-1}}$ (f)

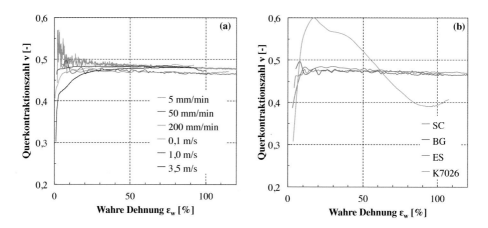

Abbildung 4.20 Querkontraktionszahl v von PVB: BG bei konstanten Wegraten (a) und Vergleich verschiedener PVB-Folien bei 50 mm min^{-1} (b)

Die Querkontraktionen der unterschiedlichen PVB-Varianten zeigen bei einer konstanten Wegrate von 50 mm min^{-1} (b) bis auf die sehr steife K7026-Folie vergleichbare Ergebnisse. Die Folien SC, BG und ES zeigen in der optischen Auswertung keine Einschnürung und ein nahezu inkompressibles Verhalten ($v \approx 0,5$). Bei der ES-Folie ist eine Reduktion der Querkontraktionszahl im Anfangsbereich zu erkennen. Die K7026-Folie schnürt

Abbildung 4.21 Rückstellvorgang bei PVB: BG direkt nach einem quasistatischen Zugversuch ohne Versagen (a), 30 min nach dem Versuch (b), 15 h nach dem Versuch (c); BG 24 h nach den dynamischen Versuchen (d) und K7026 ein Jahr nach einem quasistatischen Versuch (e)

sehr ausgeprägt ein, wodurch die Ermittlung der Querkontraktionszahl nach Erreichen der Fließgrenze bei einer wahren Dehnung von $\varepsilon_w \approx 5\,\%$ fehlschlägt.

Alle PVB-Folien zeigten nach den Versuchen ein zeitabhängiges Rückstellverhalten, welches unabhängig von der Wegrate nahezu vollständig elastisch war (Abb. 4.21). Sogar die sehr steife K7026-Folie, welche beim Versuch ein deutliches Einschnüren zeigte, nahm nach Versuchsende annähernd wieder die ursprüngliche Gestalt ein, der Rückstellvorgang dauerte nur deutlich länger.

Ethylenvinylacetat (EVA)

Die Ergebnisse der Untersuchungen an der EVASAFE™ G71-Folie sind in Abbildung 4.22 dargestellt. Im Vergleich zum PVB ist nur eine schwach ausgeprägte Abhängigkeit von der Wegrate zu erkennen (a). Mittels des beschriebenen 3D-Fits (b) wurden Spannungs-Dehnungs-Beziehungen bei konstanter Dehnrate ermittelt (c). Abbildung 4.22d vergleicht die beiden EVA-Folientypen G71 und S11 bei einer konstanten Wegrate von $50\,\text{mm}\,\text{min}^{-1}$. Beide Folien verhalten sich gummielastisch (s. Abb. 2.14). Der geringere Vernetzungsgrad von S11 gegenüber G71 wird erst bei großen Dehnungen ($\varepsilon_w \geq 100\,\%$) mit einer geringeren Steifigkeit deutlich.

Die Querkontraktionszahl v ist in Abhängigkeit der wahren Dehnung in Abbildung 4.23 dargestellt. Die G71-Folie zeigt dabei keine Abhängigkeit von der Wegrate (a). Bei hohen Dehnungen wird, obwohl keine Einschnürung in den Versuchen zu beobachten war, eine Querkontraktionszahl $v > 0,5$ ermittelt. Im Bereich kleiner Dehnungen befindet sich die Querkontraktionszahl im Bereich $v \approx 0,45$. Die EVASKY™-Folie zeigt bei allen Dehnungen ein nahezu inkompressibles Verhalten mit $v \approx 0,5$ (b).

Alle EVA-Proben zeigten bei großen Dehnungen ein ausgeprägt plastisches Verhalten: Ein Großteil der aufgebrachten Verformungen blieb auch nach sehr langer Wartezeit erhalten (Abb. 4.24).

Ionoplast

Die Ergebnisse der Untersuchungen an der Ionoplastfolie sind in Abbildung 4.25 dargestellt. Die Spannungs-Dehnungs-Beziehungen lassen bei allen Wegraten aufgrund der charakteristischen Fließgrenze auf ein elastisch-plastisches (duktiles) Materialverhalten schließen. Bei allen Versuchen war zudem ein Einschnüren der Probe zu erkennen, was sich insbesondere bei den dynamischen Versuchen aber schnell auf den gesamten probenparallelen Bereich ausbreitete. Die Abhängigkeit von der Wegrate ist stark ausgeprägt, insbesondere im Bereich des plastischen Fließens (a). Bei den Wegraten von $5\,\text{mm}\,\text{min}^{-1}$ und $50\,\text{mm}\,\text{min}^{-1}$ sind Schnittpunkte im Bereich großer Dehnungen erkennbar. Diese sind auf einen Schlupf an der Einspannung und eine damit verbundene reduzierte Dehnrate zurückzuführen. Zudem kann eine dehnungsinduzierte Temperaturerhöhung in der Probe zu einer Reduktion der Steifigkeit führen.

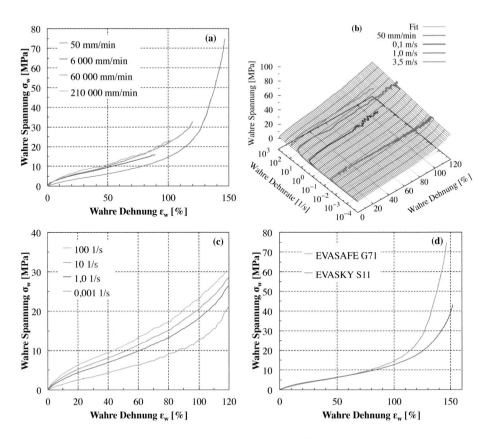

Abbildung 4.22 Ergebnisse der uniaxialen Zugversuche an EVA: G71 bei konstanten Wegraten (a), 3D-Fit (b), G71 bei konstanten Dehnraten (c) und Vergleich versch. EVA-Folien bei 50 mm min^{-1} (d)

Abbildung 4.23 Querkontraktionszahl v von EVA: G71 bei konstanten Wegraten (a) und Vergleich verschiedener EVA-Folien bei 50 mm min^{-1} (b)

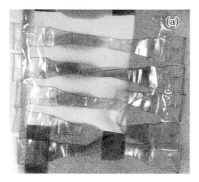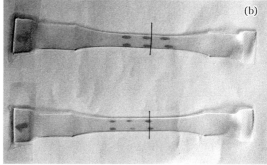

Abbildung 4.24 Rückstellvorgang bei EVA: G71 15 h nach den dynamischen Versuchen (a), S11 ein Jahr nach den quasistatischen Versuchen (b)

Aufgrund des elastisch-plastischen Verhaltens wurde in Hinblick auf eine Material-modellierung die Auswertung im 3D-Fit nicht mit der wahren Gesamtdehnung ε_w sondern mit der wahren plastischen Dehnung

$$\varepsilon_{w,pl} = \varepsilon_w - \varepsilon_{w,el} = \varepsilon_w - \frac{\sigma_{isochor}}{E} \tag{4.3}$$

durchgeführt (b). Dabei wurde für die Ermittlung der wahren elastischen Dehnung $\varepsilon_{w,el}$ die isochore Spannung $\sigma_{isochor}$ verwendet. Dieser Betrachtung liegt die Annahme zugrunde, dass beim plastischen Fließen das Volumen konstant bleibt (s. ALTENBACH, 2012 und Abb. 4.26a).

Der Elastizitätsmodul wurde zu $E = 800\,\text{MPa}$ ermittelt, wodurch sich ein idealelastisch-viskoplastisches Material ergibt. Dies ist jedoch eine Näherung, da, wie in Abbildung 4.25a erkennbar, auch das elastische Verhalten bis zur Fließgrenze dehnratenabhängig ist. Die bei konstanter Dehnrate ermittelten Spannungs-Dehnungs-Beziehungen weisen im elastischen Teil keine Dehnratenabhängigkeit mehr auf (c).

Der Vergleich zwischen geglätteter Oberfläche und original rauer Oberfläche zeigt analog zum PVB vernachlässigbare Unterschiede (d).

Die Auswertung der Querkontraktionszahl ist aufgrund der Einschnürung problematisch. Es muss der sich einschnürende Bereich genau erfasst werden, um die wahren Längs- und Querdehnungen korrekt zu ermitteln. Abbildung 4.26a zeigt die Auswertung der Versuche bei einer Wegrate von $50\,\text{mm}\,\text{min}^{-1}$ und verdeutlicht die Streuung, die durch die vordefinierten Messbereiche hervorgerufen wird. Die Auswertung von Versuch 1 und 3 liefert bis zu einer Dehnung von $\varepsilon_w \approx 60\,\%$ plausible Ergebnisse mit einer Querkontraktionszahl von $v \approx 0,3$ im elastischen Anfangsbereich und $v \approx 0,5$ nach der Fließgrenze. Bei den Versuchen 2 und 4 erfolgte die Einschnürung nicht im Bereich der Messmarken.

Abbildung 4.26 zeigt die Probekörper nach den Versuchen. Während in den quasi-statischen Versuchen (b) die Probekörper ihre aufgebrachten Verformungen auch nach

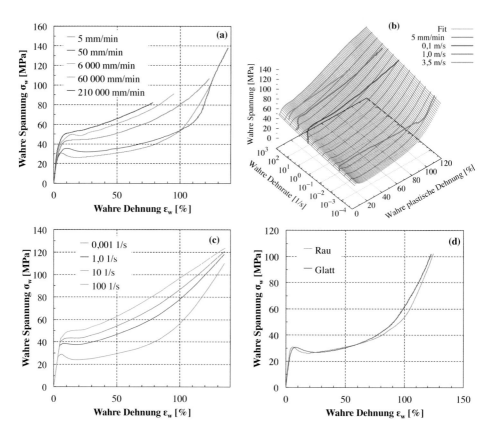

Abbildung 4.25 Ergebnisse der uniaxialen Zugversuche an der Ionoplastfolie: bei konstanten Weg-
raten (a), 3D-Fit (b), bei konstanten Dehnraten (c) und Einfluss der Oberflächenrauigkeit (d)

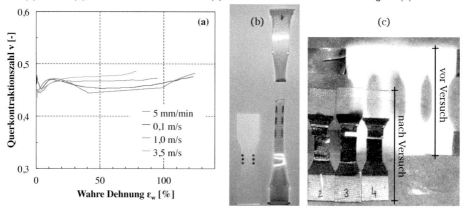

Abbildung 4.26 Ionoplastfolie: Querkontraktionszahl v bei einer Wegrate von $50\,\mathrm{mm\,min^{-1}}$ (a), Pro-
bekörper vor und nach quasistatischem Versuch (b), Probekörper nach dynamischen Versuchen (c)

sehr langer Wartezeit beibehielten, wie es bei plastischen Verformungen zu erwarten ist, zeigten die dynamischen Versuche eine starke elastische Rückverformung direkt nach den Versuchen (c). Es wird vermutet, dass durch die erhöhte Belastungsgeschwindigkeit die Probekörpertemperatur während des Versuchs den Glasübergangsbereich erreicht und somit nach Entlastung eine entropiegetriebene Rückfederung stattfindet, bevor die Temperatur an die Umgebungsluft abgegeben wird und das Material in den energieelastischen Zustand zurückkehrt (thermorheologische Kopplung).

Thermoplastisches Polyurethan (TPU)

Die Ergebnisse der Untersuchungen an der TPU PE399-Folie sind in Abbildung 4.27 dargestellt. Das Spannungs-Dehnungs-Verhalten zeigt eine weniger ausgeprägte Abhängigkeit von der Wegrate im Vergleich zum PVB (a). Bei den Kurven mit hoher Wegrate ($60\,000\,\text{mm}\,\text{min}^{-1}$ und $210\,000\,\text{mm}\,\text{min}^{-1}$) ist ein Schnittpunkt erkennbar, der wie beim Ionoplast auf einen Schlupf in der Einspannung zurückgeführt werden kann. Mittels des beschriebenen 3D-Fits (b) wurden Spannungs-Dehnungs-Beziehungen bei konstanter Dehnrate ermittelt (c). Abbildung 4.27d vergleicht die verschiedenen TPU-Folientypen bei einer konstanten Wegrate von $50\,\text{mm}\,\text{min}^{-1}$. Die in Abschnitt 2.4.5 beschriebene Abstufung der unterschiedlichen Steifigkeiten (PE501>PE399>PE429>PE499) ist erkennbar. Die Folie PE501 deutet ein duktiles Verhalten an. Die übrigen Folien verhalten sich gummielastisch (s. Abb. 2.14).

Die Querkontraktionszahl ν ist in Abhängigkeit der wahren Dehnung in Abbildung 4.28 dargestellt. Die PE399-Folie zeigt hierbei keine Abhängigkeit von der Wegrate (a). Bei kleinen Dehnungen wird eine Querkontraktionszahl $\nu \approx 0,4$ ermittelt, bei größeren Dehnungen strebt sie gegen $\nu \approx 0,5$. Die weicheren TPU-Folien PE429 und PE499 zeigen bei allen Dehnungen ein nahezu inkompressibles Verhalten mit $\nu \approx 0,5$ (b). Die steifere Folie PE501 zeigt einen vergleichbaren Verlauf wie PE399.

Alle TPU-Folien zeigten nach den Versuchen ein zeitabhängiges Rückstellverhalten, welches unabhängig von Wegrate und Typ nahezu vollständig reversibel war.

Reißfestigkeit und Reißdehnung

Neben der Spannungs-Dehnungs-Beziehung wurden soweit möglich Reißfestigkeit σ_b und Reißdehnung ε_b ermittelt. Tabelle 4.6 fasst die Ergebnisse mit Mittelwert \bar{x} und Standardabweichung s unter Annahme der Normalverteilung zusammen. Bei den dynamischen Versuchen konnte die Dehnung mittels Grauwertkorrelation nicht zuverlässig bis zum Versagen ausgewertet werden, sodass in diesem Fall die technische Reißdehnung manuell anhand der Videoaufnahmen ermittelt wurde. Eine Ermittlung der Reißfestigkeit war jedoch nicht möglich, da das Kraftsignal nur korreliert mit der ermittelten Dehnung übergeben wurde. Die Grauwertkorrelation ermöglichte aber nicht immer eine Auswertung der Dehnung bis zum Versuchsende, sodass die Kraft bei Folienriss nicht als Ergebnis vorlag.

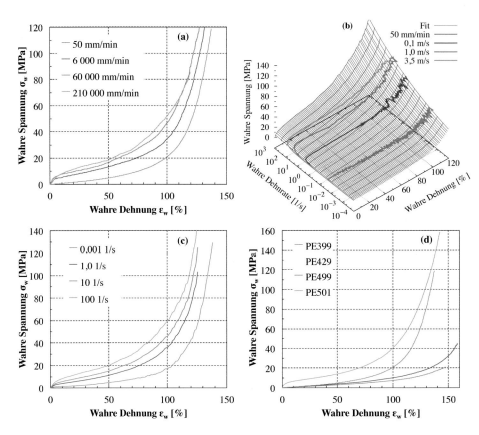

Abbildung 4.27 Ergebnisse an TPU: PE399 bei konstanten Wegraten (a), 3D-Fit (b), bei konstanten Dehnraten (c) und Vergleich verschiedener TPU-Folien bei einer Wegrate von $50\,\mathrm{mm\,min^{-1}}$ (d)

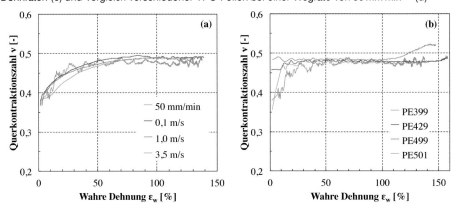

Abbildung 4.28 Querkontraktionszahl v von TPU: PE399 bei konstanten Wegraten (a) und Vergleich verschiedener TPU-Folien bei $50\,\mathrm{mm\,min^{-1}}$ (b)

Die höchsten Reißfestigkeiten mit bis zu $\sigma_b = 50\,\text{MPa}$ zeigten die Ionoplastfolie und die steife TPU-Folie (PE501). Die EVA- und TPU-Folien wiesen die größten Reißdehnungen von bis zu $\varepsilon_b = 400\,\%$ auf. Aufgrund der in den Versuchen verwendeten Pro-

Tabelle 4.6 Technische Reißfestigkeit und technische Reißdehnung der verschiedenen Zwischenmaterialien

Material	Typ	Wegrate [mm min^{-1}]	Reißfestigkeit σ_b [MPa]		Reißdehnung ε_b [%]	
			\bar{x}	s	\bar{x}	s
PVB	BG	5	24,0	3,3	250	37
	BG	50	26,4	3,3	247	18
	BG	200	25,4	1,3	208	44
	BG	6 000	-c	-c	304	56
	BG	60 000	-c	-c	316	57
	BG	210 000	-c	-c	256	12
	BG	alleb	25,6	3,2	251	39
	SC	50	16,6	0,6	340	17
	ES	50	34,9	2,3	200	13
	K7026	50	39,6	4,4	190	14
EVA	G71	50	16,2	0,9	329	6
	G71	6 000	-c	-c	360	24
	G71	60 000	-c	-c	398	35
	G71	210 000	-c	-c	384	5
	G71	alleb	16,2	0,9	370	34
	S11	50	-a	-a	-a	-a
Ionoplast	SG5000	5	43,5	1,1	289	4
	SG5000	50	49,7	2,9	348	28
	SG5000	6 000	-c	-c	336	36
	SG5000	60 000	-c	-c	255	26
	SG5000	210 0000	-c	-c	238	27
	SG5000	alleb	47,1	3,9	293	52
TPU	PE399	50	33,8	3,6	295	13
	PE399	6 000	-c	-c	406	24
	PE399	60 000	-c	-c	356	14
	PE399	210 000	-c	-c	350	12
	PE399	alleb	33,8	3,6	349	40
	PE429	50	-a	-a	-a	-a
	PE499	50	-a	-a	-a	-a
	PE501	50	46,4	1,9	317	31

[a] Proben aus der Einspannung gerutscht
[b] Mittelwert aus allen Wegraten
[c] Nicht ermittelt

bekörpergeometrie können die ermittelten Werte von Herstellerangaben und den in der Bauregelliste geforderten Mindestwerten abweichen.

4.3 Vergleich und weiterführende Auswertung der Ergebnisse

4.3.1 Vergleich verschiedener Zwischenmaterialien

Im Folgenden werden die verschiedenen untersuchten Zwischenmaterialien gegenübergestellt und bezüglich ihres mechanischen Verhaltens bewertet. Dabei werden unterschiedliche Aspekte beleuchtet.

Das Verhalten eines intakten Verbundglases wird maßgeblich durch die zeit- und temperaturabhängige Steifigkeit im Bereich kleiner Verzerrungen beeinflusst, welches anhand der Ergebnisse der DMTA beurteilt werden kann. Im gebrochenen Zustand erfährt die Zwischenschicht große Dehnungen bis zum Erreichen der Reißdehnung. Die Steifigkeit, Reißfestigkeit und Reißdehnung bei Raumtemperatur und unterschiedlichen Belastungsgeschwindigkeiten kann anhand der Ergebnisse aus den uniaxialen Zugversuchen bewertet werden. Sowohl beim intakten als auch gebrochenen Zustand wird zwischen gewöhnlichen Einwirkungen und dem außergewöhnlichen Lastfall Explosion unterschieden.

Temperatur- und zeitabhängiges Materialverhalten

Der Einfluss der Temperatur auf die Steifigkeit im Bereich kleiner Verzerrungen von verschiedenen Verbundglas-Zwischenschichten ist in Abbildung 4.29 dargestellt. Dieser Ver-

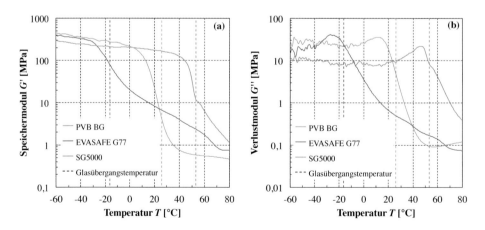

Abbildung 4.29 Vergleich der untersuchten VSG-Zwischenmaterialien im Temperatursweep (Doppelscherung bei 1 Hz): Speichermodul G' (a) und Verlustmodul G'' (b)

gleich beschränkt sich der Übersicht halber auf die Hauptprodukte der Materialgruppen PVB, EVA und Ionoplast. In Tabelle 4.7 sind die Glasübergangstemperaturen aus allen DMTA-Versuchen angegeben. Diese wurden über das Maximum des Verlustfaktors $\tan \delta$ ermittelt (s. Abb. 2.28).

Die Temperatursweeps lassen die innere Struktur der Kunststoffe erkennen (s. Abschn. 2.3.3). Das den Elastomeren zuzuordnende EVA zeigt einen sehr breiten Glasübergangsbereich (Steifigkeitsabfall von $-30\,°C$ bis $70\,°C$) mit einem anschließenden horizontalen entropieelastischen Plateau. Die Glasübergangstemperatur befindet sich unter $0\,°C$. Die anderen Produkte sind den Thermoplasten zuzuordnen, im entropieelastischen Bereich fällt die Steifigkeit mit zunehmender Temperatur stetig ab. Die Glasübergangstemperatur des PVB-Standardprodukts liegt etwa bei Raumtemperatur, beim Ionoplast liegt sie deutlich höher. Die Fließtemperatur wurde bei beiden Materialien nicht erreicht. Beim teilkristallinen Ionoplast ist zudem ein sekundäres Dispersionsgebiet im Glasübergangsbereich erkennbar, welches auf ein Aufschmelzen der kristallinen Phasen zurückzuführen ist (s. Abschn. 2.3.2). Bei der konstanten Prüffrequenz $f = 1\,Hz$ verhält sich der Ionoplast im baupraktischen Temperaturbereich deutlich steifer als die beiden anderen Materialien.

Ein Vergleich der Zeitabhängigkeit auf Grundlage der Ergebnisse der Frequenzsweeps ist hier nicht dargestellt, da die großen Streuungen aus den Versuchen mit EVA und Ionoplast die Ableitung von belastbaren Kurven nicht gestatten (s. Abb. 4.12 und 4.13). Für die Materialien PVB und Ionoplast lässt sich aber feststellen, dass sie sich im Lastfall Explosion bei Raumtemperatur und niedrigeren Temperaturen im energieelastischen Bereich befinden und damit das Verbundglas in guter Näherung als voller Verbund abgebildet werden kann. Die höchste Steifigkeit bei langen Lasteinwirkungsdauern und hohen Temperaturen zeigt die EVA-Zwischenschicht aufgrund der Vernetzung.

Tabelle 4.7 Glasübergangstemperatur T_g aus Temperatursweeps bei $f = 1\,Hz$, Ermittlung über Maximum von Verlustfaktor $\tan \delta$

Material	Typ	Zug (Streifen)	Torsion (Streifen)	Doppelscherung (Material)	Doppelscherung (Laminat)
PVB	BG	$29,7\,°C$	$25,6\,°C$	$26,0\,°C$	$42,9\,°C$ [a]
	SC	-	-	$15,0\,°C$	-
	ES	-	-	$41,5\,°C$	-
	K7026	-	-	$47,7\,°C$	-
EVA	G77	$-12,1\,°C$	$-20,7\,°C$	$-16,3\,°C$	-
	S88	-	-	$-16,7\,°C$	-
Ionoplast	SG5000	$54,6\,°C$	$55,1\,°C$	$53,1\,°C$	-

[a] Frequenz $f = 10\,Hz$

Uniaxiale Spannungs-Dehnungs-Beziehungen

Um eine Bewertung der Steifigkeit verschiedener Verbundglas-Zwischenmaterialien bis hin zu großen Dehnungen durchzuführen, sind in Abbildung 4.30 Vergleiche zwischen den Spannungs-Dehnungs-Beziehungen dargestellt. Für eine quasistatische Belastung (a) wird eine kleine Dehnrate von $\dot{\varepsilon} = 0{,}001\,\mathrm{s}^{-1}$ gewählt. Die dargestellte dynamische Belastung (b) liegt bei $\dot{\varepsilon} = 100\,\mathrm{s}^{-1}$, was nach LARCHER et al., 2012 eine sinnvolle obere Annahme für die Zwischenschicht von gebrochenem Verbundglas unter Explosionsbeanspruchung darstellt. Der Vergleich beschränkt sich der Übersicht halber auf die Hauptprodukte der Materialgruppen PVB, EVA, Ionoplast und TPU.

Bei quasistatischer Belastung verhalten sich die Materialien PVB, EVA und TPU bis zu einer wahren Dehnung von $\varepsilon_\mathrm{w} \approx 60\,\%$ vergleichbar auf einem geringen Steifigkeitsniveau. Nur die Ionoplastfolie zeigt in diesem Dehnungsbereich ein abweichendes und deutlich steiferes Verhalten mit einer ausgeprägten Fließgrenze bei $\sigma_\mathrm{w,y} \approx 30\,\mathrm{MPa}$. Bei großen Verzerrungen zeigen TPU, PVB und Ionoplast in absteigender Reihenfolge eine ausgeprägte Versteifung.

Eine Steigerung von quasistatischer zu dynamischer Dehnrate wirkt sich auf die Spannungs-Dehnungs-Beziehungen von EVA und TPU nicht signifikant aus. Die grundsätzlichen Verläufe bleiben erhalten bei einer geringen Erhöhung der Steifigkeit. Bei der Ionoplastfolie bleibt der grundsätzliche Verlauf ebenfalls erhalten, die Erhöhung der Steifigkeit ist aber deutlicher. Die Fließgrenze steigt auf $\sigma_\mathrm{w,y} \approx 50\,\mathrm{MPa}$. Bei der PVB-Folie ist eine Veränderung des Kurvenverlaufs zu erkennen: Das Spannungs-Dehnungs-Verhalten wechselt von einem typisch gummielastischen zu einem duktilen Verhalten (s. Abb. 2.14). Auch das Steifigkeitsniveau steigt deutlich an, liegt aber immer noch weit unterhalb dem der Ionoplastfolie. Dabei ist zu beachten, dass sich PVB unabhängig von der Dehnrate bei Entlastung nahezu vollständig elastisch verhält und kein wie in der Literatur oftmals bezeichnetes elastisch-plastisches Verhalten bei hohen Dehnraten (IWASAKI et al., 2006; LARCHER et al., 2012) vorliegt.

Abbildung 4.31 vergleicht die Reißfestigkeiten (a) und Reißdehnungen (b) aller Materialien. Bei den Reißfestigkeiten handelt es sich um die Ergebnisse der quasistatischen Versuche, da bei den dynamischen Versuchen die Reißfestigkeit nicht ausgewertet werden konnte. Bei den Reißdehnungen wurden die Ergebnisse von allen Wegraten gemittelt, da kein über die Streuung in den Versuchsserien hinausgehender Trend beobachtet werden konnte (s. Tab. 4.6). Bei beiden Vergleichen fehlen die Folien EVASKY™ S11, TPU PE 429 und TPU PE 499, bei denen kein Versagen im Versuch erreicht wurde.

Im Hinblick auf eine Bewertung der Ergebnisse für das Nachbruchverhalten von Verbundglas ist zwischen üblichen Einwirkungen und Explosionsbeanspruchung zu unterscheiden. Bei üblichen Einwirkungen ist meist eine hohe Steifigkeit von Vorteil, um die Deformationen des gebrochenen Verbundglases zu minimieren und eine hohe Resttragfähigkeit zu erreichen. Hier zeigen die steifen PVB-Folien ES und K7026 sowie die Ionoplastfolie die besten Ergebnisse.

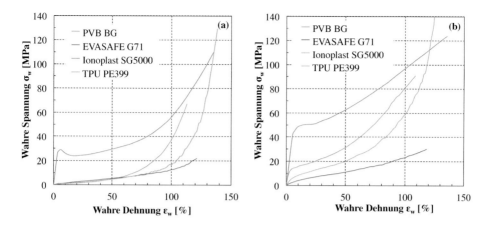

Abbildung 4.30 Vergleich der Spannungs-Dehnungs-Beziehung von PVB BG, EVASAFE™ G71, Ionoplast SG5000 und TPU PE399: quasistatische Dehnrate 0,001 s^{-1} (a) und dynamische Dehnrate 100 s^{-1} (b)

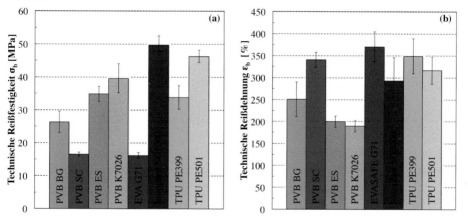

Abbildung 4.31 Vergleich der untersuchten VSG-Zwischenmaterialien: technische Reißfestigkeit σ_b (a) und technische Reißdehnung ε_b (b)

Wird bei einer Explosionsbeanspruchung der Ansatz des „balanced design" verfolgt (s. Abschn. 2.4.9), so muss das Zwischenmaterial große Verformungen der gebrochenen Verglasungen zulassen, ohne zu reißen. Dies wird durch eine niedrige Steifigkeit bei hohen Dehnraten in Kombination mit einer hohen Reißdehnung ermöglicht. Ein Einschnüren des Materials wirkt sich aufgrund der damit einhergehenden Querschnittsschwächung nachteilig aus. Bei diesen Aspekten zeigen die weiche PVB-Variante SC, die EVA-Folien und die TPU-Folien die besten Ergebnisse.

Neben der an dieser Stelle bewerteten Steifigkeit und Reißdehnung ist die Haftung zum Glas und das damit verbundene Delaminationsverhalten für die Bewertung eines Zwi-

schenmaterials hinsichtlich der Resttragfähigkeit sowohl bei üblichen Einwirkungen als auch bei Explosionsbeanspruchung ein entscheidender Parameter. Hierauf wird in Kapitel 6 näher eingegangen.

4.3.2 Materialmodelle von Verbundglas-Zwischenschichten

Für eine Abbildung des Materialverhaltens von Verbundglas-Zwischenschichten über analytische und numerische Modelle sind viele Ansätze möglich. Die Erfassung der Realität mit allen möglichen Nichtlinearitäten bezüglich der Abhängigkeit von Zeit und Temperatur, großen Verzerrungen, Be- und Entlastung, Plastizität und Folienriss ist nicht möglich. Eine Materialmodellierung stellt daher immer eine Vereinfachung der Realität dar und ist dem Ziel der Berechnung anzupassen. Je nach Aufgabenstellung sind bestimmte Annahmen angemessen, die beurteilt werden müssen, um eine geeignete Materialformulierung auszuwählen.

Für den Zustand des intakten Verbundglases ist in der Regel eine Beschränkung auf kleine Verzerrungen der Zwischenschicht gerechtfertigt, sodass das Modell der linearen Viskoelastizität angenommen werden kann. Verhält sich darüber hinaus im betrachteten Temperatur- und Zeitbereich das Material thermorheologisch einfach, kann es mittels Prony-Reihe und dem Zeit-Temperatur-Verschiebungsprinzip vollständig beschrieben werden. Eine oftmals getroffene Vereinfachung stellt hierbei die Annahme einer konstanten Querkontraktionszahl dar. Wenn die Temperatur- und Zeitabhängigkeit für die gestellte Aufgabe außer Acht gelassen werden kann, ist sogar eine linear-elastische Modellierung der Zwischenschicht ausreichend. Dies trifft beispielsweise auf kurzzeitige dynamische Belastungen wie Pendelschlag oder den Lastfall Explosion zu.

Bricht das Verbundglas, ist das Materialverhalten ungleich komplexer. Es treten große Dehnungen der Zwischenschicht auf und der Bereich der linearen Viskoelastizität wird verlassen. Das Zeit-Temperatur-Verschiebungsprinzip kann ebenfalls nicht mehr angewandt werden und einige Materialien (z.B. EVA, Ionoplast) zeigen sogar plastische Verformungen.

Ist der Einfluss von Zeit und Temperatur vernachlässigbar und die Entlastung gleich der Belastung (oder nicht von Interesse), können hyperelastische Materialmodelle angewandt werden. Sind die Dehnungen moderat, kann eine linear-elastische Beschreibung des Materials wiederum ausreichend sein.

Ist bei einem Material ohne Plastizität in der gestellten Aufgabe der Einfluss aus der Temperatur aber nicht der Zeit vernachlässigbar, können visko-hyperelastische Materialmodelle zielführend sein (ANSYS INC., 2012a). Deren Funktionsfähigkeit ist derzeit aber noch stark eingeschränkt, wie durchgeführte Beispielrechnungen gezeigt haben. Einige kommerzielle FE-Programme erlauben auch die Eingabe von Spannungs-Dehnungs-Beziehungen bei unterschiedlichen Dehnraten ohne die Bestimmung weiterer Modellparameter, siehe beispielsweise KOLLING et al., 2007. Für diese Materialmodelle können die dargestellten Ergebnisse aus den uniaxialen Zugversuchen direkt genutzt werden. Für das

untersuchte PVB wurde dies mit dem FE-Programm *LS-DYNA* in Abschnitt 6.3.2, RÜHL et al., 2012, ORTNER, 2014 und PELFRENE et al., 2015 umgesetzt.

Ist Plastizität wie bei dem untersuchten Ionoplast zu berücksichtigen, stehen visko-plastische Materialmodelle zur Verfügung (ANSYS INC., 2012a; LSTC, 2014a). Hierbei wird jedoch zumindest in den kommerziellen FE-Codes bis zur Fließgrenze ein linear-elastisches Verhalten unterstellt, weshalb auch die dehnratenkonstanten Spannungs-Deh-nungs-Beziehungen des Ionoplasts dementsprechend ausgewertet wurden (s. Abb. 4.25). Eine konkrete Umsetzung in *LS-DYNA* findet sich in ROTH, 2013. Dort konnte anhand einer Nachrechnung der Zugversuche der uniaxiale Spannungszustand validiert werden. Weiterführende quasistatische und dynamische Durchstoßversuche an der Folie zeigten, dass eine mehraxiale Charakterisierung des Ionoplastmaterials erforderlich ist, um das Materialverhalten unter dieser Beanspruchung realitätsnah zu beschreiben.

Zeit-Temperatur-Verschiebungsansätze

Die Ermittlung der viskoelastischen Materialparameter beschränkt sich auf die drei Fre-quenzsweeps mit dem Material PVB, da die Ergebnisse der DMTA-Frequenzsweeps für die Materialien EVA und Ionoplast nicht belastbar sind. Das hier vorgestellte Vorgehen ist aber allgemeingültig und im Rahmen der Anwendungsgrenzen auf beliebige Materialien übertragbar.

Vor der eigentlichen Ermittlung der viskoelastischen Materialparameter steht die ana-lytische Beschreibung des Temperatur-Zeit-Zusammenhangs (s. Abschn. 2.3.6 und 2.3.7). Das Vorgehen wird exemplarisch an den Ergebnissen der Torsions-DMTA mit 5 °C-Schrit-ten dargestellt.

Die experimentell ermittelten Verschiebungsfaktoren $\log a_T$ müssen mit einem passen-den Ansatz beschrieben werden. Falls mehrere Dispersionsgebiete existieren und abge-deckt werden sollen, kann die Anpassung auch bereichsweise mit einer Kombination von mehreren Ansätzen erfolgen, wobei eine entsprechende Umsetzung in kommerziellen FE-Programmen bisher nicht möglich ist. Für die Ergebnisse aus Abbildung 4.10d liefert die Anpassung mit einem WLF-Ansatz nach Gleichung (2.41) über alle untersuchten Tempe-raturen eine gute Übereinstimmung (Abb. 4.32a). Die Anpassung des Ansatzes an die Ver-schiebungsfaktoren aus der Masterkurvenerstellung wurde durch Minimierung der Fehler-quadratsumme durchgeführt. Eine Anpassung mit dem Arrhenius-Ansatz nach Gleichung (2.42) zeigt größere Abweichungen. Dies bestätigt die in Abschnitt 2.3.6 beschriebene Aussage, dass der Arrhenius-Ansatz vorwiegend den energieelastischen Zustand zutref-fend beschreibt.

Damit das Materialmodell in sich konsistent ist, muss die rückwirkende Beeinflussung des WLF-Ansatzes auf die Masterkurve berücksichtigt werden. Abbildung 4.32b zeigt die Veränderung, die sich durch die analytische Beschreibung des ZTV gegenüber der ur-sprünglichen Masterkurve ergibt. Aufgrund der guten Anpassung des WLF-Ansatzes an die Verschiebungsfaktoren ergeben sich nur geringe Abweichungen. In Tabelle 4.8 sind die

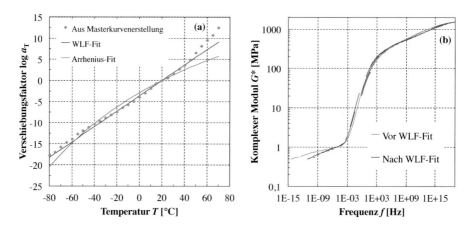

Abbildung 4.32 Auswertung der Torsions-DMTA mit 5 °C-Schritten: optimierte Verschiebungsansätze WLF und Arrhenius (a) und rückwirkende Auswirkungen des WLF-Ansatzes auf die Masterkurve (b)

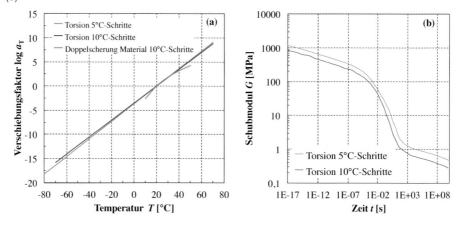

Abbildung 4.33 Vergleich der drei Wertepaare für den WLF-Ansatz mit PVB BG (a) und Prony-Reihen aus den Torsions-DMTA im Zeitbereich (b)

Tabelle 4.8 WLF-Faktoren aus den verschiedenen Frequenzsweeps an PVB BG, Referenztemperatur $T_{ref} = 20\,°C$

Versuch	c_1 [-]	c_2 [°C]
Torsion 5 °C-Schritte	$-1{,}107 \cdot 10^6$	$6{,}065 \cdot 10^6$
Torsion 10 °C-Schritte	$-1{,}069 \cdot 10^6$	$6{,}072 \cdot 10^6$
Doppelscherung (Material) 10 °C-Schritte	$-12{,}5$	$58{,}4$

WLF-Faktoren aus allen durchgeführten Frequenzsweeps angegeben. Die augenscheinlich großen Unterschiede bei der Doppelscherung entstehen durch die geringe Anzahl an isothermen Einzelversuchen, die Ergebnisse sind für diese Temperaturen aber vergleichbar (Abb. 4.33a).

Viskoelastische Materialmodelle

Das Standardmodell zur Beschreibung der Viskoelastizität ist das verallgemeinerte Maxwell-Modell oder auch Prony-Reihe genannt (s. Abschn. 2.3.5). Die Ermittlung der unbekannten Modellparameter g_i, τ_i und G_∞ stellt ein nichtlineares Optimierungsproblem mit einer hohen Anzahl an Unbekannten und mehreren Randbedingungen dar. Das im Rahmen dieser Arbeit entwickelte allgemeingültige Vorgehen wird exemplarisch an den Ergebnissen der Torsions-DMTA mit 5 °C-Schritten dargestellt.

In einem ersten Schritt ist die Anzahl der Maxwell-Elemente n für die Prony-Reihe festzulegen, je abzubildende Zeit- oder Frequenzdekade ist ein Maxwell-Element notwendig. Die Masterkurve nach dem WLF-Fit in Abbildung 4.32b erstreckt sich von $f = 1 \cdot 10^{-11}$ bis $f = 1 \cdot 10^{20}$, also über 32 Frequenzdekaden. Ohne weitere Einschränkungen ergeben sich $2n + 1 = 65$ unbekannte Modellparameter ($g_1, ..., g_n, \tau_1, ..., \tau_n, G_\infty$). Mit dem Wissen, dass ein Maxwell-Element eine Zeit- oder Frequenzdekade abbildet, wurde ein Ansatz entwickelt, die Anzahl der Unbekannten auf $n + 1$ zu reduzieren. Die Relaxationszeiten τ_i werden dabei im Abstand von einer Zehnerpotenz festgelegt und stellen keine Unbekannten mehr dar.

Anschließend müssen die verbleibenden Unbekannten so optimiert werden, dass sie die experimentell gemessenen Daten abbilden. Dabei ist zu beachten, dass für eine korrekte Materialcharakterisierung sowohl der Speichermodul G' als auch der Verlustmodul G'' beschrieben werden müssen. Die zu minimierende Zielfunktion stellt die Fehlerquadratsumme zwischen Experiment und Modell dar:

$$f(g_1, ..., g_n, G_\infty) = \tag{4.4}$$

$$\sum_{j=1}^{m} \left[(\log G'(\omega_j) - \log \bar{G}'(\omega_j))^2 + 10 \left(\log G''(\omega_j) - \log \bar{G}''(\omega_j)\right)^2 \right]$$

mit

$G'(\omega_j)$ Speichermodul nach Gleichung (2.47) ausgewertet an der Stelle ω_j,

$\bar{G}'(\omega_j)$ Speichermodul aus Experiment ausgewertet an der Stelle ω_j,

$G''(\omega_j)$ Verlustmodul nach Gleichung (2.48) ausgewertet an der Stelle ω_j,

$\bar{G}''(\omega_j)$ Verlustmodul aus Experiment ausgewertet an der Stelle ω_j,

m Anzahl der Stützstellen.

Hierbei wurde eine Logarithmierung aller Moduln vorgenommen, um niedrige Modulwerte analog der üblichen logarithmischen Darstellung stärker zu gewichten. Zudem wurde der Verlustmodul nach GÖHLER, 2010 zehnfach gegenüber dem Speichermodul gewichtet, um die starken Oszillationen des Verlustmoduls nach Gleichung (2.48) zu berücksichtigen. Die Auswertung erfolgt an den Stützstellen $j = 1, ..., m$. Es wurden fünf logarithmisch äquidistant verteilte Stützstellen je Frequenzdekade gewählt, um einen glatten Kurvenverlauf sicherzustellen.

Die Suche nach einem Minimum von Gleichung (4.4) unterliegt den Nebenbedingungen

$$0 \leq g_i < 1 \qquad \text{(weitere Einschränkung auf } g_i < 0,3 \text{ verbesserte Ergebnisse),}$$

$$\sum_{i=1}^{n} g_i \leq 1 \qquad n : \text{Anzahl der Maxwell-Elemente,} \qquad (4.5)$$

$$G_0 = \frac{G_\infty}{1 - \sum g_i}.$$

Die Optimierung mit einem rein gradientenbasierten Verfahren führt in der Regel zu lokalen Minima, sodass ein zweistufiges Verfahren entwickelt wurde, bei welchem ein genetischer Algorithmus den Startvektor für einen nachgeschalteten globalen Optimierer liefert. Bei einem genetischen Algorithmus wird – angelehnt an die biologische Evolution – eine Verbesserung der Population über mehrere Generationen angestrebt. Dazu werden in einem ersten Schritt die Individuen der bestehenden Generation gemäß der Zielfunktion bewertet. Anschließend erfolgt die Erzeugung der neuen besseren Generation mittels drei Mechanismen (Selektion, Mutation und Rekombination) (WEICKER, 2007). Die Anzahl

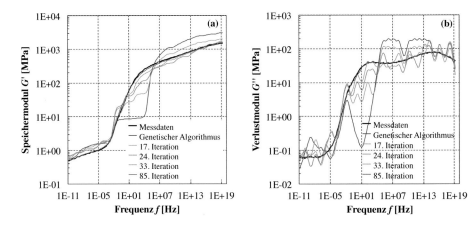

Abbildung 4.34 Optimierungsvorgang zur Ermittlung der Prony-Parameter: Speichermodul G' (a) und Verlustmodul G'' (b)

an Individuen in einer Generation wird Population genannt. Für den genetischen Algorithmus wurde eine Populationsgröße von 100 und zwölf Generationen gewählt.

Tabelle 4.9 Prony-Parameter für PVB BG, Referenztemperatur $T_{ref} = 20\,°C$

	Torsion 5 °C-Schritte $G_0 = 1633\,\text{MPa}$ $G_\infty = 0{,}41765\,\text{MPa}$		Torsion 10 °C-Schritte $G_0 = 911\,\text{MPa}$ $G_\infty = 0{,}21983\,\text{MPa}$	
i	τ_i [s]	g_i [-]	τ_i [s]	g_i [-]
1	10^{-21}	$9{,}6908 \cdot 10^{-2}$	10^{-17}	$1{,}1071 \cdot 10^{-1}$
2	10^{-20}	$2{,}1397 \cdot 10^{-2}$	10^{-16}	$5{,}9190 \cdot 10^{-2}$
3	10^{-19}	$5{,}4897 \cdot 10^{-2}$	10^{-15}	$1{,}4683 \cdot 10^{-1}$
4	10^{-18}	$5{,}6514 \cdot 10^{-2}$	10^{-14}	$1{,}2744 \cdot 10^{-3}$
5	10^{-17}	$6{,}8822 \cdot 10^{-2}$	10^{-13}	$1{,}3611 \cdot 10^{-1}$
6	10^{-16}	$7{,}0962 \cdot 10^{-2}$	10^{-12}	$6{,}0921 \cdot 10^{-2}$
7	10^{-15}	$6{,}9413 \cdot 10^{-2}$	10^{-11}	$6{,}1245 \cdot 10^{-2}$
8	10^{-14}	$6{,}5020 \cdot 10^{-2}$	10^{-10}	$5{,}7080 \cdot 10^{-2}$
9	10^{-13}	$5{,}8544 \cdot 10^{-2}$	10^{-9}	$3{,}6053 \cdot 10^{-2}$
10	10^{-12}	$5{,}2314 \cdot 10^{-2}$	10^{-8}	$6{,}3861 \cdot 10^{-2}$
11	10^{-11}	$4{,}5429 \cdot 10^{-2}$	10^{-7}	$8{,}3617 \cdot 10^{-3}$
12	10^{-10}	$3{,}9730 \cdot 10^{-2}$	10^{-6}	$6{,}1737 \cdot 10^{-2}$
13	10^{-9}	$3{,}7345 \cdot 10^{-2}$	10^{-5}	$3{,}4859 \cdot 10^{-2}$
14	10^{-8}	$3{,}4496 \cdot 10^{-2}$	10^{-4}	$4{,}6068 \cdot 10^{-2}$
15	10^{-7}	$3{,}2946 \cdot 10^{-2}$	10^{-3}	$4{,}2979 \cdot 10^{-2}$
16	10^{-6}	$3{,}4343 \cdot 10^{-2}$	10^{-2}	$3{,}9236 \cdot 10^{-2}$
17	10^{-5}	$3{,}2634 \cdot 10^{-2}$	10^{-1}	$2{,}1514 \cdot 10^{-2}$
18	10^{-4}	$3{,}7231 \cdot 10^{-2}$	$1{,}0$	$8{,}6305 \cdot 10^{-3}$
19	10^{-3}	$3{,}7813 \cdot 10^{-2}$	10^1	$2{,}0102 \cdot 10^{-3}$
20	10^{-2}	$2{,}6247 \cdot 10^{-2}$	10^2	$3{,}3657 \cdot 10^{-4}$
21	10^{-1}	$1{,}3234 \cdot 10^{-2}$	10^3	$2{,}5507 \cdot 10^{-4}$
22	$1{,}0$	$9{,}0424 \cdot 10^{-3}$	10^4	$7{,}2345 \cdot 10^{-5}$
23	10^1	$3{,}3094 \cdot 10^{-3}$	10^5	$7{,}7346 \cdot 10^{-5}$
24	10^2	$5{,}2423 \cdot 10^{-4}$	10^6	$5{,}0524 \cdot 10^{-5}$
25	10^3	$1{,}7618 \cdot 10^{-4}$	10^7	$7{,}1125 \cdot 10^{-5}$
26	10^4	$9{,}0256 \cdot 10^{-5}$	10^8	$7{,}1078 \cdot 10^{-5}$
27	10^5	$6{,}9971 \cdot 10^{-5}$	10^9	$3{,}8180 \cdot 10^{-5}$
28	10^6	$5{,}6022 \cdot 10^{-5}$	10^{10}	$1{,}0876 \cdot 10^{-4}$
29	10^7	$5{,}3284 \cdot 10^{-5}$	10^{11}	$7{,}6516 \cdot 10^{-6}$
30	10^8	$6{,}0826 \cdot 10^{-5}$		$\Sigma = 0{,}9998$
31	10^9	$5{,}0318 \cdot 10^{-5}$		
32	10^{10}	$7{,}1673 \cdot 10^{-5}$		
		$\Sigma = 0{,}9997$		

Der anschließende globale Optimierer basiert auf einem Gradientenverfahren unter Beachtung von Nebenbedingungen. Der Startvektor aus dem genetischen Algorithmus sowie bis zu 1000 weitere Startvektoren werden mit dem Ziel optimiert, ein globales Minimum zu finden. Eine detaillierte Beschreibung des Optimierungsvorgangs findet sich in LANGER, 2015, der kommentierte Algorithmus ist im Anhang A.5 wiedergegeben. In Abbildung 4.34 ist der Optimierungsvorgang dargestellt. Es wird deutlich, dass die Messdaten mit dem gewählten Ansatz abgebildet werden können und der im genetischen Algorithmus ermittelte Startvektor geeignet ist, um das globale Optimum zu finden. Vergleichsberechnungen mit der Optimierungssoftware *optiSLang* (DYNARDO GMBH, 2014) zeigten, dass diese hinsichtlich Robustheit und Schnelligkeit nicht mit dem in dieser Arbeit erstellten Optimierungswerkzeug konkurrieren kann.

In Tabelle 4.9 sind die Prony-Parameter für die beiden Masterkurven der Torsions-DMTA angegeben. Abbildung 4.33b visualisiert die erstellten Masterkurven. Die zugehörigen WLF-Faktoren finden sich in Tabelle 4.8. Da die Masterkurven bei der niedrigsten angegebenen Frequenz ($f_{\min} = 1 \cdot 10^{-11}$ Hz in Abb. 4.34) einen endlichen Modulwert aufweisen, ist der Grenzschubmodul G_∞ in den Prony-Reihen ungleich null. An dieser Stelle sei betont, dass eine Prony-Reihe generell nur einen gewissen Zeit- und Temperaturbereich erfasst und deren Anwendbarkeit stets zu überprüfen ist. Ein realer Grenzschubmodul ist nur für vernetzte Kunststoffe wie beispielsweise das untersuchte EVA möglich.

Linear-elastische Materialmodelle

Um einen Anhaltswert für die Anfangssteifigkeit der untersuchten Materialien zu geben, wurde der Elastizitätsmodul bei kleinen Verzerrungen anhand der uniaxialen Zugversuche bestimmt. Dabei wurde die Anfangssteigung der Spannungs-Dehnungs-Beziehung mittels einer Regressionsgeraden ermittelt. Solange kein Fließplateau zu beobachten war, wurden Dehnungen bis maximal 5 % in die Regression mit einbezogen. Dieses Vorgehen weicht von dem in DIN EN ISO 527-1 beschriebenen Verfahren zur Bestimmung des Zugmoduls ab, welches jedoch explizit nicht für Folien gilt.

Neben dem Elastizitätsmodul E wird zur vollständigen Beschreibung des isotropen linear-elastischen Materialverhaltens eine weitere Materialkonstante benötigt. Hierfür wird die in den uniaxialen Zugversuchen ebenfalls ermittelte Querkontraktionszahl ν bei kleinen Dehnungen herangezogen. Da die Auswertung der Querkontraktionszahl bei kleinen Dehnungen und der gewählten Auflösung mit Ungenauigkeiten behaftet ist, stellt diese Materialkonstante nur eine Abschätzung dar.

Die Auswertung des Elastizitätsmoduls erfolgte für jedes Material bei wahren Dehnraten von $\dot{\varepsilon}_{\mathrm{w}} = 0{,}001\,\mathrm{s}^{-1}$ und $\dot{\varepsilon}_{\mathrm{w}} = 100\,\mathrm{s}^{-1}$, falls Spannungs-Dehnungs-Beziehungen bei konstanten Dehnraten ermittelt wurden. Anderenfalls erfolgte die Auswertung bei einer Wegrate von $50\,\mathrm{mm}\,\mathrm{min}^{-1}$, was einer Dehnrate zu Beginn des Versuchs von etwa $\dot{\varepsilon}_{\mathrm{w}} \approx 0{,}02\,\mathrm{s}^{-1}$ entspricht. Tabelle 4.10 fasst die Ergebnisse zusammen.

Tabelle 4.10 Linear-elastische Parameter der verschiedenen Zwischenmaterialien

Material	Typ	Elastizitätsmodul E [MPa]	Querkontraktionszahl ν [-]
PVB	BG[a]	9,0	0,5
	BG[b]	447	0,45
	SC[c]	1,6	0,5
	ES[c]	676	0,4
	K7026[c]	782	0,3
EVA	G71[a]	18	0,45
	G71[b]	50	0,45
	S11[c]	24	0,5
Ionoplast	SG5000[d]	800	0,3
TPU	PE399[a]	24	0,4
	PE399[b]	126	0,4
	PE429[c]	4,3	0,5
	PE499[c]	5,3	0,5
	PE501[c]	112	0,4

[a] $\dot{\varepsilon}_{\mathrm{w}} = 0,001\,\mathrm{s}^{-1}$
[b] $\dot{\varepsilon}_{\mathrm{w}} = 100\,\mathrm{s}^{-1}$
[c] Wegrate von $50\,\mathrm{mm\,min}^{-1}$, entspricht im Bereich kleiner Dehnungen $\dot{\varepsilon}_{\mathrm{w}} \approx 0,02\,\mathrm{s}^{-1}$
[d] Aufgrund der linear-elastisch-viskoplastischen Auswertung unabhängig von der Dehnrate

Hyperelastische Materialmodelle

Die mit den Zugversuchen ermittelten Spannungs-Dehnungs-Beziehungen können bei konstanter Dehnrate bzw. konstanter Wegrate mittels hyperelastischer Materialmodelle bis hin zu großen Dehnungen abgebildet werden. Ein Wechsel der Beanspruchungsgeschwindigkeit und Effekte wie Kriechen, Relaxation oder Plastizität können damit nicht berücksichtigt werden.

Die Ermittlung der Materialkonstanten beruht auf den uniaxialen Zugversuchen. Um andere Spannungszustände mit Sicherheit korrekt abzubilden, müssen weitere Versuche wie der biaxiale Zugversuch und der Schubversuch durchgeführt und in die Parameteridentifikation mit einbezogen werden.

Die Grundlagen zur Hyperelastizität wurden in Abschnitt 2.3.4 dargestellt. Die Parameter für die dort beschriebenen Materialmodelle, die über ein Potential W definiert sind, wurden mithilfe des Programms *Ansys* (ANSYS INC., 2012a) unter der Annahme der Volumenkonstanz ($\nu = 0,5$; $J = 1$) ermittelt. Das Programm arbeitet hierbei in der Ausgangskonfiguration, also mit technischer Spannung und Dehnung. Eine Rückrechnung der uniaxialen technischen Spannungs-Dehnungs-Beziehung kann bei bekannten Parame-

tern durch Ableitung des Potentials W nach der Hauptstreckung $\lambda = 1 + \varepsilon_0$ erfolgen (s. Abschn. 2.3.4 und HOLZAPFEL, 2000):

$$\sigma_0(\lambda) = \frac{\partial W}{\partial \lambda}. \tag{4.6}$$

Die Auswertung erfolgte für jedes Material entweder bei wahren Dehnraten von $\dot{\varepsilon}_w = 0{,}001\,\mathrm{s}^{-1}$ und $\dot{\varepsilon}_w = 100\,\mathrm{s}^{-1}$ oder bei einer Wegrate von $50\,\mathrm{mm\,min}^{-1}$. Die Ergebnisse sind in den Tabellen 4.11 und 4.12 zusammengefasst. Um möglichst viele Materialien gut abzubilden, wurden höherwertige Modelle (Mooney-Rivlin mit 5 Parametern, Yeoh mit 3 Parametern und Ogden 2. Ordnung mit 4 Parametern) verwendet. Es werden nur Parameter angegeben, wenn die Anpassung optisch akzeptabel war. Insbesondere sind ein steiler Anstieg zu Beginn mit einem anschließenden Abflachen der Spannungs-Dehnungs-Kurve von den gewählten hyperelastischen Materialmodellen nicht abbildbar. Die Spannungs-Dehnungs-Beziehungen der PVB-Folien BG bei hoher Dehnrate, ES und K7026 sowie der Ionoplastfolie lassen sich somit nur unzureichend mithilfe hyperelastischer Potentiale abbilden. Für diese Fälle werden keine Materialparameter angegeben.

Abbildung 4.35 zeigt beispielhaft die Anpassung der hyperelastischen Materialmodelle an die experimentellen Ergebnisse von PVB BG. Bei quasistatischer Belastung liefern alle Modelle akzeptable Ergebnisse (a), bei der dynamischen Belastung keines (b).

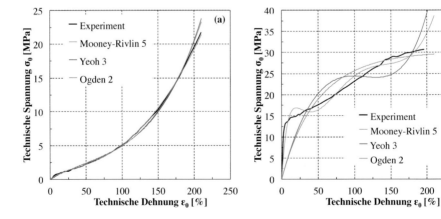

Abbildung 4.35 Anpassung der hyperelastischen Materialmodelle an die experimentellen Ergebnisse von PVB BG: quasistatische Dehnrate von $\dot{\varepsilon}_w = 0{,}001\,\mathrm{s}^{-1}$ (a), dynamische Dehnrate von $\dot{\varepsilon}_w = 100\,\mathrm{s}^{-1}$ (b)

Tabelle 4.11 Hyperelastische Parameter von PVB und EVA

Modell	Parameter	PVB BG[a]	PVB SC[c]	EVA G71[a]	EVA G71[b]	EVA S11[c]
Mooney-Rivlin	C_{10} [MPa]	-1,236E0	-6,969E-1	-6,679E0	-2,660E1	-9,412E0
	C_{01} [MPa]	2,742E0	1,062E0	9,813E0	3,605E1	1,394E1
	C_{20} [MPa]	1,907E-1	1,578E-1	3,879E-1	7,835E-1	1,385E-1
	C_{11} [MPa]	1,088E-1	-6,231E-1	-1,884E0	-4,356E0	-8,006E-1
	C_{02} [MPa]	2,529E-1	1,016E0	4,427E0	1,393E1	3,878E0
Yeoh	C_{10} [MPa]	1,101E0	2,731E-1	1,691E0	-	-
	C_{20} [MPa]	3,638E-2	9,728E-3	-1,630E-1	-	-
	C_{30} [MPa]	1,482E-2	1,104E-3	1,001E-2	-	-
Ogden	μ_1 [MPa]	1,169E-1	3,885E-3	1,622E-5	-	3,786E-4
	α_1 [-]	5,590E0	6,336E0	1,092E1	-	7,302E0
	μ_2 [MPa]	8,808E3	4,534E-1	2,400E4	-	2,924E4
	α_2 [-]	4,675E-4	2,276E0	3,179E-4	-	2,906E-4

[a] $\dot{\varepsilon}_{\mathrm{w}} = 0,001\,\mathrm{s}^{-1}$
[b] $\dot{\varepsilon}_{\mathrm{w}} = 100\,\mathrm{s}^{-1}$
[c] Wegrate von $50\,\mathrm{mm\,min}^{-1}$

Tabelle 4.12 Hyperelastische Parameter von TPU

Modell	Parameter	PE399[a]	PE399[b]	PE429[c]	PE499[c]	PE501[c]
Mooney-Rivlin	C_{10}[MPa]	-1,592E1	-8,184E1	-8,018E-1	-1,175E-1	-4,252E1
	C_{01} [MPa]	1,945E1	1,037E2	2,162E0	1,147E0	5,690E1
	C_{20} [MPa]	1,387E0	3,334E0	5,920E-2	1,866E-2	6,487E-1
	C_{11} [MPa]	-6,581E0	-1,728E1	-3,065E-1	-9,251E-2	-3,480E0
	C_{02} [MPa]	1,326E1	4,790E1	8,023E-1	2,444E-1	1,772E1
Yeoh	C_{10} [MPa]	1,305E0	-	9,578E-1	7,594E-1	-
	C_{20} [MPa]	-8,675E-2	-	-2,395E-2	-2,507E-2	-
	C_{30} [MPa]	9,889E-3	-	8,225E-4	7,723E-4	-
Ogden	μ_1 [MPa]	8,212E-3	-	6,409E-2	8,363E-2	-
	α_1 [-]	6,911E0	-	3,927E0	3,373E0	-
	μ_2 [MPa]	1,366E4	-	1,986E1	1,321E3	-
	α_2 [-]	4,408E-4	-	2,245E-1	2,612E-3	-

[a] $\dot{\varepsilon}_{\mathrm{w}} = 0,001\,\mathrm{s}^{-1}$
[b] $\dot{\varepsilon}_{\mathrm{w}} = 100\,\mathrm{s}^{-1}$
[c] Wegrate von $50\,\mathrm{mm\,min}^{-1}$

4.3.3 Vergleich der Materialkennwerte mit Literaturangaben

Zeit- und temperaturabhängiges Materialverhalten

In Tabelle 4.13 sind die aus den Temperatursweeps ermittelten Glasübergangstemperaturen T_g mit Angaben der jeweiligen Produkthersteller sowie weiteren Literaturangaben aufgelistet. Der Vergleich bestätigt die Messergebnisse. Abweichungen können hier insbesondere durch unterschiedliche Prüf- und Auswertemethoden entstehen (s. Abb. 2.28).

Für Verbundglas-Zwischenschichten aus PVB sind einige Prony-Reihen in der Literatur zu finden, wobei diese maximal 13 Maxwell-Elemente beinhalten und nicht unbedingt auf dem identischen Produkt basieren (VAN DUSER et al., 1999; ENSSLEN, 2005; SACKMANN, 2008; BARREDO et al., 2011; HOOPER et al., 2012). In Abbildung 4.36a werden die aus den beiden Torsions-DMTA ermittelten Prony-Reihen mit den Literaturangaben verglichen. Eine gute Übereinstimmung ist mit den von BARREDO et al., 2011 veröffentlichten Daten zu erkennen. Des Weiteren ist erkennbar, in welchen Zeitbereichen

Tabelle 4.13 Vergleich der Glasübergangstemperatur mit Literaturangaben

Material und Typ	Quelle	Glasübergangstemperatur T_g [°C]
PVB BG	Kuntsche[a]	27
	Herstellerangabe	≈ 30
	KOTHE, 2013	32
Standard-PVB allgemein	SAVINEAU, 2013	28 bis 32
PVB SC	Kuntsche	15
	Herstellerangabe	≈ 18
	KOTHE, 2013	20
Schallschutz-PVB allgemein	SAVINEAU, 2013	16 bis 18
PVB ES	Kuntsche	41
	Herstellerangabe	≈ 44
Steifes PVB allgemein	SAVINEAU, 2013	40 bis 45
EVASAFE G77	Kuntsche[a]	-16
	Herstellerangabe[b]	-28
EVA allgemein	SAVINEAU, 2013	-40 bis -15
Ionoplast SG5000	Kuntsche[a]	54
	Herstellerangabe	≈ 53
	KOTHE, 2013	60
	SAVINEAU, 2013	50 bis 55

[a] Mittelwert aus allen Belastungsmodi bei 1 Hz
[b] Aus DSC-Messung

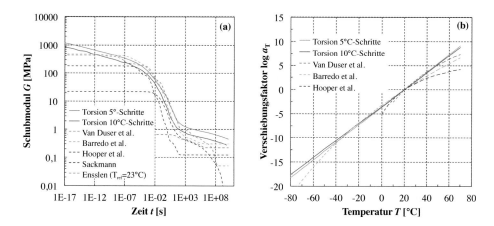

Abbildung 4.36 Vergleich des zeit- und temperaturabhängigen Verhaltens von PVB mit Literaturangaben (VAN DUSER et al., 1999; ENSSLEN, 2005; SACKMANN, 2008; BARREDO et al., 2011; HOOPER et al., 2012): Prony-Reihen (a) und WLF-Funktionen (b)

die jeweiligen Prony-Reihen wirken. Außerhalb der Wirkungsbereiche ist der zeitabhängige Schubmodul konstant. Dazugehörige WLF-Verschiebungsansätze sind in Abbildung 4.36b dargestellt, falls diese angegeben wurden. Auch dieser Vergleich bestätigt die Plausibilität der ermittelten Werte und veranschaulicht die Temperaturbereiche, in denen die jeweiligen Ansätze anwendbar sind. In SCHULER, 2003 wurden ebenfalls viskoelastische Materialparameter für eine PVB-Folie ermittelt, allerdings nur bereichsweise für bestimmte Temperaturen und Belastungsdauern. Zudem wurden verschiedene Ansatzfunktionen verwendet, weswegen ein Vergleich an dieser Stelle nicht geführt wird.

Uniaxiale Spannungs-Dehnungs-Beziehungen

Quasistatische und dynamische uniaxiale Zugversuche an Verbundglas-Folien aus PVB wurden bereits an einigen Forschungseinrichtungen durchgeführt und veröffentlicht. Meist handelt es sich um bei Raumtemperatur ermittelte technische Spannungs-Dehnungs-Beziehungen, obwohl die Angabe, ob technische oder wahre Größen dargestellt werden, selten zu finden ist. Diesen wird eine konstante Dehnrate zugeordnet, obwohl alle bei konstanter Wegrate ermittelt und kein 3D-Fit durchgeführt wurde. Oftmals ist das Vorgehen bei Durchführung und Auswertung nicht nachvollziehbar. In LARCHER et al., 2012 wird der Stand von 2012 zusammengefasst. Damals waren Untersuchungen von BENNISON et al., 2005, MORISON et al., 2007 und IWASAKI et al., 2007 veröffentlicht. Etwa zeitgleich veröffentlichte HOOPER, 2011 in seiner Dissertation ebenfalls Ergebnisse von dynamischen Zugversuchen an PVB.

Abbildung 4.37 vergleicht die Ergebnisse bei quasistatischen (a) und dynamischen (b) Dehnraten. Die Untersuchungen von BENNISON et al., 2005 stimmen gut mit den Ergeb-

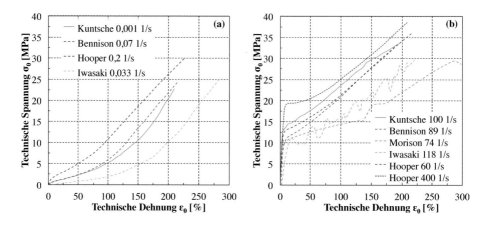

Abbildung 4.37 Vergleich der Ergebnisse an PVB mit Literaturangaben (BENNISON et al., 2005; MORISON et al., 2007; IWASAKI et al., 2007; HOOPER, 2011): quasistatische Dehnraten (a) und dynamische Dehnraten (b)

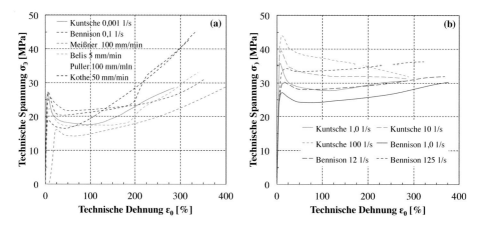

Abbildung 4.38 Vergleich der Ergebnisse an Ionoplast mit Literaturangaben (BENNISON et al., 2005; MEISSNER et al., 2005; BELIS et al., 2009; PULLER, 2012; KOTHE, 2013): quasistatische Dehnraten (a), dynamische Dehnraten (b)

nissen dieser Arbeit überein. Die Untersuchungen von HOOPER, 2011 zeigen ebenfalls vergleichbare Verläufe, jedoch auf einem höheren Spannungsniveau. Zudem ist hier bei den dynamischen Versuchen die während des Versuchs abfallende Dehnrate zu erkennen.

Generell können Abweichungen durch unterschiedliche Probekörpergeometrien und Auswertemethoden (konstante Wegrate oder konstante technische/wahre Dehnrate) entstehen. Zudem kann nicht davon ausgegangen werden, dass es sich um den gleichen PVB-Hersteller und Folientyp handelt.

Zugversuche an Ionoplastfolien sind deutlich seltener in der Literatur zu finden, insbesondere dynamische Versuche wurden nur vom Hersteller selbst durchgeführt (BENNISON et al., 2005). Ergebnisse von quasistatischen Versuchen bei Raumtemperatur finden sich darüber hinaus in MEISSNER et al., 2005, BELIS et al., 2009, PULLER, 2012 und KOTHE, 2013. Abbildung 4.38 vergleicht die Ergebnisse aus Abschnitt 4.2.3 mit denen der Literaturquellen. Die in dieser Arbeit ermittelte quasistatische Kurve (a) liegt zwischen den Ergebnissen von BELIS et al., 2009 und PULLER, 2012. Die dynamischen Ergebnisse (b) zeigen grundsätzlich vergleichbare Ergebnisse zu BENNISON et al., 2005, jedoch mit einem stärker ausgeprägten Abfall nach der Fließgrenze, welche sich auch auf einem höheren Spannungsniveau befindet.

Die bei der Ionoplastfolie gewählte komplexe Auswertemethodik mit wahren Spannungen und Dehnungen bei vorhandener Einschnürung und der Annahme eines linear-elastisch-viskoplastischen Materialverhaltens stellt eine mögliche Ursache für Abweichungen zu den Vergleichskurven dar, die mit konstanten Wegraten und ohne Berücksichtigung lokaler Dehnungen ermittelt wurden.

Von Verbundglas-Zwischenschichten aus EVA und TPU wurden bisher keine Spannungs-Dehnungs-Beziehungen bei hohen Verzerrungsraten veröffentlicht.

Die aus den uniaxialen Zugversuchen ermittelten Elastizitätsmoduln in Tabelle 4.10 können ebenfalls mit Literaturangaben verglichen werden. Für PVB ist bei quasistatischem Zug eine Angabe in DELINCÉ, 2014 mit $E = 18\,\text{MPa}$ zu finden, wobei die Wegrate als „moderat" beschrieben wird. Aus den Ergebnissen seiner dynamischen Zugversuche hat HOOPER, 2011 eine empirische Gleichung aufgestellt, welche bei einer Dehnrate von $100\,\text{s}^{-1}$ einen Elastizitätsmodul $E = 510\,\text{MPa}$ liefert, was sich mit dem in dieser Arbeit ermittelten Wert deckt. BENNISON et al., 2005 hat in seinen dynamischen Zugversuchen einen maximalen Wert von $E = 278\,\text{MPa}$ festgestellt.

In vielen weiteren Quellen wird der Schubmodul einer PVB-Folie als Ergebnis aus Kriech- oder Relaxationsversuchen am Verbundglaslaminat bestimmt. Zusammenfassungen hierzu finden sich beispielsweise in SCHULER, 2003 und SACKMANN, 2008. Da bei diesen Versuchen keine konstante Weg- oder Dehnrate vorlag, ist ein Vergleich an dieser Stelle nicht sinnvoll.

Für die Ionoplastfolie ist die Angabe eines quasistatischen Elastizitätsmoduls $E = 300\,\text{MPa}$ in DELINCÉ, 2014 sowie in der Herstellerbroschüre (DUPONT, 2009) zu finden. MEISSNER et al., 2005 geben einen mittleren Wert $E = 261\,\text{MPa}$ an, PULLER, 2012 hat in ihren Zugversuchen Werte zwischen 534 MPa bis 735 MPa ermittelt. BENNISON et al., 2005 spricht von $E \approx 500\,\text{MPa}$ unabhängig von der Dehnrate. In den vorliegenden Untersuchungen konnte hingegen eine Abhängigkeit von der Dehnrate auch im linearen Anfangsbereich erkannt werden (s. Abb. 4.25a). Der für die Auswertung angenommene konstante Elastizitätsmodul $E = 800\,\text{MPa}$ ist ein Mittelwert aus den quasistatischen und den dynamischen Zugversuchen.

Insgesamt zeigt der Vergleich mit anderen Literaturquellen, dass die ermittelten Werte für den Elastizitätsmodul plausibel sind.

In Tabelle 4.14 werden schließlich die ermittelten Mittelwerte für Reißfestigkeit und Reißdehnung mit Literaturangaben verglichen. Unterschiede können hierbei insbesondere durch die Wahl unterschiedlicher Probekörpergeometrien erklärt werden.

Tabelle 4.14 Vergleich von Reißfestigkeit und Reißdehnung mit Literaturangaben

Material und Typ	Quelle	Reißfestigkeit σ_b [MPa]	Reißdehnung ε_b [%]
PVB BG	Kuntsche[a]	25,6	251
	KURARAY, 2012	>23	>280
	KOTHE, 2013	30	259
PVB SC	Kuntsche	16,6	340
	KURARAY, 2012	>14	>300
	KOTHE, 2013	14	259
PVB ES	Kuntsche	34,9	200
	KURARAY, 2012	≈ 35	≈ 200
Sonstiges PVB dynamisch	HOOPER, 2011[a]	≈ 34	≈ 210
	MORISON, 2007[a]	≈ 26	≈ 280
EVASAFE™ G71	Kuntsche[a]	16,2	370
	DIBT, 2013a	>10	>500
Ionoplast SG5000	Kuntsche[a]	47,1	293
	DUPONT, 2009	34,5	400
	MEISSNER et al., 2005	32,5	440
	BELIS et al., 2009	33	340
	KOTHE, 2013	44	325
TPU PE399	Kuntsche[a]	33,8	349
	HUNTSMAN, 2009	45	500
	KOTHE, 2013	50	404
TPU PE501	Kuntsche	46,4	317
	HUNTSMAN, 2009	45	350

[a] Mittelwert aller untersuchten Wegraten

4.4 Zusammenfassung

Das mechanische Verhalten von Verbundglas-Zwischenschichten wurde anhand experimenteller Untersuchungen studiert. Für einen direkten Vergleich wurden unterschiedliche Zwischenschichten aus PVB, EVA, Ionoplast und TPU untersucht. Damit wird der Großteil der im Bauwesen verwendeten Zwischenschichtmaterialien abgedeckt. Aus den Versuchsergebnissen wurden Parameter für geeignete Materialmodelle abgeleitet.

Zur Charakterisierung des Materialverhaltens im intakten Zustand eines Verbundglases ist eine Beschränkung auf kleine Verzerrungen gerechtfertigt. Die zeit- und temperaturabhängige Steifigkeit bei kleinen Verzerrungen wurde mittels Dynamisch-Mechanisch-Thermischer Analysen (DMTA) untersucht. Neben Amplitudensweeps zur Bestätigung des linear-viskoelastischen Bereichs wurden Temperatursweeps zur Beurteilung der Temperaturabhängigkeit und Frequenzsweeps bei verschiedenen konstanten Temperaturen zur Ermittlung von Masterkurven für den Schubmodul in einer DMTA durchgeführt. Der Einfluss des Belastungsmodus (Zug, Druck, Scherung, Torsion etc.) auf die Ergebnisse und die Anwendbarkeit für Verbundglas-Zwischenschichten wurde anhand von vergleichenden Untersuchungen beurteilt.

Es hat sich gezeigt, dass die Torsion eines Streifens sowie die Doppelscherung mit dem reinen Material geeignet sind. DMTA mit uniaxialem Zug oder mit Doppelscherung am Dreifachlaminat werden nicht empfohlen. Die Plattentorsion im Rheometer wurde nicht untersucht, wird aber ebenfalls als geeignet erachtet, was durch weiterführende Untersuchungen noch zu bestätigen ist. Zur Ermittlung belastbarer Werte ist die Wahl verschiedener Belastungsmodi für den energieelastischen Bereich (z.B. Torsion eines Streifens) und für den entropieelastischen Bereich (z.B. Doppelscherung oder Plattentorsion) zweckmäßig. Zur Ermittlung von Masterkurven werden Temperaturschritte im Frequenzsweep von maximal $\Delta T = 5\,°C$ ab dem Glasübergangsbereich bis hin zur maximal zu untersuchenden Temperatur empfohlen.

Aus den Masterkurven des untersuchten PVB wurden Materialparameter (WLF-Faktoren und Prony-Parameter) zur Beschreibung des viskoelastischen Verhaltens abgeleitet. Hierfür wurde ein Werkzeug entwickelt, welches allgemein die Ermittlung von Prony-Reihen mit einer hohen Anzahl an Parametern durch eine zweistufige nichtlineare Optimierung ermöglicht.

Im gebrochenen Zustand erfährt die Zwischenschicht große Verzerrungen bis zur Bruchdehnung. Der Einfluss der Belastungsgeschwindigkeit auf das Spannungs-Dehnungs-Verhalten bei Raumtemperatur wurde anhand von uniaxialen Zugversuchen mit verschiedenen Wegraten (Prüfgeschwindigkeiten) von $5\,mm\,min^{-1}$ bis $210\,000\,mm\,min^{-1}$ untersucht. Insbesondere die Materialien PVB und Ionoplast zeigten eine deutliche Versteifung bei dynamischer Belastung. Entgegen oft publizierter Aussagen (z.B. IWASAKI et al., 2006) zeigten die PVB-Folien bei Entlastung ein nahezu vollständig reversibles Verhalten auch bei dynamischer Belastung.

Aus den Ergebnissen der Zugversuche wurden linear-elastische und hyperelastische Materialparameter abgeleitet. Der Einfluss aus der produktionsbedingten Oberflächenrauigkeit der Folien wurde untersucht und als vernachlässigbar befunden. Bei dem Standardprodukt PVB BG wurde zudem das üblicherweise angenommene isotrope Materialverhalten untersucht und bestätigt.

Die Angabe von Spannungs-Dehnungs-Beziehungen bei konstanten wahren Dehnraten ist nötig, um einen direkten Vergleich sowie eine Implementierung der Dehnratenabhängigkeit in numerische Materialmodelle zu ermöglichen. Dies erfolgte mittels dreidimensionaler Auswertung über Spannung, Dehnung und Dehnrate. Des Weiteren wurden Reißfestigkeit und Bruchdehnung sowie die Querkontraktionszahl von allen untersuchten Materialien bestimmt.

5 Untersuchungen zum mechanischen Verhalten von intaktem Verbundglas

5.1 Allgemeines

Das zeitabhängige Verhalten von Verbundgläsern mit PVB-Zwischenschicht wurde anhand von Kriechversuchen untersucht. Ziel der Untersuchungen war eine Validierung der in Abschnitt 4.3.2 erstellten Materialmodelle zur Berücksichtigung der Zeit- und Temperaturabhängigkeit bei geringen Verzerrungen (Prony-Parameter und Zeit-Temperatur-Verschiebungsansatz). In diesem Zusammenhang sollte mit den numerischen Simulationen die Sensibilität der Materialmodelle von Verbundglas-Zwischenschichten auf die Reaktion des gesamten Glaslaminats veranschaulicht werden.

Der Lastfall Explosion wurde experimentell in einem Stoßrohr simuliert. Bei diesen Versuchen und deren numerischen Simulationen wurde mit dicken Mehrfachlaminaten das mechanische Verhalten bis zum Glasbruch betrachtet. Ziel war es, zu zeigen, dass das mechanische Verhalten von Verbundglas im Lastfall Explosion bis zum Glasbruch numerisch gut abbildbar ist und auch Prognosen für eine Glasbemessung möglich sind. Teile dieser Untersuchungen wurden bereits in KUNTSCHE et al., 2013a und KUNTSCHE et al., 2014a veröffentlicht.

In Abschnitt 5.2 werden die durchgeführten experimentellen Untersuchungen und deren Ergebnisse dargestellt. Die numerischen Untersuchungen folgen in Abschnitt 5.3.

5.2 Experimentelle Untersuchungen

5.2.1 Zeitabhängige Belastung: Kriechversuche

Der Versuchsaufbau der Kriechversuche entsprach – soweit nicht anders angegeben – DIN EN 1288-3 mit Probekörperabmessungen von 1100 mm × 360 mm und einer Stützweite von 1000 mm. Abweichend zu dem Vierschneidenbiegeversuch DIN EN 1288-3 wurde der Versuch als Dreischneidenbiegeversuch durchgeführt. Der Versuchsaufbau ist in Abbildung 5.1 dargestellt. Die konstante Belastung wurde über 24 h gehalten, während die zeitabhängige Verformung gemessen wurde.

Abbildung 5.1 Versuchsaufbau des Kriechversuchs als Dreischneidenbiegeversuch

Als Prüfmaschine wurde eine *Zwick Z050 THW* mit werksseitig eingebauter Kraft-messdose (*Zwick Roell Xforce K* 50 kN) verwendet. Anhand eines induktiven Wegauf-nehmers (*Messotron WLG650R*) wurde bestätigt, dass der Traversenweg der Prüfmaschi-ne ausreichend genaue Ergebnisse für die maximale Durchbiegung in Feldmitte liefert.

Als Glasaufbau wurde ein Verbundglas aus 2×3 mm Kalknatron-Silikat-ESG (KNS-ESG) mit einer 1,52 mm dicken Zwischenschicht aus PVB (Trosifol$^{\circledR}$ BG) gewählt, um hohe Kriechdeformationen zu ermöglichen. Es wurde das Kriechverhalten von drei Pro-bekörpern untersucht. Die Gesamtdicke der Probekörper wurde mit einer digitalen Bügel-messschraube (*Helios Digimet 40 EX*, Genauigkeit 4 μm) ermittelt.

Die während des Versuchs konstant gehaltene Kraft ergibt sich aus dem Bemessungs-wert für den Widerstand $R_\mathrm{d} = 88$ MPa und der Annahme, dass kein Verbund zwischen den Glasplatten vorhanden ist. Bei einer Kraft von etwa 400 N entspricht die Hauptzugspan-nung im Glas dem Bemessungswert R_d. Die Kraft wurde mit einer konstanten Wegrate von 10 mm min^{-1} angefahren und anschließend kraftgeregelt 24 h gehalten. Anschließend wurden die Probekörper entlastet. Tabelle 5.1 fasst die Prüfbedingungen zusammen.

Die Ergebnisse in Abbildung 5.2 zeigen eine geringe Streuung auf, die auf die Di-ckenschwankungen der einzelnen Schichten und die Prüftemperatur zurückgeführt werden kann. Der Probekörper 1 ergab deckungsgleiche Ergebnisse mit Probekörper 3. In Abbil-dung 5.2a ist zudem erkennbar, dass bei Raumtemperatur ein Teilverbund herrscht: Die

Tabelle 5.1 Prüfbedingungen für die Kriechversuche

Probekörper	mittlere Gesamtdicke [mm]	mittlere Raumtemperatur [°C]
1	7,2	22,0
2	7,1	21,9
3	7,3	21,2

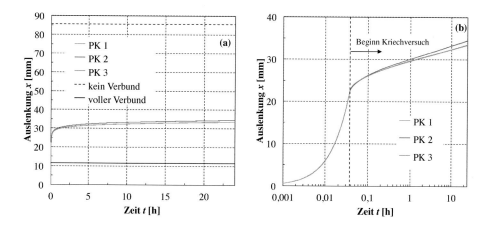

Abbildung 5.2 Ergebnisse der Kriechversuche: Zeit linear (a) und logarithmisch (b) aufgetragen

gemessene Auslenkung befindet sich zwischen den Grenzwerten „kein Verbund" und „voller Verbund" (s. Abb. 2.31). Der Teilverbund nimmt durch das viskoelastische Verhalten der Zwischenschicht kontinuierlich ab, ist am Ende der Prüfung aber immer noch deutlich vorhanden. Nach Entlastung zeigten alle Probekörper ein zeitlich verzögertes vollständig reversibles Verformungsverhalten.

5.2.2 Lastfall Explosion: Stoßrohrversuche

Das mechanische Verhalten von Verbundglas im Lastfall Explosion wurde im Rahmen dieser Arbeit anhand von Stoßrohrversuchen nach DIN EN 13541 untersucht. In dieser Versuchsreihe wurde das intakte Verhalten bis einschließlich des Glasbruchs untersucht und die untersuchten Aufbauten klassifiziert. Stoßrohrversuche zum Nachbruchverhalten werden in Abschnitt 6.2.3 beschrieben. Die Klassifizierungsanforderungen aus der Norm sowie die Grundlagen zum Prüfverfahren sind in Abschnitt 2.4.9 dargelegt.

In einem Stoßrohr wird eine Explosionsdruckwelle erzeugt, ohne dass ein Sprengsatz detoniert. Statt dessen wird Luft in der Kompressionskammer bis zu einem definierten Überdruck verdichtet (Abb. 5.3). Anschließend wird die Membran schlagartig geöffnet (bspw. durch Anstechen mit einem Stahldorn) und der Druck entweicht in die Expansionskammer. Der Probekörper wird dadurch mit einer nahezu ebenen Stoßwelle beansprucht, die im Unterschied zu einem Freiland-Sprengversuch sehr gut reproduzierbar ist.

Die Abmessungen der Probekörper betragen nach DIN EN 13541 900 mm auf 1100 mm. Der Glasrand ist umlaufend über eine Breite von 50 mm mit einer Zwischenlage aus Gummi (Härte 50 IRHD) in einen Stahlrahmen mit einem Einspanndruck von $14\,\mathrm{N\,cm^{-2}}$ geklemmt, sodass die Ränder teileingespannt sind (Abb. 5.4).

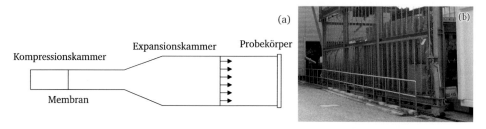

Abbildung 5.3 Schematische Darstellung eines Stoßrohrs (a) und Versuchseinrichtung am *Fraunhofer Ernst-Mach-Institut (EMI)* (b)

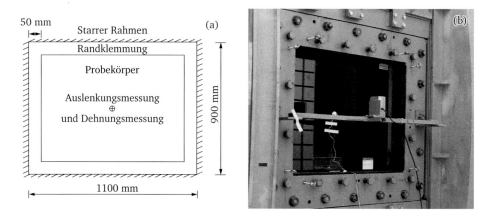

Abbildung 5.4 Abmessungen der Probekörper (a) und Einbausituation am *EMI* (b)

Untersucht wurden zwei Glaslaminattypen der Firma *Schott*, welche in Abbildung 5.5 dargestellt sind. Aufbau 1 ist eine beschusshemmende Verglasung und besteht aus drei Borosilikatgläsern mit zwei Zwischenschichten aus PVB. Zwei der Gläser sind thermisch entspannt (Boro33), das Rückglas ist thermisch vorgespannt (Pyran). Aufbau 2 ist eine Brandschutzverglasung bestehend aus sechs thermisch entspannten Kalknatron-Silikatgläsern (KNS-Float) und fünf Wasserglasschichten (s. Abschn. 2.4.7), sodass dieses Laminat eine Feuerwiderstandsklasse EI 60 nach DIN EN 357 erreicht. Die quasistatische und dynamische Festigkeit dieser Glasarten wurde in Kapitel 3 untersucht.

Die Nenndicken der Verbundgläser von 19 mm und 23 mm sind im Vergleich zu deren Länge und Breite relativ groß gewählt, um mehrere Laststufen im intakten Zustand prüfen zu können. Dies hat Auswirkungen auf das Nachbruchverhalten, da die beim Glasbruch freigesetzte Energie so groß ist, dass die vergleichsweise dünnen (Aufbau 1) oder schwachen (Aufbau 2) Zwischenschichten nach dem Bruch der Gläser direkt reißen. Somit stimmen für dicke Glaslaminate der Zeitpunkt des Glasbruchs und des Gesamtversagens des Laminats meist nahezu überein und es sind nur die beiden Zustände „Laminat intakt" und „Laminat versagt vollständig" zu unterscheiden.

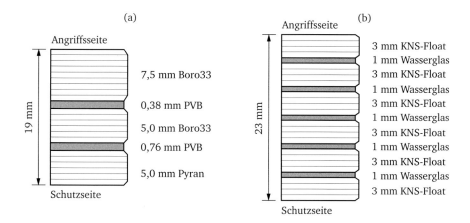

Abbildung 5.5 Untersuchte Glasaufbauten: Aufbau 1 (a) und Aufbau 2 (b)

Um das unter- und überkritische Verhalten zu untersuchen, wurde die Belastung in den einzelnen Versuchen stufenweise bis zum Versagen gesteigert (Tab. 5.2). Je Aufbau wurden drei Probekörper geprüft, um eine Klassifikation nach DIN EN 13541 zu ermöglichen. Insgesamt wurden 15 Stoßrohrversuche durchgeführt. Gemessen wurde der freie einfallende und der reflektierte Überdruck sowie die Dehnung in der Mitte des Rückglases in drei Richtungen mittels DMR. Die Messfrequenz betrug 1,0 MHz, um eine ausreichende transiente Auflösung über den zu untersuchenden Zeitbereich zu erhalten.

Für die Berechnung der Hauptzugspannungen aus den gemessenen Dehnungen wurden die in Tabelle 3.2 angegeben Elastizitätsmoduln verwendet, welche durch quasistatische Doppelring-Biegeversuche an Gläsern aus der gleichen Herstellung ermittelt wurden. Zur Gültigkeit des Übertrags eines quasistatischen auf einen dynamischen Elastizitätsmodul siehe Abschnitt 2.2.1. Die Querkontraktionszahl wurde nach den Produktnormen DIN EN 572-1 und DIN EN 1748-1-1 einheitlich zu $v = 0,2$ gewählt. Eine Übersicht über die Materialparameter der verschiedenen Glasarten gibt Tabelle 5.6.

Wenn kein Versagen zu erwarten war, wurde zudem die Auslenkung des Plattenmittelpunkts optisch mittels eines Laser-Distanzmessgeräts transient erfasst (s. Abb. 5.4). In Abbildung 5.6a werden beispielhaft alle Messdaten eines Versuchs mit Aufbau 1 bei Laststufe ER 3 veranschaulicht. In Abbildung 5.6b sind die ermittelten Hauptzugspannungen dreier Versuche mit Aufbau 2 und Laststufe ER 1 dargestellt. Die gute Reproduzierbarkeit der Stoßrohrversuche ist erkennbar.

Hochgeschwindigkeits-Videoaufnahmen (2000 fps) ermöglichten die Dokumentation des Bruchursprungs, welcher in der Mitte der Verglasung identifiziert wurde, und der Versagensmechanismen (Abb. 5.7 und 5.8).

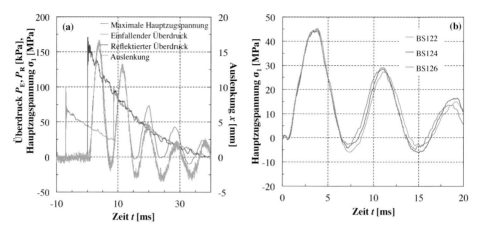

Abbildung 5.6 Messergebnisse: Aufbau 1, ER 3, BS114 (a); Aufbau 2, ER 1, BS122, BS124, BS126 (b)

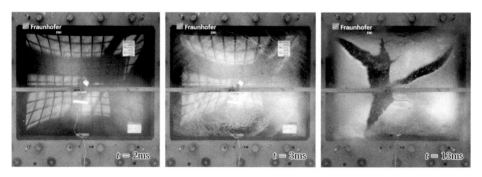

Abbildung 5.7 Einzelbilder der High-Speed Videoaufnahme (Aufbau 1, ER 4, BS121)

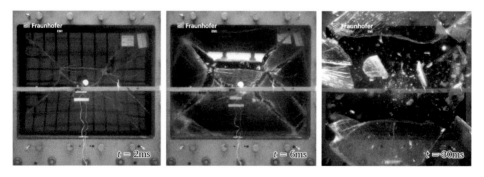

Abbildung 5.8 Einzelbilder der High-Speed Videoaufnahme (Aufbau 2, ER 2, BS127)

In Tabelle 5.2 sind die Ergebnisse der Versuche zusammengestellt. Es zeigt sich, dass das Glas entweder intakt bleibt oder das Laminat vollständig versagt. Aufbau 1 erreicht eine Klassifikation ER 3 NS, Aufbau 2 kann als ER 1 NS klassifiziert werden.

Weitere Ergebnisse sind in Tabelle 5.3 dargestellt. Anhand der gemessenen Dehnungen wurden die maximalen Spannungen und die Spannungsraten, die während der ersten Schwingung auftraten, berechnet. Bei Versagen des Laminats wurde die Bruchspannung bestimmt. Für Aufbau 1 mit einem Rückglas aus thermisch vorgespanntem Borosilikatglas ergibt sich aus den Versuchen BS115 und BS121 ein Mittelwert der Bruchspannung von 185 MPa, für Aufbau 2 mit thermisch entspanntem Kalknatron-Silikatglas 74 MPa (BS123, BS125 und BS127).

Aufgrund der geringen Stichprobe sind die Werte statistisch nicht belastbar. Sie liegen zwischen den bruchmechanisch prognostizierten charakteristischen Werten und den Mittelwerten nach Tabelle 3.6. Es wird vermutet, dass eine vergleichsweise starke Vorschädigung während des Laminationsprozesses, des Transports und der Präparation für die Versuche eingebracht wurde. Zudem wurden die Gläser durch vorangegangene Stoßrohrversuche vorbelastet und so ein subkritisches Risswachstum initiiert.

Die in den Stoßrohrversuchen ermittelten zeitlichen Verläufe von Verformung und Hauptzugspannung dienen der Validierung numerischer Modelle in Abschnitt 5.3.2. Hier-

Tabelle 5.2 Ergebnisse der Stoßrohrversuche

Aufbau	Probekörper- nummer	Gesamtdicke [mm]	Versuchs- nummer	Laststufe	Ergebnis
1	1	18,54	BS112	ER 1	intakt
			BS113	ER 2	intakt
			BS114	ER 3	intakt
			BS115	ER 4	versagt
	2	18,70	BS117	ER 2	intakt
			BS118	ER 3	intakt
	3	18,90	BS119	ER 2	intakt
			BS120	ER 3	intakt
			BS121	ER 4	versagt
2	1	23,33	BS122	ER 1	intakt
			BS123	ER 2	versagt
	2	23,03	BS124	ER 1	intakt
			BS125	ER 2	versagt
	3	23,40	BS126	ER 1	intakt
			BS127	ER 2	versagt

Tabelle 5.3 Ergebnisse der Stoßrohrversuche (Fortsetzung)

Aufbau	PK	Versuchs-nummer	Max. Hauptzug-spannung[a] [MPa]	Max. Auslen-kung[a] [mm]	Mittlere Spannungs-rate[a] [MPa s^{-1}]
1	1	BS112	56	5,8	24 000
		BS113	110	11,2	49 200
		BS114	159	16,2	72 400
		BS115	180[c]	-[b]	99 200
	2	BS117	106	10,1	48 200
		BS118	157	-[b]	72 600
	3	BS119	108	10,1	50 800
		BS120	159	-[b]	73 100
		BS121	190[c]	-[b]	101 300
2	1	BS122	45	3,3	20 800
		BS123	80[c]	-[b]	42 200
	2	BS124	45	3,1	20 700
		BS125	78[c]	-[b]	44 800
	3	BS126	44	3,5	19 600
		BS127	66[c]	-[b]	44 600

[a] Mitte des Rückglases
[b] keine Messung
[c] Bruchspannung

für wurde auch der zeitliche Verlauf des reflektierten Drucks ausgewertet, um die anzusetzende Belastung zu ermitteln.

Die Parameter der Friedlander-Gleichung (2.4) sind in Tabelle 5.4 für alle Laststufen dargestellt. Abbildung 5.9 zeigt beispielhaft die angepassten Friedlander-Kurven mit den Versuchsdaten für die Laststufen ER 1 und ER 2.

Tabelle 5.4 Parameter der Friedlander-Kurven und positiver Impuls für die Laststufen ER 1 bis ER 4

Last-stufe	Maximaler Über-druck P_R [kPa]	Dauer der positiven Druckphase t_+ [ms]	Formparame-ter A_Z [-]	Positiver Impuls i_+ [kPa ms]
ER 1	57	21	0,7	470
ER 2	110	26	1,1	1020
ER 3	160	39	1,35	2090
ER 4	210	39	1,55	2600

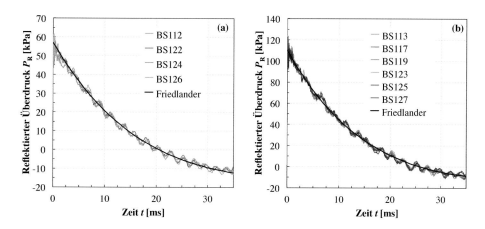

Abbildung 5.9 Messdaten und Friedlander-Kurven für die Laststufen ER 1 (a) und ER 2 (b)

5.3 Numerische Untersuchungen

5.3.1 Zeitabhängige Belastung: Simulation der Kriechversuche

Das FE-Modell in *Ansys Workbench 15.0* (ANSYS INC., 2012a) zur Simulation der Kriechversuche aus Abschnitt 5.2.1 ist in Abbildung 5.10 dargestellt. Es wurden 20-Knoten-Volumenelemente (*Solid186*) und lineare Elastizität für alle Materialien mit Ausnahme der PVB-Zwischenschicht verwendet. Um einen stabilen Kontakt zwischen den Lagerrollen und den Glasplatten zu ermöglichen, wurden in diesen Bereichen dünne elastische Zwischenschichten angeordnet (Abb. 5.10b). Die Reibung in den Rollenlagern wurde durch die Wahl eines reibungsfreien Kontakts zwischen Stahlrolle und Lager-Zwischenschicht vernachlässigt. Zwischen Glas und Lager-Zwischenschicht wurde ein Verbundkontakt gewählt. Die Simulation erfolgte unter Berücksichtigung geometrischer Nichtlinearität und Ausnutzung der Doppelsymmetrie. Die Massenträgheit wurde nicht berücksichtigt.

Abbildung 5.10 FE-Modell in Ansys Workbench: Viertelmodell unter Ausnutzung der Doppelsymmetrie (a) und Detailausschnitt der Lastrolle (b)

In Tabelle 5.5 sind die Materialkonstanten und die angesetzten Schichtdicken h, welche sich aus Tabelle 5.1 ergeben, zusammengestellt. Die Materialkonstanten des Glases wurden den Untersuchungen in Abschnitt 3.2.1 sowie der Produktnorm DIN EN 572-1, die der Stahlrollen der Ansys-Datenbank (ANSYS INC., 2012a) entnommen. Die Steifigkeit der PVB-Zwischenschicht wurde mit den Prony-Reihen aus Tabelle 4.9 und Literaturangaben (VAN DUSER et al., 1999; BARREDO et al., 2011; HOOPER et al., 2012) unter der Annahme der Volumenkonstanz abgebildet. Zur Berücksichtigung der Prüftemperatur von etwa 22 °C wurden die entsprechenden WLF-Verschiebungen angesetzt. Die Dichte von PVB entstammt Tabelle 2.7.

In einem ersten Schritt wurde das Eigengewicht aktiviert, um die daraus resultierenden Kriechverformungen zu berücksichtigen. Hierbei wirkt nur das Verbundglas und nicht die Lagerrollen. In einem zweiten Schritt wurde die Belastung entsprechend der experimentellen Untersuchungen in einer Zeit von 136 s auf 100 N (Viertelmodell) linear gesteigert und anschließend konstant gehalten. Die gewählten Zeitschrittweiten und Elementgrößen wurden anhand von Konvergenzstudien als ausreichend fein diskretisiert bestätigt.

Die Ergebnisse der Simulationen im Vergleich zu den experimentellen Messungen sind in Abbildung 5.11 dargestellt. Die beiden aus den Torsions-DMTA ermittelten Prony-Reihen aus Tabelle 4.9 zeigen deutliche Unterschiede zueinander in den Kriechkurven (a), obwohl die zeitabhängigen Schubmoduln G in Abbildung 4.33b sich nicht signifikant unterscheiden. Dies verdeutlicht die hohe Sensibilität der Reaktion von Verbundgläsern auf die Zwischenschichtsteifigkeit. Die Prony-Reihe aus dem Torsionsversuch mit 10 °C-Schritten liegt deutlich näher an den experimentellen Kriechversuchen, insbesondere die Steifigkeit zu Beginn der Kriechversuche wird gut getroffen (b).

Durch Variation des initialen Schubmoduls G_0 wird eine Prony-Reihe vertikal, durch Variation der angesetzten Temperatur T horizontal verschoben. Bei einem initialen Schubmodul von $G_0 = 750$ MPa anstelle von $G_0 = 911$ MPa oder bei einer angesetzten Temperatur von $T = 33$ °C anstelle von $T = 22$ °C wird die experimentelle Kriechkurve gut getroffen (c). Die Auswirkungen auf die Prony-Reihe durch Variation von Schubmodul oder Temperatur unterscheiden sich insgesamt stark, jedoch nicht im für den Kriechversuch relevanten Zeitbereich (d). Dies verdeutlicht, dass die Prony-Reihe nur im relevanten Zeit-

Tabelle 5.5 Materialeigenschaften im *Ansys*-Modell zur Simulation der Kriechversuche

	KNS-ESG	PVB	Rollen (Stahl)	Zwischenschicht (Lager)
E [MPa]	68 500	-[a]	200 000	100
ν [-]	0,2	0,499	0,3	0,49
ρ [t m^{-3}]	2,5	1,1	-[b]	-[b]
h [mm]	$2 \times 2,9$	1,4	-	0,5

[a] Prony-Reihen aus Tabelle 4.9 bzw. VAN DUSER et al., 1999; BARREDO et al., 2011; HOOPER et al., 2012
[b] Um Kriechen aus Eigengewicht nicht zu verfälschen, wurde die Dichte nicht berücksichtigt

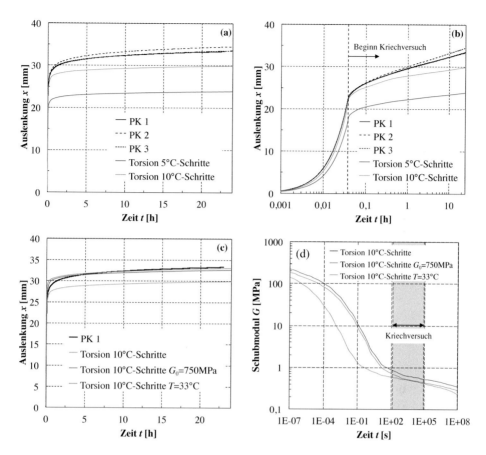

Abbildung 5.11 Vergleich der Kriechversuche in Experiment und Numerik mit Prony-Reihen aus Torsions-DMTA: Zeit linear (a) und logarithmisch (b) aufgetragen, Anpassung der Kriechversuche durch Verschiebung der Prony-Reihe (c) und Auswirkung auf den zeitabhängigen Schubmodul (d)

und Temperaturbereich korrekt ermittelt werden muss und der Anwendungsbereich daher vorher zu definieren ist.

Die vertikal verschobene Prony-Reihe in Abbildung 5.11d ähnelt stark der Ursprünglichen. Dies plausibilisiert erneut die Ergebnisse der Torsions-DMTA, zeigt aber auch die Notwendigkeit der Validierung für belastbare Prony-Reihen.

Ein Vergleich mit Prony-Reihen aus der Literatur (VAN DUSER et al., 1999; BARREDO et al., 2011; HOOPER et al., 2012) ist in Abbildung 5.12 dargestellt. Die Simulation mit der Prony-Reihe von BARREDO et al., 2011 liegt leicht über der experimentellen Kurve. Die von VAN DUSER et al., 1999 liegt leicht darunter und weist einen ungewöhnlichen Knick zu Beginn des Kriechversuchs auf, welcher auf den sprunghaften Verlauf der Prony-Reihe zurückzuführen ist (s. Abb. 4.36a). Die von HOOPER et al., 2012 angegebene Prony-Reihe

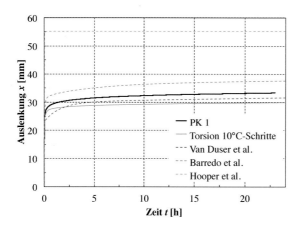

Abbildung 5.12 Vergleich der Kriechversuche in Experiment und Numerik mit Prony-Reihen aus Torsions-DMTA (s. Abschn. 4.3.2) und Literatur (VAN DUSER et al., 1999; BARREDO et al., 2011; HOOPER et al., 2012)

liefert im betrachteten Zeit- und Temperaturbereich eine nahezu konstante und deutlich zu geringe Steifigkeit. Die Literaturangaben beziehen sich zwar auf eine Zwischenschicht aus PVB aber nicht unbedingt auf das gleiche Produkt, sodass auch hierdurch Unterschiede in der Steifigkeit resultieren können.

Durch die Verwendung von thermisch vorgespanntem Glas konnten hohe Auslenkungen in den experimentellen Untersuchungen realisiert werden. Die Simulationen haben gezeigt, dass dadurch in der Zwischenschicht maximale wahre Hauptdehnungen von $\varepsilon_{w,1} \approx$ 10 % hervorgerufen wurden. Aus diesem Grund werden weiterführende Untersuchungen an den Zwischenschichtmaterialien empfohlen, um die Anwendungsgrenzen der linearen Viskoelastizität in Abhängigkeit der Temperatur zu bestimmen. Dies kann beispielsweise anhand von DMTA mit größeren Deformationen oder Relaxationsversuchen mit verschiedenen Verzerrungsniveaus erfolgen (s. Abb. 2.21). Dabei sollte vorzugsweise die Zwischenschicht auf Schub beansprucht werden, beispielsweise durch Scherung oder Torsion.

5.3.2 Lastfall Explosion: Simulation der Stoßrohrversuche

In diesem Abschnitt wird gezeigt, dass eine realitätsnahe numerische Simulation des mechanischen Verhaltens von Verbundglas unter dem Lastfall Explosion bis zum Bruch der Gläser möglich ist. Die Methode der finiten Elemente stellt hierfür ein geeignetes Hilfsmittel dar. Eine transiente Berechnung des intakten Verbundglases kann sowohl mittels expliziter als auch mittels impliziter Zeitintegration erfolgen. An dieser Stelle wird die implizite Zeitintegration gewählt, da hiermit größere Zeitschritte für eine stabile Lösung gewählt werden können. Eine konvergente Lösung mit der Einhaltung der Bewegungsgleichung stellt zudem eine Kontrolle dar, die eine explizite Zeitintegration nicht bietet (s. Abschn. 2.5).

Es wurden zwei Finite-Elemente-Programme verwendet, welche mit dem in Abschnitt 2.5 vorgestellten Newmark-Verfahren arbeiten:

- *Ansys Workbench 14.5* (ANSYS INC., 2012a)
 Komplexes Modell zur realitätsnahen Erfassung des mechanischen Verhaltens,

- *SJ Mepla 3.5.7* (SJ SOFTWARE GMBH, 2013)
 Vereinfachtes Modell zur Abschätzung der auftretenden Glasspannungen bei deutlich geringerem Rechenaufwand.

Mit diesen Modellen wurden die Stoßrohrversuche aus Abschnitt 5.2.2 abgebildet. Als Vorarbeit diente eine Parameterstudie mit beiden Programmen für eine geeignete räumliche und zeitliche Diskretisierung bei Explosionsereignissen (LANGER, 2012). Im Folgenden werden die Modelle vorgestellt und miteinander verglichen.

Modell in Ansys Workbench

Dieses Modell soll die im Versuch vorliegenden Randbedingungen möglichst vollständig und realitätsnah erfassen, was entscheidend ist, um die Verformungen und Spannungen im Glaslaminat korrekt abbilden zu können. Neben der Modellierung der Randklemmung aus Stahl und der Gummi-Zwischenlage wurden die verschiedenen Schichten der Verbundgläser mit ihren tatsächlichen Dicken berücksichtigt. Die Explosionseinwirkung wurde als Friedlander-Kurve den Versuchsdaten entnommen und dem Modell übergeben.

Es wurden 20-Knoten-Volumenelemente (*Solid186*) verwendet und lineare Elastizität für alle Materialien angesetzt, auch für die PVB-Folie. Aufgrund der geringen Verzerrungen und der kurzen Einwirkungsdauer ist eine Berücksichtigung der Visko- oder Hyperelastizität hier nicht notwendig. Dies wird durch den Vergleich zwischen Experiment und Numerik bestätigt. Um eine einfache räumliche Diskretisierung des Modells zu ermöglichen, wurde zwischen Stahlrahmen und Gummi-Zwischenlage ein Kontakt definiert. Zur Berücksichtigung des vorhandenen Einspanndrucks im Stahlrahmen wurde dieser als Verbundkontakt ausgeführt. Die restlichen Volumenkörper sind über koinzidente Knoten miteinander verbunden. Je Schicht ist ein Element über die Höhe angeordnet, die

Abbildung 5.13 FE-Modelle in *Ansys Workbench*: Aufbau 1 (a und b), Aufbau 2 (c)

Zeitschritte wurden zwischen 0,05 ms und 5 ms je nach Konvergenzverhalten programmintern gewählt. Die Modellierung wurde mittels Netz- und Zeitschrittstudien als ausreichend fein diskretisiert bestätigt. Abbildung 5.13 zeigt die *Ansys*-Modelle für Aufbau 1 und 2 (s. Abb. 5.5). Bei der Modellierung wurde die Doppelsymmetrie ausgenutzt, um die Rechenzeit zu minimieren, sodass nur ein Viertel der Platte abgebildet wurde. Die Freiheitsgrade der äußersten Knoten des Stahlrahmens wurden vollständig fixiert.

Die verwendeten Materialparameter sind in Tabelle 5.6 dargestellt. Wie in Abschnitt 5.2.2 erläutert, wurden quasistatische Doppelring-Biegeversuche an monolithischen Gläsern gleicher Herstellung durchgeführt, um den tatsächlich vorliegenden Elastizitätsmodul zu ermitteln (s. Abschn. 3.2.1). Querkontraktionszahl und Dichte der Gläser entstammen den Angaben der Produktnormen (DIN EN 572-1; DIN EN 1748-1-1) oder der Hersteller. Die in Aufbau 1 eingesetzte Zwischenschicht PVB verhält sich unter kurzzeitigen Belastungen deutlich steifer als unter quasistatischer Beanspruchung. Für eine Belastungsdauer im ms-Bereich kann in Abbildung 4.33b ein Schubmodul von $G_{\mathrm{PVB}} \approx 100\,\mathrm{MPa}$ abgelesen werden. Dies entspricht einem Elastizitätsmodul von $E_{\mathrm{PVB}} \approx 300\,\mathrm{MPa}$, wobei eine weitere Steigerung der Zwischenschichtsteifigkeit keine signifikanten Auswirkungen auf die globalen Verformungen und die im Glas erzeugten Spannungen hat. Die Querkontraktionszahl wurde mit $v = 0,49$ für ein nahezu volumenkonstantes Material eingegeben. Für die Wasserglasschichten in Aufbau 2 wurden in TU DRESDEN, 2006 Untersuchungen zum Schubverbund mittels Vierschneidenbiegeversuchen am Glaslaminat durchgeführt. Es zeigt sich, dass die Wasserglasschichten unter kurzzeitiger Belastung eine sehr hohe Steifigkeit aufweisen, die bei andauernder Belastung schnell absinkt. Die Berechnungen wurden daher mit der Annahme $G_{\mathrm{Wasserglas}} = 5000\,\mathrm{MPa}$ durchgeführt. Vergleichsrechnungen mit deutlich geringeren Steifigkeiten für die Wasserglasschichten

Tabelle 5.6 Materialeigenschaften der *Ansys*-Modelle

	Boro33	Pyran	KNS-Float	PVB	Wasser-glas	Gummi-Zwischenlage	Stahl
E [MPa]	59 000	62 300	69 000	300	12 000	180	200 000
v [-]	0,2	0,2	0,2	0,49	0,2	0,49	0,3
ρ [t m^{-3}]	2,2	2,3	2,5	1,1	2,0	1,0	7,8

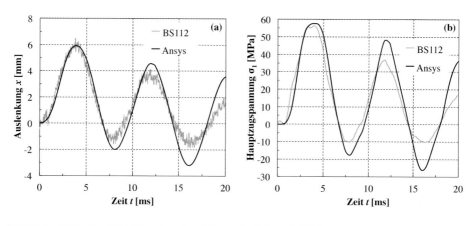

Abbildung 5.14 Vergleich Experiment und Numerik: Aufbau 1, ER 1

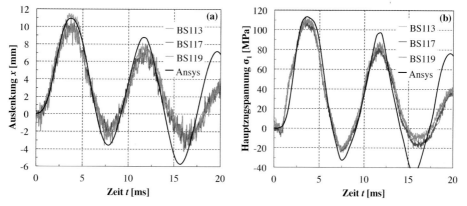

Abbildung 5.15 Vergleich Experiment und Numerik: Aufbau 1, ER 2

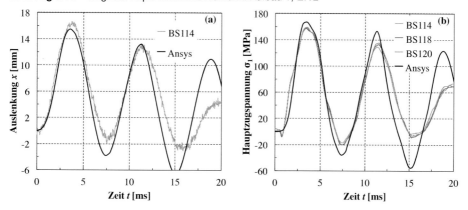

Abbildung 5.16 Vergleich Experiment und Numerik: Aufbau 1, ER 3

($G_{\text{Wasserglas}} = 500\,\text{MPa}$) zeigten, dass der Einfluss in diesem Steifigkeitsbereich vernachlässigbar ist. Für die Gummi-Zwischenlage waren zum Zeitpunkt der Berechnungen keine Materialdaten vorhanden, sodass die Steifigkeit in einem für Elastomere üblichen Bereich ($10\,\text{MPa} \leq E_{\text{Gummi}} \leq 1000\,\text{MPa}$) angenommen wurde und anhand der Deformation von Aufbau 1 bei der geringsten Laststufe ER 1 kalibriert wurde. Damit ergab sich eine Steifigkeit von $E_{\text{Gummi}} = 180\,\text{MPa}$. Die Materialeigenschaften für Stahl wurden der *Ansys*-Datenbank (ANSYS INC., 2012a) entnommen. Alle Materialdaten wurden für beide Aufbauten und alle Laststufen konstant gehalten. Die so berechneten Hauptzugspannungen in der Mitte des Rückglases sowie die Auslenkungen des Plattenmittelpunkts konnten anschließend mit den Ergebnissen der experimentellen Untersuchungen verglichen werden.

In den Abbildungen 5.14 bis 5.17 sind die Ergebnisse der Berechnungen für beide Aufbauten bei den verschiedenen Laststufen, bei denen das Glas intakt bleibt, dargestellt. Es ist eine sehr gute Übereinstimmung der berechneten mit den experimentell ermittelten Kurven festzustellen. Es ist zu beachten, dass die Finite-Element-Berechnungen keine Dämpfung berücksichtigen. Da jedoch bei der ersten Schwingung die Druckwelle intensiver als bei den folgenden Schwingungen wirkt, ist diese auch ohne Berücksichtigung einer Dämpfung größer (s. Abb. 5.6a). In Bezug auf Auslenkung und Hauptzugspannung im Glas und damit für die Prognose des Glasbruchs ist somit nur die erste Schwingung maßgebend, die weiteren Schwingungen sind nicht relevant. Des Weiteren ist anzumerken, dass nicht alle experimentellen Daten am *EMI* gefiltert wurden, sodass in einigen Versuchskurven das messtechnisch bedingte Rauschen zu erkennen ist.

Sind die Bruchspannungen bekannt, können mit den in *Ansys* berechneten Hauptzugspannungen Prognosen über das Versagen des Laminats getroffen werden. In Abbildung 5.18a ist dieser Vergleich dargestellt. Bei Aufbau 1 und Laststufe ER 3 liegt die berechnete Hauptzugspannung im Glas mit 167 MPa unter der experimentell bestimmten Bruchspannung von 185 MPa und das Glas bleibt intakt. Für die Laststufe ER 4 liegt die berechnete Hauptzugspannung mit 211 MPa über der Bruchspannung und das Glas bricht. Ebenso lässt sich für Aufbau 2 die Belastung prognostizieren, bei der Glasbruch auftritt (5.18b).

Somit lassen sich für die beiden Aufbauten auch die Belastungsparameter P_R und i_+ variieren, um die Versagenskurve in einem Druck-Impuls-Diagramm (P-I-Diagramm) zu bestimmen (Abb. 5.19). Dieses dient der Bemessung von Verglasungen bei unterschiedlichen Einwirkungsszenarien: Anhand der numerisch ermittelten P-I-Kurve kann ein Versagen des Glaslaminats für beliebige Kombinationen aus Druck und Impuls prognostiziert werden. Wird der Impuls sehr groß, nähert sich die P-I-Kurve einer Asymptoten an, welche als dynamischer Grenzwert bezeichnet wird.

Das komplexe FE-Modell in *Ansys* mit impliziter Zeitintegration erfasst das mechanische Verhalten von Verbundglas unter dem Lastfall Explosion bis zum Bruch des Glases. Da bei den dicken Laminaten der Glasbruch mit dem vollständigen Versagen des Laminats übereinstimmt, ist eine Betrachtung des Nachbruchverhaltens nicht erforderlich. Bei

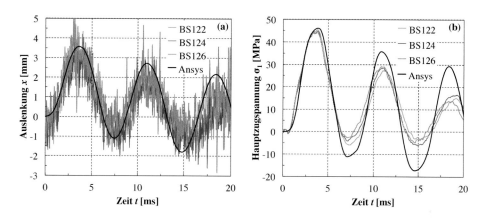

Abbildung 5.17 Vergleich Experiment und Numerik: Aufbau 2, ER 1

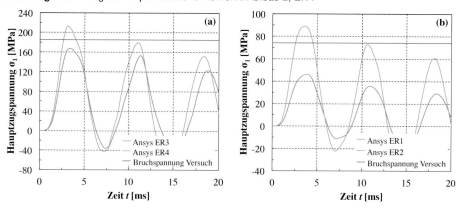

Abbildung 5.18 Vergleich zwischen berechneten Hauptzugspannungen und experimentell ermittelten Bruchspannungen: Aufbau 1 (a) und Aufbau 2 (b)

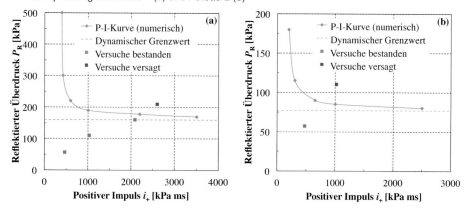

Abbildung 5.19 Druck-Impuls-Diagramm für Aufbau 1 (a) und Aufbau 2 (b)

dünneren Laminaten, bei denen sich ein Nachbruchverhalten ausbilden kann, stellt die Berechnung bis zum Glasbruch nur einen Teil des tatsächlichen Leistungsvermögens der Laminate dar. In Kapitel 6 wird dieser Aspekt eingehender betrachtet.

Modell in SJ Mepla

Dieses Modell beinhaltet mehrere vereinfachende Annahmen, die bei vergleichsweise geringem Rechenaufwand zu einer konservativen Abschätzung der maximalen Hauptzugspannungen im Glas führen. Die maßgebende Vereinfachung ist die Lagerung, bei der die Randklemmung vernachlässigt und von einer Navier-gelagerten Platte ausgegangen wird. Dabei werden die Abmessungen der Laminate auf die freie Oberfläche reduziert (800 mm x 1000 mm, s. Abb. 5.4). Das Laminat wird als monolithische Platte mit der Nenndicke und den Eigenschaften des Glases nach Tabelle 5.6 abgebildet. In Aufbau 1 werden die mechanischen Eigenschaften der beiden Glasarten Boro33 und Pyran gemäß ihres Volumenanteils gemittelt. Schließlich werden die Friedlander-Kurven nach Tabelle 5.4 linearisiert (Formparameter $A_Z = 0$, s. Gl. 2.4), wobei Maximaldruck und positiver Impuls beibehalten werden. Die Berechnung erfolgt wie im *Ansys*-Modell unter Berücksichtigung der geometrischen Nichtlinearität und unter Ausnutzung der Doppelsymmetrie. Abbildung 5.20 zeigt das FE-Modell sowie die vorgenommene Linearisierung der Friedlander-Kurven für die Laststufen ER 1 bis ER 4.

SJ Mepla verwendet 9-Knoten-Schalenelemente. Um eine ausreichende Diskretisierung in Raum und Zeit sicherzustellen, wurden Netz- und Zeitschrittstudien durchgeführt. Eine Elementkantenlänge von 50 mm und eine Zeitschrittlänge von 0,05 ms ergeben hierbei bereits konvergente Ergebnisse.

Als Ergebnisse der Berechnungen können wie in *Ansys* Auslenkung und Hauptzugspannung zu jedem berechneten Zeitschritt ausgegeben werden. Abbildung 5.21 zeigt exemplarisch einen Vergleich zwischen dem komplexen Modell in *Ansys* und dem vereinfachten Modell in *SJ Mepla* mit Aufbau 1 und Laststufe ER 1. Aufgrund der getroffenen Annahmen weichen Periode und Amplitude leicht ab. Das Modell in *SJ Mepla* liefert eine etwas höhere Beanspruchung des Glases.

In Abbildung 5.22 werden die maximalen Hauptzugspannungen im Rückglas beider Aufbauten bei den untersuchten Laststufen verglichen. Es zeigt sich, dass das vereinfachte Modell stets etwas höhere Werte und damit eine konservative Abschätzung der Beanspruchung des Glases liefert. Im Hinblick auf die erforderliche Rechendauer ist das vereinfachte Modell deutlich effizienter gegenüber dem komplexen *Ansys*-Modell. Einen Vergleich für die untersuchten Aufbauten zeigt Tabelle 5.7.

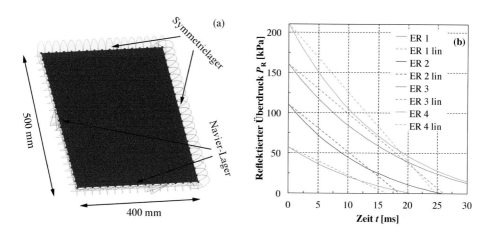

Abbildung 5.20 Modell in *SJ Mepla* (a) und Linearisierung der Friedlander-Kurven (b)

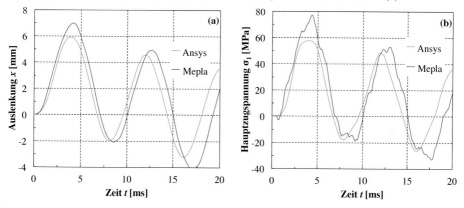

Abbildung 5.21 Exemplarischer Vergleich *Ansys* und *SJ Mepla*: Aufbau 1, ER 1

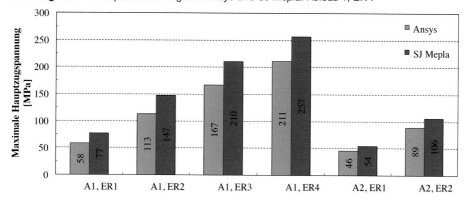

Abbildung 5.22 Vergleich der Ergebnisse von *Ansys* und *SJ Mepla*

Tabelle 5.7 Vergleich der Effizienz zwischen den FE-Modellen in *Ansys* und *SJ Mepla*

	Elementtyp	Aufbau 1		Aufbau 2	
		Elementanzahl	t^a	Elementanzahl	t^a
Ansys	20-Knoten-Volumenelemente	20 033	2650 s	34 883	18 145 s
SJ Mepla	9-Knoten-Schalenelemente	80	16 s	80	16 s

a Rechendauer auf einer Workstation mit vier Kernen à 3,3 GHz

5.4 Zusammenfassung

Das mechanische Verhalten von intaktem Verbundglas ohne Berücksichtigung des Nachbruchverhaltens wurde anhand von experimentellen und numerischen Untersuchungen im Hinblick auf das zeitabhängige Verhalten und den Lastfall Explosion untersucht.

Verbundgläser mit PVB-Zwischenschicht wurden in einem Dreischneidenbiegeversuch mit konstanter Kraft über eine Zeitdauer von 24 h belastet. Dabei wurde die Auslenkung gemessen, um das zeitabhängige Kriechverhalten zu studieren. Die numerischen Untersuchungen validieren die in Abschnitt 4.3.2 dargestellten Materialmodelle zur Berücksichtigung der Zeit- und Temperaturabhängigkeit (Prony-Reihe und WLF-Konstanten).

Die Reaktion von Verbundgläsern auf die Steifigkeit der Zwischenschicht ist allerdings sehr sensibel, solange diese sich auf einem niedrigen Niveau ($G \leq 10$ MPa) befindet. Geringe Veränderungen der Prony-Reihe führen hier zu einer signifikanten Beeinflussung der Kriechsimulation. Aufgrund der vorgestellten Ergebnisse wird zur Bemessung von Verbundglas unter zeit- und temperaturabhängigen Belastungen die Betrachtung von auf der sicheren Seite liegenden Grenzkurven empfohlen. Diese sind anhand von Wiederholungsmessungen beispielsweise mittels DMTA im vorher zu definierenden relevanten Zeit- und Temperaturbereich zu erstellen und mittels Validierungsexperimenten zu bestätigen. Für eine Abschätzung bei der Verwendung von Verbundgläsern mit der untersuchten PVB-Zwischenschicht (Trosifol® BG) kann die Prony-Reihe aus der Torsions-DMTA mit 10 °C-Schritten nach Tabelle 4.9 mit einem reduzierten initialen Schubmodul von $G_0 = 750$ MPa verwendet werden. Um sicherzustellen, dass die Materialmodelle der linearen Viskoelastizität für den jeweiligen Anwendungsfall mit ausreichender Genauigkeit gültig sind, sollten in weiterführenden Untersuchungen die Linearitätsgrenzen für das verwendete Material experimentell bestimmt und mit den maximalen Verzerrungen in der Simulation verglichen werden (s. Kap. 7).

Der Lastfall Explosion wurde mit Mehrfachlaminaten im Stoßrohr untersucht. Die experimentellen Untersuchungen haben gezeigt, dass bei den vergleichsweise dicken Laminaten der Zeitpunkt des Glasbruchs nahezu mit dem Gesamtversagen übereinstimmt und kein Resttragvermögen vorhanden ist. Als Ergebnisgrößen wurden einfallender und reflek-

tierter Überdruck gemessen und Hochgeschwindigkeitsaufnahmen durchgeführt. Zudem wurden in der Mitte der lastabgewandten Glasplatte die Dehnungen in drei Richtungen und die Auslenkung gemessen. Die experimentellen Daten wurden mit den Ergebnissen numerischer Simulationen verglichen. Es konnte gezeigt werden, dass die Zeit- und Temperaturabhängigkeit der Zwischenschichten bei diesen kurzzeitigen dynamischen Belastungen vernachlässigbar ist und näherungsweise sogar mit einem monolithischen Querschnitt gerechnet werden kann. Die Abbildung der Lagerung wirkt sich dagegen maßgeblich auf die Simulationsergebnisse aus. Wird diese realitätsnah erfasst, liegen auch abgeleitete Ergebnisgrößen wie die Hauptzugspannung im Glas sehr nah an den experimentellen Messungen. Anhand solcher validierter Modelle können zuverlässige Prognosen getroffen werden, ob eine Verglasung unter einer gegebenen Belastung bricht und Druck-Impuls-Diagramme erstellt werden.

Vereinfachte FE-Modelle liefern sehr schnelle Berechnungsergebnisse für eine konservative Abschätzung der auftretenden Glasspannungen im Lastfall Explosion.

Auf der Widerstandsseite wird die Verwendung der charakteristischen Werte für die Kurzzeitfestigkeit aus Tabelle 3.6 empfohlen.

6 Untersuchungen zum Nachbruchverhalten von Verbundglas im Lastfall Explosion

6.1 Allgemeines

Das Nachbruchverhalten von Verbundglas wird maßgeblich von den Randbedingungen (Lagerung, Glasabmessungen, Einwirkung), dem Glasaufbau und dem Material- und Delaminationsverhalten der Zwischenschicht beeinflusst, siehe Abschnitt 2.4.1.

Untersuchungen zum Materialverhalten verschiedener Zwischenschichten unter unterschiedlichen Belastungsgeschwindigkeiten sind in Abschnitt 4.2.3 dargelegt. Darüber hinaus wurden im Rahmen dieser Arbeit das Delaminationsverhalten in Abhängigkeit der Belastungsgeschwindigkeit sowie die Auswirkung von Steifigkeit und Delaminationsverhalten beim Lastfall Explosion experimentell untersucht.

Um gezielt den Einfluss der Haftung (Adhäsion) bei gleichbleibender Steifigkeit der Zwischenschicht zu studieren, wurde das PVB-Standardprodukt für den Baubereich BG in den drei verschiedenen Haftungsgraden R10, R15 und R20 betrachtet. Eine Variation der Steifigkeit erfolgte durch die Verwendung der PVB-Folientypen SC, BG und ES.

Zusammen mit FRANZ, 2015 wurden Haftungsversuche und TCT Tests zur Beurteilung des Delaminationsverhaltens durchgeführt. In der vorliegenden Arbeit wurde der Einfluss der Belastungsgeschwindigkeit auf das Delaminationsverhalten mit Hinblick auf den Lastfall Explosion studiert. In FRANZ, 2015 lag der Schwerpunkt auf der Beurteilung der Resttragfähigkeit unter quasistatischer Belastung.

Zudem wurde das Nachbruchverhalten von Verbundgläsern mit den verschiedenen Zwischenschichtmaterialien im Lastfall Explosion anhand von Stoßrohrversuchen untersucht.

Das mechanische Verhalten von Verbundglas im Lastfall Explosion kann bis zum Bruch mit numerischen Simulationen erfasst werden, siehe Abschnitt 5.3.2. Um auch den gebrochenen Zustand numerisch abzubilden, wurden zwei unterschiedliche Ansätze betrachtet. Die Ergebnisse der Simulationen wurden mit den experimentellen Untersuchungen verglichen und kritisch hinterfragt, um eine Orientierung für weiterführenden Forschungsbedarf zu geben.

Teile der vorgestellten Untersuchungen zum Nachbruchverhalten von Verbundglas im Lastfall Explosion wurden bereits in SCHNEIDER et al., 2015 und PELFRENE et al., 2015 veröffentlicht.

6.2 Experimentelle Untersuchungen

6.2.1 Haftungsversuche

Zur Beurteilung und zum Vergleich der Haftung der untersuchten PVB-Folien wurden unterschiedliche Versuche durchgeführt, welche in Abschnitt 2.4.8 beschrieben sind. Neben dem Pummelwert wurde die Haftung auf zwei Arten quantifiziert. Der Pull-Test liefert die Haftfestigkeit unter Zugbelastung (Modus I), der Schertest die Haftfestigkeit unter Scherbelastung (Modus II). Dabei wurde ein möglicher Einfluss der Belastungsgeschwindigkeit anhand von zwei Prüfgeschwindigkeiten untersucht. Eine detaillierte Beschreibung der Versuche findet sich in FRANZ, 2015.

Bis auf die ES-Folie, welche nur in der Nenndicke 0,76 mm produziert wird, wurden die zwei Nenndicken 0,76 mm und 1,52 mm untersucht. Der Einfluss der Foliendicke auf die Ergebnisse war nicht signifikant, sodass hier keine Unterscheidung in der Auswertung getroffen wurde. Falls bei einem Versuch ein Glasbruch auftrat, wurde dieser nicht in die Auswertung mit einbezogen. Tabelle 6.1 fasst die Anzahl der durchgeführten und ausgewerteten Versuche zusammen.

In Tabelle 6.2 sind die Ergebnisse der Haftungsversuche wiedergegeben. Es zeigt sich, dass sich der Folientyp mit mittlerer Haftung (BG R15) deutlich näher bei der niedrigen Haftung (BG R10) als bei der hohen Haftung (BG R20) einordnet. Des Weiteren ist auffällig, dass die ES-Folie unter Scherung das erwartete sehr hohe Haftungsniveau zeigte, unter Zug jedoch nicht. Ob dies an der Probekörpercharge lag, ist in Wiederholungsprüfungen noch zu untersuchen. Die Haftung der SC-Folie lag auf einem niedrigen Niveau.

Tabelle 6.1 Versuchsmatrix der Haftungsversuche, Anzahl der ausgewerteten Versuche (Anzahl der durchgeführten Versuche)

PVB-Folientyp	Pummeltest	Zughaftung		Scherhaftung	
		6 mm min^{-1}	600 mm min^{-1}	6 mm min^{-1}	600 mm min^{-1}
BG R10	5 (5)	5 (5)	5 (5)	19 (21)	8 (10)
BG R15	5 (5)	5 (5)	5 (5)	20 (21)	9 (10)
BG R20	5 (5)	7 (7)	5 (5)	9 (19)	6 (10)
SC	-[a]	5 (5)	5 (5)	9 (11)	-
ES	-[a]	6 (6)	4 (4)	5 (11)	-

[a] Der Pummeltest bei $-18\,°C$ ist nur auf Standard-PVB (BG) anwendbar

Tabelle 6.2 Ergebnisse der Haftungsversuche

PVB-Folientyp	Pummeltest [-]	Zughaftung [MPa]		Scherhaftung [MPa]	
		6 mm min^{-1}	600 mm min^{-1}	6 mm min^{-1}	600 mm min^{-1}
BG R10	3-4	$9,2 \pm 1,5$	$8,7 \pm 1,2$	$7,5 \pm 3,0$	$9,4 \pm 1,6$
BG R15	4-6	$10,8 \pm 1,4$	$8,4 \pm 1,1$	$7,0 \pm 1,5$	$9,9 \pm 1,5$
BG R20	8-9	$12,5 \pm 0,3$	$16,8 \pm 2,2$	$12,0 \pm 2,8$	$16,2 \pm 2,2$
SC	-[a]	$4,7 \pm 0,7$	$6,9 \pm 0,4$	$5,4 \pm 2,7$	-[b]
ES	-[a]	$7,6 \pm 1,6$	$10,3 \pm 1,9$	$13,3 \pm 0,7$	-[b]

[a] Der Pummeltest bei $-18\,°C$ ist nur auf Standard-PVB (BG) anwendbar
[b] keine Versuche durchgeführt

6.2.2 Through Cracked Tensile (TCT) Test

Die Haftungsversuche zeigen einen Anstieg der Haftung bei erhöhter Prüfgeschwindigkeit. Dies ist bei allen Scherversuchen sowie bei den Zugversuchen mit Ausnahme der Varianten BG R10 und BG R15 zu erkennen. Inwiefern das Delaminationsverhalten von dem Folienmaterial und der Belastungsgeschwindigkeit beeinflusst wird, wurde anhand von TCT Tests mit drei konstanten Wegraten $6\,\text{mm\,min}^{-1}$, $600\,\text{mm\,min}^{-1}$ und $60\,000\,\text{mm\,min}^{-1}$ ($\stackrel{\triangle}{=} 1{,}0\,\text{m\,s}^{-1}$) untersucht.

Bei einem TCT Test werden beide Gläser einer Verbundglasprobe in der Mitte koinzident gebrochen und die Probe anschließend senkrecht zur Bruchkante gezogen. Abbildung 6.1 zeigt schematisch den TCT Test und den Vorgang der Probenpräparation: Mit einem Glasschneider wurden die Oberseiten beider Gläser angeritzt, der Bruch wurde anschließend durch Anziehen der Rändelschraube einer Schnittlaufzange erzeugt. Durch diesen weggesteuerten Glasbruch ist die ungewollt eingebrachte Anfangsdelamination gering.

Da zwischen Glasprobe und Einspannung Schlupf auftreten kann, ist der gemessene Traversenweg der Prüfmaschine nicht zur Auswertung geeignet. Aus diesem Grund wurden Markierungen auf die Probekörper geklebt, deren Positionen anhand des in Abschnitt 4.2.3 beschriebenen Algorithmus optisch ausgewertet wurden.

Anschließend wurden die Proben in eine Einspannvorrichtung gespannt und der weggesteuerten Zugprüfung unterworfen. Das Einspannwerkzeug wurde aus Aluminium angefertigt, um das Gewicht auf die dynamischen Versuche mit der Wegrate $60\,000\,\text{mm\,min}^{-1}$ hinsichtlich der Massenträgheit abzustimmen. Diese wurden wie die dynamischen Zugversuche am reinen Folienmaterial (s. Abschn. 4.2.3) am *Fraunhofer LBF* mit der Hochgeschwindigkeitsprüfmaschine *Zwick Amsler HTM 5020* bei $23\,°C$ und $34\,\%$ rF durchgeführt. Die Versuche bei den Wegraten $6\,\text{mm\,min}^{-1}$ und $600\,\text{mm\,min}^{-1}$ wurden am *Institut für Statik und Konstruktion* mit der Universalprüfmaschine *Zwick Z050 THW Allround-Line* bei $(21 \pm 1)\,°C$ und $(54 \pm 2)\,\%$ rF durchgeführt. Abbildung 6.2 zeigt beide Versuchsaufbauten mit dem Einspannwerkzeug.

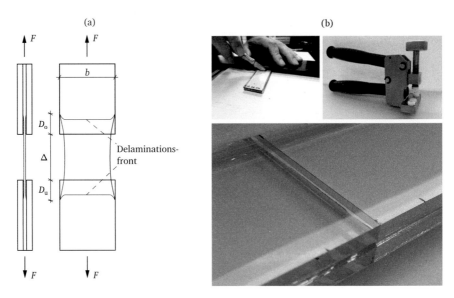

Abbildung 6.1 Schematische Darstellung des TCT Tests (a) und Vorgehen zur Erzeugung des koinzidenten Glasbruchs (b)

Abbildung 6.2 TCT Test am *Institut für Statik und Konstruktion* (a) und am *Fraunhofer LBF* (b)

Die Probekörper waren Verbundgläser aus 2×3 mm Kalknatron-Silikat-Floatglas (KNS-Float) und einer $1{,}52$ mm dicken Zwischenschicht. Bei der Lamination wurden die Gläser einmal mit der Zinnbad- und einmal mit der Feuerseite zur Folie ausgerichtet, um beide Grenzflächen zu berücksichtigen. Es wurden vier unterschiedliche Zwischenschichten auf PVB-Basis untersucht, welche auch in den später beschriebenen Stoßrohrversuchen zum Lastfall Explosion eingesetzt wurden. Neben der Wegrate wurde die Breite der Probekörper variiert, um einen möglichen Randeinfluss zu erfassen. Tabelle 6.3 fasst die durchgeführten TCT Tests zusammen.

Tabelle 6.3 Versuchsmatrix der TCT Tests; Anzahl der durchgeführten Versuche je Wegrate und Probenbreite

PVB-Folientyp	6 mm min^{-1}		600 mm min^{-1}		60 000 mm min^{-1}
	30 mm	50 mm	30 mm	50 mm	50 mm
BG R10	10	10	10	10	7
BG R15	10	10	10	10	7
BG R20	10	10	10	10	6
ES	10	10	10	10	-

Die Videoaufnahme für die optische Auswertung der Separation Δ (s. Abb. 6.1a) und des Delaminationsfortschritts $D = D_\mathrm{u} + D_\mathrm{o}$ erfolgte für jede Wegrate mit unterschiedlicher Ausrüstung. Für die langsame Wegrate 6 mm min^{-1} wurde eine *uEye UI-2280SE* mit einer Auflösung von 5 Megapixel und einer Bildrate von 1,075 fps gewählt. Die Versuche mit mittlerer Wegrate 600 mm min^{-1} wurden mit einer *Casio EX-ZR700* (2,07 Megapixel mit 29,97 fps) aufgezeichnet. Für die dynamische Wegrate 60 000 mm min^{-1} kam eine s/w-Hochgeschwindigkeitskamera mit 18 000 fps und einer Auflösung von 256×496 Pixel zum Einsatz.

Abbildung 6.3 zeigt den Delaminationsfortschritt von repräsentativen Proben bei der höchsten Wegrate für die unterschiedlichen Haftgrade. Es ist erkennbar, dass mit niedriger und mittlerer Haftung (BG R10 und BG R15) auch bei der höchsten Belastungsgeschwindigkeit eine ausgeprägte Delamination stattfindet. Die Folie mit hoher Haftung (BG R20) zeigt dagegen kein Delaminationsverhalten, sondern beginnt bereits zu Beginn des Versuchs zu reißen.

Anhand der optisch ausgewerteten Separation Δ und des gemessenen Kraftsignals können Kraft-Separations-Beziehungen erstellt werden. Um die Probekörperbreite und die Foliendicke zu berücksichtigen, wird mittels Division durch die Folienfläche in der Ausgangskonfiguration die Kraft zu einer technischen Folienspannung σ_0 umgerechnet. Abbildung 6.4 zeigt die Spannungs-Separations-Beziehungen für repräsentative Proben geordnet nach Wegrate und Folientyp. Die gesamten Ergebnisse der TCT Tests sind im Anhang A.6 wiedergegeben. Ein signifikanter Randeinfluss konnte nicht beobachtet werden, die Probekörper mit 30 mm und 50 mm Breite lieferten vergleichbare Spannungs-Separations-Beziehungen.

Die Folientypen BG R10 und BG R15 zeigen wie in den Haftungsversuchen (Tab. 6.2) keine signifikanten Unterschiede in den Ergebnissen. Bei der niedrigen Wegrate 6 mm min^{-1} wurde in den Versuchen ein erneutes Anhaften der bereits delaminierten Folie beobachtet, was sich durch einen Anstieg im Kraftsignal bemerkbar machte. Dies war bei den höheren Wegraten nicht der Fall. Hier blieb die Kraft, welche zur Delamination benötigt wurde, während des Versuchs nahezu konstant. Bei der höchsten Wegrate sind starke Oszillationen im Kraftsignal insbesondere bei Versuchsbeginn zu erkennen. Beide

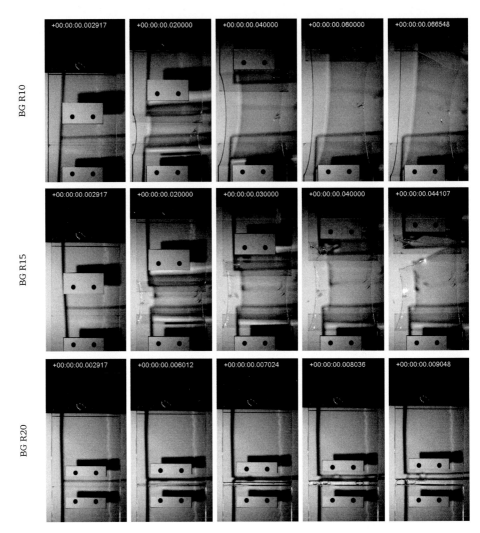

Abbildung 6.3 Delaminationsfortschritt bei der höchsten Wegrate ($60\,000\,\mathrm{mm\,min^{-1}} \stackrel{\wedge}{=} 1{,}0\,\mathrm{m\,s^{-1}}$), Zeitangabe in Sekunden

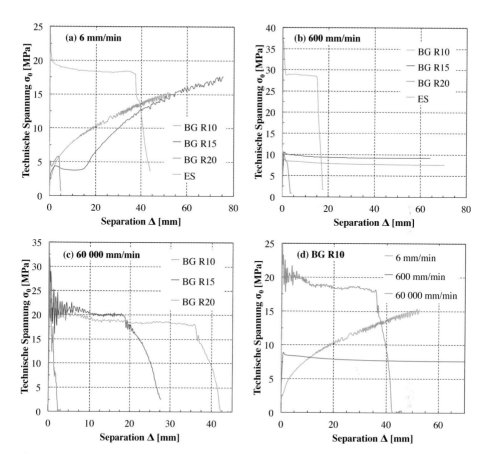

Abbildung 6.4 Repräsentative Spannungs-Separations-Beziehung aus den TCT Tests: Vergleich verschiedener Folientypen bei gleichen Wegraten (a-c), Vergleich verschiedener Wegraten bei BG R10 (d)

Folientypen zeigen ein stark ausgeprägtes Delaminationsvermögen, also kein Reißen bis hin zu sehr großen Separationen.

Der Folientyp BG R20 zeigt ein vollständig anderes Verhalten. Aufgrund der höheren Haftung bei gleichbleibender Steifigkeit und Reißdehnung kann nahezu keine Delamination erzeugt werden, die Folie reißt kurz nach Versuchsbeginn ein und versagt. Dies ist in den Videoaufnahmen sowie durch das Abfallen des Kraftsignals bei sehr geringen Separationen zu erkennen. Das Spannungsniveau liegt nicht signifikant höher gegenüber dem der Folientypen mit geringerer Haftung. Das Potential im Nachbruchverhalten kann daher als gering eingeschätzt werden.

Die steife ES-Folie zeigt ein deutlich erhöhtes Spannungsniveau gegenüber den BG-Folien, das Delaminationsvermögen ist jedoch geringer als bei den Folientypen BG R10 und BG R15.

Eine Erhöhung der Wegrate erzeugt bei allen Zwischenschichtmaterialien ein steiferes Verhalten und damit ein höheres Spannungsniveau im TCT Test. Damit einher geht eine Reduktion des Delaminationsvermögens. Die Folien mit geringer und mittlerer Haftung BG R10 und BG R15 zeigen aber auch bei der höchsten Wegrate von $60000\,\text{mm}\,\text{min}^{-1}$ noch ein ausgeprägtes Delaminationsvermögen, sodass hier ein günstiges Nachbruchverhalten unter kurzzeitiger dynamischer Belastung zu erwarten ist.

Das Delaminationsvermögen der ES-Folie ist bei der mittleren Wegrate von $600\,\text{mm}\,\text{min}^{-1}$ bereits sehr gering, sodass hier die Haftung im Vergleich zur Bruchspannung bei kurzzeitigen Belastungen zu hoch ist, um ein günstiges Nachbruchverhalten im Lastfall Explosion erwarten zu lassen. Diese Annahmen werden im folgenden Abschnitt anhand der Stoßrohrversuche bestätigt.

Die Belastungsdauer aus dem TCT Test mit der höchsten Wegrate ist mit den Stoßrohrversuchen vergleichbar: Ein Folienriss tritt je nach Haftgrad im Bereich von 10 ms bis 100 ms nach Belastungsbeginn auf (s. Abb. 6.3 und Tab. 6.5). Der vergleichsweise einfache und damit kostengünstige TCT Test mit hohen Belastungsgeschwindigkeiten kann somit genutzt werden, um anstelle der kosten- und zeitintensiven Stoßrohrversuche zur Bewertung der Leistungsfähigkeit einer Zwischenschicht in Bezug auf das Nachbruchverhalten im Lastfall Explosion herangezogen werden. Hierfür wird als einfaches Prüfkriterium vorgeschlagen, dass sich ein Delaminationsfortschritt einstellen muss. Dazu muss die Bruchspannung des Zwischenmaterials in Verbindung mit der Dicke eine höhere Kraft aufnehmen können, als zur Delamination benötigt wird. Bei Festlegung auf ein Material kann demnach durch die Wahl einer dickeren Folie ein ausgeprägtes Nachbruchverhalten erzielt werden.

Aus den Versuchen lassen sich auch die erzeugte Dehnrate sowie die Energiefreisetzungsrate für die Delamination ableiten. Hierfür sind jeweils die delaminierten Flächen bei Erreichen des konstanten Kraftniveaus zu bestimmen. Bei der für den Lastfall Explosion interessanten hohen Wegrate war dies jedoch nicht möglich, da die optische Auflösung für den relevanten Bildausschnitt zu gering war und das Kraftsignal im Anfangsbereich stark oszillierte. Für die beiden niedrigeren Wegraten $6\,\text{mm}\,\text{min}^{-1}$ und $600\,\text{mm}\,\text{min}^{-1}$, welche für das Nachbruchverhalten unter quasistatischer Belastung interessant sind, wurde die Energiefreisetzungsrate in FRANZ, 2015 bestimmt.

Die prinzipielle Idee zur Abschätzung der Dehnrate soll für zukünftige Untersuchungen nachfolgend erläutert werden: Der theoretische zeitliche Verlauf der Kraft F in einem idealen TCT Test ist in Abbildung 6.5 vergleichend mit einem realen Versuch dargestellt. Aus dem bilinearen Kraftverlauf und der Annahme der linearen Elastizität kann die technische Dehnrate $\dot{\varepsilon}_0$ ermittelt werden.

Abbildung 6.5 Theoretischer Verlauf von Kraft F, technischer Foliendehnung ε_0 und technischer Dehnrate der Folie $\dot{\varepsilon}_0$ bei einem TCT Test unter Annahme eines linear-elastischen Materialverhaltens (a) und experimentell gemessener Kraft-Zeit-Verlauf im Anfangsbereich (b)

Die Kraft erreicht nach einer gewissen Zeit t^* ein konstantes Niveau, ab dem eine zeitlich konstant fortschreitende Delamination erfolgt. Bei linear-elastischem Materialverhalten ist die technische Dehnung, welche sich aus der Separation Δ und der Delaminationslänge $D = D_\mathrm{u} + D_\mathrm{o}$ zu $\varepsilon_0 = \Delta/D$ bestimmen lässt, ebenfalls konstant (s. Abb. 6.1a). Die technische Dehnrate ist somit bis zum Zeitpunkt t^* konstant und ergibt sich zu

$$\dot{\varepsilon}_0 = \frac{\varepsilon_0(t^*)}{t^*} = \frac{\Delta(t^*)}{D(t^*)\,t^*}\,.\tag{6.1}$$

6.2.3 Stoßrohrversuche

Zur Untersuchung des Nachbruchverhaltens von Verbundgläsern unter Explosionsbeanspruchung wurden Stoßrohrversuche nach DIN EN 13541 durchgeführt. Im Unterschied zu den Untersuchungen zum intakten Zustand (Abschn. 5.2.2) waren die Laminate dünner und die Zwischenschichten aus PVB dicker. Somit stellte sich ein ausgeprägtes Nachbruchverhalten ein.

Die Probekörper bestanden jeweils aus 2×6 mm thermisch entspanntem Kalknatron-Silikat-Floatglas (KNS-Float) und einer $1{,}52$ mm dicken Zwischenschicht. Die Untersuchungen beschränkten sich auf Zwischenschichten aus PVB, da nur eine begrenzte Anzahl an Versuchen durchführbar war. Zudem wird mit PVB-Folien der größte Marktanteil repräsentiert, wobei durch Variation des Folientyps gezielt unterschiedliche Aspekte verglichen werden konnten.

Mit den experimentellen Untersuchungen wurden unterschiedliche Ziele verfolgt: Der Einfluss der Haftung von Zwischenschicht zum Glas stellt den Untersuchungsschwerpunkt

dar. Hierzu wurden drei verschiedene Haftgrade bei gleicher Steifigkeit (Folientypen BG R10, BG R15 und BG R20) betrachtet. Des Weiteren sollte der Einfluss der Zwischenschichtsteifigkeit anhand der Folientypen BG und ES studiert werden. Schließlich sollte durch die Auslenkungsmessungen die Grundlage für eine Validierung der numerischen Modelle geschaffen werden.

Die Versuche wurden am *Fraunhofer Ernst-Mach-Institut (EMI)* durchgeführt. Die Abmessungen der Probekörper, der eingesetzte Versuchsrahmen und die Messtechnik waren mit den Stoßrohrversuchen zum intakten Zustand identisch, siehe Abschnitt 5.2.2. Anstelle einer DMR wurde ein linearer Dehnmessstreifen (DMS) verwendet, da nur der Zeitpunkt des Glasbruchs von Interesse war. Die Auslenkungsmessung erfolgte dann, wenn kein totales Versagen zu erwarten war. Alle Versuche wurden mittels Hochgeschwindigkeits-Videoaufnahmen mit einer Bildrate von 1000 fps dokumentiert. Zur Quantifizierung des Splitterabgangs wurde das Gewicht jeder Verglasung vor und nach dem Versuch erfasst. Zudem wurde die Temperatur der Probekörperoberfläche vor Versuchsbeginn gemessen.

Um ein geeignetes Lastniveau zur Untersuchung des Nachbruchverhaltens festlegen zu können, wurden zwei Tastversuche mit der PVB-Zwischenschicht mit mittlerer Haftung (BG R15) ohne DMS und Auslenkungsmessung durchgeführt. Da die in DIN EN 13541 definierten Laststufen ER 1 bis ER 4 relativ große Stufen darstellen, wurden Zwischenstufen definiert, welche entsprechend ihrer Belastungsintensität mit ER 0,8 und ER 1,6 bezeichnet werden.

Eine Übersicht über die durchgeführten Versuche und die gemessenen Belastungsparameter P_R, i_+ und A_Z je Laststufe zeigt Tabelle 6.4. Die Anzahl der Versuche mit Auslenkungsmessung sind in Klammern angegeben.

Anhand der Gewichtsmessung wurde der Massenverlust ermittelt, welcher die abgegangenen Glassplitter quantifiziert. Hierdurch kann ein Rückschluss auf das Gefährdungspotential gezogen werden. Ein Testcontainer zur detaillierten Bewertung der entstehenden Gefährdung (s. Abb. 2.46) stand nicht zur Verfügung.

Tabelle 6.4 Versuchsmatrix der Stoßrohrversuche an Verbundgläsern, Versuchsanzahl (Versuchsanzahl mit Auslenkungsmessung)

PVB-Folientyp		ER 0,8	ER 1	ER 1,6	ER 2	ER 3
	P_R:	47 kPa	57 kPa	87 kPa	110 kPa	160 kPa
	i_+:	350 kPa ms	470 kPa ms	780 kPa ms	1020 kPa ms	2090 kPa ms
	A_Z:	0,6	0,7	0,9	1,1	1,35
BG R10		-	-	1 (1)	2 (0)	-
BG R15		-	-	2 (2)	2 (1)	1 (0)
BG R20		-	2 (2)	1 (0)	-	-
ES		1 (0)	2 (0)	1 (0)	-	-

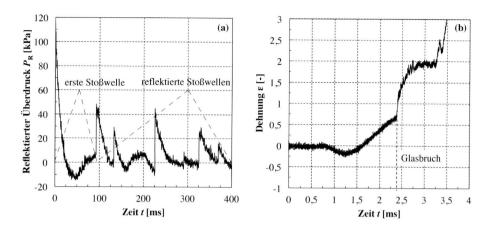

Abbildung 6.6 Druck-Zeit-Verlauf eines Stoßrohrversuchs mit Laststufe ER 2 unter Berücksichtigung von Reflektionen (a), Identifikation des Glasbruchs anhand der DMS-Daten (b)

Bei Stoßrohrversuchen entstehen Reflektionen der Druckwelle im Rohr, welche den Probekörper zu einem späteren Zeitpunkt erneut belasten. Abbildung 6.6a veranschaulicht dies am Beispiel eines gemessenen Druck-Zeit-Verlaufs bei einer Laststufe ER 2. Bleibt das Glas während der ersten Stoßwelle intakt, so können die nachfolgenden reflektierten Stoßwellen vernachlässigt werden, da sie eine deutlich geringere Intensität als die erste Stoßwelle aufweisen und ihr Auftreten weit außerhalb der Eigenfrequenz liegt. Für die Untersuchungen zum intakten Zustand reicht daher eine Beschreibung der Belastung über die erste Stoßwelle mittels Friedlander-Gleichung (2.4) aus.

Bricht dagegen das Glas während der ersten Stoßwelle, können die nachfolgenden Stoßwellen eine weitere relevante Schädigung bewirken. Für die Bewertung des Nachbruchverhaltens wurde daher zwischen der Schädigung durch die erste Stoßwelle und der Schädigung am Ende des Versuchs unterschieden. Dazu wurden die Hochgeschwindigkeits-Videoaufnahmen ausgewertet.

Zur Quantifizierung der Schädigung wurden die folgenden vier Ergebnisklassen (EK) mit absteigender Leistung definiert:

3: Keine sichtbare Schädigung, kein Glasbruch,

2: Glasbruch, aber kein Riss der Zwischenschicht,

1: Anriss der Zwischenschicht, aber Verglasung verbleibt im Rahmen,

0: Totales Versagen, Teile des Laminats werden herausgerissen.

Tabelle 6.5 fasst die Ergebnisse der einzelnen Versuche zusammen. Die Zeit bis zum Glasbruch wurde anhand der DMS-Daten ermittelt (Abb. 6.6b), die Zeit bis zum Folienriss

anhand der Hochgeschwindigkeits-Videoaufnahmen. Letztere bestätigen auch, dass der Glasbruch stets in der Mitte der Verglasung initiiert wurde.

Abbildung 6.7 zeigt die Probekörper nach Versuchsende. Neben der Belastungsstufe (ER) ist die zugeordnete Ergebnisklasse (EK) nach der letzten Stoßwelle angegeben. In Abbildung 6.8 sind die Ergebnisklassen über der angesetzten Laststufe nach der ersten Stoßwelle (a) und nach Versuchsende (b) aufgetragen. Bei Erreichen der Ergebnisklasse drei wurde die Glasfestigkeit nicht überschritten und es kann damit auch keine Aussage über das Nachbruchverhalten getroffen werden. Daher werden bei der Beurteilung der Leistungsfähigkeit des Zwischenmaterials nur die Ergebnisklassen null bis zwei betrachtet. Das Erreichen einer hohen Ergebnisklasse bei einer hohen Laststufe (Bereich oben rechts) stellt ein gutes Nachbruchverhalten dar. Eine niedrige Ergebnisklasse bei niedriger Laststufe (Bereich unten links) verdeutlicht ein schlechtes Nachbruchverhalten.

Der Folientyp BG R10 zeigt die besten Ergebnisse. Eine verringerte Haftung bewirkt auch unter kurzzeitiger dynamischer Belastung eine stärkere lokale Delamination im Bereich der Glasbrüche. Dadurch vermindert sich an diesen Stellen die Dehnung in der Zwischenfolie und die Wahrscheinlichkeit des vollständigen Versagens durch Erreichen der

Tabelle 6.5 Ergebnisse der Stoßrohrversuche zum Nachbruchverhalten

Nr.	PVB-Typ	Last-stufe	Proben-temp. [°C]	EK[a]	EK[b]	Massen-verlust [%]	Zeit bis Glasbruch [ms]	Zeit bis Folienriss [ms]
BS174	BG R15	ER 2	14,8	2	2	-[c]	-[c]	-[e]
BS175	BG R15	ER 3	15,8	0	0	-[c]	-[c]	14
BS176	BG R15	ER 2	18,1	0	0	19,8	2,0	13
BS177	BG R15	ER 1,6	13,9	2	0	16,6	2,4	111
BS178	BG R15	ER 1,6	15,0	2	1	8,5	2,3	-[c]
BS179	BG R10	ER 1,6	13,9	2	2	13,2	2,6	-[e]
BS180	BG R10	ER 2	14,4	2	2	6,2	2,6	-[e]
BS181	BG R10	ER 2	20,6	2	1	12,1	2,1	110
BS182	BG R20	ER 1,6	15,7	1	0	11,4	2,4	12
BS183	BG R20	ER 1	19,4	2	1	3,8	3,4	97
BS184	BG R20	ER 1	20,6	1	1	4,7	2,9	12
BS185	ES	ER 1,6	13,4	0	0	27,9	2,7	8
BS186	ES	ER 1	16,8	2	0	8,7	3,6	89
BS187	ES	ER 0,8	22,8	3	3	0,0[d]	-[d]	-[e]
BS188	ES	ER 1	22,8	3	3	0,0[d]	-[d]	-[e]

[a] Ergebnisklasse nach der ersten Stoßwelle
[b] Ergebnisklasse nach Versuchsende
[c] keine Messung/nicht auswertbar
[d] kein Glasbruch
[d] kein Folienriss

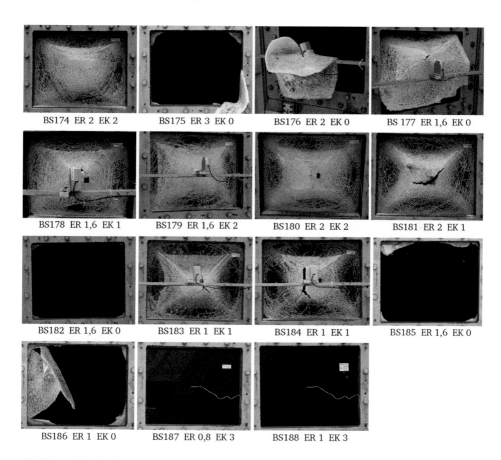

BS174 ER 2 EK 2 BS175 ER 3 EK 0 BS176 ER 2 EK 0 BS 177 ER 1,6 EK 0

BS178 ER 1,6 EK 1 BS179 ER 1,6 EK 2 BS180 ER 2 EK 2 BS181 ER 2 EK 1

BS182 ER 1,6 EK 0 BS183 ER 1 EK 1 BS184 ER 1 EK 1 BS185 ER 1,6 EK 0

BS186 ER 1 EK 0 BS187 ER 0,8 EK 3 BS188 ER 1 EK 3

Abbildung 6.7 Dokumentation der Stoßrohrversuche nach letzter Stoßwelle, Angabe von Laststufe (ER) und Ergebnisklasse (EK)

Bruchdehnung sinkt. Dies wird durch den Vergleich mit der hohen Haftung bei gleicher Steifigkeit (BG R20) deutlich und stimmt mit Beobachtungen aus dem Kugelfallversuch überein (KURARAY, 2012). Die Folie mit der mittleren Haftung ordnet sich erwartungsgemäß dazwischen ein, wobei der Unterschied zur geringen Haftung, wie bereits festgestellt, geringer ist als der Unterschied zur hohen Haftung.

Eine erhöhte Steifigkeit wirkt sich nachteilig auf das Nachbruchverhalten aus, wie die Ergebnisse der ES-Folie verdeutlichen. Brach bei diesen Probekörpern das Glas, so trat ein vollständiges Versagen auf.

Dass hingegen eine verringerte Adhäsion zu einer höheren Gefährdung durch Splitterflug führt, kann anhand des gemessenen Massenverlusts nicht bestätigt werden (s. Tab. 6.5). Ein direkter Vergleich der unterschiedlichen Zwischenfolien ist nur bei gleicher Laststufe möglich, sodass eine statistisch belastbare Aussage aufgrund der geringen Versuchs-

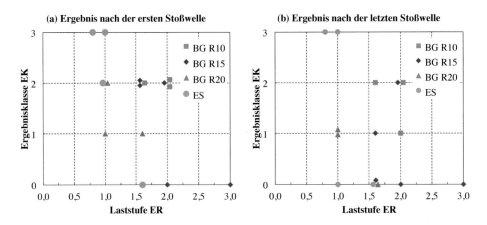

Abbildung 6.8 Ergebnisse der Stoßrohrversuche zum Nachbruchverhalten: Ergebnisklasse über Laststufe nach der ersten Stoßwelle (a) und nach Versuchsende (b)

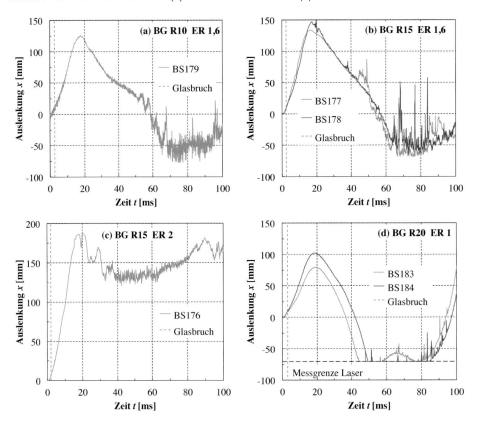

Abbildung 6.9 Gemessene Verläufe der Auslenkung des Plattenmittelpunkts

anzahl nicht möglich ist. Ein Trend zu erhöhtem Massenverlust bei verringerter Adhäsion ist nicht erkennbar. Ebenfalls kann kein Einfluss der gemessenen Oberflächentemperatur der Verglasung auf das Ergebnis beobachtet werden.

Ein Versagen durch Einschneiden der Glasbruchstücke in die Folie konnte bei keinem Versuch beobachtet werden. Das Versagen trat durch ein Reißen der Zwischenfolie auf, welches auf ein Überschreiten der Bruchdehnung zurückzuführen ist.

In Abbildung 6.9 sind die gemessenen Auslenkungen des Plattenmittelpunkts über die Zeit dargestellt. Es ist erkennbar, dass auch im Nachbruchbereich die Streuung der Messergebnisse bei gleicher Zwischenschicht und Belastungsstufe gering ist (b, d). Diese Daten können deswegen zur Validierung von numerischen Modellen verwendet werden.

Die Dicke der Einzelgläser wurde durch die Gewichtsmessung vor dem Versuch unter Annahme der Dichte von Glas und Folie, der Foliendicke und der Probekörperfläche zu $(5,90 \pm 0,02)$ mm bestimmt.

6.3 Numerische Untersuchungen: Simulation der Stoßrohrversuche

6.3.1 Globaler Ansatz

Ein Ansatz, das Verformungsverhalten einer gebrochenen Verglasung unter kurzzeitiger dynamischer Belastung numerisch abzubilden, besteht darin, die Steifigkeit des Verbundglases nach dem Glasbruch global zu reduzieren. Dieser Ansatz wurde in den FE-Programmen *SJ Mepla 3.5.9* (SJ SOFTWARE GMBH, 2013) und *Ansys Workbench 15.0* (ANSYS INC., 2012a) mit impliziter Zeitintegration untersucht. In beiden Programmen wurde zum einen das Verbundglas mit dem entsprechenden Laminataufbau und zum anderen eine monolithische Ersatzplatte modelliert. Eine Übersicht über die untersuchten Modellierungsansätze gibt Tabelle 6.6. Für eine detaillierte Beschreibung der Berechnungen wird auf STANGE, 2015 verwiesen. Im Folgenden werden die gewonnenen Erkenntnisse zusammengefasst.

Es zeigt sich, dass alle vier Modelle den intakten Zustand gut wiedergeben. Nach dem Glasbruch kann jedoch keines der Modelle die gemessene Auslenkung der Plattenmitte zufriedenstellend beschreiben. Abbildung 6.10 veranschaulicht dies an einem Vergleich zwischen Simulationen und Experiment. Dabei wird das zeitliche Verformungsverhalten in die drei Phasen bis zum Glasbruch (I), bis zur maximalen Auslenkung (II) und Rückschwingen (III) eingeteilt.

Die beste Anpassung an die Realität ist mit dem Verbundglas-Modell in *Ansys* möglich, da es die meisten frei wählbaren Parameter bietet. Selbst mit diesem Modell kann jedoch die Phase II nicht bis zum Ende mit den experimentellen Daten in Übereinstimmung gebracht werden. Dies ist mit den komplexen mechanischen Zusammenhängen im

Tabelle 6.6 Untersuchte Modelle mit globaler Reststeifigkeit

| | SJ Mepla | | Ansys | |
	Verbundglas	**Monolithisch**	**Verbundglas**	**Monolithisch**
Laminataufbau	Glas/PVB/Glas	Ersatzplatte	Glas/PVB/Glas	Ersatzplatte
Lagerung	Navier-Lagerung	Navier-Lagerung	Randklemmung	Randklemmung
Materialverhalten Glas nach Bruch	linear-elastisch: $E_{oben} = E_{unten}$	linear-elastisch	linear-elastisch: $E_{oben} \neq E_{unten}$	hyperelastisch
Materialverhalten PVB	linear-elastisch	-	linear-elastisch, hyperelastisch, elastisch-plastisch	-

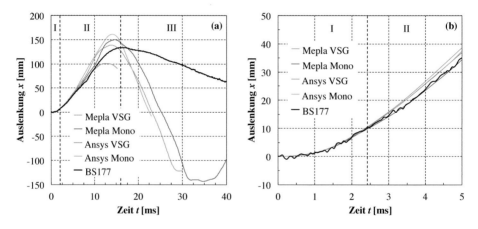

Abbildung 6.10 Vergleich des Verformungsverhaltens von Simulationen und Experiment (a) und Detailausschnitt des Anfangsbereichs (b)

Nachbruchverhalten zu begründen, welche durch den einfachen Ansatz der globalen Steifigkeitsreduktion nicht abgebildet werden können.

Doch selbst bei einer korrekten Abbildung des zeitlichen Verformungsverhaltens nach Glasbruch stellt sich die Frage nach der Praxisrelevanz eines solchen Modells. Eine Simulation, die das Nachbruchverhalten mittels globaler Steifigkeitsreduktion abbildet, kann nicht die lokalen Beanspruchungen in der Zwischenschicht und die Interaktion mit den Glasbruchstücken widerspiegeln. Eine Bemessung ist demnach nur mit einem verschmierten Widerstandswert oder einer Verformungsgrenze analog zum Einfreiheitsgradschwinger möglich. Beides kann nur empirisch bestimmt werden und ist abhängig von den ge-

wählten Randbedingungen wie Laminataufbau, Abmessungen und Lagerung. Das eigentliche Ziel, das mechanische Verhalten von Verbundglas unter Explosionsbeanspruchung besser zu verstehen und die kosten- und zeitintensiven experimentellen Untersuchungen zu minimieren, kann mit einem globalen Ansatz nicht erreicht werden.

6.3.2 Diskreter Ansatz

Vorgehen

Ein anderer Ansatz, um das Nachbruchverhalten von Verbundglas unter Explosionsbeanspruchung numerisch zu simulieren, ist das Löschen von Elementen (Erosion) zur diskreten Abbildung von Rissen im Glas. Dies ist nur mit expliziter Zeitintegration möglich, da durch den entstehenden plötzlichen Massen- und Energieverlust des Systems keine Konvergenz bei impliziter Zeitintegration erreicht wird.

Die Untersuchungen erfolgten im Rahmen eines gemeinsamen Forschungsprojektes mit Joren Pelfrene (Universiteit Gent) und wurden in PELFRENE et al., 2015 veröffentlicht. Als FE-Programm wurde *LS-DYNA R7.1.1* (LSTC, 2014a) gewählt. Das Programm verwendet zur Zeitintegration die Methode der zentralen Differenzen (s. Abschn. 2.5) und wird insbesondere bei der Crashsimulation von Automobilen und anderen kurzzeitigen dynamischen Ereignissen eingesetzt.

In einem ersten Schritt wurden die gewählten Randbedingungen und Modellierungsgrundsätze anhand von experimentellen Untersuchungen zum intakten Zustand validiert. Anschließend erfolgte die Implementierung eines Bruchkriteriums für das Glas sowie eines Ansatzes zur Abbildung der lokalen Delamination an den Rissen und die Validierung im Nachbruchverhalten anhand der in Abschnitt 6.2.3 vorgestellten Stoßrohrversuche.

Ziel der numerischen Untersuchungen war, das mechanische Verhalten möglichst realitätsnah zu erfassen. Mit einem solchen Werkzeug können Verglasungen unter Explosionsbeanspruchung auch bei Berücksichtigung des Nachbruchverhaltens bemessen und versuchstechnisch schwer messbare Aspekte wie lokale Delaminationen und tatsächliche Dehnraten der Zwischenschicht untersucht werden. Dazu sollten die Möglichkeiten, die ein kommerzielles FE-Programm derzeitig bietet, angewandt und kritisch hinterfragt werden.

Beschreibung des numerischen Modells

Zur Abbildung eines Verbundglases können unterschiedliche Modellierungsansätze von einem einfachen Schalenmodell bis hin zu der Verwendung von Volumenelementen für alle Bauteile verfolgt werden (s. Abschn. 1.3). Eine umfassende Übersicht hierzu gibt KOLLING et al., 2012.

In dieser Arbeit wurde ein Volumen-Schalen-Modell für das Verbundglas verwendet, wobei die PVB-Zwischenschicht mit drei Volumenelementen über die tatsächliche Dicke

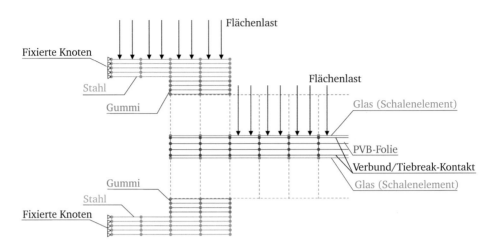

Abbildung 6.11 Schematische Darstellung des FE-Modells in *LS-DYNA*

und die beiden Glasplatten als Offset-Schalenelemente abgebildet wurden. Offset bedeutet, dass die Bezugsebene der Schalen nicht deren Mittelebene sondern in diesem Fall deren Oberfläche ist. Die Knoten der Schalenelemente wurden an der jeweiligen Oberfläche der PVB-Volumenelemente positioniert. Eine Modellierung ohne Offset oder als drei geschichtete Schalen ist in *LS-DYNA* mit den verfügbaren Kontaktbedingungen nicht möglich, da die Rotationsfreiheitsgrade der Schalen bei flächigen Kontakten nicht gekoppelt werden (LSTC, 2014b). Aus diesem Grund kann bei der Verwendung von Schalenelementen für die Glasplatten auch kein Verbundglas mit mehr als zwei Glasplatten modelliert werden. Eine vollständige Modellierung mit Volumenelementen führt zu einem erhöhtem Rechenaufwand. Zudem kann ein unrealistisches Bruchbild bei der Verwendung mehrerer Volumenelemente über die Dicke der Glasplatte entstehen, da der Rissfortschritt auch über die Plattendicke simuliert werden muss. Dies begründet den gewählten Modellierungsansatz, welcher bereits bei Impaktsimulationen zu guten Ergebnissen geführt hat (SUN et al., 2005; LIU et al., 2012; ALTER et al., 2013).

Die Modellierung der Randklemmung aus Stahl und Gummi gleicht der Beschreibung in Abschnitt 5.3.2 für die Simulation des intakten Zustands. Als Elemente wurden jeweils vier Volumenelemente über die Dicke verwendet, die Lagerung erfolgte über die Fixierung aller Freiheitsgrade der äußersten Knotenreihe des Stahlblechs. Abbildung 6.11 veranschaulicht schematisch das FE-Modell.

Als Volumenelemente wurden vollintegrierte 8-Knoten-Elemente gewählt. Für die Schalenelemente wurden vollintegrierte Belytschko-Tsay Elemente (BELYTSCHKO et al., 1984) mit vier Knoten und fünf Integrationspunkten über die Dicke verwendet. Hierbei wurde anstelle der üblichen Integrationsregel nach Gauß die nach Lobatto verwendet (DAVIS et al., 1975), um die Spannungsergebnisse an der Schalenoberfläche zu erhalten.

Für Glas und Stahl wurde eine linear-elastische Materialmodellierung mit den für die Materialien üblichen Parametern gewählt. Die Gummieinlage zwischen Stahl und Glas wurde mit einem hyperelastischen Materialmodell nach Neo-Hooke abgebildet, um auch große Verzerrungen numerisch stabil halten zu können (s. Abschn. 2.3.4). Die Steifigkeit des Gummis wurde anhand experimenteller Untersuchungen zum intakten Zustand kalibriert. Im Hinblick auf das Nachbruchverhalten wurde der Zwischenschicht ein hyperelastisches Materialmodell zugewiesen, um auch große Dehnungen zu berücksichtigen. Da die klassischen hyperelastischen Materialmodelle nur eine konstante Dehnrate abbilden können, wurde für die PVB-Zwischenschicht die dehnratenabhängige Hyperelastizität nach KOLLING et al., 2007 gewählt (s. Abschn. 2.3.4).

Zur Abbildung des Bruchvorgangs im Glas wurde den Schalenelementen ein Versagenskriterium zugewiesen. Hierbei wurde ein Hauptspannungskriterium und ein elastisch-plastisches Versagenskriterium auf Brauchbarkeit untersucht.

Der Verbund von Stahl und Gummi wurde mittels koinzidenter Knoten erzeugt. Zwischen Gummi und Glas wurde ein automatischer Reibungskontakt verwendet, um auch große Verformungen in der Ebene realistisch abbilden zu können. Der Reibungskoeffizient wurde zu $C_f = 0,7$ angenommen, wobei eine Variation hier keinen signifikanten Einfluss zeigte. Das Laminat aus Glas und PVB wurde mit einem Verbundkontakt realisiert. Zur Simulation der Delamination im gebrochenen Zustand wurde ein Tiebreak-Kontakt untersucht. Tabelle 6.7 fasst die Eigenschaften des gewählten FE-Modells in *LS-DYNA* zusammen.

Tabelle 6.7 Zusammenfassung des FE-Modells in *LS-DYNA*

Bauteil	Elementformulierung	Materialmodell	Kontaktformulierung
Stahlrahmen	vollintegrierte Volumenelemente	linear-elastisch ($E = 210\,\text{GPa}$, $v = 0,3$)	Koinzidente Knoten
Gummi-Zwischenlage	vollintegrierte Volumenelemente	Neo-Hookesche Hyperelastizität ($G_0 = 200\,\text{MPa}$)	Autom. Kontakt m. Reibung ($C_f = 0,7$)
Glas	vollintegrierte Schalenelemente[a]	linear-elastisch mit Versagen ($E = 70\,\text{GPa}$, $v = 0,2$)	Verbundkontakt[b]
PVB	vollintegrierte Volumenelemente	Dehnratenabhängige Hyperelastizität (KOLLING et al., 2007) ($K = 2\,\text{GPa}$, $v = 0,495$)	

[a] 5 Integrationspunkte über Dicke
[b] oder Tiebreak-Kontakt zur Abbildung der Delamination

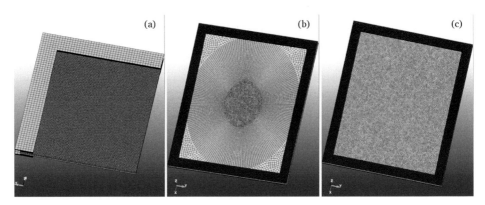

Abbildung 6.12 FE-Modelle in *LS-DYNA*: für intakten Zustand (a), für gebrochenen Zustand mit regelmäßigem (b) und unregelmäßigem Netz (c)

Zur Validierung des intakten Zustands wurde die Doppelsymmetrie ausgenutzt und ein regelmäßiges Netz verwendet (Abb. 6.12a). Bei Abbildung des gebrochenen Zustands wurden vorwiegend Glaselemente an der Symmetrieachse gelöscht, wodurch auch die zugehörige Randbedingung wirkungslos wurde. Aus diesem Grund wurde für die Abbildung des gebrochenen Zustands am Gesamtmodell gerechnet. Es wurden zwei Netzarten untersucht: Abbildung 6.12 zeigt das regelmäßige (b) und das unregelmäßige Netz (c). Die Dicken der Glasplatten wurden in allen Berechnungen zu jeweils 5,9 mm angesetzt.

Validierung des intakten Zustands

Die gewählten Randbedingungen und Modellierungsgrundsätze wurden anhand experimenteller Untersuchungen zum intakten Zustand validiert. Da die in Abschnitt 5.2.2 vorgestellten Versuche zum intakten Zustand mit Laminataufbauten mit mehr als zwei Glasplatten erfolgten und bei den in Abschnitt 6.2.3 vorgestellten Versuchen zum gebrochenen Zustand keine Auslenkungsmessungen erfolgten, wenn das Glas nicht brach, standen keine eigenen Untersuchungsergebnisse für diese Validierung zur Verfügung. Aus diesem Grund erfolgte die Validierung im intakten Zustand mit experimentellen Untersuchungen des *Fachverband Konstruktiver Glasbau e. V.* (BURMEISTER et al., 2005). Dort wurden ebenfalls Verbundgläser mit 2×6 mm dicken Glasplatten und einer Zwischenschicht aus PVB von der Firma *Kuraray* auf ihre Explosionshemmung im Stoßrohr untersucht und die Auslenkung in Versuchen gemessen, bei denen das Glas nicht brach. Die Versuche wurden in der gleichen Einrichtung und unter den gleichen Randbedingungen wie die Versuche in dieser Arbeit durchgeführt.

Es wurden vier Probekörper im Normprüfrahmen getestet, bei denen das Glas intakt blieb. Dabei wurden zwei verschiedene Foliendicken untersucht. Tabelle 6.8 fasst die Ergebnisse zusammen und zeigt die gute Übereinstimmung der numerischen Simulationen

Tabelle 6.8 Vergleich von Experiment und Simulation im intakten Zustand

Versuchs-nummer	Laminataufbau Glas/PVB/Glas [mm]	Friedlander-Parameter			Experiment		Simulation	
		P_R [kPa]	i_+ [kPa ms]	A_Z [-]	x^a [mm]	t^b [ms]	x^a [mm]	t^b [ms]
G655	6/0,76/6	46	370	0,60	12,5	5,0	12,1	5,0
G656	6/0,76/6	58	520	0,65	15,0	5,0	15,0	5,0
G672	6/2,28/6	46	370	0,60	10,5	5,0	10,6	5,0
G675	6/2,28/6	30	220	0,30	7,0	5,0	7,0	5,0

a Maximale Auslenkung in der ersten Schwingung
b Zeit bis zur maximalen Auslenkung in der ersten Schwingung

mit den experimentellen Untersuchungen im intakten Zustand. Als Einwirkungen wurde die Friedlander-Gleichung (2.4) mit den angegebenen Parametern dem FE-Modell übergeben.

Mit dem Modell zum intakten Zustand wurden darüber hinaus mehrere Parameter variiert, um deren Einfluss auf die Berechnungsergebnisse zu studieren:

Mit einer generellen maximalen Elementkantenlänge von 10 mm sowie einem Element über die Dicke für die PVB-Folie ist das FE-Modell ausreichend fein diskretisiert. Da die PVB-Folie im gebrochenen Zustand hohen Verzerrungen unterworfen ist, werden dennoch drei Volumenelemente über die Dicke verwendet. Für Stahl und Gummi sind jeweils vier Volumenelemente über die Dicke, für die Schalenelemente (Glas) fünf Integrationspunkte über die Dicke ausreichend.

Die Reibung im automatischen Kontakt zwischen Gummi und Glas zeigt bei Werten zwischen $0 \leq C_f \leq 1,5$ keine signifikanten Auswirkungen auf das zeitliche Verformungsverhalten des Plattenmittelpunkts.

Bei der Materialmodellierung von PVB wurde neben der dehnratenabhängigen Hyperelastizität ein linear-elastischer Ansatz mit $E = 300 \, \text{MPa}$ analog Abschnitt 5.2.2 untersucht. Beide Varianten zeigen vergleichbare Ergebnisse und bestätigen, dass ein linear-elastischer Ansatz für die Simulation des intakten Zustands ausreichend ist.

Eine realitätsnahe Modellierung der Randbedingungen unter Berücksichtigung der Teileinspannung ist unbedingt notwendig. Bei Vernachlässigung der Randklemmung und einfacher Navier-Lagerung der Platte bei ansonsten identischer Modellierung entstehen um 60 % höhere maximale Verformungen bei gleichzeitiger Reduktion der Eigenfrequenz um etwa 30 %.

Schließlich wurden verschiedene Steuerungseinstellungen für die Elementansätze, die Hourglass-Stabilisierung und die Kontaktansätze untersucht, um die gewählten Einstellungen als geeignet zu bestätigen.

Abbildung des Nachbruchverhaltens

Die Berechnung des gebrochenen Zustands mit dem Ansatz der Erosion führt zwangsläufig zu einer Netzabhängigkeit, welche zumindest in lokalen Ergebnisgrößen ohne aufwändige Regularisierung nicht zu verhindern ist. Wie diese Netzabhängigkeit als Vorteil zu nutzen ist, wird später erläutert.

Die derzeitige Leistungsfähigkeit von FE-Berechnungen lässt eine durchaus feine aber immer noch limitierte Diskretisierung zu. Aus diesem Grund beschränkt sich die Validierung im gebrochenen Zustand auf feste Netzgrößen. Zur Untersuchung der Netzabhängigkeit wurden zwei unterschiedliche Netzstrukturen für das Laminat gewählt: Eine regelmäßige Netzstruktur, welche die Richtung der in den experimentellen Untersuchungen vorwiegend beobachteten radialen und konzentrischen Risse vorgibt (Abb. 6.12b) und eine unregelmäßige zufällige Netzstruktur, bei welcher der Riss keine Vorzugsrichtung aufgezwungen bekommt (Abb. 6.12c). Bei beiden Netzvarianten wurde die feinste Diskretisierung gewählt, mit welcher die Berechnungen auf dem zur Verfügung stehenden PC (Workstation mit acht Kernen à 2,9 GHz) noch in einem Tag durchführbar waren. Eine Übersicht über die untersuchten Netze gibt Tabelle 6.9. Im Folgenden werden die drei wichtigsten Aspekte der Modellierung näher beleuchtet, bevor der Vergleich zwischen den endgültigen numerischen Simulationen und den Experimenten folgt.

Versagenskriterium von Glas

In *LS-DYNA* stehen unterschiedliche Versagenskriterien zur Verfügung. Ein Kriterium, welches das Versagen von Glas treffend beschreibt, ist das der maximalen Hauptzugspannung (Rankine-Kriterium, s. Abschn. 2.2.2). Dieses Kriterium kann mit der zusätzlichen Materialkarte *MAT_ADD_EROSION* in das Modell eingefügt werden. Die Anwendung führte im vorliegenden Modell allerdings zu numerischen Instabilitäten. Das plötzliche Löschen des Elements in einem Zeitschritt erzeugte im benachbarten Element starke hochfrequente Spannungsoszillationen, was zu großflächiger Erosion und damit unrealistischen Bruchbildern führte (Abb. 6.13).

Aus diesem Grund wurde auf das Material *MAT_MODIFIED_PIECEWISE_ LINEAR_PLASTICITY* zurückgegriffen, welches nach Erreichen der Bruchspannung ei-

Tabelle 6.9 Untersuchte Netze zum gebrochenen Zustand in *LS-DYNA*

Netzstruktur	Element-kantenlängen	Zeitschritt-größe	Element-anzahl	Anzahl an Freiheits-graden	Rechendauer für 100 ms[a]
Regelmäßig	4 mm bis 10 mm	$2{,}1 \cdot 10^{-4}$ ms	205 508	739 016	22 h
Unregelmäßig	8 mm	$2{,}1 \cdot 10^{-4}$ ms	248 897	877 680	23 h

[a] auf einer Workstation mit acht Kernen à 2,9 GHz

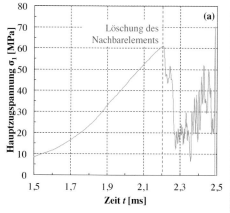
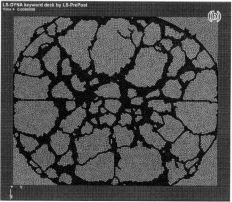

Abbildung 6.13 Anwendung des Rankine-Kriteriums für Glas: Spannungsoszillationen in einem Element nach dem Löschen des benachbarten Elements (a), Bereiche großflächiger Erosion bei Laststufe ER 1 nach 10 ms (b)

ne geringe plastische Verfestigung vor dem Löschen zulässt, wodurch das Versagen weicher wurde und keine exzessive Erosion mehr auftrat. Nachteilig hierbei ist, dass das Versagen aufgrund einer von-Mises-Vergleichsspannung initiiert wird. Bei einem reinen biaxialen Zugzustand, wie er in Plattenmitte auf der Rückseite der Verglasung annähernd herrscht, entspricht dieses Versagenskriterium dem des Rankine-Kriteriums. Allerdings wird nach von-Mises keine Zug-Druck-Unterscheidung getroffen, sodass das Glas auf Druck ebenso versagt. Dennoch wird dieses Kriterium für die endgültige Modellierung verwendet, da das Bruchbild auf der Schutzseite und die Abbildung der globalen Steifigkeit gut mit den Experimenten übereinstimmt. In Tabelle 6.10 sind die final verwendeten Einträge der Materialkarte angegeben. Die Steifigkeit wurde DIN EN 572-1, 2012 entnommen, da das verwendete Glas nicht dem aus Kapitel 3 entsprach. Die Festigkeit wurde DIN 18008-4 entnommen. Eine Variation der Festigkeit gemäß Tabelle 3.6 wirkt sich auf den Zeitpunkt des Glasbruchs aus, das Nachbruchverhalten wird dadurch aber nicht signifikant beeinflusst.

Tabelle 6.10 Einträge in der Materialkarte *MAT_MODIFIED_PIECEWISE_LINEAR_PLASTICITY*

Dichte	Elastizitäts-modul	Querkontrak-tionszahl	Fließ-spannung	Tangenten-modul	Plastische Versagens-dehnung
RO [kg m^{-3}]	E [MPa]	PR [-]	SIGY [MPa]	ETAN [MPa]	FAIL [%]
2 500	70 000	0,2	81	0,3	0,01

Durch die Implementierung eines eigenen Materialmodells (*User Material Subrouting*, *UMAT*) besteht die Möglichkeit, das Rankine-Kriterium mit einer Schädigung vor der Elementlöschung zu realisieren. Dadurch wird nach Erreichen des Versagenskriteriums die Spannung im Element schrittweise reduziert und das Versagen weicher. Wenn die Schädigungsenergie gleich der Bruchenergie von Glas gesetzt wird, kann auch ein physikalischer Bezug geschaffen werden – die Massenbilanz wird aber weiterhin verletzt. Dies wird für weiterführende Untersuchungen empfohlen, um die Realitätsnähe von Glasversagen und Bruchbild zu verbessern (s. Kap. 7).

Materialgesetz der Zwischenschicht

Die Spannungs-Dehnungs-Beziehung der untersuchten Zwischenschichten aus PVB weist eine starke Abhängigkeit von der Dehnrate auf. In Abbildung 4.19c wurden anhand von uniaxialen Zugversuchen am gleichen Folienmaterial Spannungs-Dehnungs-Beziehungen bei konstanter wahrer Dehnrate ermittelt. Diese Kurven wurden in *LS-DYNA* dem Materialmodell **MAT_SIMPLIFIED_RUBBER* nach KOLLING et al., 2007 zugewiesen. Die gewählte Materialformulierung stellt jedoch keine tatsächliche Viskosität dar, sodass bei Entlastung keine Hysteresen abgebildet werden können. Mittels Schädigungsparameter ist eine Anpassung auf die Entlastung möglich. Da in diesem Fall jedoch nur sehr kurzzeitige Einwirkungen untersucht wurden, konnten Entlastungsvorgänge in erster Näherung vernachlässigt werden.

In Tabelle 4.6 sind Werte für die Reißdehnung der PVB-Folie angegeben, welche ebenfalls anhand der uniaxialen Zugversuche ermittelt wurden. Diese können dazu dienen, bei der Materialmodellierung der Zwischenschicht ein Versagenskriterium zu definieren, um auch den Folienriss als endgültiges Versagen abbilden zu können. Allerdings ist die im FE-Modell zu beobachtende wahre Dehnung der Zwischenschicht mit maximal $\varepsilon_w = 14\,\%$ deutlich geringer als die wahre Reißdehnung mit etwa $\varepsilon_w = 125\,\%$, obwohl auch Folienrisse im Experiment beobachtet wurden. Dies folgt aus der zu großen Ausgangsdehnlänge der Zwischenschicht, welche durch das Löschen eines Elements entsteht. Um Beanspruchungen in der Zwischenschicht im Bereich des Versagens zu erreichen, müssten noch deutlich feinere Diskretisierungen realisiert werden. Aus diesem Grund ist auch eine Auswertung der Dehnrate mit dem erstellten Modell nicht aussagekräftig.

Delamination der Zwischenschicht vom Glas

Die Delamination der Zwischenschicht vom Glas ist Voraussetzung zur Erzeugung einer Ausgangsdehnlänge, damit bei einem Glasbruch mit infinitesimaler Breite der Risse eine endliche Dehnung in der Zwischenschicht erzeugt werden kann (s. Abschn. 6.1). Dies muss im numerischen Modell berücksichtigt werden, wenn lokale Ergebnisgrößen in der Zwischenschicht betrachtet werden sollen.

Wird der Bruchvorgang im Glas wie in dem vorgestellten FE-Modell mittels Löschen von Elementen erzeugt, entsteht automatisch eine Ausgangsdehnlänge für die Zwischenschicht, welche der Kantenlänge des gelöschten Elements entspricht. Dies spiegelt zwar nicht den realen lokalen Vorgang wider, kann jedoch als Ansatz genutzt werden, die angesprochene Netzabhängigkeit vorteilhaft auszunutzen. Wird die Elementkantenlänge entsprechend dem Delaminationsvermögen der Zwischenschicht gewählt, so kann ohne aufwändige Modellierung des Delaminationsvorgangs eine korrekte Beanspruchung der Folie im Rissbereich simuliert werden. Die Bestimmung des realen Delaminationsvermögens unter der gegebenen Belastung stellt versuchstechnisch hohe Anforderungen. Anhand eines Through Cracked Bending (TCB) Tests, ist aber eine Abschätzung möglich (FRANZ, 2015). Der ausschließlich in Folienebene belastende TCT Test ist dagegen nicht geeignet, da bei diesem ein konstanter unbegrenzter Delaminationsfortschritt einsetzt, falls die Folie ausreichend steif und dick ist.

Anhand der Simulationsergebnisse ist davon auszugehen, dass die gewählte Elementkantenlänge deutlich zu groß ist, um das reale Verhalten lokal korrekt abzubilden. Mit Steigerung der Leistungsfähigkeit von Rechnern und FE-Programmen kann aber zukünftig eine weitere Verfeinerung der Diskretisierung erfolgen und dieser Ansatz untersucht werden.

Falls der Bruchvorgang im Glas mit infinitesimalen Breiten simuliert wird, kann die Delamination mittels Kohäsivzonenmodellen numerisch abgebildet werden. *LS-DYNA* bietet hierfür den Tiebreak-Kontakt an. Dieser verhält sich im Gegensatz zu üblichen Kohäsivzonenmodellen bis zum Erreichen der Haftfestigkeit unendlich steif. Anschließend fällt die aufnehmbare Spannung linear bis zur endgültigen Separation ab. Als Eingabeparameter werden die Haftfestigkeit in normaler und tangentialer Richtung sowie die Separation angegeben, aus denen sich die Energiefreisetzungsrate ergibt. Die angesetzten Werte sind in Tabelle 6.11 zusammengefasst und aus Tabelle 6.2 sowie FRANZ, 2015 entnommen. Die Simulationen zeigen ein ausgeprägtes Abplatzen von Glaselementen, wodurch die PVB-Folie in weiten Teilen freigelegt wird und daraus ein zu weiches Verhalten im Nachbruchbereich resultiert (Abb. 6.14 und 6.15a). Aus diesem Grund wurde der Ansatz eines Tiebreak-Kontaktes nicht weiter verfolgt.

Tabelle 6.11 Einträge in der Kontaktkarte *CONTACT_AUTOMATIC_SURFACE_TIEBREAK*

Option	Haftfestigkeit normal	Haftfestigkeit tangential	Separation	Resultierende Energiefreisetzungsrate
OPTION	NFLS [MPa]	SFLS [MPa]	PARAM [mm]	$[\mathrm{J\,m^{-2}}]$
8^a	10,0	10,0	0,3	1500

[a] Option 8 ermöglicht Tiebreak-Kontakt mit Offset-Schalen und Volumenelementen

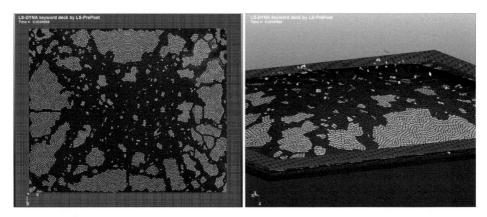

Abbildung 6.14 Anwendung des Tiebreak-Kontakts in *LS-DYNA*: Belastung ER 1,6 nach 10 ms

Vergleich mit Stoßrohrversuchen

Mit den erstellten Modellen wurde ein Vergleich der zeitlichen Auslenkung zu den experimentell gemessenen Daten gezogen (Abb. 6.15). Für die Laststufe ER 1,6 wurden die niedrige und mittlere Haftung (BG R10 und BG R15) aufgrund der geringen Unterschiede zusammengenommen. Es zeigt sich, dass mit den Modellen ohne Tiebreak-Kontakt die globale Steifigkeit korrekt getroffen wird und auch im Nachbruchverhalten, welches nach 2 ms bis 3 ms beginnt, das Verformungsverhalten gut wiedergegeben werden kann. Insbesondere die Versuche mit hoher Haftung bei der Laststufe ER 1 (b) lassen sich mit beiden Netzstrukturen gut reproduzieren. Bei den Versuchen mit Laststufe ER 1,6 (a) zeigt das unregelmäßige Netz näher an den experimentellen Messungen liegende Ergebnisse.

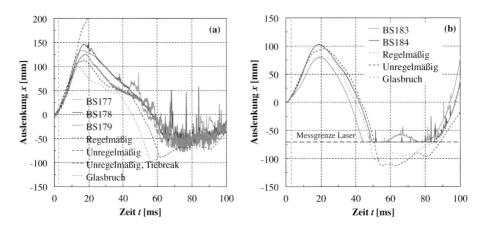

Abbildung 6.15 Vergleich der numerischen Simulation mit den experimentellen Messdaten: BG R10 und BG R15 bei ER 1,6 (a); BG R20 bei ER 1 (b)

In Abbildung 6.16 ist ein Vergleich der Bruchbilder bei hoher Haftung (BG R20, ER 1) zu drei Zeitpunkten dargestellt. Auch hier zeigt sich eine gute Übereinstimmung zwischen der numerischen Simulation und dem Experiment.

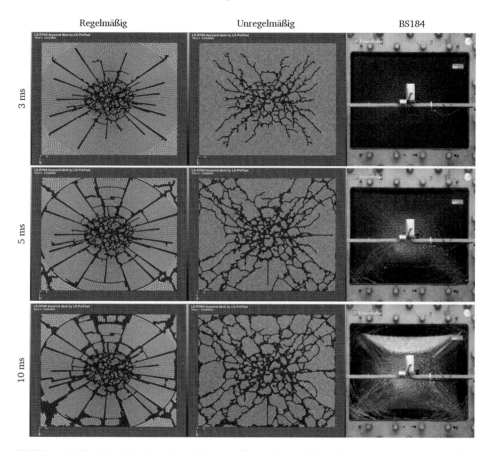

Abbildung 6.16 Vergleich des Bruchbilds von Simulation und Experiment mit hoher Haftung (BG R20) zu drei Zeitpunkten bei Laststufe ER 1

6.4 Zusammenfassung

Das Delaminationsverhalten von Zwischenschicht und Glas wirkt sich maßgeblich auf das Nachbruchverhalten von Verbundglas aus. Im Rahmen dieser Arbeit wurde der Einfluss der Belastungsgeschwindigkeit auf das Delaminationsverhalten experimentell untersucht. Des Weiteren wurden experimentelle und numerische Untersuchungen zum Nachbruchverhalten im Lastfall Explosion durchgeführt. Die Untersuchungen umfassen verschiedene Zwischenfolien aus PVB mit unterschiedlicher Adhäsion und Steifigkeit.

Anhand von Haftungsversuchen (Pummeltest, Zughaftung, Scherhaftung) wurde die Adhäsion quantifiziert. Darauf aufbauend wurde anhand von TCT Tests der Einfluss der Belastungsgeschwindigkeit auf das Delaminationsverhalten untersucht. Wird diese gesteigert, erhöht sich die Steifigkeit der Zwischenschicht und damit das Kraftniveau im Versuch. Das Delaminationsvermögen, also die maximale Separation vor einem Folienversagen, sinkt dagegen. Die Zwischenschichten mit geringer Haftung zeigten aber auch bei sehr hohen Belastungsgeschwindigkeiten ein ausgeprägtes Delaminationsverhalten, was auf ein positives Verhalten im gebrochenen Zustand schließen lässt.

Dies bestätigte sich in den Stoßrohrversuchen, bei denen der Einfluss des Zwischenmaterials auf das Nachbruchverhalten im Lastfall Explosion untersucht wurde. Die Zwischenfolien mit geringer Steifigkeit und niedriger Haftung lieferten hier die besten Ergebnisse mit einem ausgeprägten Nachbruchverhalten. So können höhere Belastungen vor dem endgültigen Versagen der Verglasung aufgenommen werden. Gleichzeitig werden große Deformationen erreicht, wodurch ein großer Teil der einwirkenden Energie dissipiert und deswegen nicht an die Unterkonstruktion weitergeleitet wird. Diese Erkenntnis kann dazu dienen, Zwischenfolien zu optimieren, sowohl bei der Auswahl der am Markt verfügbaren Produkten als auch bei der Produktentwicklung einer speziellen Zwischenschicht für explosionshemmende Verglasungen. Eine erhöhte Gefährdung infolge Splitterflug infolge der geringeren Haftung konnte nicht festgestellt werden.

Anstelle der kosten- und zeitintensiven Stoßrohrversuche kann der TCT Test mit hoher Belastungsgeschwindigkeit herangezogen werden, um eine Zwischenschicht hinsichtlich ihres Nachbruchverhaltens im Lastfall Explosion zu bewerten. Als Prüfkriterium wird die Einstellung eines Delaminationsfortschritts vorgeschlagen.

Zur numerischen Abbildung des mechanischen Verhaltens von Verbundglas im Lastfall Explosion unter Berücksichtigung des gebrochenen Zustands wurden zwei Ansätze verfolgt. Der Ansatz einer globalen Steifigkeitsreduktion führte dabei zu keinen zufriedenstellenden Ergebnissen. Die diskrete Simulation von Rissen im Glas mit expliziter Zeitintegration zeigte im zeitlichen Verformungsverhalten eine sehr gute Übereinstimmung mit den experimentellen Messdaten. Lokale Ergebnisgrößen wie die Dehnung der Zwischenschicht im Bereich des Glasbruchs können jedoch mit den derzeit zur Verfügung stehenden Mitteln noch nicht realitätsnah abgebildet werden.

7 Zusammenfassung und Ausblick

Die vorliegende Arbeit behandelt unterschiedliche Aspekte zum mechanischen Verhalten von Verbundglas. Neben der allgemeinen Behandlung zeitabhängiger Belastungen liegt der Schwerpunkt auf dem Lastfall Explosion, der die kurzzeitige dynamische Einwirkung einer Stoßwelle infolge einer Detonation bezeichnet. Dabei wird zwischen dem intakten Zustand vor dem Glasbruch und dem Nachbruchverhalten unterschieden. Auf beide Zustände wirkt sich das von Temperatur und Belastungsdauer abhängige Materialverhalten der Kunststoff-Zwischenschichten aus. Ein Großteil der im Bauwesen eingesetzten Zwischenmaterialien wurde vergleichend untersucht und hinsichtlich der Eignung für bestimmte Anwendungssituationen bewertet.

Die Festigkeit von Glas ist aufgrund des subkritischen Risswachstums ebenfalls von der Belastungsdauer abhängig. Zur Quantifizierung der Festigkeitssteigerung bei kurzzeitigen dynamischen Einwirkungen gegenüber den normativ festgelegten Werten wurden mit unterschiedlichen Glasarten quasistatische Doppelring-Biegeversuche mit einer Spannungsrate von $2\,\mathrm{MPa\,s^{-1}}$ und Pendelschlagversuche mit Spannungsraten von $1000\,\mathrm{MPa\,s^{-1}}$ bis $10\,000\,\mathrm{MPa\,s^{-1}}$ durchgeführt. Die Ergebnisse wurden mit einem bruchmechanischen Modell verglichen, um Prognosen für die Kurzzeitfestigkeit und Modifikationsbeiwerte zur Ermittlung einer Bemessungsspannung unter kurzzeitiger dynamischer Einwirkung nach DIN 18008-1 abzuleiten. Dabei wurden erstmals alle Bereiche des subkritischen Risswachstums berücksichtigt. Für thermisch entspanntes Kalknatron-Silikatglas ergibt sich in Abhängigkeit der Spannungsrate und Initialrisstiefe eine Steigerung gegenüber der quasistatischen Belastung von 30 % bis 50 %. Um die große Streuung in den Festigkeitsuntersuchungen zu verringern, wird für weiterführende Untersuchungen eine gezielte Vorschädigung der Probekörper empfohlen. Auf die aufwändige messtechnische Instrumentierung der Pendelschlagversuche kann bei Verwendung eines validierten Finite-Elemente-Modells verzichtet werden. Werden Prüfungen ohne gezielte Vorschädigung durchgeführt, können unterschiedliche Probekörpergeometrien bei quasistatischer und dynamischer Belastung mit der Methode der gewichteten Hauptspannungen berücksichtigt werden (SHEN, 1997).

Im intakten Zustand von Verbundglas ist eine Beschränkung auf kleine Verzerrungen der Zwischenschicht in den meisten Fällen gerechtfertigt. Dies ermöglicht die Anwendung der linearen Viskoelastizität zur Beschreibung des zeitabhängigen Verhaltens der Kunststoffe. Verhält sich die Zwischenschicht im relevanten Temperatur- und Zeitbereich darüber hinaus thermorheologisch einfach, kann das Zeit-Temperatur-Verschiebungsprinzip

angewandt und somit das mechanische Verhalten von Verbundglas vollständig beschrieben werden. Dynamisch-Mechanisch-Thermische Analysen an verschiedenen Zwischenmaterialien wurden in verschiedenen Belastungsmodi durchgeführt, um einen Vergleich der Materialien zu ermöglichen und Empfehlungen für eine geeignete Versuchsmethodik abzuleiten. Aufgrund des signifikanten Steifigkeitsabfalls im Glasübergangsbereich wird empfohlen, unterschiedliche Belastungsmodi für den energie- und den entropieelastischen Bereich zu verwenden. Günstig haben sich hier die Torsion eines Streifens im energieelastischen Bereich und die Doppelscherung am reinen Folienmaterial im entropieelastischen Bereich erwiesen. Die in dieser Arbeit nicht untersuchte Platte-Platte-Anordnung im Rheometer wird ebenfalls für den entropieelastischen Bereich als geeignet erachtet, was in weiterführenden Untersuchungen zu bestätigen ist.

Zur Parameteridentifikation für die viskoelastischen Materialmodelle wurden Werkzeuge entwickelt, um die Verwendung einer beliebigen Anzahl an Maxwell-Elementen zu ermöglichen. Anhand von Kriechversuchen mit Verbundgläsern wurden die abgeleiteten Materialparameter für die Zwischenschicht aus PVB validiert. Die Ermittlung der Anwendungsgrenzen der linearen Viskoelastizität stellt eine noch offene Fragestellung dar.

Im Lastfall Explosion kann das mechanische Verhalten von intaktem Verbundglas zutreffend prognostiziert werden. Dies wurde anhand eines Vergleichs von Finite-Elemente-Simulationen mit experimentellen Untersuchungen im Stoßrohr bestätigt. Mithilfe validierter Finite-Elemente-Modelle ist somit eine Prognose des Glasbruchs und eine darauf aufbauende Bemessung von explosionshemmenden Verglasungen möglich, um den Aufwand der sonst notwendigen kosten- und zeitintensiven Stoßrohrversuche zu minimieren. Dabei ist eine linear-elastische Modellierung der Zwischenschicht in der Regel ausreichend.

Nach Glasbruch erfährt die Zwischenschicht große Dehnungen bis zum Bruch. Um dieses Verhalten genauer zu untersuchen, wurden uniaxiale Zugversuche mit verschiedenen Zwischenmaterialien durchgeführt. Die aufgebrachten Belastungsgeschwindigkeiten umfassen Dehnraten bei quasistatischer Belastung bis hin zum Lastfall Explosion. Die Ergebnisse dienen neben dem Vergleich der Zwischenmaterialien untereinander der Verwendung in Materialmodellen für numerische Simulationen. Hierzu wurde eine Auswertung in Spannungs-Dehnungs-Beziehungen bei konstanter wahrer Dehnrate vorgenommen. Darüber hinaus wurde für die untersuchte Zwischenschicht aus PVB die Annahme der Isotropie bestätigt und Reißfestigkeit, Bruchdehnung und Querkontraktionszahl aller untersuchten Materialien ausgewertet. Schließlich wurden linear-elastische und hyperelastische Materialparameter aus den Spannungs-Dehnungs-Beziehungen abgeleitet. Weiterer Forschungsbedarf wird in der Auswirkung mehraxialer Beanspruchung insbesondere bei der Ionoplastfolie, der thermomechanischen Kopplung (verzerrungsinduzierte Temperaturänderung der Zwischenschicht, welche wiederum deren Steifigkeit beeinflusst) und in der Untersuchung und Beschreibung des Entlastungsvorgangs (Relaxation, zeitabhängige reversible und irreversible Verformungen) gesehen.

Neben dem Spannungs-Dehnungs-Verhalten der Zwischenschicht beeinflusst die De-lamination der Zwischenschicht vom Glas maßgeblich das Nachbruchverhalten. Für den Lastfall Explosion wurden Kleinbauteilversuche (TCT Tests) und Bauteilversuche im Stoß-rohr durchgeführt, um die Einflüsse aus Haftung und Steifigkeit auf das Nachbruchverhal-ten zu untersuchen. Ein optimiertes Zwischenmaterial muss demnach bei hohen Dehnra-ten eine geringe Haftung, eine geringe Steifigkeit und eine hohe Bruchdehnung aufweisen. Anstelle der aufwändigen Stoßrohrversuche kann der vergleichsweise einfach durchzufüh-rende TCT Test mit hohen Belastungsgeschwindigkeiten zur Bewertung, Auslegung und Optimierung einer Zwischenschicht dienen. Als einfaches Bewertungskriterium, ob die gewählte Dicke der Zwischenschicht ausreichend ist, wird die Einstellung eines Delami-nationsfortschritts vorgeschlagen. Um die dabei erzeugte Dehnrate auswerten zu können, ist allerdings eine hohe optische Auflösung (≥ 100 px mm^{-1}) im Anfangsbereich nötig.

Die Ergebnisse der Stoßrohrversuche zum Nachbruchverhalten wurden außerdem für einen Vergleich mit numerischen Simulationen verwendet. Der zeitliche Verlauf der Aus-lenkung kann bei einer diskreten Abbildung der Risse gut nachvollzogen werden. Es wurde ein Finite-Elemente-Modell erstellt, welches den Bruchvorgang im Glas mit dem Löschen von Elementen bei Erreichen des Versagenskriterium simuliert. Die Abbildung realisti-scher Dehnungen der Zwischenschicht im Bereich der Risse im Glas ist mit diesem Mo-dell jedoch nicht möglich. Eine deutlich feinere Diskretisierung durch höhere Leistungs-fähigkeit der Rechner in Verbindung mit einer stabilen Simulation des Glasversagens wird hierfür als notwendig erachtet. Die Elementkantenlänge ist dabei entsprechend der sich tatsächlich einstellenden Delamination zu wählen. Diese kann beispielsweise anhand ei-nes TCB Tests ermittelt werden. Ein anderer Ansatz ist die Abbildung von Rissen im Glas mit infinitesimaler Breite, in Verbindung mit einer stabilen Simulation der Delami-nation. In jedem Fall ist die Modellierung des Glasversagens hinsichtlich Realitätsnähe (Rankine-Kriterium) und Stabilität zu verbessern. Erst wenn die lokale Beanspruchung der Zwischenschicht realitätsnah im numerischen Modell erfasst wird, kann eine sichere Bemessung von Verbundglas im Lastfall Explosion unter Beachtung des Nachbruchver-haltens ohne zusätzliche experimentelle Bestätigungen erfolgen.

Literatur- und Normenverzeichnis

Literatur

ARA (2005): Applied Research Associates: Window Glazing Analysis Response & Design WINGARD: Technical Manual.

ARA (2010): Applied Research Associates: A.T.-Blast, 3.0.

ALI, A., HOSSEINI, M. und SAHARI, B. (2010): A review of Constitutive Models for Rubber-Like Materials, in: *American Journal of Engineering and Applied Sciences* Bd. 3.1, S. 232–239.

ALTENBACH, H. (2012): *Kontinuumsmechanik - Einführung in die materialunabhängigen und materialabhängigen Gleichungen*, 2. Aufl., Springer.

ALTER, C., KOLLING, S. und SCHNEIDER, J. (2013): »Verhalten von Glas und Simulation des Nachbruchverhaltens von Verbundglas bei kurzzeitiger Beanspruchung«, in: *2. Darmstädter Ingenieurkongress*, Darmstadt, S. 395–399.

ANSYS INC. (2012b): Ansys Autodyn, 14.5.

ANSYS INC. (2012a): Ansys, 15.0.

BASF (2011): Thermoplastische Polyurethan Elastomere (TPU): Elastollan - Materialeigenschaften.

BARREDO, J. et al. (2011): Viscoelastic vibration damping identification methods. Application to laminated glass, in: *Procedia Engineering* Bd. 10, S. 3208–3213.

BECKER, F. (2009): Entwicklung einer Beschreibungsmethodik für das mechanische Verhalten unverstärkter Thermoplaste bei hohen Deformationsgeschwindigkeiten, Dissertation, Martin-Luther-Universtiät Halle-Wittenberg.

BELIS, J. et al. (2009): Failure mechanisms and residual capacity of annealed glass/SGP laminated beams at room temperature, in: *Engineering Failure Analysis* Bd. 16, S. 1866–1875.

BELYTSCHKO, T., LIN, J. I. und TSAY, C.-S. (1984): Explicit algorithms for the nonlinear dynamics of shells, in: *Computer Methods in Applied Mechanics and Engineering* Bd. 42.2, S. 225–251.

BELYTSCHKO, T., GRACIE, R. und VENTURA, G. (2009): A review of extended/generalized finite element methods for material modeling, in: *Modelling and Simulation in Materials Science and Engineering* Bd. 17.4, S. 043001.

BENNISON, S. J. et al. (2005): »Laminated Glass for Blast Mitigation: Role of Interlayer Properties«, in: *Glass Processing Days 2005*, Tampere, S. 494–496.

BENNISON, S. J., QIN, M. und DAVIES, P. (2008): »High-Performance Laminated Glass for Structurally Efficient Glazing«, in: *Innovative Light-weight Structures and Sustainable Facades*, Hongkong.

BENSON, D. J. (1992): Computational methods in Lagrangian and Eulerian hydrocodes, in: *Computer Methods in Applied Mechanics and Engineering* Bd. 99.2-3, S. 235–394.

BIGGS, J. M. (1964): *Introduction to Structural Dynamics*, McGraw-Hill.

BMJV (2013): Bundesministerium der Justiz und für Verbraucherschutz: Verordnung über energiesparenden Wärmeschutz und energiesparende Anlagentechnik bei Gebäuden (Energieeinsparverordnung - EnEV 2014).

BRINSON, H. und BRINSON, C. (2008): *Polymer Engineering Science and Viscoelasticity*, New York: Springer.

BRODE, H. L. (1955): Numerical Solutions of spherical blast waves, in: *Journal of Applied Physics* Bd. 26, 766 ff.

BURMEISTER, A. und KRANZER, C. (2005): Verbundsicherheitsglas unter Blastbelastung - Experimentelle Untersuchungen - Bericht I-67/05, Fachverband Konstruktiver Glasbau.

BUTCHART, C. und OVEREND, M. (2012): »Delamination in fractured laminated glass«, in: *engineered transparency international conference at glasstec*, Düsseldorf, S. 249–257.

CALLEWAERT, D. (2011): Stiffness of Glass/ionomer Laminates in Structural Applications, Dissertation, Univesiteit Gent.

CHEN, W. W. und SONG, B. (2011): *Split Hopkinson (Kolsky) Bar*, 1. Aufl., Springer.

CHRISTOFFER, J. (1990): Ermittlung von Schneelasten in Abhängigkeit von der Liegedauer. Abschlussbericht des Deutschen Wetterdienstes gefördert durch das Institut für Bautechnik, Stuttgart.

CICCOTTI, M. (2009): Stress-corrosion mechanisms in silicate glasses, in: *Journal of Applied Physics* Bd. 42.21, S. 214006–214024.

CORMIE, D., MAYS, G. und SMITH, P. (2009): *Blast effects on buildings*, Second Edi, London: Thomas Telford.

COURANT, R., FRIEDRICHS, K. und LEWY, H. (1928): Über die partiellen Differenzengleichungen der mathematischen Physik, in: *Mathematische Annalen* Bd. 100.1, S. 32–74.

COURANT, R. und FRIEDRICHS, K. (1948): *Supersonic Flow and Shock Waves*, New York: Springer.

CZANDERNA, A. und PERN, F. (1996): Encapsulation of PV modules using ethylene vinyl acetate copolymer as a pottant: A critical review, in: *Solar Energy Materials and Solar Cells* Bd. 43.2, S. 101–181.

DIBT (2010a): Allgemeine bauaufsichtliche Zulassung Z-70.3-143: Verbund-Sicherheitsglas aus SentryGlas 5000.

DIBT (2010b): Allgemeine bauaufsichtliche Zulassung Z-70.3-156: GEWE-composite Verbund-Sicherheitsglas.

DIBT (2011): Allgemeine bauaufsichtliche Zulassung Z-70.3-170: Verbund-Sicherheitsglas aus SentryGlas SGP 5000 mit Schubverbund.

DIBT (2012): Allgemeine bauaufsichtliche Zulassung Z-70.3-89: Verbund-Sicherheitsglas mit PVB-Folie Trosifol SC.

DIBT (2013a): Allgemeine bauaufsichtliche Zulassung Z-70.3-148: Verbund-Sicherheitsglas mit der Verbundfolie der Produktfamilie EVASAFE von Bridgestone.

DIBT (2013b): Allgemeine bauaufsichtliche Zulassung Z-70.3-197: Verbund-Sicherheitsglas mit einer Verbundfolie der Produktfamilie EVASKY von Bridgestone.

DIBT (2013c): Muster-Liste der Technischen Baubestimmungen - Fassung September 2013.

DIBT (2014a): Allgemeine bauaufsichtliche Zulassung Z-70.3-197: Verbund-Sicherheitsglas mit einer Verbundfolie der Produktfamilie EVASAFE mit Ansatz eines Schubverbundes.

DIBT (2014b): Bauregelliste A, Bauregelliste B und Liste C.

DAVIS, P. J. und RABINOWITZ, P. (1975): *Methods of Numerical Integration*, New York: Academic Press.

DELINCÉ, D. (2014): Experimental Approaches for Assessing Time and Temperature Dependent Performance of Fractured Laminated Safety Glass, Dissertation, Universiteit Gent.

DOMININGHAUS, H. (2012): *Kunststoffe - Eigenschaften und Anwendungen*, 7. Aufl., Springer.

DU BOIS, P. A. und SCHWER, L. (2012): Blast modeling with LS-DYNA - course notes. DYNAmore GmbH, Stuttgart.

DUPONT (2009): DuPont SentryGlas: Architectural Safety Glass Interlayer Brochure.

DUPONT (2010): SentryGlas von DuPont: Verarbeitungshinweise.

DYNARDO GMBH (2014): optiSLang, 4.2.0.

EIRICH, M. (2013): Untersuchung des isotropen Dehnungsverhaltens von PVB anhand von quasi-statischen Zugversuchen, BSc-Thesis, Technische Universität Darmstadt.

ENSSLEN, F. (2005): Zum Tragverhalten von Verbund-Sicherheitsglas unter Berücksichtigung der Alterung der Polyvinylbutyral-Folie, Dissertation, Ruhr-Universität Bochum.

FAHLBUSCH, M. (2007): Zur Ermittlung der Resttragfähigkeit von Verbundsicherheitsglas am Beispiel eines Glasbogens mit Zugstab, Dissertation, Technische Universität Darmstadt.

FEIRABEND, S. (2010): Steigerung der Resttragfähigkeit von Verbundsicherheitsglas mittels Bewehrung in der Zwischenschicht, Dissertation, Universität Stuttgart.

FERRETTI, D., ROSSI, M. und ROYER-CARFAGNI, G. (2012): »Through Cracked Tensile Delamination Tests with Photoelastic Measurements«, in: *Challenging Glass 3*, Delft, S. 641–652.

FERRY, J. D. (1980): *Viscoelastic properties of polymers, 3rd Ed.* New York: Wiley.

FINK, A. (2000): Ein Beitrag zum Einsatz von Floatglas als dauerhaft tragender Konstruktionswerkstoff im Bauwesen, Dissertation, Technische Universität Darmstadt.

FRANZ, J. (2015): Untersuchungen zur Resttragfähigkeit von gebrochenen Verglasungen, Dissertation, Technische Universität Darmstadt.

FRIED, A. (1995): Zum Schubverhalten von VSG, Diplomarbeit, Universität Karlsruhe.

FRIEDLANDER, F. G. (1946): The Diffraction of Sound Pulses. I. Diffraction by a Semi-Infinite Plane, in: *Proceedings of the Royal Society of London. Series A, Mathematical and Physical Sciences* Bd. 186.1006, S. 322–344.

GALAC, A. P. und GRIEBEL, G. (2002): Patent EP 1 321 290 B1: Verfahren zur Herstellung von Verbundglas.

GLASSTRESS (2012): Scattered Light Polariscope SCALP-04 Instruction Manual Ver. 4.5.1.

GÖHLER, J. (2010): Das dreidimensionale viskoelastische Stoffverhalten im großen Temperatur- und Zeitbereich am Beispiel eines in der automobilen Aufbau- und Verbindungstechnik verwendeten Epoxidharzklebstoffs, Dissertation, Technische Universität Dresden.

GOM (2007): Gesellschaft für Optische Messtechnik. Aramis: Benutzerhandbuch - Software. Aramis v6.1 und höher.

GRELLMANN, W. und SEIDLER, S. (2011): *Kunststoffprüfung*, 2. Aufl., München: Carl Hanser Verlag.

GROSS, D. und SEELIG, T. (2011a): *Bruchmechanik - Mit einer Einführung in die Mikromechanik*, 5. Aufl., Springer.

GROSS, D., HAUGER, W. und WRIGGERS, P. (2011b): *Technische Mechanik 4*, 8. Aufl., Springer.

G'SELL, C. und JONAS, J. J. (1979): Determination of the plastic behaviour of solid polymers at constant true strain rate, in: *Journal of Materials Science* Bd. 14.3, S. 583–591.

GY, R. (2003): Stress corrosion of silicate glass: a review, in: *Journal of Non-Crystalline Solids* Bd. 316, S. 1–11.

HABENICHT, G. (2009): *Kleben: Grundlagen, Technologien, Anwendungen*, 6. Aufl., Springer.

HARWOOD, J. A. C., MULLINS, L. und PAYNE, A. R. (1965): Stress Softening of Natural Rubber Vulcanizates. Part II. Stres Softening Effects in Pure Gum and Filler Loaded Rubbers, in: *Journal of Applied Polymer Science* Bd. 9, S. 3011–3021.

HENRYCH, J. (1979): *The Dynamics of explosions and its use*, Amsterdam: Elsevier Science Publisher.

HILCKEN, J. (2015): Zyklische Ermüdung von thermisch entspanntem und thermisch vorgespannten Kalk-Natron-Silikatglas, Dissertation, Technische Universität Darmstadt.

HIPPE, J. (2013): Untersuchungen der Biegefestigkeit von Glas unter quasi-statischer und hochdynamischer Einwirkung, BSc-Thesis, Technische Universität Darmstadt.

HOLZAPFEL, G. A. (2000): *Nonlinear Solid Mechanics - a continuum approach for engineering*, Wiley.

HOOPER, P. et al. (2012): On the blast resistance of laminated glass, in: *International Journal of Solids and Structures* Bd. 49, S. 899–918.

HOOPER, P. (2011): Blast performance of silicone-bonded laminated glass, Dissertation, Imperial College London.

HUNTSMAN (2009): Product Overview - Optical Aliphatic Films.

HUNTSMAN (2010): A guide to thermoplastic polyurethanes (TPU).

IWASAKI, R. und SATO, C. (2006): The influence of strain rate on the interfacial fracture toughness between PVB and laminated glass, in: *Journal de Physique IV* Bd. 134, S. 1153–1158.

IWASAKI, R. et al. (2007): Experimental study on the interface fracture toughness of PVB (polyvinyl butyral)/glass at high strain rates, in: *International Journal of Crashworthiness* Bd. 12.3, S. 293–298.

KAISER, W. (2011): *Kunststoffchemie für Ingenieure*, München: Carl Hanser Verlag.

KALISKE, M. und ROTHERT, H. (1997): On the finite element implementation of rubber-like materials at finite strains, in: *Journal of Engineering Computations* Bd. 14.2, S. 216–232.

KASPER, R. (2005): Tragverhalten von Glasträgern, Dissertation, RWTH Aachen.

KEMPE, M. D. et al. (2007): Acetic acid production and glass transition concerns with ethylene-vinyl acetate used in photovoltaic devices, in: *Solar Energy Materials and Solar Cells* Bd. 91.4, S. 315–329.

KERKHOF, F., RICHTER, H. und STAHN, D. (1981): Festigkeit von Glas - Zur Abhängigkeit von Belastungsdauer und -verlauf, in: *Glastechnische Berichte* Bd. 54.8, S. 265–277.

KINNEY, G. und GRAHAM, K. (1985): *Explosive Shocks in Air*, Second Edi, New York: Springer.

KOLLING, S. et al. (2007): A tabulated formulation of hyperelasticity with rate effects and damage, in: *Computational Mechanics* Bd. 40, S. 885–899.

KOLLING, S. et al. (2012): Deformations- und Bruchverhalten von Verbundsicherheitsglas unter dynamischer Beanspruchung, in: *Stahlbau* Bd. 81.3, S. 219–225.

KONRAD, M. und GEVERS, M. (2010): »Advanced laminated glass modelling for safety FEA«, in: *9. LS-DYNA Anwenderforum*, Bamberg.

KOTHE, M. (2013): Alterungsverhalten von polymeren Zwischenschichtmaterialien im Bauwesen, Dissertation, Technische Universität Dresden.

KOTT, A. (2006): Zum Trag- und Resttragverhalten von Verbundsicherheitsglas, Dissertation, ETH Zürich.

KRANZER, C., GÜRKE, G. und MAYRHOFER, C. (2005): »Testing of Bomb Resistant Gla-
zing Systems Experimental Investigation of the Time Dependent Deflection of Blast
Loaded 7.5 mm Laminated Glass«, in: *Glass Processing Days 2005*, Tampere, S. 497–
503.

KUNTSCHE, J. und SCHNEIDER, J. (2014a): »Experimental and numerical investigation of
the mechanical behavior of explosion resistant glazing«, in: *engineered transparency
international conference at glasstec*, Düsseldorf, S. 175–184.

KUNTSCHE, J. und MÖNNICH, S. (2012): »Quasi-statische und dynamische Zugei-
genschaften verschiedener Kunststoff-Zwischenschichten von Verbundglas«, in: *For-
schungskolloquium Baustatik-Baupraxis*, Wesel.

KUNTSCHE, J. und SCHNEIDER, J. (2013a): »Explosion resistant glazing - experimental
tests and numerical simulation«, in: *Glass Performance Days 2013*, Tampere, Finnland,
S. 85–89.

KUNTSCHE, J., SCHNEIDER, J. und KOLLING, S. (2013b): »Mechanische Eigenschaf-
ten von Glas-Verbundma- terialien unter hohen Verzerrungsraten«, in: *2. Darmstädter
Ingenieurkongress*, Darmstadt, S. 401–405.

KUNTSCHE, J. und SCHNEIDER, J. (2014b): »Mechanical behavior of polymer interlayers
in explosion resistant glazing«, in: *Challenging Glass 4 & COST Action TU0905 Final
Conference*, Lausanne, S. 447–454.

KUNTSCHE, J. et al. (2015): »Viscoelastic Properties of Laminated Glass - Theory and
Experiments«, in: *Glass Performance Days 2015*, Tampere, Finnland.

KURARAY (2012): TROSIFOL Manual, Troisdorf.

KUTTERER, M. (2005): Verbundglasplatten - Schubverbund und Membrantragwirkung,
in: *Stahlbau* Bd. 74.1-2, S. 39–46.

LSTC (2014b): LS-DYNA Keyword User's Manual - R7.1.

LSTC (2014a): LS-DYNA, R7.1.1.

LANGER, S. (2012): Numerische Simulation von Explosionsereignissen auf Verglasungen,
BSc-Thesis, Technische Universität Darmstadt.

LANGER, S. (2015): Untersuchung der viskoelastischen Materialeigenschaften von VSG-
Zwischenschichten, MSc-Thesis, Techische Universität Darmstadt.

LARCHER, M. et al. (2012): Experimental and numerical investigations of laminated glass
subjected to blast loading, in: *International Journal of Impact Engineering* Bd. 39.1,
S. 42–50.

LIU, Q. et al. (2012): »Simulation and Test Validation of Windscreen Subject to Pedestrian
Head Impact«, in: *12th International LS-DYNA Users Conference*, Detroit.

LOUTER, C. et al. (2010): Experimental investigation of the temperature effect on the
structural response of SG-laminated reinforced glass beams, in: *Engineering Struc-
tures* Bd. 32.6, S. 1590–1599.

MACKNIGHT, W. J. und EARNEST, T. R. (1981): The Structure and Properties of Iono-
mers, in: *Journal of Polymer Science: Macromolecular Reviews* Bd. 16, S. 41–122.

MEISSNER, M. und BUCAK, O. (2005): Trag- und Resttragfähigkeitsuntersuchungen an Verbundglas mit der Zwischenlage SentryGlas(R) Plus - Abschlussbericht, München.

MENCIK, J. (1992): *Strength and Fracture of Glass and Ceramics*, Amsterdam: Elsevier.

MICHALSKE, T. A. und FREIMAN, S. W. (1983): A molecular mechanism for stress corrosion in vitreous silica, in: *Journal of the American Ceramic Society* Bd. 66.4, S. 284–288.

MILLS, C. A. (1987): The design of concrete structure to resist explosions and weapon effects, Edinburgh.

MOONEY, M. (1940): A Theory of Large Elastic Deformation, in: *Journal of Applied Physics* Bd. 11, S. 582–592.

MORISON, C. (2007): The resistance of laminated glass to blast pressure loading and the coefficients for single degree of freedom analysis of laminated glass, Dissertation, Cranfield University.

MORISON, C., ZOBEC, M. und FRENCESCHET, A. (2007): »The measurement of PVB properties at high strain rates, and their application in the design of laminated glass under bomb blast«, in: *ISIEMS 2007, International Symposium on Interaction of the Effects of Munitions with Structures*, Orlando.

NASDALA, L. (2010): *FEM-Formelsammlung Statik und Dynamik*, 1. Aufl., Vieweg+Teubner.

NIE, X. und CHEN, W. W. (2010): Dynamic Ring-on-Ring Equibiaxial Flexural Strength of Borosilicate Glass, in: *International Journal of Applied Ceramic Technology* Bd. 7.5, S. 616–624.

NIELSEN, J. H., OLESEN, J. F. und STANG, H (2009): The Fracture Process of Tempered Soda-Lime-Silica Glass, in: *Experimental Mechanics* Bd. 49, S. 855–870.

NORVILLE, H. S. (2005): »Injuries Caused by Window Glass in the Oklahoma City Bombing«, in: *Glass Processing Days 2005*, S. 383–387.

ORTNER, L. (2014): Untersuchung des hochdynamischen Dehnungsverhaltens von VSG-Zwischenmaterialien, Vertieferarbeit, Technische Universität Darmstadt.

OVEREND, M. und ZAMMIT, K. (2012): A computer algorithm for determining the tensile strength of float glass, in: *Engineering Structures* Bd. 45.0, S. 68–77.

PANZNER, G. et al. (2014): Patent WO 2014005813 A1: Durchschusshemmendes Verbundglas.

PELFRENE, J. et al. (2015): Critical assessment of the post-breakage performance of blast-loaded laminated glazing: experimental and numerical simulation, in: *International Journal of Impact Engineering* Bd. Preprint.

PERONI, M. et al. (2011): Experimental investigation of high strain-rate behaviour of glass, in: *Journal of Applied Mechanics and Materials* Bd. 82, S. 63–68.

PULLER, K. (2012): Untersuchung des Tragverhaltens von in die Zwischenschicht von Verbundglas integrierten Lasteinleitungselementen, Dissertation, Universität Stuttgart.

RANKINE, W. J. M. (1857): On the Stability of Loose Earth, in: *Philosophical Transactions of the Royal Society of London* Bd. 147, S. 9–27.

RÖSLER, J., HARDERS, H. und BÄKER, M. (2012): *Mechanisches Verhalten der Werkstoffe*, 4. Auflage, Springer Vieweg.

ROTH, M. (2013): Materialmodellierung und -charakterisierung von Ionoplastfolien zur numerischen Simulation von Verbundsicherheitsglas unter stoßartiger Belastung, MSc-Thesis, Technische Universität Darmstadt.

RÜHL, A. et al. (2012): »Characterization and Modeling of Polymer Interlayers for Laminated Glass«, in: *11. LS-Dyna Forum*, Ulm, S. 146–147.

RUTNER, M. et al. (2008): Stahlkonstruktionen unter Explosionsbeanspruchung, in: *Stahlbau Kalender 2008*, hrsg. von U. KUHLMANN, Berlin: Ernst & Sohn, Kap. 6.

SJ SOFTWARE GMBH (2013): SJ Mepla, 3.5.9.

SAT-REPORT (2013): *Scientific and Technical Report: Guideline for a European Structural Design of Glass Components – Draft Version*, Techn. Ber.

SACHS, L. und HEDDERICH, J. (2006): *Angewandte Statistik: Methodensammlung mit R*, 12. Aufl., Springer.

SACKMANN, V. (2008): Untersuchungen zur Dauerhaftigkeit des Schubverbunds in Verbundsicherheitsglas mit unterschiedlichen Folien aus Polyvinylbutyral, Dissertation, TU München.

SALEM, J. und TANDON, R. (2010): Test method variability in slow crack growth properties of sealing glasses, in: *International Journal of Fatigue* Bd. 32, S. 557–564.

SAVINEAU, G. (2013): »Polymer Interlayer«, in: *Proceedings Structural Glass COST Training School 2013*, Darmstadt, S. 105–139.

SCHITTICH, C. et al. (2006): *Glasbau Atlas*, 2. Aufl., Institut für internationale Architektur-Dokumentation.

SCHNEIDER, F., SONNTAG, B. und KOLLING, S. (2004): Numerische und experimentelle Untersuchung des Tragverhaltens einer Verbund-Sicherheitsglasscheibe unter Berücksichtigung des gerissenen Zustands, in: *Bauingenieur* Bd. 79.November, S. 516–521.

SCHNEIDER, F. (2005): Ein Beitrag zum inelastischen Materialverhalten von Glas, Dissertation, Technische Universität Darmstadt, S. 197.

SCHNEIDER, J., KUNTSCHE, J. und NEUGEBAUER, J. (2015): Two engineering aspects of explosion resistant glazing, in: *Proceedings of the ICE - Structures and Buildings* Bd. xx, subm.

SCHNEIDER, J. (2001): Festigkeit und Bemessung punktgelagerter Gläser und stoßbeanspruchter Gläser, Dissertation, Technische Universität Darmstadt, S. 243.

SCHNEIDER, J. et al. (2012): »Tensile properties of different polymer interlayers under high strain rates«, in: *engineered transparency international conference at glasstec*, Düsseldorf, S. 427–437.

SCHOLZE, H. (1988): *Glas - Natur, Struktur und Eigenschaften*, Dritte, ne, Berlin: Springer.

SCHOTT AG (2014): Produktbroschüre PYRAN, PYRANOVA, NOVOLAY secure, PYRANOVA secure.

SCHULA, S. (2015): Charakterisierung der Kratzanfälligkeit von Gläsern im Bauwesen, Dissertation, Technische Universität Darmstadt.

SCHULER, C. (2003): Einfluss des Materialverhaltens von Polyvinylbutyral auf das Tragverhalten von Verbundsicherheitsglas in Abhängigkeit von Temperatur und Belastung, Dissertation, TU München.

SCHUSTER, M. (2014): Untersuchung des zeitabhängigen Materialverhaltens von VSG-Zwischenschichten, MSc-Thesis, Technische Universität Darmstadt.

SCHWARZL, F. R. (1990): *Polymermechanik*, Springer.

SESHADRI, M. et al. (2002): Mechanical response of cracked laminated plates, in: *Acta Materialia* Bd. 50, S. 4477–4490.

SHEN, X. (1997): Entwicklung eines Bemessungs- und Sicherheitskonzeptes für den Glasbau, Dissertation, Technische Hochschule Darmstadt, S. 48.

SIEBERT, G. und MANIATIS, I. (2012): *Tragende Bauteile aus Glas - Grundlagen, Konstruktion, Bemessung, Beispiele*, 2. Aufl., Ernst & Sohn.

SMITH, D. C. (2001): »Glazing for Injury Alleviation Under Blast Loading - United Kingdom Practice«, in: *Glass Processing Days 2001*, S. 335–340.

SOBEK, W., KUTTERER, M. und MESSMER, R. (2000): Untersuchungen zum Schubverbund bei Verbundsicherheitsglas – Ermittlung des zeit- und temperaturabhängigen Schubmoduls von PVB, in: *Bauingenieur* Bd. 75.1, S. 41–46.

STAMM, K. und WITTE, H. (1974): *Sandwichkonstruktionen: Berechnung, Fertigung, Ausführung*, Springer.

STANGE, R. T. P. (2015): Numerische Untersuchungen zum Nachbruchverhalten von Verbundglas unter kurzzeitiger dynamischer Beanspruchung, MSc-Thesis, Technische Universität Darmstadt.

SUN, D.-Z., OCKEWITZ, A. und ANDRIEUX, F. (2005): »Modelling of the failure behaviour of windscreens and component tests«, in: *4. LS-DYNA Anwenderforum*, Bamberg, BII: 23–32.

TU DRESDEN (2006): Prüfbericht Nr. 2006/47: Untersuchung des Schubverbunds der Zwischenschicht der Brandschutzverglasung Pyranova, Dresden: Institut für Baukonstruktion.

TAMMANN, G. (1933): *Der Glaszustand*, Leipzig: L. Voss.

THE MATHWORKS INC. (2014): Matlab, R2014b.

THOMPSON, G. M. (2010): »Detailed Windscreen Model for Pedestrian Head Impact«, in: *9. LS-DYNA Anwenderforum*, Bamberg.

TIMMEL, M. et al. (2007): A finite element model for impact simulation with laminated glass, in: *International Journal of Impact Engineering* Bd. 34.8, S. 1465–1478.

TRELOAR, L. R. G. (2005): *The Physics of Rubber Elasticity - Third Edition*, Oxford: Clarendon Press.

VALLABHAN, C. V. G., DAS, Y. C. und RAMASAMUDRA, M. (1992): Properties of PVB Interlayer Used in Laminated Glass, in: *Journal of Materials in Civil Engineering* Bd. 4.1, S. 71–76.

VAN DUSER, A., JAGOTA, A. und BENNISON, S. J. (1999): Analysis of Glass/Polyvinyl Butyral Laminates Subjected to Uniform Pressure, in: *Journal of Engineering Mechanics* Bd. 125.4, S. 435–442.

WEI, J. und DHARANI, L. R. (2006): Response of laminated architectural glazing subjected to blast loading, in: *International Journal of Impact Engineering* Bd. 32, S. 2032–2047.

WEICKER, K. (2007): *Evolutionäre Algorithmen*, Teubner.

WIEDERHORN, S. M. (1967): Influence of Water Vapor on Crack Propagation in Soda-Lime Glass, in: *Journal of the American Ceramic Society* Bd. 50.8, S. 407–414.

WOICKE, N. et al. (2004): Three-Dimensional Thermorheological Behavior of Isotactic Polypropylene Across Glass Transition Temperature, in: *Journal of Applied Polymer Science* Bd. 94.3, S. 877–880.

WÖLFEL, E. (1987): Nachgiebiger Verbund: Eine Näherungslösung und deren Anwendungsmöglichkeiten, in: *Stahlbau* Bd. 56.6, S. 173–180.

WÖRNER, J.-D., SCHNEIDER, J. und FINK, A. (2001): *Glasbau - Grundlagen, Berechnung, Konstruktion*, Springer.

WU, C. D., YAN, X. Q. und SHEN, L. M. (2010): A numerical study on dynamic failure of nanomaterial enhanced laminated glass under impact, in: *IOP Conference Series: Materials Science and Engineering* Bd. 10.

ZOBEC, M. et al. (2015): Innovative design tool for the optimization of blast-enhanced facade systems, in: *Journal of Facade Design and Engineering* Bd. Preprint.

Normen und technische Richtlinien

ASTM D1505 (1968): Standard Method of Test for Density of Plastics by the Density-Gradient Technique.

ASTM D2765 (2011): Standard Test Methods for Determination of Gel Content and Swell Ratio of Crosslinked Ethylene Plastics.

ASTM D4065 (2006): Standard Practice for Plastics: Dynamic Mechanical Properties: Determination and Report of Procedures.

ASTM D412 (2006): Standard Test Methods for Vulcanizes Rubber and Thermoplastic Elastomers - Tension.

ASTM D638 (2010): Standard Test Method for Tensile Properties of Plastics.

ASTM D696 (2003): Standard Test Method for Coefficient of Linear Thermal Expansion of Plastics Between $-30\,°C$ and $30\,°C$ with a Vitreous Silica Dilatometer.

ASTM D792 (2008): Standard Test Methods for Density and Specific Gravity (Relative Density) of Plastics by Displacement.

ASTM E1640 (2004): Standard Test Method for Assignment of the Glass Transition Temperature By Dynamic Mechanical Analysis.

ASTM F 1642 (2004): Standard Test Method for Glazing and Glazing Systems Subject to Airblast Loadings.

DIBT (2003): Technische Regeln für die Verwendung von absturzsichernden Verglasungen (TRAV).

DIBT (2006a): Technische Regeln für die Bemessung und Ausführung punktförmig gelagerter Verglasungen (TRPV).

DIBT (2006b): Technische Regeln für die Verwendung von linienförmig gelagerten Verglasungen (TRLV).

DIN 1259-1 (2001): Glas - Teil 1: Begriffe für Glasarten und Glasgruppen.

DIN 18008-1 (2010): Glas im Bauwesen - Bemessungs- und Konstruktionsregeln - Teil 1: Begriffe und allgemeine Grundlagen.

DIN 18008-2 (2010): Glas im Bauwesen - Bemessungs- und Konstruktionsregeln - Teil 2: Linienförmig gelagerte Verglasungen.

DIN 18008-4 (2013): Glas im Bauwesen - Bemessungs- und Konstruktionsregeln - Teil 4: Zusatzanforderungen an absturzsichernde Verglasungen.

DIN 52338 (1985): Prüfverfahren für Flachglas im Bauwesen - Kugelfallversuch für Verbundglas.

DIN 53479 (1991): Prüfung von Kunststoffen und Elastomeren; Bestimmung der Dichte.

DIN 53504 (2009): Prüfung von Kautschuk und Elastomeren - Bestimmung von Reißfestigkeit, Zugfestigkeit, Reißdehnung und Spannungswerten im Zugversuch.

DIN 53513 (1990): Prüfung von Kautschuk und Elastomeren - Bestimmung der viskoelastischen Eigenschaften von Elastomeren bei erzwungenen Schwingungen außerhalb der Resonanz.

DIN 53535 (1982): Prüfung von Kautschuk und Elastomeren - Grundlagen für dynamische Prüfverfahren.

DIN 7724 (1993): Polymere Werkstoffe - Gruppierung polymerer Werkstoffe aufgrund ihres mechanischen Verhaltens.

DIN EN 12150-1 (2000): Glas im Bauwesen - Thermisch vorgespanntes Kalknatron-Einscheibensicherheitsglas - Teil 1: Definition und Beschreibung.

DIN EN 12600 (2003): Glas im Bauwesen - Pendelschlagversuch - Verfahren für die Stoßprüfung und Klassifizierung von Flachglas.

DIN EN 1288-1 (2000): Glas im Bauwesen - Bestimmung der Biegefestigkeit von Glas - Teil 1: Grundlagen.

DIN EN 1288-2 (2000): Glas im Bauwesen - Bestimmung der Biegefestigkeit von Glas - Teil 2: Doppelring-Biegeversuch an plattenförmigen Proben mit großen Prüfflächen.

DIN EN 1288-3 (2000): Glas im Bauwesen - Bestimmung der Biegefestigkeit von Glas - Teil 3: Prüfung von Proben bei zweiseitiger Auflagerung (Vierschneiden-Verfahren).

DIN EN 13123-1 (2001): Fenster, Türen, Abschlüsse - Sprengwirkungshemmung - Anforderungen und Klassifizierung - Teil 1: Stoßrohr.

DIN EN 13123-2 (2004): Fenster, Türen, Abschlüsse - Sprengwirkungshemmung - Anforderungen und Klassifizierung - Teil 2: Freilandversuch.

DIN EN 13124-1 (2001): Fenster, Türen, Abschlüsse - Sprengwirkungshemmung - Prüfverfahren - Teil 1: Stoßrohr.

DIN EN 13124-2 (2004): Fenster, Türen, Abschlüsse - Sprengwirkungshemmung - Prüfverfahren - Teil 2: Freilandversuch.

DIN EN 13541 (2012): Glas im Bauwesen - Sicherheitssonderverglasung - Prüfverfahren und Kasseneinteilung des Widerstandes gegen Sprengwirkung.

DIN EN 1748-1-1 (2004): Glas im Bauwesen - Spezielle Basiserzeugnisse - Borosilicatgläser - Teil 1-1: Definitionen und allgemeine physikalische und mechanische Eigenschaften.

DIN EN 1991-1-1 (2010): Eurocode 1: Einwirkungen auf Tragwerke - Teil 1-1: Allgemeine Einwirkungen auf Tragwerke - Wichten, Eigengewicht und Nutzlasten im Hochbau.

DIN EN 1991-1-3 (2010): Eurocode 1: Einwirkungen auf Tragwerke - Teil 1-3: Allgemeine Einwirkungen - Schneelasten.

DIN EN 1991-1-4 (2010): Eurocode 1: Einwirkungen auf Tragwerke - Teil 1-4: Allgemeine Einwirkungen - Windlasten.

DIN EN 1991-1-5 (2010): Eurocode 1: Einwirkungen auf Tragwerke - Teil 1-5: Allgemeine Einwirkungen - Temperatureinwirkungen.

DIN EN 357 (2005): Glas im Bauwesen - Brandschutzverglasungen aus durchsichtigen oder durchscheinenden Glasprodukten - Klassifizierung des Feuerwiderstandes.

DIN EN 572-1 (2012): Glas im Bauwesen - Basiserzeugnisse aus Kalk-Natronsilicatglas - Teil 1: Definition und allgemeine physikalische und mechanische Eigenschaften.

DIN EN ISO 12543-1 (2011): Glas im Bauwesen - Verbundglas und Verbund-Sicherheitsglas - Teil 1: Definition und Beschreibung von Bestandteilen.

DIN EN ISO 12543-2 (2011): Glas im Bauwesen - Verbundglas und Verbund-Sicherheitsglas - Teil 2: Verbund-Sicherheitsglas.

DIN EN ISO 12543-3 (2011): Glas im Bauwesen - Verbundglas und Verbund-Sicherheitsglas - Teil 3: Verbundglas.

DIN EN ISO 12543-4 (2011): Glas im Bauwesen - Verbundglas und Verbund-Sicherheitsglas - Teil 4: Verfahren zur Prüfung der Beständigkeit.

DIN EN ISO 527-1 (2012): Kunststoffe - Bestimmung der Zugeigenschaften - Teil 1: Allgemeine Grundsätze.

DIN EN ISO 527-3 (2003): Kunststoffe - Bestimmung der Zugeigenschaften - Teil 3: Prüfbedingungen für Folien und Tafeln.

DIN EN ISO 6721-1 (2011): Kunststoffe - Bestimmung dynamisch-mechanischer Eigenschaften - Teil 1: Allgemeine Grundlagen.

DIN PrEN 16612 (2013): Glas im Bauwesen - Bestimmung des Belastungswiderstandes von Glasscheiben durch Berechnung und Prüfung - Entwurf.

DIN PrEN 16613 (2013): Glas im Bauwesen - Verbundglas und Verbundsicherheitsglas - Bestimmung der mechanischen Eingenschaften von Zwischenschichten - Entwurf.

DIN PrEN 6032 (2013): Luft und Raumfahrt - Faserverstärkte Kunststoffe - Prüfverfahren - Bestimmung der Glasübergangstemperatur - Entwurf.

GSA (1997): Security Criteria.

GSA (2003): Standard Test Method for Glazing and Window Systems Subject to Dynamic Overpressure Loadings (GSA-TS01-2003).

ISO 16933 (2007): Glass in building - Explosion-resistant security in glazing - Test and classification for arena air-blast loading.

ISO 16934 (2007): Glass in building - Explosion-resistant security in glazing - Test and classification by shock-tube loading.

UFC 3-340-02 (2008): Structures to resist the effects of accidental explosions (TM 5-1300).

A Anhang

Inhalt des Anhangs

A.1 Kurzzeitfestigkeit von Glas: Doppelring-Biegeversuche

A.1.1 Versuchsergebnisse

Tabelle A.1 Doppelringbiegeversuche: Dicke h in mm, gemittelt aus zwei Messungen

Probekörper-nummer	KNS-Float	KNS-ESG	Boro33	Boro40	Pyran
1	$4{,}83^a$	$4{,}84^a$	$4{,}95^a$	$5{,}05^a$	$4{,}96^a$
2	$4{,}84^a$	$4{,}83^a$	$4{,}94^a$	$4{,}93^a$	$5{,}05^a$
3	4,84	4,85	4,93	4,95	4,92
4	4,85	4,83	4,96	5,04	4,91
5	4,84	4,86	4,93	4,94	5,05
6	4,84	4,83	4,96	4,99	5,02
7	4,83	4,86	4,94	4,97	4,92
8	4,84	4,84	4,97	4,98	4,97
9	4,84	4,83	4,93	4,96	4,91
10	4,83	4,83	4,98	4,92	4,92
11	4,84	4,83	4,91	4,95	4,98
12	4,84	4,85	4,91	4,95	4,97
13	4,85	4,86	4,94	4,95	4,95
14	4,85	4,83	4,93	4,96	4,91
15	4,84	4,83	4,97	4,96	5,04
16	4,84	4,86	4,96	4,99	4,94
17	4,84	4,85	4,93	4,95	4,98
18	4,83	4,86	4,97	5,04	4,97
19	4,85	4,84	4,93	4,99	5,00
20	4,85	4,83	4,93	5,05	4,91
21	4,84	4,84	4,96	5,06	4,96
22	4,83	4,85	4,98	4,94	5,05
23	4,85	4,83	4,96	5,00	5,02
24	4,84	4,86	4,93	5,04	5,02
25	4,85	4,84	4,94	4,99	4,96
26	4,85	4,83	4,92	4,90	4,96
27	4,82	4,85	4,95	4,93	5,00
28	4,85	4,86	4,95	4,99	5,04
29	4,83	4,85	4,94	4,90	4,92
30	4,85	4,86	4,92	4,92	4,92
31	4,85	4,85	-	-	-
32	4,84	4,85	-	-	-
33	4,85	4,85	-	-	-
34	4,84	4,86	-	-	-
35	-	4,83	-	-	-

a DMS-Messung zur E-Modul-Bestimmung

Tabelle A.2 Doppelringbiegeversuche: Oberflächendruckspannung σ_r in MPa, gemittelt aus drei Messungen

Probekörper-nummer	KNS-Float	KNS-ESG	Boro33	Boro40	Pyran
1	0,5	-121,7	-2,1	0,1	-97,0
2	2,2	-127,1	-0,3	-0,9	-97,4
3	-0,1	-108,1	-1,1	-1,8	-94,9
4	0,8	-102,6	-0,4	-0,6	-92,5
5	0,0	-108,2	0,6	1,3	-96,0
6	0,2	-103,1	-0,5	3,4	-97,0
7	-0,2	-103,7	2,0	-2,3	-95,3
8	1,6	-123,3	-1,7	-1,1	-97,9
9	-0,4	-122,2	-0,7	1,2	-89,3
10	-0,1	-121,1	-1,0	0,5	-94,8
11	-0,6	-111,6	-1,7	1,8	-91,3
12	0,2	-126,6	1,6	-0,6	-91,8
13	2,8	-103,0	-0,7	0,8	-90,7
14	0,2	-108,8	-0,9	1,5	-94,6
15	-0,7	-113,0	2,2	-0,2	-91,1
16	0,4	-100,8	-0,7	-0,7	-89,9
17	0,7	-130,1	-0,8	-1,2	-93,4
18	0,6	-114,3	0,1	-0,4	-92,2
19	-0,5	-100,1	-0,8	1,9	-93,7
20	-0,1	-104,8	-0,8	-0,5	-93,6
21	1,5	-106,1	-0,9	-0,1	-95,2
22	2,3	-110,2	-0,4	-0,4	-92,0
23	0,7	-98,5	-0,7	-0,9	-95,2
24	1,7	-102,6	-1,0	-1,0	-91,7
25	-0,7	-95,7	2,9	-0,8	-98,6
26	1,0	-97,0	2,1	0,6	-91,4
27	1,3	-110,2	-1,0	-0,4	-95,6
28	1,7	-125,0	3,2	0,8	-93,5
29	0,6	-106,0	-1,4	-0,1	-96,0
30	0,1	-121,5	-1,2	0,0	-92,2
31	-0,5	-113,3	-	-	-
32	2,5	-105,6	-	-	-
33	0,2	-100,8	-	-	-
34	0,5	-123,4	-	-	-
35	-	-128,6	-	-	-

Tabelle A.3 Doppelringbiegeversuche: Bruchspannung σ_b in MPa

Probekörper-nummer	KNS-Float	KNS-ESG	Boro33	Boro40	Pyran
1	97,2	207,4	125,0	100,5	211,5
2	112,9	218,7	91,4	179,6	175,9
3	113,7	203,9	146,8	194,0	188,7
4	130,3	203,6	173,9	168,1	203,5
5	$-^a$	235,8	115,2	$-^a$	284,2
6	121,2	225,4	124,2	124,4	201,7
7	97,8	222,3	165,0	$-^a$	205,3
8	142,5	216,8	$-^a$	155,5	254,9
9	111,5	191,6	171,2	128,2	195,3
10	139,5	202,8	129,8	208,4	173,7
11	100,0	169,8	129,8	124,0	297,2
12	105,9	234,9	161,2	186,2	246,4
13	138,1	232,5	129,3	113,2	251,9
14	129,4	227,2	196,1	129,0	278,4
15	112,6	184,4	73,3	$-^a$	208,1
16	$-^a$	213,7	154,3	139,0	238,6
17	134,4	260,4	68,3	$-^a$	182,9
18	113,1	298,3	130,3	120,1	246,4
19	82,2	214,1	$-^a$	102,4	226,2
20	134,9	217,8	145,2	99,7	212,8
21	131,2	187,1	187,4	$-^a$	259,7
22	148,7	229,4	77,6	125,9	202,6
23	168,1	180,2	$-^a$	139,6	248,5
24	166,1	206,2	138,3	$-^a$	$-^a$
25	118,1	207,3	131,3	88,0	225,9
26	165,5	229,0	130,7	178,2	255,2
27	145,0	175,6	96,3	116,3	$-^a$
28	134,4	244,2	145,3	$-^a$	237,2
29	123,5	195,6	150,4	115,8	230,0
30	121,6	251,1	176,3	208,6	198,5
31	140,6	198,5	-	-	-
32	156,3	220,0	-	-	-
33	133,8	207,0	-	-	-
34	161,9	246,6	-	-	-
35	-	207,9	-	-	-

a Bruch außerhalb des Lastrings

Tabelle A.4 Doppelringbiegeversuche: Initialrisstiefe a_i in μm

Probekörper-nummer	KNS-Float	KNS-ESG	Boro33	Boro40	Pyran
1	7,0	4,9	2,6	4,5	3,1
2	5,0	4,0	5,6	1,1	7,3
3	4,9	5,3	1,8	0,9	5,1
4	3,6	5,3	1,2	1,3	3,6
5	$-^a$	3,0	3,2	$-^a$	1,0
6	4,3	3,6	2,7	2,7	3,8
7	6,9	3,8	1,4	$-^a$	3,5
8	3,0	4,1	$-^a$	1,6	1,4
9	5,1	6,9	1,2	2,5	4,4
10	3,1	5,4	2,4	0,8	7,8
11	6,6	12,1	2,4	2,7	0,8
12	5,8	3,0	1,4	1,0	1,6
13	3,2	3,2	2,4	3,3	1,5
14	3,7	3,5	0,9	2,4	1,0
15	5,0	8,2	9,5	$-^a$	3,3
16	$-^a$	4,4	1,6	2,0	1,9
17	3,4	2,1	11,2	$-^a$	6,0
18	5,0	1,3	2,4	2,9	1,6
19	10,1	4,3	$-^a$	4,3	2,3
20	3,4	4,1	1,8	4,5	3,0
21	3,6	7,7	1,0	$-^a$	1,3
22	2,7	3,3	8,3	2,6	3,7
23	2,1	9,1	$-^a$	2,0	1,6
24	2,1	5,1	2,1	$-^a$	$-^a$
25	4,5	5,0	2,3	6,1	2,3
26	2,1	3,4	2,4	1,1	1,4
27	2,9	10,3	4,9	3,1	$-^a$
28	3,4	2,6	1,8	$-^a$	1,9
29	4,1	6,3	1,7	3,2	2,2
30	4,2	2,4	1,2	0,8	4,1
31	3,1	5,9	-	-	-
32	2,4	3,9	-	-	-
33	3,4	5,0	-	-	-
34	2,2	2,5	-	-	-
35	-	4,9	-	-	-

a Bruch außerhalb des Lastrings

A.1.2 Auswertung mit Weibull-Verteilung

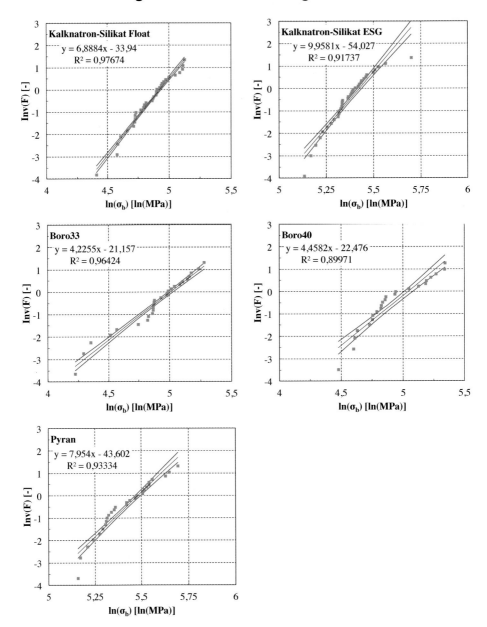

Abbildung A.1 Bruchspannungen der Doppelring-Biegeversuche, Auswertung mit Weibull-Verteilung, Angabe von Regressionsgerade und 95 %-Konfidenzintervall

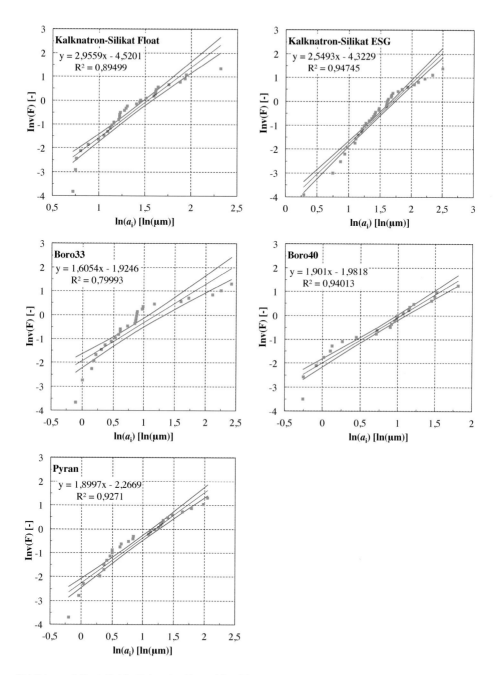

Abbildung A.2 Initialrisstiefen der Doppelring-Biegeversuche, Auswertung mit Weibull-Verteilung, Angabe von Regressionsgerade und 95 %-Konfidenzintervall

A.2 Kurzzeitfestigkeit von Glas: Pendelschlagversuche

A.2.1 Versuchsergebnisse

Tabelle A.5 Pendelschlagversuche: Dicke h in mm, gemittelt aus drei Messungen

Probekörper-nummer	KNS-Float	KNS-ESG	Boro33	Boro40	Pyran
1	4,84	4,85	4,97	4,99	5,01
2	4,85	4,85	4,96	5,00	4,90
3	4,83	4,85	4,98	4,98	4,99
4	4,9	4,85	4,92	4,99	4,99
5	4,88	4,87	4,96	5,00	5,00
6	-	4,85	4,96	4,98	-

Tabelle A.6 Pendelschlagversuche: Bruchspannung σ_b in MPa

Probekörper-nummer	KNS-Float	KNS-ESG	Boro33	Boro40	Pyran
1	221	376[a]	162	232	270[a]
2	122	242[a]	179	211	263[a]
3	210	396[a]	162	177	168[a]
4	216	395[a]	150	180	205[a]
5	168	-[b]	162	143	301[a]
6	-	286[a]	220	205	-

[a] Erhöhtes Pendelgewicht und Reifendruck
[b] Glasbruch durch Pendelrückschlag

Tabelle A.7 Pendelschlagversuche: Initialrisstiefe a_i in µm

Probekörpernummer	KNS-Float	KNS-ESG
1	1,90	1,75
2	9,45	6,18
3	2,13	1,32
4	1,40	1,44
5	3,90	_[a]
6	-	2,76

[a] Glasbruch durch Pendelrückschlag

A.2.2 Auswertung mit Weibull-Verteilung

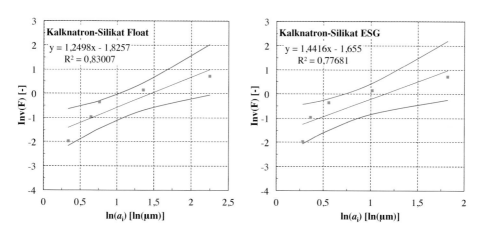

Abbildung A.3 Initialrisstiefen der Pendelschlagversuche, Auswertung mit Weibull-Verteilung, Angabe von Regressionsgerade und 95 %-Konfidenzintervall

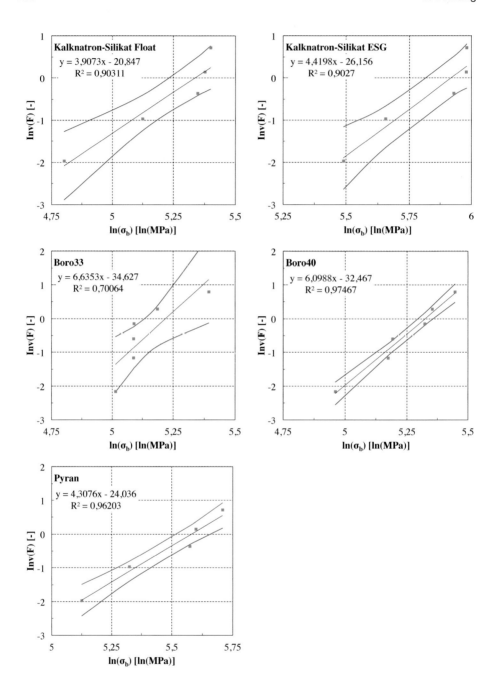

Abbildung A.4 Bruchspannungen der Pendelschlagversuche, Auswertung mit Weibull-Verteilung, Angabe von Regressionsgerade und 95 %-Konfidenzintervall

A.3 Zwischenschichten: DMTA

Die Abmessungen der Probekörper wurden mit einer digitalen Bügelmessschraube (*Helios Digimet 40 EX*, Genauigkeit 4 µm) vermessen.

Tabelle A.8 Vorgaben zur DMTA bei Temperatursweeps im Zugmodus

Einstellungen	Einheit	PVB BG	EVA G77	SG5000
Untere Temperaturgrenze T_{min}	[°C]	−120	−100	−120
Obere Temperaturgrenze T_{max}	[°C]	+100	+100	+100
Heizrate \dot{T}	[K min^{-1}]	2,0	2,0	2,0
Frequenz f	[Hz]	1,0	1,0	1,0
max. Kraftamplitude \bar{F}	[N]	8,0	8,0	8,0
max. Deformation \bar{x}	[µm]	10	20	10
Offset	[%]	130	120	130
Einspannlänge l	[mm]	5,5	5,5	5,5
Probenbreite b	[mm]	6,3	6,1	5,8
Probendicke h	[mm]	1,5	0,6	1,6

Tabelle A.9 Vorgaben zur DMTA bei Temperatursweeps im Torsionsmodus

Einstellungen	Einheit	PVB BG	EVA G77	SG5000
Untere Temperaturgrenze T_{min}	[°C]	−80	−80	−80
Obere Temperaturgrenze T_{max}	[°C]	+80	+80	+80
Heizrate \dot{T}	[K min^{-1}]	1,0	1,0	1,0
Frequenz f	[Hz]	1,0	1,0	1,0
max. Deformation $\bar{\gamma}$	[%]	0,02	0,02	0,02
Vorspannkraft	[N]	0,2	0,2	0,2
Einspannlänge l	[mm]	26,4	26,2	26,0
Probenbreite b	[mm]	10,1	10,0	10,1
Probendicke h	[mm]	1,5	0,7	1,0

Tabelle A.10 Vorgaben zur DMTA bei Temperatursweeps in der Doppelscherung (Material)

Einstellungen	Einheit	PVB				EVA		SG5000
		BG	SC	ES	K7026	G77	S88	
T_{\min}	[°C]	−80	−80	−80	−80	−80	−80	−80
T_{\max}	[°C]	+80	+80	+80	+80	+80	+80	+80
\dot{T}	[K min^{-1}]	2,0	2,0	2,0	2,0	2,0	2,0	2,0
f	[Hz]	1,0	1,0	1,0	1,0	1,0	1,0	1,0
\bar{F}	[N]	4,0	4,0	4,0	4,0	4,0	4,0	4,0
\bar{x}	[µm]	2,0	2,0	2,0	2,0	2,0	2,0	2,0
\varnothing	[mm]	11,1	10,0	10,1	11,2	11,5	11,4	11,2
h	[mm]	0,7	1,1	0,9	0,8	0,7	0,9	1,0

Tabelle A.11 Vorgaben zur DMTA bei Temperatursweeps in der Doppelscherung (Laminat)

Einstellungen	Einheit	PVB BG
Untere Temperaturgrenze T_{\min}	[°C]	−80
Obere Temperaturgrenze T_{\max}	[°C]	+80
Heizrate \dot{T}	[K min^{-1}]	1,0
Frequenz f	[Hz]	10,0
max. Kraftamplitude \bar{F}	[N]	140
max. Deformation $\bar{\gamma}$	[%]	1,0
Probendurchmesser \varnothing	[mm]	20,0
Foliendicke h	[mm]	1,4

Tabelle A.12 Vorgaben zur DMTA bei Frequenzsweeps im Torsionsmodus: 10 °C-Schritte/5 °C-Schritte

Einstellungen	Einheit	PVB BG	EVA G77	SG5000
Untere Temperaturgrenze T_{\min}	[°C]	−80/−80	−80/−80	−80/−80
Obere Temperaturgrenze T_{\max}	[°C]	+70/+80	+80/+80	+80/+80
Temperaturschritte ΔT	[°C]	10/5	10/5	10/5
Untere Frequenzgrenze f_{\min}	[Hz]	0,01/0,01	0,01/0,01	0,01/0,01
Obere Frequenzgrenze f_{\max}	[Hz]	50/50	50/50	50/50
Messpunkte[a]	[-]	10/10	10/10	10/10
max. Deformation $\bar{\gamma}$	[%]	0,1/0,02	0,02/0,02	0,1/0,02
Vorspannkraft (Zug)	[N]	0,3/0,3	0,3/0,3	0,3/0,3
Einspannlänge l	[mm]	32,0/28,4	32,2/28,3	39,6/38,3
Probenbreite b	[mm]	10,0/10,1	10,0/10,1	10,0/10,0
Probendicke h	[mm]	1,7/1,5	0,7/0,7	1,0/1,0

[a] pro Frequenzdekade, logarithmisch äquidistant verteilt

Tabelle A.13 Vorgaben zur DMTA bei Frequenzsweeps in der Doppelscherung (Material)

Einstellungen	Einheit	PVB BG	EVA G77	SG5000
Untere Temperaturgrenze T_{min}	[°C]	−40	−40	−40
Obere Temperaturgrenze T_{max}	[°C]	+50	+50	+80
Temperaturschritte ΔT	[°C]	10	10	10
Untere Frequenzgrenze f_{min}	[Hz]	0,01	0,01	0,01
Obere Frequenzgrenze f_{max}	[Hz]	100	100	100
Messpunkte[a]	[-]	5	5	5
max. Kraftamplitude \bar{F}	[N]	4,0	4,0	4,0
max. Deformation \bar{x}	[µm]	2,0	2,0	2,0
Probendurchmesser ⌀	[mm]	10,0	10,5	10,3
Probendicke h	[mm]	0,7	0,7	0,9

[a] pro Frequenzdekade, logarithmisch äquidistant verteilt

Tabelle A.14 Vorgaben zur DMTA bei Frequenzsweeps in der Doppelscherung (Laminat)

Einstellungen	Einheit	EVA G77	SG5000
Untere Temperaturgrenze T_{min}	[°C]	−80	−80
Obere Temperaturgrenze T_{max}	[°C]	+100	+100
Temperaturschritte ΔT	[°C]	10	10
Untere Frequenzgrenze f_{min}	[Hz]	0,01	0,01
Obere Frequenzgrenze f_{max}	[Hz]	100	100
Messpunkte[a]	[-]	10	10
max. Kraftamplitude \bar{F}	[N]	100	100
max. Deformation $\bar{\gamma}$	[%]	1,0	1,0
Probendurchmesser ⌀	[mm]	20,0	20,0
Probendicke h	[mm]	1,5	1,5

[a] pro Frequenzdekade, logarithmisch äquidistant verteilt

A.4 Zwischenschichten: Zugversuche

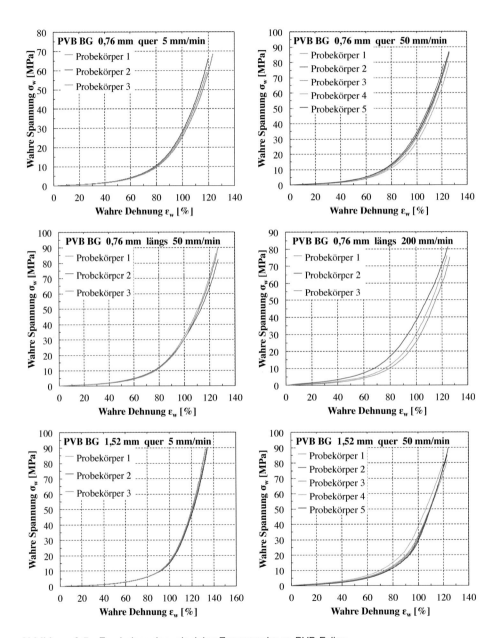

Abbildung A.5 Ergebnisse der uniaxialen Zugversuche an PVB-Folien

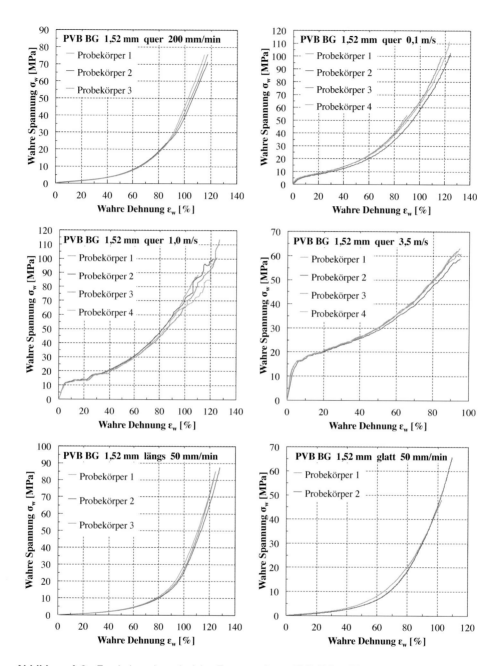

Abbildung A.6 Ergebnisse der uniaxialen Zugversuche an PVB-Folien (Fortsetzung 1)

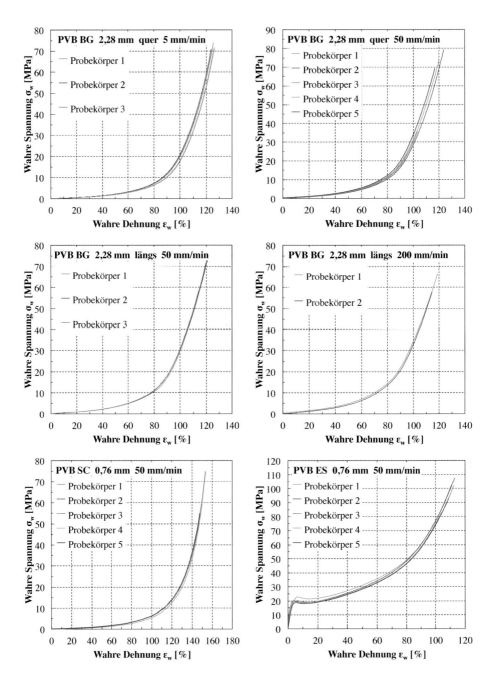

Abbildung A.7 Ergebnisse der uniaxialen Zugversuche an PVB-Folien (Fortsetzung 2)

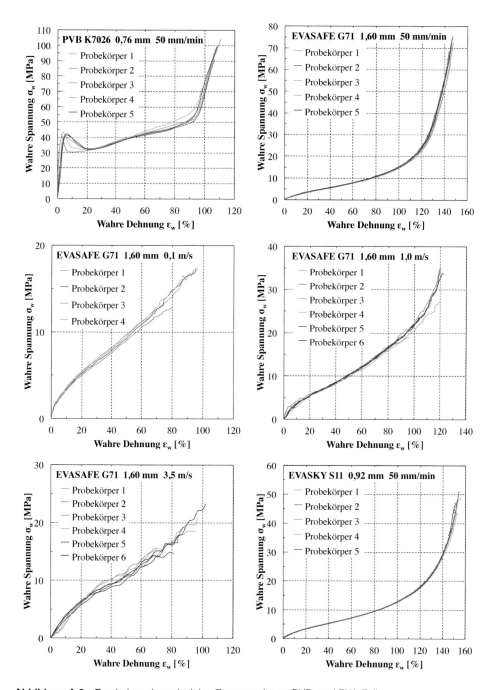

Abbildung A.8 Ergebnisse der uniaxialen Zugversuche an PVB- und EVA-Folien

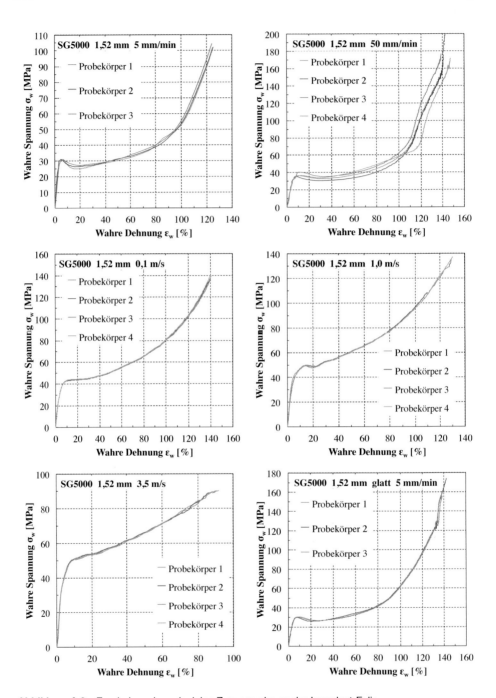

Abbildung A.9 Ergebnisse der uniaxialen Zugversuche an der Ionoplast-Folie

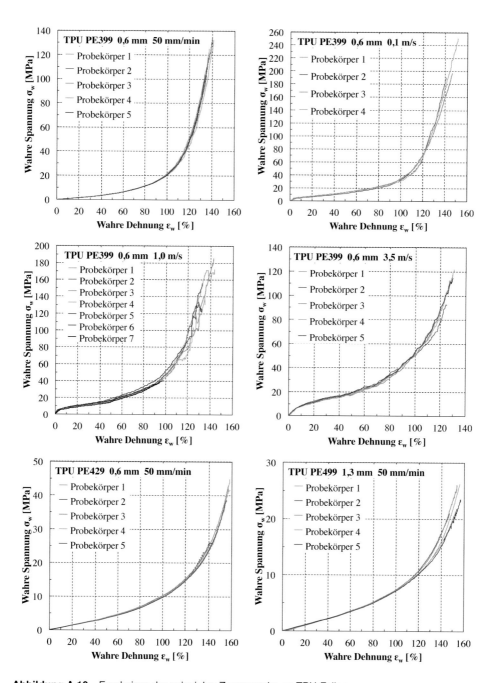

Abbildung A.10 Ergebnisse der uniaxialen Zugversuche an TPU-Folien

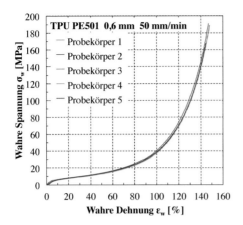

Abbildung A.11 Ergebnisse der uniaxialen Zugversuche an TPU-Folien (Fortsetzung)

A.5 Zwischenschichten: Algorithmus zur Ableitung von Prony-Parametern

A.5.1 Genetischer Algorithmus

```
% Verwendet in Matlab R2014b (THE MATHWORKS INC., 2014)

% Beispieleinträge entsprechend anpassen

% Anzahl der unbekannten Feder-Dämpfer-Elemente N festlegen
N = 32;
n = N+1;

% untere Grenzen der Parameter anpassen
GinfMin = 0;
gMin = 0;

% Länge des Vektors lb auf N+1 anpassen (N Einträge mit gMin)
lb = [GinfMin gMin gMin ... gMin];

% obere Grenzen der Parameter anpassen
GinfMax = 1.5;
gMax = 0.3;

% Länge des Vektors ub auf N+1 anpassen (N Einträge mit gMax)
ub = [GinfMax gMax gMax ... gMax];

% Nebenbedingung: sum(gi)<1
% Toleranz der Nebenbedingung mit b anpassen
% Länge des Vektors A auf N+1 anpassen (N Einträge mit 1)
A = [0 1 1 ... 1];
b = [1-1e-3];

% Populationsgröße und Generationenanzahl festlegen
options = gaoptimset('TolFun', 1e-8, 'PopulationSize', 100, 'Generations', 12, 'PlotFcns',
@gaplotbestf, 'UseParallel', true)

% Aufruf des genetischen Algorithmus ga, Bezug auf Zielfunktion myfun
[x, fval, exitflag, output, population, scores] = ga(@myfun, n, A, b, [], [], lb, ub, [],
options);
```

A.5.2 Gradientenverfahren

% Verwendet in Matlab R2014b (THE MATHWORKS INC., 2014)

% Anzahl der unbekannten Feder-Dämpfer-Elemente N festlegen
N = 32;
n = N+1;

% untere Grenzen der Parameter anpassen
GinfMin = 0;
gMin = 0;

% Länge des Vektors lb auf N+1 anpassen (N Einträge mit gMin)
lb = [GinfMin gMin gMin ... gMin];

% obere Grenzen der Parameter anpassen (N Einträge mit gMax)
% stärkere Einschränkung aus den Ergebnissen des genetischen Algorithmus möglich
GinfMax = 0.7;
gMax = 0.2;

% Länge des Vektors ub auf N+1 anpassen (N Einträge mit gMax)
ub = [GinfMax gMax gMax ... gMax];

% Nebenbedingung: sum(gi)<1
% Toleranz der Nebenbedingung mit b anpassen
% b kann gegenüber dem genetischen Algorithmus reduziert werden
% Länge des Vektors A auf N+1 anpassen (N Einträge mit 1)
A = [0 1 1 ... 1];
b = [1-1e-5];

% Vorgabe der aus dem genetischen Algorithmus ermittelten Prony-Parameter
% als Startwerte für den Vektor x0
x0 =[0.537699444106820 1.08868517192767e-05 ... 1.16465241677516e-05];

% Anzahl der maximalen Iterationen und weitere Optionen festlegen
options = optimoptions(@fmincon,'Algorithm','interior-point', 'MaxIter',500,
'TolCon',1e-10, 'TolFun', 1e-6, 'TolX',1e-10, 'PlotFcns', @optimplotfval,
'UseParallel', true);

% Definition des Optimierungsproblems mit Bezug auf Zielfunktion myfun
problem = createOptimProblem('fmincon','x0',x0, 'objective',@myfun,'lb',lb, 'ub',
ub,'Aineq', A, 'bineq', b,'options',options);

% Aufruf des globalen Optimierers mit Gradientenverfahren
% Maximale Berechnungszeit in Sekunden festlegen
gs = GlobalSearch('Display', 'iter','TolX',1e-6,'MaxTime',3600, 'StartPointsToRun',

```
'bounds-ineqs');
[x, fval, eflag, output] = run(gs,problem);
```

A.5.3 Zielfunktion

% Verwendet in Matlab R2014b (THE MATHWORKS INC., 2014)

```
function f = myfun(x)
```

```
Ginf = x(1)
gi = [x(2:length(x))]
G0 = [Ginf/(1-sum(gi))]
sumgi = sum(gi)
```

% tauMax entsprechend t(max) für eingelesene Messdaten wählen
% Länge des Vektors taui auf N anpassen

```
tauMax = 1E+10;
taui = [tauMax tauMax*10^-1 tauMax*10^-2 ... tauMax*10^-31];
```

```
syms w;
```

```
G(w) = Ginf + G0*sum(gi.*(taui.^2).*(w.^2)./(1+(taui.^2).*(w.^2)));
V(w) = G0*sum(gi.*taui.*w./(1+(taui.^2).*(w.^2)));
```

% Excel Tabelle mit Messdaten:
% 1. Spalte: Kreisfrequenz
% 2. Spalte: Speichermodul
% 3. Spalte: Verlustmodul

```
Mdat = xlsread('Dateiname');
wm = [Mdat(:,1)];
Gm = [Mdat(:,2)];
Vm = [Mdat(:,3)];
```

% Zielfunktion f

```
f = sum((log(G(wm))-log(Gm)).^2+10*(log(V(wm))-log(Vm)).^2);
f = double(f)
```

```
end
```

A.6 Nachbruchverhalten: TCT Tests

Schema der Probekörperbezeichnung:

1. Ziffer: Geschwindigkeit (1: 6 mm min^{-1}, 2: 600 mm min^{-1}, 3: 60000 mm min^{-1})

2. Ziffer: Material (1: PVB BG R10, 2: PVB BG R15, 3: PVB BG R20, 4: PVB ES)

3. Ziffer: Probekörpernummer (1-10: 30 mm Breite, 11-20: 50 mm Breite, Ausnahme 60000 mm min^{-1}: alle Probekörper 50 mm Breite)

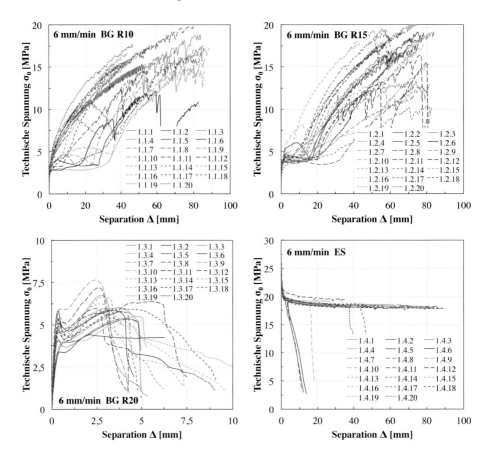

Abbildung A.12 TCT-Tests mit 6 mm min^{-1}

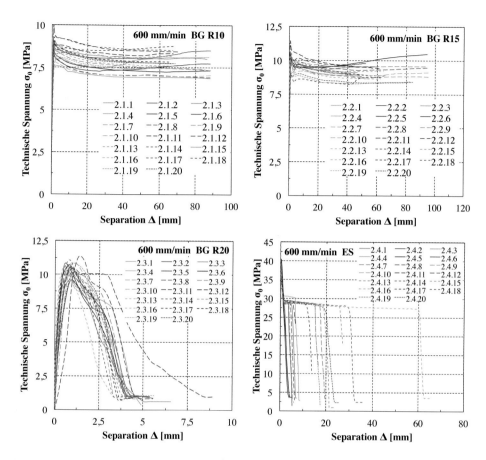

Abbildung A.13 TCT-Tests mit 600 mm min^{-1}

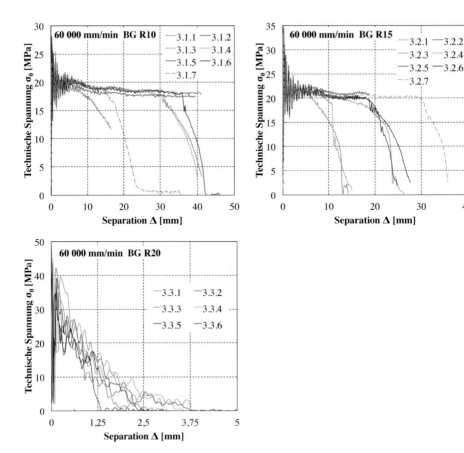

Abbildung A.14 TCT-Tests mit 60 000 mm min^{-1}